LEROY NEIMAN

LeRoy Neiman

The Life of America's Most Beloved and Belittled Artist

TRAVIS VOGAN

THE UNIVERSITY OF CHICAGO PRESS

Chicago and London

The University of Chicago Press, Chicago 60637
The University of Chicago Press, Ltd., London
© 2024 by The University of Chicago
Published 2024
Printed in the United States of America

33 32 31 30 29 28 27 26 25 24 1 2 3 4 5

ISBN-13: 978-0-226-82007-1 (cloth)
ISBN-13: 978-0-226-82008-8 (e-book)
DOI: https://doi.org/10.7208/chicago/9780226820088.001.0001

Library of Congress Cataloging-in-Publication Data

Names: Vogan, Travis, author.
Title: LeRoy Neiman : the life of America's most beloved and
 belittled artist / Travis Vogan.
Description: Chicago : The University of Chicago Press, 2024. |
 Includes bibliographical references and index.
Identifiers: LCCN 2024002402 | ISBN 9780226820071 (cloth) |
 ISBN 9780226820088 (ebook)
Subjects: LCSH: Neiman, LeRoy, 1921–2012. | Artists—United
 States—Biography. | Sports artists—United States—Biography.
Classification: LCC N6537.N39 V64 2024 | DDC 709.2 [B]—dc23/
 eng/20240126
LC record available at https://lccn.loc.gov/2024002402

⊚ This paper meets the requirements of ANSI/NISO Z39.48-1992
(Permanence of Paper).

FOR POLLY

There is no artist in America who is as loved by the people. No one. Hey, I'm not bragging, you know? I've got the magic.

—LEROY NEIMAN

It's not what Picasso or Matisse did. But it's reaching a lot of people.

—LEROY NEIMAN

Contents

Illustrations

Pure Neimanism

A December 1981 article in *Sports Illustrated*'s miscellaneous "Scorecard" section opens by expressing astonishment at the utter pervasiveness of LeRoy Neiman's art. It reported that three of the celebrity artist's colorful sports-themed prints were hanging in an eighth-floor conference room at the Arms Control and Disarmament Agency building in Geneva, where a collection of American and Soviet diplomats met to negotiate limits on intermediate-range nuclear weapons. The Americans and Soviets sat on opposite sides of a large, stately table. The US envoys faced windows looking out onto Lake Geneva and the Alps. The Russians beheld a wall filled with Neiman's vibrant depictions of hockey, tennis, and football. "We wouldn't be surprised if those seating arrangements wind up costing the US side a Pershing II missile or two," *Sports Illustrated* quipped.[1] Neiman's art, the magazine joked, is obnoxious—a tacky irritant that might derail the tense negotiations. Over twenty years later, an issue of Marvel Comics' *Astonishing X-Men* featured the telepathic superhero Emma Frost threatening to ruin a sleazy socialite at a ritzy art fundraiser. "Tell me," Frost seethes, "would you like to spend the rest of your life obsessed with the works of LeRoy Neiman?"[2] Associating with Neiman, Frost implies, would guarantee the sophisticate's professional and social demise by suggesting his tastes are pedestrian.

LeRoy Neiman—the cigar-chomping and mustachioed artist famous for his vivid illustrations of the high life for *Playboy* magazine, portraits of athletes and entertainers, and appearances on sports television—stood among the twentieth century's best-known, wealth-

iest, and most polarizing artists. He was famous enough for sports magazines and comic books to drop his name with confidence that their readers would get the reference. He was notorious enough for them to wager that audiences would not only recognize Neiman but also be aware of his reputation as a purveyor of bad art that panders to the undiscerning. Few artists have achieved the sort of sustained infamy that would enable sites as diverse as *Sports Illustrated* and *Astonishing X-Men* to use their maligned image as a gag.

And these lighthearted jests represent a decidedly gentler portion of the cutting excoriation Neiman regularly attracted—much of which accused him of being an opportunistic schlockmeister who filtered popular subject matter through a splashy, Technicolor style that borrowed from impressionist and abstract expressionist traditions. Critics accused Neiman of creating easily digestible work that seamlessly jibed with the mass cultural products that made him famous. Neiman's legions of fans, however, adored his stylish but legible renderings of popular culture. And they paid handsomely to display those works in their living rooms, dens, offices, and restaurants.

Neiman billed himself as a creative and entrepreneurial maverick who managed to find a loyal audience without needing the support of the traditional art establishment. "I've got a little of everything in my work," the artist said, "but it adds up to something unique. No one else can paint the way I do." When pressed to describe his style, LeRoy maintained that he did not believe any established school or tradition could adequately characterize his singular approach. "It's pure Neimanism," he declared. "It's never been copied."[3]

Considering Neiman's accessible style, popular subject matter, flamboyant persona, and impeccable timing, the artist seems like he could have been the product of a savvy marketing team looking to sell art to the millions who read *Playboy*, loved sports, and watched TV— a mainly middle-class and male audience not traditionally known for frequenting museums or using its disposable income to purchase art. The businesspeople, of course, eventually caught on and found more ways to capitalize on LeRoy than the entrepreneurial artist could ever have imagined himself. But Neiman's actual ascendance as a celebrity

artist has a fanciful and even Algeresque quality: He was raised by a poor single mother in Depression-era St. Paul, Minnesota. The self-described street kid had a knack for art but lacked the social and economic resources necessary to transform his hobby into a career. He dropped out of high school at seventeen and was drafted into World War II, where he served as an army cook in the European theater.

After returning from war, Neiman used the GI Bill to enroll at the School of the Art Institute of Chicago. He aspired to become a serious artist, the type whose works hang in galleries and fetch record-breaking prices at auction. But he initially settled into a more practical career as a fashion illustrator. LeRoy still painted during his free time and became especially interested in Chicago's decadent nightlife. His creative interests made him a good match for Hugh Hefner, a publisher whom Neiman met through his day job. Hefner recruited Neiman to help create an urbane style for *Playboy*, the men's magazine he had launched in 1953. LeRoy became the artist-in-residence for Hefner's pleasure-seeking empire and designed many of the visual hallmarks that made *Playboy* into one of America's trendiest and most controversial publications.

The artist parlayed his work for Hefner into jobs depicting sports and entertainment, two of *Playboy*'s favorite topics. He developed an uncanny knack for identifying rising stars and using his art to promote those figures and gain their favor. LeRoy helped create images for the boxer Muhammad Ali and the football player Joe Namath—two of the most marketing-savvy and culturally significant athletes of their time—that were rooted in the cosmopolitan manliness he showcased in *Playboy*. The artist became a fixture at big-ticket sporting events, a precursor to the Goodyear Blimp who amplified the spectacular scenes he documented. The ABC television network took notice and hired Neiman to enhance its sports broadcasts, which led to TV appearances at the Olympics, the Super Bowl, and championship prizefights. Millions watched Neiman sketch and paint the events on camera, often live and in prime time. Complementing *Playboy* and network television, LeRoy's art contributed to a postwar, middle-brow taste culture that fused sex, sports, and entertainment. His work

became the preferred decor for those who identified with and aspired to participate in this exciting and pleasure-seeking lifestyle.

The attention-hungry painter maximized his exposure by cutting an unmistakable and Salvador Dalí–inspired public figure that included a jet-black handlebar mustache, long cigars dangling from his mouth, loud suits, Panama hats, and eye-catching young female assistants who handed him pens and combed his hair when it became tousled. Few salable subjects managed to escape LeRoy's attention, whether Sugar Ray Robinson, Tina Turner, or Pelé. And Neiman's attention made his subjects even more salable. He was ringside at Muhammad Ali and Joe Frazier's 1971 Fight of the Century, courtside for Billie Jean King and Bobby Riggs's 1973 Battle of the Sexes, and on the sidelines during the Super Bowl III victory that Joe Namath guaranteed. When CBS decided to air the 1978 Super Bowl in prime time—a first in sports TV—it hired LeRoy to spice up the broadcast by "painting" his impressions of the game on an experimental Electronic Palette. Noticing Neiman's renown in popular culture, the Carter administration invited the artist to document the March 1979 signing of the landmark Egypt-Israel peace treaty at the White House.

The unprecedented exposure sparked unprecedented demand for Neiman's art. LeRoy capitalized on the market by moving beyond original works to licensing prints and posters that could accommodate a broad range of customers. In perhaps the most audacious move of his career, Neiman partnered with the fast-food chain Burger King during the 1976 Olympics to give away posters of his sports paintings along with the purchase of a meal. Neiman's artwork, then, was virtually everywhere: magazines, posters, advertisements, TV broadcasts, bedroom walls, and restaurants. It was even on the hoods of sports cars after LeRoy collaborated with a Connecticut Chevrolet dealer to design a limited-edition series of LeRoy Neiman Corvettes in 1984.

His pervasive work was not, however, in museums or other places devoted to hosting art and facilitating its appreciation. Neiman's art was actively denied entry into those rarefied spaces largely because of its ubiquity and the relatively unschooled audience it attracted. The *New York Times'* John Russell charged that Neiman "makes modern

art for people who hate art." "Neiman's paintings require no work from viewers," echoed the *Los Angeles Times*' Harper Hilliard: "Like TV, they provide a passive kind of enjoyment."[4] Such reviews disregarded Neiman's creations as "kitsch," or frivolous art that, as Clement Greenberg famously put it "provides vicarious experience for the insensitive." More specifically, Neiman's work embodies middlebrow art, a variety of kitsch that, as Dwight Macdonald argued "pretends to respect the standards of High Culture while in fact it waters them down and vulgarizes them."[5] According to critics like Russell and Hilliard—whose judgments were informed by Greenberg and Macdonald—Neiman's work was not simply bad; it was offensive because it masqueraded as art without offering the sorts of intellectual and aesthetic challenges that they believed respectable art ought to provide.

The critical scorn often responded less to Neiman's art itself than to its appearance in settings that did not stereotypically house art—what the sociologist Pierre Bourdieu called "art worlds."[6] But the popular arenas used Neiman's work—and his status as an easily identifiable "artist," with all the sartorial trimmings—to build a sense of middlebrow respectability. They also served a democratizing function that made his art available to groups of people who might not have had the resources to purchase art or even visit a museum. Many loved Neiman precisely because his work appeared in *Playboy* and on TV—the very reasons he drew such venomous contempt. Neiman enthusiasts, contrary to Russell's perspective, do not hate art. Rather, they like art that many believe is invalid. "You don't have to have a college degree to understand it," admitted the Minnesota-based art dealer Robert Varner, who built his business around buying and selling Neimans.[7] While that middlebrow accessibility ensured tremendous profits for Neiman and his dealers, it also threatened to muddy the divisions separating cultural elites from everyday folks—socioeconomically tinged boundaries that one's taste in art helps to fortify.[8]

And Neiman did not follow the unspoken rules by which "legitimate" artists are supposed to abide. Art, for instance, should be a product of unique creative inspiration, not a calculated effort to make

money.[9] LeRoy claimed he would paint in the same style regardless of his astounding commercial success. But his art was far from priceless. He worked fast, mainly by commission, and would paint about anything if clients agreed to his ample rates. Like most contractors, Neiman charged by the scope of the job. "It's all about size," he told the *Washington Post* in 1997. "The bigger, the more expensive."[10] LeRoy was sure to depict his often-influential subjects in a flattering light. While he claimed to prefer his rose-tinted approach, it also shrewdly helped him to access image-conscious figures and recruit more customers. Neiman made no apologies for the millions of dollars such jobs generated. "Excellence, success, and financial reward go together," he told the *Chicago Tribune* in 1978. "I can't possibly do what I've done without getting money for it in our society."[11]

Neiman not only made lots of money but also boasted about it—another art world no-no. "I'm not just loved. I'm superloved," he said. "People love my paintings, they don't just like them. I have a generous talent going for me and I have always been a hotshot."[12] While this was an unusual way for an artist to talk, LeRoy's braggadocio was comfortably at home in the popular and brand-conscious settings where he circulated. It reflected Hugh Hefner's hypermasculine posturing, Muhammad Ali's claims that he was "the Greatest," and Joe Namath's audacious promise that his Jets would win the Super Bowl. To be sure, other artists did commercial work without suffering the same mocking disdain Neiman endured. Andy Warhol had diverse business interests and was open about his pursuit of money. But Warhol's commercialism was always glazed with an ambiguous coating of irony, which dangled the possibility that he was satirizing as much as participating in American business culture. Neiman, in contrast to his similarly ostentatious contemporary, came off like a corporate-friendly pitchman eager to please his audience. "If you want a Neiman, you get a Neiman," he said of his commissions.[13] Neiman paired his creative talents and flashy image to build name-brand art, which he authenticated with an oversize trademark signature.

Badmouthing LeRoy became an easy way for cultural elites to broadcast their pedigree. "Taste," wrote the poet and critic Paul

Valéry, "is composed of a thousand distastes." "Taste classifies," Bourdieu added, "and it classifies the classifier."[14] Neiman bashing composed as powerful a statement of one's status as casually name-dropping Hilma af Klint or Clyfford Still.

LeRoy fancied himself a populist dissident who was unfairly outcast by a petty and hypocritical art establishment that strategically suppressed its economic motives. "In the art world you are supposed to make all your money within the prescribed limits the critics set up," he huffed. "And I didn't. And they resented it."[15] LeRoy loved antagonizing snobby gatekeepers with his fame and wealth. But he also desperately craved their approval. Neiman, in short, tried to have it both ways—with minimal success. He never seemed to understand—or at least never admitted to understanding—how he could at once be so beloved and so belittled. But Neiman provides a lens through which to consider the tensions between mainstream popularity and critical esteem in art culture.

While critics regularly smeared Neiman's art as simplistic, the artist himself could be inscrutable. He repeatedly claimed—and seemed to believe—that he was producing fine art. But LeRoy, much like Dalí and Warhol, was also a canny huckster. He used his distinctive persona to create a salable brand for his art while reassuring his audience that "Neimans" were legitimate works deriving from his uncompromised aesthetic vision. The line separating Neiman's earnest creative inspiration from his calculated business strategy, however, was a murky one. Neiman himself sometimes seemed to have trouble distinguishing his true self from the image he spent so many decades refining.

Like his commissioned paintings, Neiman tailored comments to his audience, demonstrating a capriciousness that makes him hard to pin down. He was a hardscrabble and foul-mouthed Midwesterner who wound up owning ten units in the exclusive Hotel des Artistes on Manhattan's Upper West Side. He lived a lavish and sybaritic life, but he was also a cheapskate perpetually searching for angles to exploit. LeRoy could be at turns self-mocking and thin-skinned. He was willing to camp it up alongside Liberace on *Late Night with David Letter-*

man but would fly off the handle when journalists failed to capital-
ize the *R* in his first name. He was a devoted husband for fifty-five
years and a swinger who gloated about his girlfriends, many of whom
doubled as his assistants. And Neiman was both a shameless show-
man and a guarded introvert. He took his sketch pad everywhere. It
was a prop and part of his gaudy uniform that reliably commanded
attention. But the tablet also brokered awkward social interactions
by composing a barrier that insulated LeRoy from an often unfriendly
outside world.

Neiman has not received much consideration despite—but also
because of—his incredible fame. His work is not included in most
major museums. And when it does show up in such prestigious
locales, it tends to be relegated to the periphery, as if it might poison
their featured works if placed too close to them. The sole Neiman that
the Art Institute of Chicago has on permanent display is at a student
center down the street from its museum—a piece that was installed
only as a condition of a $5 million gift LeRoy gave his alma mater in
2011. Art historians have not given Neiman more than passing men-
tion, and even Allen Guttmann's *Sports and American Art*—the only
scholarly survey of American sports art—provides LeRoy with but a
single short paragraph that snidely dismisses the artist and those who
admire his work.[16]

Neiman maintained that he would never trade his adoring popular
audience for critical praise. But he spent millions of dollars on efforts
to secure a favorable place in history, which was one expense about
which he was decidedly not tightfisted. Neiman's staff helped him
compile a massive archive of his works and papers. The Smithsonian
eventually took eighty-one boxes, but many more remain at his old
studio in Manhattan and in off-site storage facilities. He wrote books
and produced documentaries that carefully inserted himself into rec-
ognized artistic and intellectual traditions. Neiman also made huge
donations that attached his name to institutions that would otherwise
be unwilling to associate with him. "They have a certain say about the
quality of my work," the artist said of his critics, "and hopefully his-

torians could turn that around."[17] He spent extravagantly in hopes of eventually tilting his narrative in a more laudatory direction.

This book—the first on the artist that he did not write or commission—takes Neiman seriously. It might not be the biography that the chronically self-aggrandizing artist would have chosen, and it is not a reclamation project that argues he ought to be placed alongside contemporaries like Helen Frankenthaler, Jasper Johns, or even Warhol. Instead, it both tells Neiman's unlikely story and puts him into the intersecting cultural contexts he helped to reshape through interviews with those who knew him, critical analyses of his works, and explorations of his archives—including journals, datebooks, sketches, and artifacts that are not publicly available. This contextualization shows how Neiman contributed to the creation of a middlebrow taste culture that jostled norms governing what art is, where it is welcome, and who should have access to it. It also demonstrates how Neiman helped to remake many of popular culture's most popular settings into sites of creative achievement that deployed art for a variety of aesthetic and commercial purposes. To some, LeRoy's presence made these sites even more impressive. To others, his involvement further degraded the already lowbrow. Indeed, one's opinion about Neiman said a lot about where they fit into cultural hierarchies and how they hoped to be perceived. LeRoy Neiman and his colorfully vibrant Neimanism illustrate the persistent but conflicted place of popular culture in art and art in popular culture.

PART 1

Underdog

1

LeRoy Runquist

Neiman described his hometown of St. Paul, Minnesota as a place that "championed appearances" during the Depression era, when he grew up.[1] These appearances maintained rigid social hierarchies. Raised mostly by a struggling single mother, LeRoy came up in Frogtown—one of St. Paul's poorest and roughest neighborhoods—where the youngster spent his surplus of unsupervised time on the streets donning ill-fitting hand-me-downs while playing sandlot football, ducking bullies, and drawing. No one tried to dissuade him from dropping out of high school shortly after beginning the eleventh grade.

But the street-smart Neiman became a perceptive student of the elaborate facades that wielded so much power in St. Paul. He noticed how those pretenses built identities, granted access, and created barriers that made some seem crucially important and made others seem expendable. He also realized that he could manipulate them to his advantage. "I don't know if 'LeRoy Neiman' is the real LeRoy Neiman anymore," he said in 1989, after decades of molding his image into a glossy commercial product. "I created him."[2]

LeRoy knew better than most that identity is pliable. He was not born LeRoy Joseph Neiman and did not arrive in 1927—as he maintained throughout most of his career. Instead, he came into the world as LeRoy Leslie Runquist in 1921. His name was changed to Neiman (pronounced "nigh-man") after his mother married her second husband Jack in 1926. And Neiman did not adopt the pronunciation "knee-man"—the one that art dealers, talk-show hosts, and stadium announcers would use—until he joined the army in 1942. He tweaked

the specifics of his life story from interview to interview, sometimes
to protect his delicate ego, sometimes to cultivate an air of mystique,
and sometimes just to provide outlandish copy that might spark more
attention.

While the details of his biography changed along with his mood,
LeRoy always couched it through a rags-to-riches narrative that saw
him rise out of destitution in St. Paul. "I came from the toilet," he said
bluntly. "I came from the bottom." This element of his story required
little exaggeration. LeRoy insisted that "few artists come from real
poverty" and claimed that his humble background gave him a unique
position in the world of art. He eventually became a wealthy elite who
wore designer suits, jetted around the world, and puffed on hand-
rolled Cuban cigars. But he maintained his roots as a tough Midwest-
erner who spoke in a clipped nasal twang that melded Minnesota and
Chicago accents.[3] Beyond his own self-styling, circumstances specific
to Depression-era St. Paul shaped Neiman into a sharp-witted hustler
who had crafted himself into an artist.

* * *

LeRoy Runquist was born at seven forty in the morning on June 8,
1921, in Braham, Minnesota—a five-hundred-person railroad town
about sixty miles north of St. Paul. His father, Charles Julius Run-
quist, was a thirty-nine-year-old immigrant from Stockvik, Sweden,
who spent his days working for his older brother John's prosperous
road construction company, which specialized in laying the railroad
tracks that were connecting the northern Midwest to the rest of the
rapidly industrializing country. LeRoy's mother, Lydia Sophia Run-
quist (née Serline), was a twenty-three-year-old housewife who came
from a modest but comfortable family of Braham farmers.[4] Neither
Charlie, as most called him, nor Lydia was educated beyond the fifth
grade. The Serlines needed Lydia to help on the farm. And Charlie
went to work for his brother as soon as he arrived stateside. His En-
glish was choppy, and he never bothered to learn much more than
what was needed to get by on a job site or order a drink. Lydia and

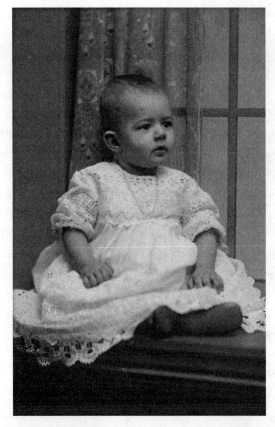

FIGURE 1. LeRoy Neiman, ca. 1923.
Courtesy of the LeRoy Neiman and Janet Byrne Neiman Foundation.

Charlie eloped in Duluth shortly before the November 27, 1919, birth of their first son, Charles Earl Runquist Jr.

Like most families in the sparsely populated region, the Runquists and Serlines knew one another long before Charlie and Lydia became an item. Lydia's father John Oscar "J. O." Serline, also a Swedish immigrant, even did business with John Runquist. But Charlie was not the sort of man whom the conservative Serlines would have preferred for their daughter, who, by all accounts, was beautiful, outgoing, and witty—sometimes to the point of gleeful irreverence. Even John Runquist expressed bewilderment at Lydia's decision to marry his

ne'er-do-well kid brother. Both Runquist boys were impulsive, short tempered, and given to drink. Charlie, however, lacked his brother's reliability, tact, and business acumen. LeRoy later described his father as a "don't-give-a-shit guy" who was fun to be around but untrustworthy.[5] A corner of Charlie's chin was missing from a gun fight—that was the story, anyway—which added to his image as a ruffian.

Lydia never drank, smoked, or swore. But she was rebellious in other ways, and the small-town girl desperately sought to expand her world beyond Braham's tiny perimeter. She was not defiant enough, however, to leave the farm without being married to a man who could support her. And coupling with Charlie was far preferable to having his child out of wedlock, which would have been unthinkable even for the relative nonconformist.

Charlie got Lydia off the Serline farm—but not very far. They initially settled in Grasston, an even smaller town five miles northeast, and lived on John Runquist's property. Despite the new address, the Runquists effectively remained part of the greater Braham community for the first years of their marriage. Braham was the sort of "lost Swede town" that Nick Carraway recalled in St. Paul native F. Scott Fitzgerald's *The Great Gatsby* while reminiscing about his bucolic Minnesota homeland. It was dominated by Swedish immigrants who arrived in the area toward the end of the nineteenth century to farm. Braham's establishment came shortly after the Great Northern Railroad built its "Bee Line," a spur that ran north from Coon Rapids and connected to its east–west line that joined St. Cloud to Duluth and Two Harbors on Lake Superior. The train passed through once daily, transforming the hamlet into what the *Braham Journal* proudly called "the busiest hive in the Great Northern Bee Line."[6]

Those working Braham's land typically labored seven days a week, stopping for only a few hours on Sunday mornings, when they funneled into either the town's Methodist or Lutheran house of worship. What little local news there was tended to revolve around farming, the railroad, and church. Even as a weekly publication, the *Braham Journal* had trouble filling more than a few pages. LeRoy Runquist's birth was registered in its "Local Notes" section: "A baby boy was born

to Mr. and Mrs. Chas. Runquist at the Braham Hospital June 8th."[7] It was the first bit of publicity LeRoy ever received.

LeRoy's first months were the happiest times of the budding Runquist family's ultimately brief run. The household moved from Grasston north to Duluth shortly after LeRoy's birth to be closer to Charlie, although he still spent most nights sleeping at work camps. Even so, Charlie quickly tired of family life and left Lydia in 1922 with Charles Jr., LeRoy, and another child on the way. He was living and working in Minong, Wisconsin—sixty miles southeast of Duluth— when Lydia had Phyllis May Runquist on November 26. The family's cramped quarters necessitated that baby LeRoy share a crib with his new sister, who died after only three months. She did not have "even a photograph to claim her existence," lamented LeRoy about the sibling he did not remember and never got to know.[8]

By 1923, Lydia Runquist was a single mother of two young kids dealing with the privation of an absent husband and the heartbreak of losing her only daughter. "She dealt with adversity naturally," LeRoy wrote of his mom, "the boredom of living was replaced by the suffering of being."[9] Lydia did not have the time to dwell on her trauma. Instead, she had to figure out how to feed, clothe, and shelter her boys. Less immediate considerations necessarily faded into the background. LeRoy admits that his earliest memories are "grey, dim, blurred mostly blank." But he does distinctly recall "never having been lovingly held in anyone's arms or people making funny faces at me up close. I was sort of on my own to stagger about."[10] Neiman's compulsive desire for attention and persistent insecurity as an adult might be traced back to his mother's seeming indifference toward him when he was young. Lydia could have felt the need to distance herself emotionally from her sons after losing Phyllis. She may have also wanted the boys to grow up tough in an unforgiving world that indiscriminately doles out pain in unbearable portions and without reason—a world that can have one see a husband and daughter vanish in a matter of months. More likely, what might have seemed like coldness was the effort of a busy, worried, and grieving mother trying to get by on what little she could patch together. Lydia did not have the luxury of being able to

dote on her sons, however much they might have wanted or needed her attention.

Regardless of the hardship, Lydia was too proud to return to Braham. She moved her sons to St. Paul and supported them by waiting tables. The work barely made ends meet, and three times the young mother was forced to dodge landlords when rent was due by waking her boys before sunrise and furtively moving them to another tiny apartment. Nevertheless, Lydia remained an "independent spirit" and enjoyed the rollicking 1920s lifestyle when she had the time, which, like money, was always in short supply.[11] She bobbed her hair, competed in marathon dances to make extra cash, and enjoyed the notice she received from her male customers, many of whom sought her company after her shifts ended. Nosy neighbors thought Lydia was a floozy, and some even accused her of being a prostitute. She shrugged off the rumors and told her boys that the local blabbermouths were simply jealous. But the gossip smarted. Although free spirited, Lydia was also a deeply self-conscious woman who cared a great deal what people thought and stewed over seemingly minor interactions that she worried may have tarnished her reputation. LeRoy inherited her hardy exterior and ability to laugh off criticism. He used the same rationale Lydia employed to deflect the St. Paul rumor mill when dismissing the critics who savaged his work: they were envious that he became rich and famous without needing their blessing. But like Lydia, he was pained by the jabs.

* * *

Lydia had no shortage of interest from men. But few suitors were willing to take on the responsibility of raising two kids and dealing with a surly ex-husband who periodically surfaced to ruffle the boys' hair and give Lydia a few inadequate dollars of child support before blowing out of town. In 1926, she married Jack Neiman, a leather factory worker who served as her sons' main father figure through their formative years. Like Charlie, Jack was significantly older than Lydia. Neiman did not formally adopt the boys, but Lydia changed their surnames to match her new moniker and baptized them into the

Catholic Church, which she also joined after marrying Jack. LeRoy started going by LeRoy Joseph Neiman and Charles Jr. began answering to Earl, perhaps an effort to conceal what official traces of their biological father remained. LeRoy resented the name change, which he described as a "terrible thing to do to a kid."[12] But the shift built the appearance of a normal, functional family. Lydia would no longer face the stigma of being a single mother, and the boys would not be asked why they were not Neimans like their parents.

The newly constituted family rented part of a home on Grand Avenue, just a few blocks east of the Mississippi River in the Macalester-Groveland neighborhood, and integrated into working-class St. Paul culture. They went to church at St. Mark's on Dayton Avenue most Sundays, and the boys attended the parish's primary school, which was overseen by the Sisters of St. Joseph of Carondelet. Lydia and Earl remained devout Catholics for the rest of their lives. LeRoy claimed to be a believer and was married in the church. But he did not regularly practice once he was out of the house. He was, however, amused by the lives-of-saints stories that were tucked away in the St. Mark's pews' missals and would scan through them to pass the time during mass.[13] Although meant to teach lessons about faith, piety, and forgiveness, the saints' lives had just enough gore and adventure to keep the restless congregant interested. They were the closest thing church offered to the comic books LeRoy and Earl devoured when they could scrounge up enough change to buy them.

But the Neiman household was not a happy one. Jack, whom Neiman described as a temperamental loaf, was frequently out of work and drank excessively. He became moodier and more reliant on alcohol once the Depression made money even tighter. LeRoy recalls "no conversation of any subject of interest at the table," and the kids were discouraged from participating in what little chitchat did transpire.[14] The meals commonly ended in shouting matches stoked by Jack's imbibing and Lydia's refusal to tolerate his brutishness. Neighbors recalled "awful fight scenes" at their place that could be heard across the street.[15]

The Neimans were not so desperate that they needed to skip out

on rent, but in 1930, they moved east to 733 Blair Street in St. Paul's less expensive and harder-edged Frogtown district. Officially known as Thomas Dale, the Frogtown neighborhood sits northwest of downtown St. Paul. The neighborhood was built on marshy lowlands where frogs would gather to fill the air with their low, droning choir.[16] Frogtown was a working-class and mostly Catholic community filled with first- and second-generation European immigrants from Germany, Austria, Poland, Sweden, Hungary, and Ireland. The neighborhood reflected other urban lowlands of the era, which tended to separate a city's poorest inhabitants from the affluent communities that resided at an elevated remove.[17] The Neimans attended St. Vincent de Paul, and the brothers enrolled in the church's school, which, like St. Mark's, was overseen by the Sisters of Carondelet. Many Frogtown men, Jack Neiman among them, worked factory jobs or forged brass at the St. Paul Foundry on Como and Western Avenues. Others were employed by Great Northern, either directly or at one of the railroad shops on Dale Avenue and Minnehaha that serviced the trains.

Frogtown was one of the few parts of St. Paul where members of the working class could afford to raise a family. The neighborhood had lax zoning regulations that created a particularly dense environment.[18] Two-story commercial buildings sat on most corners, and Frogtown's residential lots were narrow, separated by only a couple of feet on either side. Most families lived in rickety wood-frame and brick homes. They maximized the space they had by regularly adding small alley houses behind their main dwellings, and those with second stories commonly converted their upper floors into rental units. The piecemeal carpentry produced jagged and uneven buildings that often sank and leaned because the city allowed construction on soggy lots.

But Frogtown's cramped population and robust commercial offerings created a vibrant culture separate from downtown St. Paul where a combination of English, German, Hungarian, and Polish was spoken. Bars like the Nickel Joint on Blair Avenue filled up on Saturday afternoons when the factory and railroad-shop workers were excused after a half day and given their weekly pay. The watering holes cashed paychecks and gladly allowed patrons to spend as much as they liked

before returning home for the rest of their brief weekends. Those customers who stuck around into the evening could see, wager on, and even participate in amateur boxing matches. Most households found room in their small yards to plant vegetable gardens and fruit trees. Neighbors would sometimes combine their modest harvests to make massive steel kettles of Bohemian goulash.[19] LeRoy detested the hearty stew, but he appreciated how the humble dish symbolized the shared sense of culture in Frogtown.

This neighborliness did not extend to Frogtown's African American community, which mostly lived near Rondo Street and was attracted to the neighborhood for the same economic reasons that drew white people. The densely populated white community expressed discomfort living so close to Black people. "One remark that always immediately concluded any discussion without rebuttal was about the negroes on Rondo Street," LeRoy remembered. "How'd you like to have them living next door to you?"[20] This point of view perplexed Neiman. He sympathized more with leftist attitudes that would urge the Frogtown community—white and Black—to direct their angst at the ruling class.

The Depression hit Frogtown particularly hard, forcing many of the factories to close and slowing business at the foundry and railroad to the point where layoffs were widespread. The jobless men spilled out onto the streets and into the taverns—some of the only local businesses that managed to stay afloat during the 1930s. "For the laboring working man," Neiman commented, "not being able to work was even worse or just as bad as we kids not being able to play."[21] The bars set up boxing bags for patrons to blow off steam and assert some of the manliness that had diminished along with their economic prospects.

The kids of Frogtown also felt the hard times, but in different ways. "You just could never be satisfied with too little," LeRoy reflected of his childhood. But Neiman also identified a "tremendous advantage" of growing up in an environment where the adults were too preoccupied to pay much attention to their children, who were basically left to run wild. While LeRoy lamented the lack of attention he received at home, he also valued the independence that his largely unsuper-

vised childhood enabled: "When I was a kid, poverty was a plus. It set you free and kept you on the streets."[22] He ran with a rowdy group of street urchins. More mischievous than criminal (although the boundaries were fuzzy), the teenagers spent idle days in search of kicks. "Our lives," he wistfully recalls, "were aimless and dream-laden." The more introverted Earl did not run with LeRoy's scruffy pack. "It never appealed to him," LeRoy said.[23] Lydia's first born was bookish, cerebral, and risk averse. He kept to himself and preferred to stay at home doodling and reading.

LeRoy's Frogtown gang invented ways to have fun. "Imagination comes out of not having things," Neiman said. They built racing cars from wheels dug out of trash heaps or scrapped from decommissioned baby buggies. Because they did not have proper ice skates, they strapped skate blades onto their shoes in the winter. They also started passing time at the nearby pool halls and taverns. Those places, for better or worse, proved more formative than the makeshift racetracks and frozen ponds. Long before the kids were old enough to order a drink, they would soak up stories of adventure and hard luck from the world-wise regulars. It was early fieldwork for Neiman's ongoing study of man at his leisure. Later on, LeRoy compared the "color and smell of pool chalk" to "Proust's madeleine" because of the way it transported him back to his childhood days hanging around in Frogtown's saloons. When he was feeling especially sentimental, Neiman would work the blue chalk into his pastels.[24]

* * *

The Depression made St. Paul's already-stark socioeconomic divisions even more apparent. The city's elites lived south of Frogtown on Summit Avenue. Summit boasts a four-and-a-half-mile run of palatial houses—the longest stretch of Victorian homes in the United States—perched on a bluff. The homes on the imposing street literally look down on the rest of the city. LeRoy experienced this contrast daily while living on Grand Avenue when he and Earl walked through the Summit area on their way to and from St. Mark's. "Families of means look at street kids with a certain amount of curiosity," he remem-

bered of the glances he attracted while commuting through the posh area.[25] He intrigued the wealthy children, most of whom attended St. Paul Academy. These rich kids were wary of the comparatively feral working-class boys, and perhaps a little jealous of their freedom and worldliness. But they would not have been envious after one of the many snowfalls that blanket St. Paul. Once Neiman moved to Frogtown, he and his buddies woke early on snowy days and plodded roughly two miles up the hill to shovel the winding Summit driveways for some spending money before returning home to clear their own shorter stretches of sidewalk. Neiman no doubt locked eyes with a few Summit Avenue kids while he labored outside their homes in the cold and they ate breakfast or practiced piano inside. Such momentary glances made abundantly clear where each sat on St. Paul's social ladder. And they formed a tremendous chip on Neiman's shoulder that he never lost despite the riches he eventually acquired.

Beyond Neiman's immediate experience, many trenchant observations of social class in early twentieth-century America were rooted in Minnesota. F. Scott Fitzgerald spent much of his childhood in St. Paul, and for a time he lived in a rented brownstone rowhouse on 599 Summit. Fitzgerald described his hometown as distinctively smug among Midwestern cities. It is "blood brother of Indianapolis, Minneapolis, Kansas City, Milwaukee, and Co.," he wrote of St. Paul in 1923, but "feels itself a little superior to the others." His 1922 story "The Popular Girl" took aim at Summit Avenue—barely disguised as Crest Avenue—by describing its "pretentious stone houses" as "a museum of American architectural failures."[26] Those in St. Paul, according to Fitzgerald, had money but lacked sophistication, a point that Summit's overdone architecture illustrated.

Fitzgerald felt out of place on Summit and once referred to himself as "a poor boy in a rich town."[27] But Fitzgerald was in another class entirely from Neiman, who would not have developed into the artist he became had he grown up on Summit instead of in Frogtown. "When I saw that world close up enough to paint its brash, brassy life of conspicuous consumption," LeRoy wrote near the end of his life, "I never lost sight of what it looked like from the bottom up."[28] Nei-

man was introduced to these social divisions principally through the sort of work people in Frogtown had to perform and the comparative leisure those on Summit enjoyed. The sociologist Thorstein Veblen, who spent his formative years in Minnesota, explained how the freedom from physical labor signals one's membership in the leisure class. Members of the leisure class differentiate themselves by consuming goods that fulfill no immediate need but instead announce their membership and status within the elite community.[29] Such conspicuous consumption—the clothes one wears, the car one drives—was just as important in distinguishing the Summit Avenue crowd from the rest of St. Paul as the physical landscape that set them high above the city's poorer sections. Sinclair Lewis, another Minnesotan who briefly lived on Summit, made a career of mocking such superficialities with novels like *Main Street* (1920) and especially *Babbitt* (1922), which were set in a fictionalized version of Neiman's home state around the time when he was born.

Neiman did not discover these canonical Midwestern writers and the vocabulary they forged until he began studying art and attending college in his twenties. But he understood their perspectives intuitively as a youngster by witnessing how social divisions are created and normalized through the consumption of items that serve no necessary purpose beyond advertising one's status. He developed what he described as his artistic "credo" by observing the behaviors surrounding leisure. "The waiter is as important as the diner," he insisted. "The stablehand is as important as the thoroughbred owner." His ultimate mission in art was to "investigate life's social strata from the workingman to the millionaire."[30] Neiman sought to explore how leisure culture exalts certain groups while marginalizing others that are, ironically, instrumental to its operations: the diner sipping champagne and the waiter who brings the drink, the kid practicing piano inside a Summit Avenue parlor and the boy shoveling snow so his wealthier counterpart can take the time to learn Brahms. Neiman—especially during the early portions of his long career—took care to include those different sides of leisure in his work.

Neiman also noticed how the performance of social standing through consumption extended beyond the leisure class. He knew early on that he would probably never break into the Summit Avenue community. So, the young LeRoy paid special attention to the rough men he encountered at the taverns and emulated their manners. He began slicking his black hair back with pomade, and he learned the proper way to chalk a pool cue and sidle up to the table before taking a shot, the precise angle at which he should cock his hat, and how to grimace with contentment after taking a sip of liquor. LeRoy also started smoking cheap cigars, another essential item in the 1930s sporting man's uniform. Harvesters and White Owls were five cents apiece, and King Edwards cost an additional penny. He preferred the ten-cent Dutch Masters and would smoke the premium stogies when he had the rare surplus of money. On these special occasions, LeRoy and his friends waited to light up and would first strut around with the more expensive cigars dangling out of their shirt pockets, the branded labels clearly visible to all they encountered.[31] "You have a choice between leaving the band on the cigar or removing it," Neiman said in the 1996 documentary *The Art of the Cigar*: "Now if you're a peasant, you come from my background, you keep it on." It was one of the only mechanisms LeRoy had to display some status in his community.

* * *

While the young Neiman was honing his personal style among the St. Paul demimonde, his parents continued to struggle at home. Their marital problems were exacerbated by the stresses of the Great Depression. Jack ceased to be the provider Lydia thought she married, and his drinking and temper escalated as his economic prospects wilted. And Lydia was not the obedient Catholic wife Jack may have been expecting. LeRoy's last memory of his stepfather was a pathetic one of Jack sliding a Gillette Blue Blade "along the rim of a water glass, round and round in endless rotations to sharpen the edge of the blade and eke out of a few more shaves."[32] The fourteen-year-old Neiman

was not sad to see Jack leave, but he empathized with the desperation his first stepfather must have felt as a poor, uneducated, and unskilled man struggling through the Depression.

Neiman did not mention ever seeing Jack again after Lydia divorced him in 1935. Nor did he express any desire to contact the man who gave him his last name. There was less yelling after Jack departed but also fewer dollars to go around. Flung into even deeper poverty, Lydia moved Earl and LeRoy to a one-room apartment on Marshall Avenue and went back to waiting tables.

Charlie Runquist, also remarried and redivorced since the initial split from Lydia, would sporadically check in. But most of the time the boys had no inkling where their biological father was or when he might return. At one point, Charlie worked in Cuba for a year, helping to oversee his older brother's most distant construction contract. Other times, he would set off to pursue some vague opportunity that he was convinced might translate into quick money. Charlie always eventually turned back up in Minnesota when things went dry or he had worn out his welcome.

LeRoy had begun occasionally joining his dad on crews around the time Jack and Lydia separated. He earned forty-five cents an hour working as a gandy dancer, one of the men who lays down train track and hammers in the ties to secure it. The labor exposed LeRoy to the rough and itinerant fringes of working-class life. The men on the crews composed a variety of poor worker different from Frogtown's comparatively domesticated factory and railroad-shop laborers. These hardened frontiersmen drank on the job and rarely interacted with women apart from the Native American sex workers who followed behind their crews. Charlie bought LeRoy one of the women's services as a gift for his fourteenth birthday—a present that even the pubescent youngster found shockingly inappropriate. The jobs helped Neiman to reconnect with Charlie, but they also left him wondering whether their relationship was worth salvaging. Charlie was more avuncular coworker than loving father. He was happy to spend time with LeRoy so long as he did not have to take responsibility for him.

"I liked him well enough," LeRoy said of his dad, "but he was no role model."[33]

While LeRoy received little support from Charlie and Jack, his extended family in the country north of St. Paul offered a safety net that few of his Frogtown buddies enjoyed—and one that suggests he was not quite as impoverished as he often insisted. For most of their childhood, Earl and LeRoy spent chunks of their summers on the Serline farm in Braham. The Serline quarters were not luxurious, but they were far better than a cramped one-room apartment. "They lived with nature and all its consequence," Neiman said of his family. "Accomplishment to them was the ability to work hard and ensure nature's powers."[34] LeRoy admired his grandparents' industriousness, but like Lydia, he had no interest in permanently adopting their way of life.

J. O. Serline did little farming himself by the time Earl and LeRoy were visiting Braham. He spent most of this time serving in local government and was commissioner of Isanti County for thirty-five years. Serline was successful but restrained—a model of Protestant work ethic uninterested in the flamboyance that characterized St. Paul's leisure class.

LeRoy's uncle John Runquist, who lived down the road from Braham in Grasston, was as extravagant as J. O. Serline was reserved. Runquist seemed to embody the American Dream mythos. In 1885, the eighteen-year-old Swedish orphan arrived in Philadelphia with a third-grade education and what amounted to a few dollars in his pocket. Following so many of his countrymen, he settled in Minnesota—originally in the Duluth and Two Harbors area. Runquist found employment as a railroad laborer, worked his way up to a foreman, and gradually amassed enough capital to send for his siblings.[35] He eventually started his own contracting company and did most of his work clearing land and building tracks for the Duluth, Missabe, and Iron Range Railway, which primarily transported iron from the mines near Hibbing to Duluth and Two Harbors. Runquist steadily expanded his company and secured contracts across North America, including the Cuba job that Charlie worked. He also supplemented

his income by trading and training racehorses, which was as much a way to show off his wealth as an investment that would increase it. Uncle John was a gambler in business and in leisure who went broke multiple times, only to find ways to regain his fortune.

The bombastic Runquist was a literal and figurative politician who knew how to build alliances that would satisfy his interests. He served as the republican chairperson of Two Harbors and a presidential elector. He loomed so large in Two Harbors that a section of the town near his base of operations was informally called "Runquistville." His civic efforts sometimes brought him into contact with J. O. Serline, whose responsibilities as county commissioner intersected with Runquist's contracts for work on public land.

Uncle John had a keen understanding of publicity and used it to establish himself as a beloved man of the people. In 1909, a *Duluth Evening Herald* series called "Well Known Duluthians in Caricature" featured a drawing of Runquist. The illustration shows Runquist laying railroad track alone in the prairie. He wears shirtsleeves and a bowtie beneath overalls while hammering ties into the ground. The caricature depicts Runquist as a beacon of progress who is at once a visionary entrepreneur and a rank-and-file worker. He is not above getting his hands dirty and doing the sort of hard physical toil he pays employees to perform. "It matters not to John Runquist the position in life one occupies, your financial rating or social connections," gushed an article in the *Two Harbors Iron News*. "The calloused hand of the laborer in overalls, be he a friend, is greeted with as hearty a handshake and is as welcome in his table as the man in broadcloth."[36] Runquist was known as a rare captain of industry who had not lost touch with the little guy.

Runquist's sterling image came in handy when he was scrutinized for the dangerous work his employees performed, which routinely resulted in varying degrees of dismemberment and sometimes even death. He was sued regularly by workers who were injured on jobs and the families of those who perished. The local papers, however, resolutely defended him against such grievances and depicted the plaintiffs as indolent moneygrubbers. The *Two Harbors Iron News* virtually

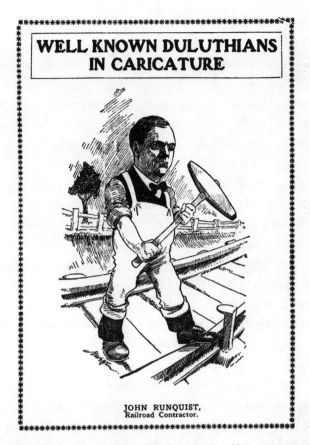

WELL KNOWN DULUTHIANS IN CARICATURE

JOHN RUNQUIST,
Railroad Contractor.

FIGURE 2. Caricature of John Runquist, *Duluth Evening Herald*, June 9, 1909, 3. Minnesota Historical Society.

taunted Samuel Thompson after a local court dismissed his $15,000 lawsuit against Runquist, which he filed after his eye was blown out in a dynamite blast: "The plaintiff will have to defer indefinitely the pleasure of tucking $15,000 of John's money is his vest pocket." Speaking of Runquist in familiar and affectionate terms, the newspaper treated the complaint as an affront to the community and expressed satisfaction that the plaintiff would get nothing from the local hero.[37]

But Runquist was also something of a gangster. When he sued W. H. Ferrell, of Princeton, Minnesota, in 1911, Uncle John showed up to court carrying a large hickory club. Although Runquist facetiously referred to the bat as a "walking stick," it was clear that he was send-

ing a message to Ferrell. When the *Princeton Union* asked Runquist why he was carrying the cudgel, "he remarked that he considered it necessary to be prepared for emergencies, as, from all accounts, he was liable to at any time meet a 'prominent' citizen with a shillalah who would be liable to contest the right of way with him."[38] Uncle John was effectively challenging Ferrell to a street fight. The local paper took no issue with Runquist's bullying, and, in fact, seemed to fault Ferrell for testing the businessman's temper and forcing his usually beneficent hand. Runquist unsurprisingly won the lawsuit.

LeRoy sketched Uncle John from memory in 1982. The pen-and-marker drawing captures Runquist, whom Neiman likened to a large and beady-eyed predatory bird, in profile and in motion.[39] The stout businessman wears a suit and tight-fitting fedora while taking a long stride on spindly legs. His face is scrunched and conveys a sense of focused urgency to reach whichever engagement he is heading toward. His right hand grasps a folded umbrella to ensure that any inclement weather will not slow his progress or ruffle his appearance. The umbrella also resembles a truncheon that the short-fused entrepreneur might use to thwack anyone who dared to impede him.

Runquist moved his family to Grasston in 1899. Uncle John became enamored of the region while working in the area and decided it would be an ideal place for him to raise horses. He purchased several thousand acres and built a four-hundred-acre farm west of Grasston's main drag. Runquist set out transforming Grasston into his veritable fiefdom—an actual Runquistville. He established a livery stable, blacksmith shop, and a lumberyard, and he was responsible for platting parcels of land. Uncle John also erected a building in the center of town that housed a bank, general store, confectionery shop, casket company, pool hall, and, on the second floor, small opera house. The *Two Harbors Iron News* gave Runquist sole credit for Grasston's renovation from a desolate way station into busy hub. "Through the influence, determination and progressiveness of one man mainly, the sleepy little burg has within a few years been transformed into a hustling and up-to-date-little village. For its size there is not a neater or better business point in the state than Grasston. Who was this man

that put Grasston on the map?" the paper asked. "The cry is universal; we doubt if a single voice in the territory on which Grasston radiates as a central point would say not the name of John Runquist."[40] Uncle John made sure there was no mistaking his importance. He hired the Braham Monument Company to engrave his last name on a large block of granite, which he then placed above the door of the bank. It would be understandable for someone passing through Grasston to think it was called Runquist. This was precisely the point. Uncle John was an egotistical small-town big shot—the type of moneyed Midwesterner Sinclair Lewis skewered in his novels. But LeRoy was smitten. "We looked up to anyone who had some flash in those spare and unsentimental times," he wrote of his childhood.[41] No one was flashier than Uncle John.

The poor and effectively fatherless LeRoy must have felt good hanging around with one of the region's most powerful men. Runquist identified with his scrappy nephew and lamented Charlie's fatherly negligence. Uncle John would take LeRoy to horse races and buy the kid shoes when he needed them, which was often. When LeRoy was fifteen, Runquist let the boy chauffer his burgundy Packard as they ran errands. Neiman says he lied to his uncle and told him he had a driver's license. Just as likely, Uncle John—not the sort to let much get past him—turned a blind eye and let LeRoy have some fun driving a luxury car for an afternoon. In his diaries, Neiman recalled that his uncle's Packard was the same color as the Queen of England's Daimler limousine. The comparison indicates the kingly regard in which the young LeRoy held his Uncle John.[42] Uncle John was Neiman's first hero. He was wealthy but also tough—and he made sure that everyone knew it. Neiman's eventual showiness can be traced back to his beloved uncle's swagger. And LeRoy's oversized signature descended from the engraved block of granite Runquist so ostentatiously installed above Grasston's bank.

LeRoy's trips to the country, whether he was baling hay at the Serline farm or cruising around with his uncle, exposed him to a different side of social life that he did not encounter in Frogtown. He was part of the servant class in St. Paul. But when he went up north, he

stayed with family members who hired out their help. Experiencing this socioeconomic spectrum gave the already-perceptive Neiman a more sophisticated view of social class than his pals who lived in Frogtown year round. LeRoy hung around with a thoroughbred owner and identified with stable hands; he dined at nice restaurants with his uncle and lived with a mother who waited tables.

* * *

Uncle John set the tone for Neiman's idolization of other Depression-era Minnesotans who played by their own rules and managed to live high despite the hard times, especially the mysterious hoodlums whose exploits made for salacious local legends. St. Paul had a reputation as a "sanctuary for criminals" on account of a layover agreement that allowed known fugitives to lay low so long as they spent their money freely and did not break any laws within city limits. The criminals had to register when they arrived in town and pay a fee. In exchange for the payoffs, the visiting felons received protection and tip-offs about any imminent raids by the Federal Bureau of Investigation.[43]

The amnesty system lowered St. Paul's crime rates. But it did not stop the hoodlums from transgressing outside of the city—including Minneapolis. As a result of the city's special tolerance for criminals, if not crime, career outlaws flocked to St. Paul to live permanently or simply to stay for a spell while they were on the run and needed to let things cool off. The Barker-Karpis Gang, run by Alvin "Creepy" Karpis, Ma Barker, and her sons, operated out of St. Paul. The bootlegger Leon Gleckman, sometimes referred to as the "Al Capone of St. Paul," made enough payoffs to local officials to be able to run his criminal enterprise from a permanent suite in the St. Paul Hotel. A 1932 Justice Department memo reported that Gleckman "controlled the local government" in Minnesota's capital city.[44] As Karpis, who eventually landed in Alcatraz for his involvement in two local kidnappings, wrote in his memoir: "Of all the Midwest cities, the one that I knew best was St. Paul, and it was a crook's haven. Every criminal of any importance

in the 1930s made his home at one time or another in St. Paul. If you were looking for a guy you hadn't seen in a few months you usually thought of two places—prison or St. Paul."[45]

After the repeal of prohibition in 1933, St. Paul's criminal class had to find ways to stay solvent outside of bootlegging. They began to ignore the layover agreement and commit more serious offenses within city limits. Federal law enforcement officials labeled St. Paul "a hotbed of crime" and a "poison spot of the nation" after a string of robberies and kidnappings.[46] But the Frogtown kids venerated these high-profile malefactors. "A myth of romance surrounded them," LeRoy wrote, one enhanced by their cartoonish nicknames and the hair-raising stories that popular detective magazines relayed about their exploits.[47] The gangsters were making money at a time when most were broke. And many viewed their bank heists as deserved punishment for institutions that had mercilessly foreclosed thousands of homes. John Dillinger—whom FBI director J. Edgar Hoover deemed "Public Enemy No. 1" for a time—was the most glamorized of St. Paul's wayfaring criminals. Like John Runquist, Dillinger was both a bigwig and commoner who dressed sharp, understood publicity, and had no problem resorting to violence.

In 1934, Dillinger and his girlfriend were hiding out at the Lexington Court Apartments on the corner of Lexington Parkway and Lincoln Avenue. The landlord grew suspicious and contacted authorities when she noticed that the excessively private couple seldom left during the day and always used the rear entrance when coming and going. Federal agents and local police raided the apartment on March 31, but Dillinger associate Homer Van Meter started shooting before they had a chance to identify him. The unexpected firefight created enough space for the fugitives to escape. But only four months later, the FBI gunned Dillinger down outside of Chicago's Biograph Theater. Van Meter was killed the following month in a Frogtown shootout at the intersection of Marion Street and University Avenue. These criminals took on the aura of fashionable martyrs—deviant versions of the saints about whom LeRoy read at mass—and left an

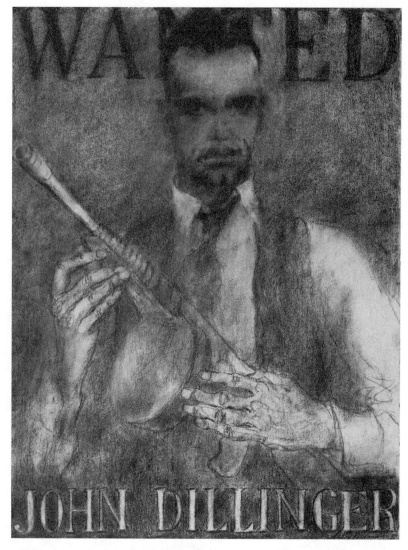

FIGURE 3. LeRoy Neiman, *John Dillinger*, 1997.
© 2023 LeRoy Neiman and Janet Byrne Neiman Foundation / Artists Rights Society (ARS), NY.

indelible mark on Neiman and his pals, who would travel to the sites of gangland battles and stick their fingers in the bullet holes as if they were touching Babe Ruth's bat.[48]

Sports stars were the only local heroes whose notoriety rivaled that of the gangsters. St. Paul had a lively sporting culture that included

St. Paul Saints baseball, University of Minnesota football, auto racing, and hockey. But boxing, as Neiman put it, "was king." The city was known for producing scientific Irish fighters such as My Sullivan, Billy Miske, Mike Gibbons, and Tommy Gibbons. Like Uncle John and the gangsters, the boxers were mainly working-class men who had found an unlikely pathway to glamour and wealth. The culture of boxing overlapped with the taverns, pool halls, and street corners LeRoy knew so well, all of which frequently hosted both organized and impromptu fights. "In this game, everyone is from the streets," Neiman said. "There are very few college degrees in boxing." And boxers—like those road construction workers who lost a finger or an eye on the job—carried their battle scars with them. "All their features were rearranged," Neiman remarked about the local pugs. "They were proud of it. It was a mark of prestige at the time."[49]

Frogtown siblings and St. Vincent alumni Mike and Tommy Gibbons were St. Paul's most celebrated fighters. Mike Gibbons was called the "St. Paul Phantom" because of his crafty footwork and feinting. He retired in 1922 without ever having been knocked out and opened the Gibbons Brothers Gym in the lower level of the Hamm's Building on St. Peter Street. The facility was also known as the Rose Room Gym because of its faded floral wallpaper, an ironic contrast to the establishment's macho business. LeRoy and his gang regularly dropped by Gibbons's gym while shooting pool at a parlor in the same building. They listened to the local hero recite old stories and pounded the heavy bags when his boxers were not using them to train. Gibbons would shoo the boys away when they got too rambunctious, but he always let them return. The charismatic former fighter enjoyed the attention, and he knew what it was like to be a kid in Frogtown growing up with few role models and lots of idle time.

Tommy Gibbons, a heavyweight, became even more famous than his brother. The fighter gained national attention for squaring off against Jack Dempsey in July 1923. Gibbons lost the bout by a decision, but he gave Dempsey—the most famous athlete in the country at the time—one of the toughest fights of his career.[50] The performance was enough to ensure Gibbons's celebrity in St. Paul for the rest of his life.

He rode his notoriety to become sheriff of Ramsey County in 1934. The local symbol of toughness was elected with the expectation that he would help clean up St. Paul and crack down on the payoffs that had allowed criminals to run rampant. Ramsey County, it seemed, needed a veritable superhero to take on the area's similarly mythologized scoundrels.

The Faust Theater, a Tudor building with a brick facade, was a key purveyor of the myths that captured LeRoy's imagination. The cinema sat on the corner of University Avenue and Dale Street, less than a mile from the spot where Van Meter was killed. The movies aided LeRoy's romanticized view of St. Paul's gangsters and boxers—two staples of the Classical Hollywood cinema—and offered mythic archetypes Neiman used to fabricate his own identity as he came of age.[51] James Cagney helped LeRoy develop a tough-guy sneer, John Garfield showed that sensitivity and masculinity were not mutually exclusive, and Clark Gable's mustache provided a blueprint for the facial hair that would eventually compose the centerpiece of his look.

LeRoy aspired to be a big shot on par with his uncle and the gangsters, boxers, and movie stars. Although he did not have the temperament to be a hoodlum, Neiman dabbled in sports. He most seriously pursued boxing. Nothing delivered more local clout among his peer group than fighting as a Golden Glover under Mike Gibbons's tutelage. But the "injury-prone" LeRoy was not much of an athlete. "I loved boxing. It was my best sport, but that was because I played everything else badly," he conceded.[52] The priests at St. Vincent's organized boxing classes in the church basement to give the kids something semiconstructive to do after school. The sparring sessions often thrust Neiman into the ring against the school's toughest kids. Although he fared poorly, he knew that facing the bullies "with the protection of the gloves under supervision in God's house" was far preferable to dealing with them in the bare-knuckle "school yard and alley brawls they were all instigating."[53] The priests, he surmised, would not let him take too vicious a beating in the church basement. "I had a natural powder-puff left jab employed defensively solely to keep my opponent at arm's length," he recalled. "I could even slip a left Mike

Gibbons St. Paul style for the same purpose, to avoid being hit. But I'd always get struck by the follow up."[54] LeRoy was just good enough in the ring to be able defend himself outside of it.

But Neiman did have a knack for drawing, which was not the sort of activity that was romanticized on the streets. He went from pursuing sports to sketching other kids at play.[55] LeRoy plunged into his avocation and began carting a sketch pad everywhere, a practice he maintained for the rest of his life. He discovered that he could use his talents to build an identity and even make some money. Drawing, if done properly, attracted positive attention and brokered social interactions—whether meeting girls or avoiding awkward conversations. People were generally flattered to be sketched, and they tended to remember Neiman after he drew them. LeRoy also quickly learned that his subjects recalled him more fondly if he gave them a memorable performance and, above all, made them look good. While Neiman would rather have been a prizefighter, he concluded that an artist would have to do. It was far preferable to blending in.

2

Street Artist

Drawing was a favorite activity around LeRoy's household that Earl gravitated toward before his little brother became seriously interested in it. The boys started out by tracing comic strips from the daily paper. They were especially infatuated by George Storm's *Bobby Thatcher* and Percy Crosby's *Skippy Skinner*, syndicated cartoons about the adventures of precocious but down-and-out youngsters. LeRoy eventually graduated from tracing comic strips to creating his own. Neiman's *Honest Abe* starred a childhood version of Abraham Lincoln. Like Thatcher and Skinner, LeRoy's Abe is a virtuous youngster whose adventures showed off his unusual character. Mimicking the newspapers, Neiman drew his comic with only a black crayon six days a week and did full-color editions on Sundays.

As with his other interests, LeRoy was mainly left alone to pursue his passion for art. "There was no one around saying, 'Why are you copying this comic book junk. You should be emulating the old masters," he recalled. "No one criticized me, no one praised me."[1] Lydia was more or less indifferent to her sons' art, and she threw most of their drawings away. She did not find their work offensive or bad; she simply thought it was trash like any other stray scrap of paper. To Lydia, drawing was a pastime, not a career path. The family had little space and moved around so frequently that Lydia could not afford to be sentimental and save boxes of keepsakes. She did, however, save a sketch LeRoy completed of a crying baby wearing a bib and diaper when he was eight. Lydia pasted the piece onto the inside back cover of her Bible, which suggests she cared a bit more than LeRoy realized.

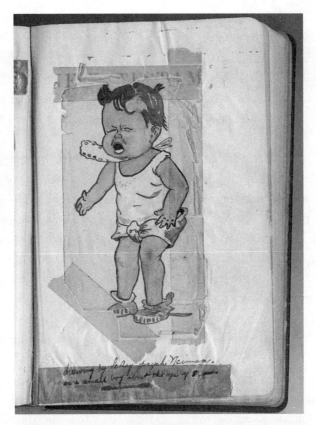

FIGURE 4. LeRoy Neiman, drawing of a baby, ca. 1929.
© 2023 LeRoy Neiman and Janet Byrne Neiman Foundation / Artists Rights Society (ARS), NY.

Despite Lydia's relative inattention to his art, Neiman received positive reinforcement at St. Vincent's from Sister Marie de Lourdes. Sister Marie was a younger nun who exhibited greater kindness and patience than her more draconian peers. Her compassionate pedagogy was a welcome contrast to the knuckle-rapping approach common in parochial classrooms at the time. Sister Marie took a shine to LeRoy, and because St. Vincent's did not offer separate art courses, she would regularly stay after school to draw with him. She gave him some pointers but mostly offered praise and validation. When LeRoy was in sixth grade, Sister Marie urged him to enter a painting into a national contest. The artwork depicted a school of trout from Mille

Lacs Lake—a body of water near Braham that Neiman fished during his summers in the country. He won the award, a distinction he said "went virtually unnoticed at school and home," and the painting was not saved. But Sister Marie paid attention and was one of the first people to make LeRoy feel talented. He later described her as "the guardian angel who had recognized something in me I hadn't known myself."[2]

The enthusiastically supportive Sister Marie was unequipped to supply serious training in art history or technique. And Neiman did not attend museums with his family or on school field trips. He instead patched together an informal education through the art that was freely available around town. While walking by the Minnesota state capitol, just blocks from Frogtown, Neiman frequently paused to gaze up at the *Progress of State* quadriga, a golden Romanesque statue above the south portico. The first gallery LeRoy visited was the collection of governors' portraits permanently displayed inside the capitol. Although he later identified this as "a really dumb way to learn because the paintings were so bad," he acknowledged that "in the slums it's the best available."[3] Despite their shortcomings, the portraits further introduced Neiman to painting's miraculous powers of creation. He became especially fascinated by those portraits of governors who wore eyeglasses. How, the young Neiman wondered, can one paint something that is clear? The feat made apparent art's profound and borderline magical abilities, even in amateurish portraits of mostly forgotten Midwestern politicians.

He noticed a different sort of magic in the reproductions of Jules Adolphe Breton's *The Song of the Lark* (1884) and Jean-François Millet's *The Angelus* (1857–1859) that hung in the halls of St. Vincent's. The late nineteenth-century French realist paintings offer somber but dignified representations of the poor agricultural community's devotion to the land and the hard days they endure. *Song of the Lark* features a barefoot peasant woman carrying a scythe at sunrise who gazes into the distance as she embarks on her long workday. She has a look of beatific tranquility despite the arduous labor, and her back heel is lifting as if she were about to float toward her tasks or be taken

to them by the higher power that informs her humble activities. Set at dusk, *Angelus* depicts two farmhands taking a momentary break from harvesting potatoes to say a prayer for the departed, a daily ritual that is prompted by the bells from a church tower in the distance. The laborers interrupt their work to honor the dead before finishing what's left of the day, which stretches beyond sundown. "These two paintings had a telling, lasting effect, as was the school's intention," Neiman said. "They both represented tranquility, hard work, the soil, and peasantry. In the 30s in the heart of the Depression they actually represented hope."[4] The widely reproduced oil paintings especially resonated with Neiman because they reminded him of his family in Braham. They also motivated LeRoy to seek out other works in books at the local public library. He initially gravitated toward similar celebrations of rural life such as Millet's *The Gleaners* (1857) and the French Fauvist Raoul Dufy's more modern *Wheatfield* (1929), which departs from the realism of Breton and Millet with a vivid landscape that includes red and blue horses plowing golden farmland.[5]

LeRoy got more serious about art when he finished up at St. Vincent's and entered Washington High School. "I was kind of a child prodigy in art," he immodestly recalled. Neiman knew his artistic talent was the key resource at his disposal. "I could draw better than anyone in my class so I capitalized on it," he said matter-of-factly. LeRoy equated his path to that of an inner-city athlete with a prodigious fastball or devastating left hook. He endured some razzing around Frogtown because of art's effeminate associations compared to baseball or boxing. But he was nevertheless able to align himself with the sporting crowd by making posters for football games and school dances. And Washington High had designated art courses taught by Bessie Mulholland, another young female teacher who continued Sister Marie's mentorship by overseeing the posters LeRoy made. "It was a bit like being an athlete," he said. "In Washington High School I was a star. I was the artist wherever I was."[6]

LeRoy was savvy enough to know that he did not hail from the social class that most artists represent. His family could not send him to art school, or to any college for that matter. And even if Lydia were

invested in LeRoy's aspirations, she did not have the education that would enable her to provide him with helpful guidance. A meandering autobiographical meditation in Neiman's personal papers titled "The Artist from Poverty" outlines some of the frustrating and deflating challenges he faced as a poor kid pursuing art. "His parents didn't point things out," LeRoy wrote in third person, "explain things to him as a child because they didn't know and understand themselves. He puzzled when he saw something new [and] had to work it out himself. If he asks questions of his parents there was no explanation."[7] Neiman understood that his disadvantages spanned beyond money. He lacked access to the invisible cultural know-how that middle- and upper-class folks use to navigate society and protect their stature within it. The aspiring artist knew that such elusive assets were as important as raw talent.

But as a kid who drove around with John Runquist, read *Bobby Thatcher*, and worshipped Abraham Lincoln, Neiman was idealistic enough to believe that folks from his background could conquer the long odds if they were sufficiently clever and industrious. That romanticism complemented his belief that great artists are born, a misconception that further betrays the lack of cultural resources at his disposal. It also molded him into a headstrong pupil who met most feedback with irritation. "I always drew alone," he wrote, "no approval necessary." Even at school he "found teacher assistance broke my concentration and I regarded it as an interference."[8] He preferred those like Sister Marie and Bessie Mulholland, who offered boundless affirmation without much criticism.

Embracing his rough-hewn background, stubborn attitude, and common-man ethos, LeRoy started referring to himself as a "street artist." "I came from the streets and I paint from the streets. And that's what I am," he said.[9] The teenage Neiman possessed talent, ambition, and even a budding artistic philosophy. Forging a career in art, however, required tact and compromise. He realized that he needed an angle—just like a pool shark, boxing manager, or any other grifter who roamed Frogtown looking to make a buck when there weren't many to go around. But to develop a niche, the willful artist

had to pay attention to the marketplace and adjust his craft accordingly. He could not simply ignore the world around him and paint from his heart.

* * *

LeRoy first sold his art by providing pen-and-ink tattoos on the St. Vincent's playground. Those schoolmates brave enough to endure the pain and risk blood poisoning gave Neiman three cents to etch a cartoon character into their flesh with a steel-tip pen. The most popular were Betty Boop and Popeye. To dodge the ever-watchful nuns patrolling the schoolyard, Neiman would hide an ink bottle in his shirt pocket. "I would pull the stopper and without removing the bottle from my pocket dip my pen into the well and make with drawing on students' arms, sometimes drawing blood," and often producing infectious blisters that only vaguely resembled the cartoons he carved.[10] He learned to etch the tattoos upside down to better conceal the illicit activity from the nuns while also adding an element of showmanship. Between the ages of twelve and fourteen, Neiman convinced a Frogtown grocery store owner to let him paint weekly signs on his windows with a calcimine mixture LeRoy made by combining chalk and water. Neiman also flattered his client by painting his visage alongside the products. "This gave me tremendous power as a kid," LeRoy recalled of learning how to monetize his talent while exploiting customers' vanity.[11]

Neiman was increasingly adrift as he stood on the precipice of adulthood. While many of his cronies were graduating from adolescent mischief to out and out crime, LeRoy's interest in art provided him a vague goal, however unrealistic, that his buddies did not possess. His ambitions also partially alienated him from his neighborhood gang. He would periodically peel off from his group to study the portraits in the capitol, peruse the library's art books, or check out the state fair's annual art exhibit. "Most of my friends when I was a kid wound up in prison or some type of house of correction," he remembered.[12] LeRoy saw no clear path to a career in art and did not have any prospects apart from infrequent jobs like the grocery store.

Artists, he came to believe, were French eccentrics who discoursed at salons over glasses of absinthe, not unkempt kids from Frogtown.

LeRoy dropped out of high school in November 1937, not long after beginning the eleventh grade. He did not mind school and paid attention to the material that interested him, especially art and literature. But Neiman was still living at home with Lydia and Earl. He needed to make money, and there was little sense of what continuing his education at Washington High might get him. If anything, high school seemed to be burning up the daylight hours he could use to earn a wage. Most of his friends had already stopped attending by that point. None of the adult men in Neiman's orbit were high school graduates, and the most successful person he knew—Uncle John—made it only through the third grade. Even Bobby Thatcher was a drop out.[13]

But the Depression made it difficult for Neiman to find consistent employment. He loaded barrels of beer at the Hamm's and Schmidt's breweries, took some work on road crews with Charlie, and baled hay on the farm in Braham, which his uncle Ames had taken over when J. O. Serline passed away in 1937. LeRoy still carried his sketchbook around and drew when he got the chance. After days laying tracks with Charlie's crews, Neiman would spend his evenings sketching by kerosene lamp the workers playing cards, drinking, and purchasing some momentary sexual companionship.[14] While his ambitions to become an artist had taken a back seat to his more immediate needs, his creative fascination with the intertwined relationship of leisure and labor had not waned.

* * *

The closest thing to a stable job that LeRoy was able to secure after leaving Washington High was the farmwork in Braham, where his family felt obligated to employ him whether or not they needed his help. He decided he might be able to earn some money, receive vocational training, and, at the very least, keep busy by signing up for a six-month term in the Civilian Conservation Corps (CCC), a New Deal initiative established with jobless and uneducated young men like him in mind. Most of the enrollees, like Neiman, were dropouts who could

not find steady employment. The CCC was as invested in keeping such young men off the streets as it was in putting them to work.

The largest peacetime labor force the US government had ever assembled, the CCC had camps scattered throughout the country's more remote regions. Cadets performed a range of conservation-related work specific to their location.[15] Beyond the conservation, the CCC endeavored to give enrollees a sense of purpose, to teach them skills that might lead to employment, and to help them support their families back home. Cadets received a monthly stipend of $30 but were allowed to keep only $5 to $8. The remainder went to a designated dependent in need.

Neiman joined in October 1938—less than a year after dropping out of Washington High. The only professional experience the seventeen-year-old noted on his application was his farmwork in Braham. At that point, LeRoy had grown into a slender but still round-faced young man who stood five foot eleven and weighed 155 pounds. The only issues listed on his physical intake exam were mild nearsightedness and acne, nothing that would hinder his acceptance.[16] LeRoy listed Lydia, who could desperately use extra money, as the beneficiary for his allotments.

To match recruits with suitable tasks, CCC applications had enrollees list primary and secondary occupational preferences. Neiman unsurprisingly noted "art work (commercial art)" as his main inclination—and he made sure that the educational history portion of his questionnaire mentioned the courses he took with Bessie Mulholland at Washington High. His second occupational selection was "road construction." The form at once illustrates Neiman's sustained desire to become an artist and his limited occupational horizons beyond that single objective. If he could not pursue art, he figured that he might as well just work in road construction, which, given his experience with Charlie, he at least knew how to do.

LeRoy reported to Fort Snelling, just outside of the Twin Cities, for basic training on October 17, 1938. The following day he was assigned to the Baptism Camp, deep in the Superior National Forest near Isabella, Minnesota. Neiman worked primarily on the dense and frigid

woodland, which was at its coldest during the October–March stretch when he served. Baptism Camp cadets devoted most of their energies to timber-stand improvement—a practice that cuts smaller trees and undesirable species to ensure the forest's overall health. LeRoy remembered long, subzero hikes in wooden snowshoes carting two-man crosscut saws from the access roads into the forest. One day in March 1939, his crew had to trudge several miles back to camp when a blizzard unexpectedly hit and trapped the trucks that shuttled them to the job site.

Beyond cutting down trees, Neiman developed an interest in cooking while in the CCC. He learned how to make dishes far preferable to the mostly fried meals Lydia prepared and found the culinary arts to be an invigorating creative outlet. Above all, it was far warmer in the kitchen than it was in the woods. But his most memorable and fulfilling experience came with the illustrating he did for the camp's newsletter, *The Baptism Blade*.

Most CCC camps published mimeographed monthly newsletters. The publications offered job training, fostered community, and provided morale boosts by giving updates on camp activities, comings and goings, intramural sports, and news from the outside world. They also served as propaganda that extolled the CCC's mission. An editorial in the *Baptism Blade*'s March 1939 issue reads like a promotional pamphlet for the New Deal program: "'Little things lead to big ones,' runs an old saying. The training and learning while working under the Technical Service of this camp during your period of enrollment may be a stepping stone to success in the outside."[17]

Neiman's cover illustration for the *Blade*'s March 1939 issue was captioned "Homeward Bound" and celebrated those cadets who were cycling out by featuring an overjoyed enrollee leaving camp. The young man slightly resembles Bobby Thatcher and demonstrates Neiman's comfort drawing in the cartoon idiom. The uniformed cadet clutches a suitcase in his left hand, which trails behind as he speeds out of camp—past the cabins in the background and the American flag billowing in the center of the remote outpost—to pursue the many opportunities that presumably await. The illustration echoes Neiman's

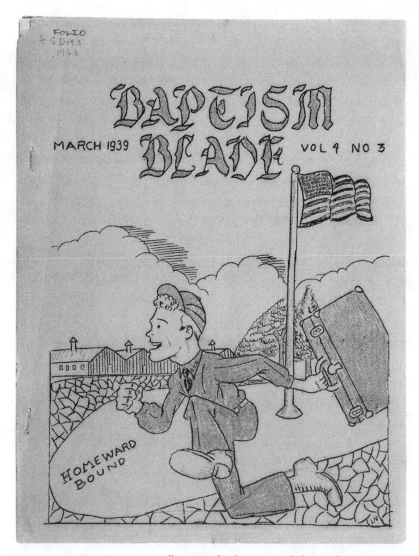

FIGURE 5. LeRoy Neiman, cover illustration for the *Baptism Blade*, March 1939. Minnesota Historical Society.

sketch of his Uncle John striding in profile: the cadet dashes with a confidence that suggests he knows precisely where he is headed. The words *Baptism Blade* wreathe the cover's upper frame in a clumsily stenciled imitation of ornate newspaper titling. LeRoy marked the drawing with only his initials and subtly placed them in the bottom

right corner—a contrast to the oversized signatures that would eventually accompany his paintings. The cover art shows both Neiman's natural talent and lack of formal training, which would have helped with his perspective, spacing, and scale. The *Blade* work was more an opportunity to practice than an occasion for instruction, which the headstrong artist probably would have dismissed anyhow.

Neiman framed either side of the March 1939 *Blade*'s masthead with images of the same handsome CCC enrollee. On the left, the well-groomed and clear-eyed cadet is sporting his government-issue uniform and standing above captions marking him as "The CCC Man." The image on the right shows the same man, now in a suit and tie, listed as "The Job Hunter." The words "From this" hover above the cadet on the left and "To this" float atop the job hunter on the right to offer a before-and-after dramatization of the self-improvement the CCC facilitates. LeRoy's rendering of the sharp-dressed and confident man resembles J. C. Leyendecker's familiar drawings of square-jawed young professionals for Arrow Collars and Shirts while providing early evidence of Neiman's promise in fashion illustration, which would pay most of his bills during the early 1950s.

LeRoy contributed several other drawings to the *Blade* that augmented its news items and commemorated camp life. The most personal of them focuses on the cadets of Barracks 7, who were set to cycle out of the camp with him. Again done in a comic-strip style, in the image he positions himself as the star by putting his likeness on the immediate left and making himself slightly larger than the other figures. Neiman's cartoon avatar happily bids adieu to Harold Lindquist, who wrote for the *Blade*. The comic then showcases a parade of other Barracks 7 personalities and shares their divergent plans. The *Blade*'s editor in chief Raymond Gatz palms his forehead with anxiety because so many of his staffers are leaving, a trio of pals called the Feather Merchants say goodbye, a cadet named Majerus laments that he will have to find new poker buddies after his colleagues depart, and a slickly pompadoured man named Tauber decides to stay on for an extra term. The illustration reveals the cliques, games, and inside jokes that composed the culture of Barracks 7. It also demonstrates

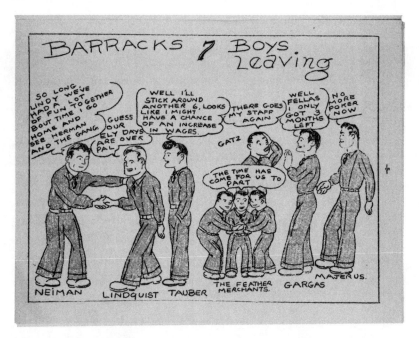

FIGURE 6. LeRoy Neiman, illustration for the *Baptism Blade* to celebrate the Barracks 7 cadets cycling out of Neiman's CCC camp, March 1939.
Minnesota Historical Society.

Neiman's ability to establish himself as a key part of camp during his six-month term. A separate *Blade* item ribbed LeRoy as a likable braggart by referring to him as "Needle Nose Neiman."[18] The CCC's intention to give enrollees experiences that would lead to a greater sense of purpose seemed to work on Neiman.

LeRoy was honorably discharged on March 25, 1939. His CCC exit evaluation listed his personality as "cooperative, sincere, self-confident, and dependable" and gave his overall "Manner of Performance" and "Ability as a Workman" good marks. His contribution to the *Blade* was listed as an "outstanding accomplishment" and earned him a certificate in "Camp Journalism."[19] The assessment effectively functioned as a recommendation that listed the sort of profession Neiman might excel at. He could presumably take it, along with a sample copy of the *Blade*, to job placement agencies in the hope that it would secure him work as an illustrator or a sign painter.

The recently dismissed cadet, though, did not fulfill the optimis-

tic trajectory foretold by his illustration of the CCC Man-turned-Job Hunter. The best position he could find after returning to St. Paul was working alongside Earl as a baler at the Waldorf Paper Company, which manufactured cardboard boxes. It was better than nothing but far from what he had hoped his CCC experience might yield. When an affable supervisor encouragingly mentioned the Waldorf's generous retirement plan for those who stuck with it until they were sixty-five, the rookie baler grew terrified at the prospect of spending the rest of his life making boxes.

Later in 1939, Lydia married Ernst G. Hoelscher, a mechanic and World War I veteran who had served in the army as a field artillery corporal. They wed 150 miles south of St. Paul in Mason City, Iowa, and their marriage certificate inaccurately recorded the wedding as Lydia's second—an error she likely orchestrated to avoid the embarrassment of two prior divorces. The certificate also lists Lydia's middle name as Phyllis—a tribute to her daughter. Hoelscher was less volatile than her previous two husbands, and the couple stayed together until his death in 1962. He also brought greater financial stability, which relieved LeRoy of the burden of helping to support his mother.

* * *

LeRoy grew increasingly strapping as he drifted into adulthood. His acne cleared up, his shoulders broadened, and he sprouted a mustache, which spread no farther than the corners of his mouth at that point. Neiman also started attracting women, who were drawn to his unique combination of traditional manliness and artistic sensitivity. He and his buddies practiced a sexist but commonplace double standard that insisted their "steady girls" remained pure, virginal, and obedient while the men did as they pleased. It was a set of expectations he more or less maintained for the rest of his life and exploited heartily once fame and wealth enhanced his prospects. His most serious romance was Lorayne Fredine, whom LeRoy liked enough to buy a gold ankle chain with their names engraved on a heart-shaped charm.[20]

Although LeRoy was getting by, he was still directionless, unfulfilled, and often downhearted. A photo of Neiman with Ernst Hoe-

FIGURE 7. Neiman with his brother Earl and his sister-in-law, Marlys, n.d.
Courtesy of the LeRoy Neiman and Janet Byrne Neiman Foundation.

lscher, Earl, and his eventual sister-in-law Marlys shows the group
lounging in the grass on a sunny afternoon. Ernst, Earl, and Marlys
smile while LeRoy looks pensively toward the ground with a cigar
resting between his fingers. The sensitive young man seems lost in
sullen contemplation while everyone else is enjoying a nice day out-
side. Neiman was no longer a kid, he was living with his mother and
stepfather, and his ambitions to be an artist were beginning to seem
like pipe dreams. LeRoy, in fact, was starting to resemble the jobless
Frogtown men he once pitied. "The Depression had cast a pall over
everything," he reflected, "especially those at the very bottom of the
heap."[21] Neiman felt trapped within St. Paul's already-rigid social hier-
archies during a time when class mobility, though never easy, was
virtually impossible.

So, LeRoy continued kicking around St. Paul until he was drafted
into the army shortly after the attack on Pearl Harbor. He and
Lorayne immediately became engaged—a routine practice for hasty
draftees who wanted someone to be thinking about them back home
while they were off to war. "She promised she'd wait for me, I swore

celibacy," Neiman says of the relationship. They both failed to hold up their end of the bargain. The long-distance romance gradually fizzled and the couple was little more than cordial pen pals by the war's end. Although not particularly enthusiastic about joining the service—and certainly scared of how things might turn out—LeRoy claimed that he felt "rescued" by World War II.[22] He had never left the Midwest, was mostly out of work, and no more wanted to marry Lorayne than he sought to spend his life making boxes at Waldorf. Military service gave him a dangerous but certain way out of Frogtown and toward some undefined future that the morose young man daydreaming on the lawn may have been trying to picture.

Neiman returned to Fort Snelling for induction on July 23, 1942. From there he was sent to Camp Callan in La Jolla, California, for basic training. While molding the young charges into shape, a drill sergeant took to pronouncing Neiman as "knee-man" instead of "nigh-man." LeRoy had enough street smarts to know it was unwise to correct the despotic instructor, who was just as likely trying to provoke the grunt as he was making an honest mistake. But he viewed the new pronunciation as a way to establish an identity separate from the long-gone stepfather whose name lingered on. Neiman as "knee-man" would be his own thing—a fresh start coinciding with his departure from Minnesota. Earl, who also served in the army during World War II and was stationed mostly in Italy, stuck with the original pronunciation.

LeRoy did not expect military service to be a breeze, but it immediately became apparent that the army would be uncomfortably dangerous and intolerably arduous if he did not develop a schtick. "I realized I had to have a gimmick," he said. The best he could come up with was volunteering for the Cooks and Bakers School. Neiman exaggerated the informal training he received cooking while in the CCC and was granted the assignment. He enjoyed the work and found it to be the only thing for which he showed any genuine aptitude aside from art. More important, he figured the kitchen would be safer than the front lines. Cooks traveled just behind the troops and did not set up shop in unstable situations. They were also "spared most of the compulsory

FIGURE 8. Neiman in the army, n.d.
Courtesy of the LeRoy Neiman and Janet Byrne Neiman Foundation.

training exercises that the rest of the troop was subjected to," which suited LeRoy just fine.[23]

Cooks faced a lower risk of death, but the work was not easy. Neiman was assigned to combat training with the 461st Anti-Aircraft Artillery Automatic Weapons Battalion at Camp Haan, near Riverside, California. Ten weeks of the training program took place east of Camp Haan in the Mojave Desert.[24] LeRoy and his colleagues labored out of stuffy vans in the blazing heat, just as unforgiving in its own way as the northern Minnesota cold was. He coped by embracing the creativity that cooking enabled. "I expressed myself," he said. "I treated it as an art form despite all the limitations." Neiman styled himself as an eccentric and temperamental chef who frequently wore his toque blanche off duty. He took pride in his versions of military staples like "shit on a shingle"—creamed chipped beef over toast. And he got some early experience dealing with criticism when the soldiers would gripe about their meals.[25]

After the training, LeRoy's battalion moved by rail to Camp Shanks in Orangetown, New York, before shipping out to Britain on July 7, 1943. They then spent nearly a year in England and Wales, where Neiman ran coffee wagons. LeRoy, who was assigned to the battalion's D Battery, arrived in Normandy on June 14, 1944, seven days after the D-Day invasion began.[26] Despite his role as a cook on the periphery of the action, Neiman witnessed some grisly sights. "Dead Germans littered the roads with their punctured helmets and burned-out tanks," he grimly remembered of his battalion's 1,668-mile voyage from France through Belgium and Luxembourg and into Germany. "Sometimes it was local farmers mistakenly killed by our own guns." Colleagues were suddenly absent at mealtimes—maimed or killed. "The suffering was unspeakable," Neiman recalled. The battery— cooks and all—spent one frigid February day helping to remove dead bodies from a battlefield near Krinkelt, Belgium.[27] LeRoy was later admitted to Hines Veterans Hospital outside of Chicago for a nervous breakdown caused in part by combat stress reaction, now known as post-traumatic stress disorder (PTSD).

Despite the "pure terror" Neiman recalled about the war, the memories he tended to share highlighted his carefree shenanigans and love affairs amid the violent chaos—a hedonistic focus that helped to sculpt the rakish masculinity so central to his image while softening the impact of the anguish he endured. "I was exposed to all that stuff [combat], but I was never interested in it," he offhandedly told *Chicago's American* in 1959. "No esthetic reason. No cowardly reason. It didn't make much sense, really, in all seriousness."[28] The way LeRoy tells it, he was principally concerned with finding ways to have fun as the world around him crumbled. While in basic training he replaced the contents of his heavy pack with inflated condoms to lighten the load. And he became an expert at forming pillows under his blankets into a humanoid shape so he could sneak out after curfew. The condoms again came in handy when they were distributed to cover soldiers' rifle muzzles while they trekked up the beaches of northern France. Neiman instead used them to keep his cigars dry. He had no intention of firing his gun anyhow.

While Neiman enjoyed cooking—especially the hat—he never gave up drawing, even though the hobby was more stigmatized in the army than it was in Frogtown. "In the Army, you were a fag if you drew," he said.[29] He counteracted potentially ostracizing stereotypes by using his talent to flatter and entertain. LeRoy sketched portraits of fellow soldiers and drew pictures of their sweethearts from photographs for them to send home.[30] He took it upon himself to boost morale—and distract his fellow soldiers from the stresses of war—by painting murals of food on the mess hall's walls. Recalling his illustrations for the Frogtown grocery store, Neiman drew large and colorful images of fresh meats, fish, and vegetables. Unlike his earlier work, the murals ironically highlighted the contrast between the mostly canned provisions the army served and the gourmet spread Neiman painted on the walls. Although he did not have formal permission to create the frescoes, the soldiers liked them so much that he was left alone as long as he painted during his spare time. Eventually, the multitalented cook was sought out to stencil army symbols on helmet liners and to draw a swastika on the barrels of his battalion's guns for every Nazi plane shot down.[31]

And LeRoy's military service gave him new insights into the social strata that preoccupied his work. Such divisions were rigidly reinforced in the army and came into focus during the meals. Neiman observed how the mess hall's seating arrangements and the order in which soldiers were served mapped onto their rankings. LeRoy also noticed authority figures demanding specific meals and how their requests were less oriented toward satisfying their stomachs than distinguishing themselves from the rank and file—a literal form of conspicuous consumption.[32] He understood how the officers' status was possible only because of the labor their subordinates provided and their willingness to respect the borders that maintain institutional hierarchies. While he was not about to subvert this inflexible system, the clever soldier used his talents to manipulate it. He fed officers' egos by sketching their portraits, taking care to make them look as good as possible without drifting beyond recognizability. As a result, these authorities—not unlike the Frogtown toughs—got to

know Neiman and were more likely to give the artist a better work assignment or look the other way when he missed curfew.[33] Neiman loved to sketch and did so habitually, but he consciously deployed his talents in ways that would work to his social and material advantage.

Neiman's 2002 drawing *Normandy Chow Line*, done in brick red pastel, meditates on his experience at war. The sketch is captioned "view from the mess truck" and displays a weary soldier from behind filling his tray with food. It offers a rare glimpse of cooks' perspective during war, following just behind the carnage and sustaining those on the front lines. The sketch's red shading evokes the smoldering and hazy humidity in the aftermath of D-Day. Its depiction of the solitary soldier momentarily refueling before getting back to work also echoes Breton's *Song of the Lark* and Millet's *Angelus*, which were also set in the French countryside when it was not fully day or night. But Neiman's piece trades their pastoral calm for war's eerie brutality. While Breton's peasant woman faces the day with hope for the bounty it might bring, Neiman's soldier walks into an indistinct but assuredly violent future. *Normandy Chow Line* demonstrates Neiman's ability to create highly expressive art when he was not tasked with glorifying a product or cause.

One of Neiman's wartime flings helped him secure a transfer to Eupen, Belgium, to work as a Red Cross illustrator. He started out making murals for a "donut dugout," a temporary cafeteria for soldiers. LeRoy couldn't resist sexing up his work for his weary and horny compatriots by painting a tiny nude jumping over and through donuts or peeking out from behind a sandwich. The curvy and impish woman anticipated the Femlin that Neiman would design for *Playboy* a decade later. He was subsequently assigned to create murals for officers' clubs and GI beer halls as well as sets for the United Service Organization shows that came through to entertain the troops. LeRoy also connected with a widowed German woman named Annie during his time in Eupen—the only wartime affair that saw him become emotionally attached. The spellbound soldier went AWOL to be with "his first true love" full-time. The war was all but over by that time, and LeRoy figured that his unit did not really need him. But the military

police soon found the errant soldier, who was not trying very hard to hide, and escorted him back to the base. LeRoy went on trial for desertion but was shown mercy for the commonplace infraction, convicted on a reduced charge, and fined $100.[34]

Once the war ended, Neiman signed up to serve as an artist in the Army of Occupation. One of his principal tasks while stationed in Freiburg, Germany, was to create posters warning troops about the dangers of venereal disease. Such messages were a staple of wartime health advisories in the days before penicillin. The campaigns cast the maladies as veritable Axis weapons because they laid up GIs as effectively as any injury suffered on the battlefield. The grave advisories became fodder for crass jokes among soldiers and prompts for them to brag about their sexual adventures. LeRoy recognized the campaigns' counterproductive dimensions and struck an ironic and titillating tone with his VD posters. He proudly described his works as "bordering on pornography." Soldiers ripped his lurid prints off the walls to keep as souvenirs, which Neiman took as a great compliment. "During the war, posters like this were considered unimportant," he reflected, "but they were important to me, because it was only then that I positively knew I would be an artist."[35] They also further convinced Neiman that purposeful art should be accessible and could range in tone from serious to silly to erotic.

LeRoy was honorably discharged on November 20, 1945, despite his Belgian escapade. He ended his military career as a technician fourth grade (T/4) and earned five battle stars for the 461st's contributions in Normandy, northern France, Ardennes, Rhineland, and Central Europe. Before shipping out from Rotterdam, the erstwhile Catholic took a brief side trip to see Peter Paul Rubens's massive three-paneled altarpiece *Elevation of the Cross* at the Cathedral of Our Lady in Antwerp, a mural that demonstrated the medium's potential beyond mess halls and officers' clubs. Neiman sailed across the Atlantic to Boston and was eventually transported to the separation center at Camp McCoy, Wisconsin, where Lydia was waiting to drive him home. Earl had returned shortly before his younger brother, and she was overjoyed that both of her sons had made it back alive and in one piece.

LeRoy saw enough death in Europe to gain a new appreciation of life's fragility. The experience convinced him that he had to commit to his dream of becoming an artist—despite his lack of money, education, and connections. Neiman made the liberating realization that he "had nothing to lose." He was lucky to be alive and figured that failure would be far preferable to giving up. And his job prospects after returning to St. Paul were not appreciably better than they were before he left. He could use his cooking experience to get a position slinging hash, go back to the box factory, move to Braham, or join up with a road construction crew. None of those options seemed appetizing to the veteran, who had consistently gone to great lengths to avoid manual labor. "I had no idea how I would pursue life as an artist, but it was time to stop stalling," he wrote.[36] At that point LeRoy had fulfilled the "four prerequisites" he would later sarcastically identify as necessary criteria for an artist to succeed: "1) He should begin life at the poverty level; 2) come from a broken home; 3) be a high school dropout; and 4) have an undistinguished military career."[37] Neiman also learned about the support for education recently made available for military veterans—even mediocre soldiers like him—through the GI Bill.

Embarking on his new quest, LeRoy got in touch with the closest thing he knew to an art-world insider—his former Washington High art teacher Bessie Mulholland. She recommended that he look into the St. Paul School of Art and meet its most notorious teacher, Clement Haupers.

3

A Roguish Role Model

It is unsurprising that Bessie Mulholland would have known Clement Haupers and how to reach him. St. Paul journalist Ricardo J. Brown described Haupers as "the only celebrity we had" in the midcentury Minnesota art scene.[1] He was an ostentatious man-about-town who lived a bohemian lifestyle and was known to don a purple velvet tuxedo while holding court at Twin Cities art exhibits and taverns. Beyond producing his own work, Haupers devoted much of his professional energies to administrative positions designed support local art. If anyone in St. Paul could guide Neiman's quest to become a working artist, it was Clem Haupers.

Born in 1900, Haupers shared Neiman's humble St. Paul background. He showed creative promise early on, but his family lacked the resources to support his interest in art. In fact, they needed him to help pay the bills. So Haupers left school at fourteen to enroll in a typing and shorthand course. He then briefly clerked at the Northwestern Blaugas Company in St. Paul before securing a better paying position as a stenographer with the Chicago, Milwaukee, and St. Paul Railroad. He found opportunities to study art independently during his off hours by taking in exhibitions at the Minneapolis School of Art, thumbing through the James J. Hill Library's art books, and visiting the Thomas B. Walker art collection, which was then housed at the lumber baron's mansion on Eighth Street and Hennepin Avenue.

One of the librarians Haupers met during his informal studies recommended that the young enthusiast visit the museum at the Art Institute of Chicago.[2] Fortunately, the railroad provided free weekend

passes for its employees—the mind-numbing job's only perk. Haupers would catch the earliest Saturday-morning train and head straight to the museum to spend the day exploring its enormous collection, especially the paintings. He typically stayed until closing, when he would walk downtown to see music and burlesque dancing before boarding the midnight train back north to St. Paul. "I got a liberal education thanks to the railroad passes," he later reminisced.[3]

With the Chicago day trips, Haupers's interest in art swelled into an obsession. He began attending evening classes at the Minneapolis School of Fine Art in 1918, and he joined the St. Paul Student Art League, a weekend painting club run by Clara Mairs. While at the Art League Haupers developed a relationship with Mairs, twenty-two years his senior, that matured into a lifelong romantic and creative partnership. Their union was a favorite topic in the St. Paul art world's gossip mill given their age difference, the fact that they never married or had children, and, above all, Haupers's penchant for both male and female bedmates. Mairs persuaded Haupers to quit the railroad and attend art school full-time in 1921. He studied for only six months before dropping out because of a combination of financial difficulties and frustration with the school's inflexible curriculum. But he leveraged his business training and Mairs's professional contacts to secure a full-time position as secretary of the Minnesota State Art Society.[4]

By 1923 Haupers and Mairs saved enough money to travel to Paris and study with the cubist painter André Lhote. They joined a wave of American expatriates—including their fellow St. Paulite F. Scott Fitzgerald—who gravitated to the exciting and freethinking city during the interwar years. After studying during the day, Haupers sketched the late-night gaiety at Paris cabarets, where he saw even bawdier acts than the performances he witnessed on his weekend jaunts to Chicago.

Haupers transformed many of his Parisian sketches into paintings that anticipate the decadent work of his eventual protégé. *Two Girls, One Sailor* (1926) depicts a stage performance in a dark club from the perspective of an audience member. Two half-dressed women gyrate alongside a sailor as a violinist accompanies from the orchestra pit.

By including the musician and other offstage elements that build the spectacle, *Two Girls, One Sailor* points out how burlesque clubs packaged these sexual fantasies for consumption. This commentary is clearer in *Charleston* (1928), which centers on three women performing the dance after which the painting is named. The trio is on stage and illuminated by the circular beam from a spotlight. Like *Two Girls, One Sailor*, a fiddler plays just below the front of the stage. But the scene in *Charleston* is depicted from the point of view of a spotlight operator. This perspective gestures to the labor, artifice, and business that converge to produce the stage show.

The Parisian bona fides gave Haupers distinction and credibility when he returned to St. Paul. He was a big fish in a relatively small pond who flaunted his recently acquired pedigree by sporting a beret (he brought several back from France). "Nobody else in St. Paul wore a beret," Brown observed.[5] Haupers's work steadily veered away from urban leisure scenes like *Charleston* to focus on landscapes, portraits, and printmaking. He attracted modest recognition after returning to the United States. In 1930, the Ashcan school artist John Sloan included Haupers's *Small House, Cagnes* in a show he curated for the American Institute of Graphic Arts in New York. The following year, Haupers had an oil painting titled *Algerian Scene* accepted for exhibition at the Art Institute of Chicago—a special thrill given the formative influence that its museum had on him.[6]

Haupers parlayed his recognition into a job as superintendent of fine arts for the Minnesota State Fair, a post he held from 1931 through 1942. His main responsibility was running the fair's annual exhibit. He was specifically charged with returning the show to its original purpose of elevating local art and artists, a mission from which the exhibition had strayed. Haupers, in fact, oversaw the state fair shows Neiman perused as an adolescent, shaping LeRoy's understanding of art long before the two met. This commitment to boosting local art made Haupers a natural choice to serve as the Minnesota director of the Works Progress Administration's Federal Arts Project (FAP) when the New Deal agency launched in 1935.[7]

The FAP was devised to supply employment opportunities for

artists. It also offered public art instruction and strove to bring art-work to communities that otherwise seldom encountered it.[8] Haupers directed the Minnesota FAP for eighteen months before being pro-moted to director of the Midwest region, which covered seven states. Haupers's tenure culminated in 1941, when he moved to Washington, DC, for two years to serve as the assistant to national FAP director Holger Cahill. A 1943 *ARTnews* magazine survey named Haupers's FAP efforts "the single greatest factor toward the development of younger artists" in Minnesota.[9]

Haupers described the bulk of his FAP work as "public relations" that sold an often-skeptical public on the prospect of supporting the arts during times when many did not have enough to eat or pay rent. He focused his efforts on the regions beyond Minneapolis and St. Paul, which already had a healthy art culture. "I made a deliberate effort to do as little in the Cities as possible," he recalled. "I wanted to get out. The Cities had enough."[10] The eclectic projects included three-dimensional maps for the Minnesota State Academy for the Blind in Faribault and Richard Haines's seventy-two-foot-long Thomas Hart Benton–style mural in Sebeka's high school auditorium—a piece that remains the small town's key landmark. Haupers's FAP initiatives helped to spark art awareness in people like Lydia, who might have been more enthusiastic about her sons' interests had she been exposed to projects like the Sebeka mural or known that artists can use their skills to produce practical items like maps for the blind.

"Haupers relentlessly exhibited a Midwestern pragmatism," wrote the Minnesota Historical Society curators Brian Szott and Ben Gess-ner. "He used every opportunity to point out that 'art is work,' that the 'artist is a craftsperson' and that the 'artist is not separate from society.'"[11] Haupers discouraged artists from being too precious about their work or feeling entitled to support from programs like the FAP, which was discontinued in 1943 when federal resources were diverted to supporting World War II. Those who sought to establish a career in art needed to be scrappy and self-reliant: "I would like everyone to really get into the rat race and try to market himself early in the game, to cut out all these extra fellowships and things, these subsidies. They

are dangerous. Because it tends to segregate the individual." Aspiring artists, he also believed, would inevitably have to make creative compromises to support themselves. "If an artist doesn't have the drive to express what he sees around him and turn it into something that someone will buy, I say he's in the wrong business," Haupers put it frankly. "After it is all said and done there just ain't no free lunch."[12]

The hardened realist practiced what he preached. He taught evening classes at the St. Paul School of Art and took on a broad range of freelance projects after the FAP folded. Few jobs were beneath his dignity so long as they paid his requested rate. A family in the wealthy Minneapolis suburb of St. Louis Park hired Haupers to paint a princess and feather fans on their amusement room walls. Another affluent household contracted him to paint cherubs on the headboards of their children's beds. "I didn't get to do my own work as much as I'd like," he later recalled. "But I did as well as I have done because I'm flexible."[13] Impressed by Haupers's ability to support himself, the University of Minnesota art professor H. Harvard Arnason invited him to discuss freelancing with his class. Haupers asked Arnason how long he would like him to talk with the class. When Arnason suggested thirty or forty-five minutes, Haupers paused to consider the request and responded, "That will be 150 dollars." Arnason, who expected Haupers to give the presentation as a personal favor, protested the steep cost. But Haupers reminded his colleague that charging for such services is precisely how he developed the business skills that Arnason wanted him to impart: "That's one way that a freelancer makes his living, he sells his words when he can't sell his hands."[14]

While Haupers was pragmatic in business, his outlandish demeanor and style strategically fed into stereotypes of artists as flamboyant iconoclasts. He paired his signature beret with a wardrobe that included bright color combinations of corduroy trousers and flannel shirts. Before approaching the lectern to give an FAP-related presentation in rural Minnesota, Haupers paused to adjust his cherry red beret and light up a cigar. "They're expecting an artist," he told a colleague as smoke began rising from the end of his stogie, "and they're not going to be disappointed."[15] It was exactly the sort of performance

Neiman would eventually offer audiences to broadcast his position as a swashbuckling painter.

* * *

Neiman began taking night classes with Haupers at the St. Paul School of Art shortly after returning from war. The courses were filled mostly with casual Sunday painters who sought an opportunity to practice, share their work, and receive some pointers. Haupers did not pull punches when commenting on his students' art, regardless of their ambitions. Neiman recalls one instance when a kindly local physician presented a heartfelt painting of an automobile wreck on a country highway. It depicted a gallant doctor attending to some injured passengers on the side of the road near a dairy farm. But Haupers "said in so many words that it was a subject unsuitable to a painting," a blunt review that left the doctor visibly embarrassed in front of his classmates. Neiman disagreed with Haupers's biting assessment of the piece, which he described as a "successful landscape," but the occasion left him eager to impress the prickly educator.[16]

LeRoy was enthralled by Haupers's attitude and appearance before seeing any of the teacher's work or receiving his advice. "Clement was my idea of what an artist should look like," he recalled. "He was my idol, mentor, and roguish role model—he lived the full-bore vie boheme."[17] Neiman became an acolyte as much as a student. He did not simply want to learn how to paint and draw. He sought an identity and craved a mentor who would guide his transformation.

Shortly after returning to St. Paul, Neiman anxiously visited Haupers's studio and asked the teacher to look at some of his army sketches. LeRoy wanted to know whether Haupers thought he could make a serious run at a career in art. Haupers happened to have "a very busty redhead" posing for a portrait when Neiman dropped in. "I had him sit down, gave him a pad and charcoal," Haupers recollected, "and it was like throwing a duck into the water." The teacher immediately recognized Neiman's natural talent, especially his drafting abilities, which bordered on prodigious. But he also noticed that the young veteran had little technical knowledge. Haupers schooled

LeRoy on composition, space organization, and color mixing while providing the student with a vocabulary that would help him to make sense of the work he produced and plug it into artistic traditions. "I gave him the whole run down," Haupers said. "He dug into his color analysis and he was a damn good student."[18]

Neiman's thirst for training required more than the three evening course meetings Haupers offered each week. The teacher and student often continued their conversations after class, when they would discuss art and literature over drinks until the bars closed. They debated, for instance, the relative merits of Henri de Toulouse-Lautrec, whom Neiman admired and Haupers dismissed as a mere illustrator— a surprising perspective given how works like *Two Girls, One Sailor* and *Charleston* explore some of Lautrec's favorite themes. Haupers encouraged LeRoy to delve deeper into Twin Cities art culture by visiting the Walker Art Center—which had moved from Thomas Walker's estate into a freestanding building in 1927—to see Franz Marc's vibrant *The Large Blue Horses* (1911), and he introduced Neiman to the work of local artists like the sculptor Paul Manship and the regionalist lithographer Adolf Dehn. He also recommended the writings of Fitzgerald and praised the writer's acerbic depictions of the moneyed St. Paul communities that neither Haupers nor Neiman were permitted to access while growing up poor in the city. Haupers offered Neiman the beginnings of a liberal education that the high school dropout never received.

One autumn morning in 1946 Haupers invited LeRoy to accompany him on a drive to the country south of St. Paul to paint the prismatic fall landscape *en plein air*. A nostalgic Neiman later described the duo bumping along the road in Haupers's jalopy as "a veritable caricature of bohemian artists on a mission to search out the sublime vista." Haupers finally pulled over near some bluffs. But when the painters went to gather their supplies from the trunk, Haupers realized that he had forgotten his brushes. He politely declined LeRoy's offer to lend him an extra brush and sent the student on his way to paint whatever scene wound up inspiring him. Neiman was astounded when he returned a few hours later to find Haupers completing a landscape at

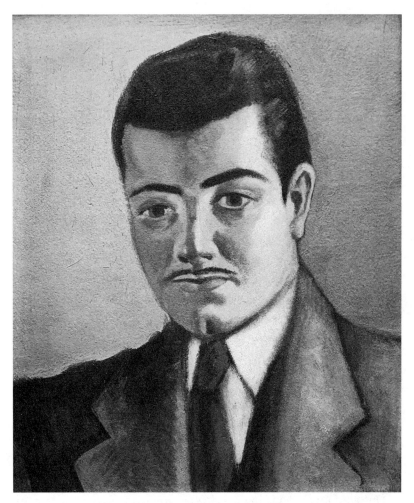

FIGURE 9. Clement Haupers, portrait of LeRoy Neiman, n.d.

his easel, with a brush fashioned out of an oak leaf he had foraged. "He painted nature with nature," the dumbfounded student exclaimed.[19] The achievement left an indelible imprint, similar to the transparent glasses painted on the governors' portraits at the Minnesota state capitol. If those portraits made Neiman think of art as a form of magic, Haupers's performance in the country presented artists as alchemists who conjured their visions into reality.

Haupers genuinely liked LeRoy, identified with the student's working-class roots, and respected his tenacious work ethic. The two

maintained semiregular correspondence until the teacher's death in 1982. While Haupers admired Neiman, he did not particularly enjoy the artwork that eventually made his student famous. "I think he is very brilliant but terribly superficial," he remarked after LeRoy had hit it big.[20] But Haupers did appreciate Neiman's persistence. LeRoy took his education seriously and was willing to do whatever was necessary to forge a career in art. Haupers helped Neiman develop his own creative voice—however different it might have been from his own—and gave him tips on how to scare up work.

A commission that Neiman secured in 1947 demonstrates the overlapping artistic, social, and stylistic lessons he took from Haupers. LeRoy was having a spirited conversation over drinks with the St. Paul journalist Carol Pinsky and her husband. They stumbled onto the topic of portraiture, and the Pinskys expressed an interest in someday having theirs painted if they could find the right artist to do it for a reasonable price. The Pinskys also insisted that the artist they hired would enjoy total creative freedom. "There isn't a sucker alive who would pay good dough for a portrait over which he didn't have control," Neiman retorted between slurps of his cocktail. His counterpoint was a sly proposition. And the Pinskys took the bait. They demonstrated their conviction by hiring Neiman to paint them. LeRoy arrived early in the morning on the day when the Pinskys arranged to sit for the portrait. He wore a shabby straw hat and carefully arranged a day's worth of cigars and a bottle of bourbon alongside his brushes, porcelain palette, and easel. As Carol Pinsky recalls: "He spent the first hour perusing our wardrobes and deliberately chose a pair of blood-red lounging pajamas for me and a wine-colored robe for my husband. He painted steadily until nine at night when he slumped on the floor and called the painting done."[21] The episode shows that Neiman, like his mentor, was a business-savvy performer as well as a painter. He got the Pinsky job by schmoozing, made sure his clients received a memorable performance from a sufficiently quirky artist, and supplied them with a portrait that they agreed to accept in whatever state he presented it. Haupers would have been proud—despite what he might have thought about the portrait itself.

Neiman's brief apprenticeship under Haupers convinced him to use his GI Bill funding to pay for art school. He passed his high school equivalency exam and began considering different programs. Lydia wanted him to stay close to home and attend the Minneapolis School of Fine Arts. Neiman was also initially leaning toward the local option, especially since he had become seriously involved with a woman named Mickey. But Haupers urged Neiman to consider the School of the Art Institute of Chicago—where the teacher would have loved to enroll had he been given the chance. He pointed out that art schools provide benefits that span beyond the professional certifications they confer, a point that neither LeRoy nor Lydia fully realized. The Art Institute's global reputation, alumni network, facilities, and metropolitan location would afford Neiman opportunities that Minneapolis's school simply could not furnish. Haupers convinced Neiman that the road to becoming a professional artist would be far more arduous if he remained in the Twin Cities. "I said, 'For God's sake, Lee, there's no one [at the Minneapolis School of Fine Arts] who knows any more than I've given you.' I said, 'Go to Chicago because you don't know from Shinola what the whole field's about.'"[22] The school's application asked potential students why they had decided to apply for admission to the school. LeRoy listed Haupers's recommendation as the single motivation driving his application. The teacher's advice proved indispensable. The Art Institute became the launching pad for Neiman's professional career, and he later described Chicago as the place where his aesthetic was "born."[23]

4

Midwestern Bohemian

LeRoy did not have to leave Mickey behind when he left for Chicago. Instead, he convinced her to join him. They moved down in August 1947 for the school year that would begin the following month. Neiman sent a card to Lydia and Ernst as soon as the couple arrived in Chicago and checked into the YMCA hotel downtown. It featured an illustration of a northwest-facing view of Chicago's skyline from Grant Park, just east of the YMCA alongside Lake Michigan. LeRoy drew a circle around the Art Institute in the picture's foreground. The card read:

> August 9, 1947
> Dear Folks,
>
> Well, we are here and it's great. We have a corner, outside room on the 17th floor of the YMCA Hotel so we can see out for many miles in two directions (one over the lake). We stayed in Rockford on Wednesday nite, and got in here at 8:30 on Thursday morning. The trip went fine except I backed into a concrete post at Mendota and smashed a rear fender and taillight all to hell. Outlined on the photo is the Chicago Art Institute, where I'm going to school.
>
> Love,
> LeRoy[1]

The note shows Neiman's excitement on the cusp of his new life as an artist in Chicago. He could not wait to tell Lydia and Ernst about

the picturesque city and the school he would be attending right in the middle of it. The dispatch also underscores the young artist's provincialism. He presents Chicago as an exotic metropolis with which he and his family were largely unfamiliar despite their relative proximity. LeRoy presumes that his mother and Ernst will be impressed by the fact that he and Mickey are staying on the seventeenth floor of a massive hotel with a view of the lake, even though they were renting a small room in a budget YMCA.

The couple rented an apartment on 2620 North Drake, about seven miles northwest of downtown. While thrilling, the transition from St. Paul to Chicago strained the duo's relationship from the start. Neiman later claimed he was never particularly confident that their romance would last. But he was intimidated by moving to the city and enrolling in the prestigious art school, and he craved support during the vulnerable time. Much like during his engagement to Lorayne, he needed someone to help him manage a stressful situation; that person, however, did not need to be Mickey.

The early days in Chicago also marked the beginnings of Neiman's struggles with PTSD from his time at war—a manifestation that was likely triggered by the sudden and combined stress of the transition away from the familiar comforts of St. Paul, the pressures of school, and his relationship problems. "I hadn't really ever dealt with the postwar shock that was still eating away at me," Neiman later wrote.[2] His mental health eventually deteriorated to the point at which he checked himself into the Hines Veterans Hospital west of Chicago for what was then euphemistically termed "exhaustion." War-related PTSD was still a highly stigmatized condition despite the many returning veterans who suffered from it, and Neiman felt humiliated and emasculated as soon as he entered Hines. LeRoy's shame outweighed his anguish, and he left the hospital without completing his evaluation and treatment.

Neiman was allowed to keep his sketchbook during the brief stay, and his drawings depict the fellow Hines patients as a forlorn and vacant-eyed lot. The prideful artist did not admit that he suffered from PTSD until decades later, preferring instead to claim that his

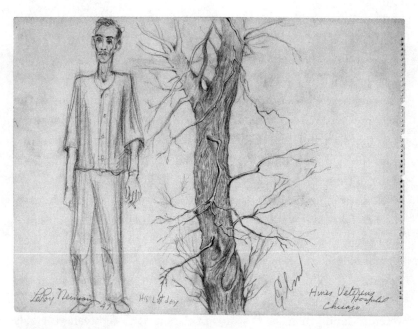

FIGURE 10. LeRoy Neiman, sketch from the Hines Veterans Hospital, 1947.
© 2023 LeRoy Neiman and Janet Byrne Neiman Foundation / Artists Rights Society
(ARS), NY.

girlfriend trouble drove him to temporary lovesick madness. Neiman
was fine with being viewed as a hopeless romantic who cracked up
over women but not as an apparent coward who was scarred by war.
Mickey actually helped LeRoy to enter and leave the hospital. But the
couple split up shortly thereafter. Neiman missed enough class amid
the episode that his design instructor reported that "it is difficult to
evaluate him because he is ill."[3] But he did not fail any courses, and he
managed to finish the year in good academic standing.

Unable to afford the rent on Drake without Mickey's help, Nei-
man briefly found a place on Chicago's South Side that he shared
with some schoolmates before making his way closer downtown
to an apartment building at 13 West Ontario. He spent time in Chi-
cago's pulsating Loop district—packed with taverns, clubs, and strip
joints—until 1961. Although he was initially driven downtown for
economic reasons, it proved a familiar and comforting environment.
LeRoy steadily found his bearings, learned to balance life and work,

and settled into an urban bohemian lifestyle that took advantage of postwar Chicago's many cultural offerings. He also learned to get by on a shoestring budget. When Neiman would visit a bar to watch televised prizefights, for instance, he would insist on splitting a twenty-five-cent beer with a friend, which irked the waitstaff but allowed the fledgling artist to stretch his limited income.[4] At school, he sometimes stole tubes of paint, especially the more expensive cadmium pigments, from the campus art-supply store and scraped globs of the precious material from unattended palettes to use in his own work.[5]

Neiman joined a raft of mostly working-class GI Bill students at the School of the Art Institute (SAIC) that included Cosmo Campoli, Leon Golub, Thomas Kapsalis, Seymour Rosofsky, and H. C. Westermann. The students, most of whom enrolled while in their mid-twenties, were markedly different in age and experience from the SAIC's traditionally younger and more affluent matriculants. The veterans found themselves seated in class next to eighteen-year-olds fresh out of high school. But the cohort forged a supportive community. Many of the artist-veterans were identified with the "Monster Roster"—an audacious collection of mostly SAIC alumni known for working in distorted and expressionistic figuration, existential themes, and mythological imagery during the 1950s. Neiman knew this group of local artists—which the critic Franz Schulze named after the Chicago Bears' "Monsters of the Midway" moniker—but he was not identified with the movement.[6]

While he was not the only working-class or GI Bill student at the SAIC, Neiman remained insecure about his social status and clung to the protective streetwise image he crafted in Frogtown. An official student photo displays LeRoy peering dispassionately into the camera with his head cocked to the right and his left eyebrow slightly arched. He wears a freshly greased pompadour, and a thin Clark Gable–style mustache hovers above his faintly pursed lips. He seems unimpressed and moderately inconvenienced by having to sit for the school photographer.

As Haupers rightly predicted, LeRoy thrived in his new environment once he acclimated. If he were so inclined, the student could

saunter over to the Art Institute between classes to see Breton's original *Song of the Lark*—an astronomical difference from the weathered reproduction of the painting at St. Vincent's. Like his fellow students, Neiman became caught up in the excitement surrounding the emergence of abstract expressionism, or ab-ex, and its hotshot action painters—a youthful and iconoclastic movement whose work complemented the improvisational jazz music he was beginning to take in at South Side nightclubs. Neiman called ab-ex "the big shock of my life" up to that point in his artistic training. "It changed my work. I was an academically trained student, and suddenly you could pour paint, smear it on, broom it on!"[7] Always interested in pruning his look, LeRoy began cribbing from ab-ex idol Jackson Pollock's unruly tendency to wear paint-splattered clothes in public. It was an early draft of the uniform he would not perfect until the mid-1960s.

"Going to art school after the war gave me new strength," LeRoy reflected. "I knew what it was to be a nonentity, and if I was going to make anything of myself, I knew I had to do it myself. Once you get caught up with people who are more informed and knowledgeable, more sophisticated and worldly, you're driven to keep up with them as best as you can."[8] He was eager to impress his professors, and he strove to make up for his late academic start by taking extra weekend classes; reading widely across art history, literature, and sociology; and attending local poetry readings when he got the chance. "I worked hard in class. Taking a crack at everything that presented itself. Every day was discovery day. I was sampling, discarding, learning."[9]

Of all of Neiman's SAIC professors, the Russian painter Boris Anisfeld made the most lasting impression. Anisfeld became famous by painting sets for Sergei Diaghilev's Ballets Russes. The artist's reputation preceded him upon his 1918 arrival in America, when *Vogue* lauded him as "the first and chief of great Russian scene painters."[10] He came to Chicago in 1921 to create the settings for the Chicago Opera Company's world premiere of Sergei Prokofiev's *The Love for Three Oranges*. Anisfeld began to teach painting at the SAIC, which then included a school of drama, in 1929.

Neiman gravitated toward Anisfeld for many of the same reasons

FIGURE 11. Neiman while studying at the School of the Art Institute of Chicago, 1948.
Courtesy of the LeRoy Neiman and Janet Byrne Neiman Foundation.

that drew him to Haupers. Anisfeld was an enigmatic and sagacious presence who wore his white hair in a bob, had a scraggly beard, spoke in a heavy Russian accent, and preferred to paint by candle-light. LeRoy considered the teacher "a true mystic straight out of Dostoevsky."[11] The romantic Anisfeld often declared, "I do not paint what I see but what I feel," and boasted that his ideas came to him fully formed in sudden bursts of inspiration. "I always see a thing first in color," he remarked. "It comes to me as a fairly complete concep-tion, and I rarely have to alter the essential character of my initial impressions." Neiman claimed that Anisfeld's greatest piece of advice was that artists should always paint "from the heart."[12] Anisfeld took umbrage when the preeminent Chicago chronicler and socialite Studs Terkel once referred to him as a scene designer, a comment that was not intended as an insult. "I will not stand this 'scene designer.' I am an artist!" Anisfeld shot back.[13] But Anisfeld was not entirely unbend-ing, and much like Haupers, he let the marketplace shape his work. He spent much of his career operating in the service of production companies. While he may have painted as he felt, he also had to be sure his clients were satisfied.

LeRoy described Anisfeld as "my greatest teacher" and "the man who taught me how to paint." Beyond recommending that students work from their hearts, Anisfeld was known for carefully training them to mix colors and use different shades to create the illusion of depth. He encouraged students to use color liberally and to exper-iment with dramatic juxtapositions that would plumb its symbolic dimensions. LeRoy fell under the spell of another charismatic mentor. "His remarkable personality took such a hold of me that it took me at least five years to regain my American identity," he said of Anisfeld's influence.[14]

And LeRoy claimed that Anisfeld thought he "was his best pupil." Neiman did well in Anisfeld's courses, but the teacher hardly seemed blown away by his work. His yearly evaluation for Neiman in 1949 rated the student's attitude as "excellent" but listed his initiative, dependability, and ability as merely "good." Anisfeld's 1950 assess-ment demoted LeRoy's attitude to "good." Despite the unexceptional

marks, Anisfeld did award Neiman a commendation for his Still Life Painting course.[15] Thrilled to have impressed the exacting professor, Neiman posed with a painting he produced for the class—a still life depicting a cask of wine and some fruit on a table. The student's contented grin—an earnest contrast to the nonplussed smirk in his student photo—hints at the satisfaction he took at gaining Anisfeld's hard-won approval.

LeRoy received class commendations in Fashion Illustration and Figure Drawing as well as an SAIC-wide award for the 1949–1950 school year. He performed well enough, but by no means enjoyed the star status he had back at Washington High. Neiman's attitude, personality, and work ethic—not his creativity or technical skill—were the qualities that drew the highest praise among his teachers. Michael M. Ursulescu, instructor of Figure Drawing, lauded Neiman as "very dependable" and a "very hard worker." Salcia Bahnc, professor of the Pictorial Composition course, noted "a natural sense of the elegant in his work" that LeRoy matched with "a good deal of charm."[16]

The faculty assessments that did remark on LeRoy's technical and creative ability suggested that he showed the most promise in the field of commercial art. Another Figure Drawing instructor, John Rogers Cox, called him an "excellent draftsman," and Composition professor Edgar Rupprecht commented on LeRoy's depictions of "super sophisticated, decadent types" and found the student's "technique admirably fitted for such subjects."[17] The evaluations were tracking Neiman into a career in fashion illustration—a commonplace path for SAIC graduates—which traded in the sorts of sophisticates LeRoy was proving himself so adept at drawing. The professors implied that Neiman's good attitude and considerable charm would serve him well in a commercial atmosphere while gently hinting that LeRoy did not have a future in fine art.

While Neiman's faculty mentors were recommending suitable professional pathways, the student maintained little interest in specializing. He took inspiration from the abstract expressionists, impressionists, fauvists, Ashcan social realists, contemporary Monster Roster Chicagoans, and English satirists like William Hogarth and Thomas

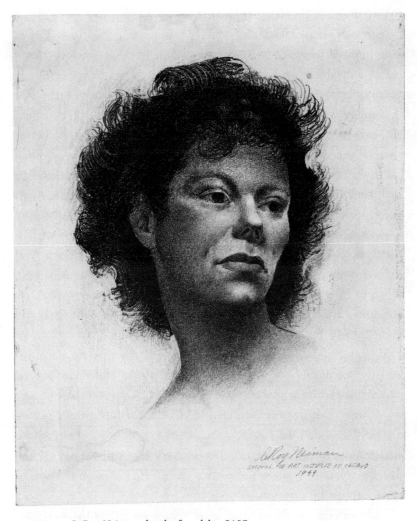

FIGURE 12. LeRoy Neiman, sketch of model at SAIC, 1949.
© 2023 LeRoy Neiman and Janet Byrne Neiman Foundation / Artists Rights Society
(ARS), NY.

Rowlandson. LeRoy eventually cited his major influences as "Leonardo and Rubens for spirit. Tintoretto for space, and Fragonard for brushwork." He borrowed freely from a vast range of work, spanning Thomas Hart Benton's Works Progress Administration murals, Jackson Pollock's action paintings, and Oskar Kokoschka's lesser-known expressionist portraits.[18]

77

But the eclectic Neiman knew that he wanted to follow in the footsteps of Haupers and Anisfeld by emphasizing painting. He was disappointed when the SAIC tracked him into illustration, which LeRoy considered a relatively frivolous field shaped by cynical business imperatives rather than creative inspiration—despite the fact that many respectable artists did commercial work. The prospect of a career in commercial art became less disheartening, however, once Neiman began studying Toulouse-Lautrec. He had always liked Lautrec—and defended the artist during his late-night bull sessions with Haupers. But something clicked after he visited a Lautrec exhibition at the Art Institute in summer 1949. It was the largest Lautrec show ever held in America at that point. He saw in Lautrec's work a witty and colorful template he could apply to postwar America. And Neiman's interest in Lautrec's art, much of which was commercial, began to convince him that there were exciting creative possibilities in fashion illustration, which, he claimed, "encouraged the fluid and loose line of a Lautrec drawing."[19]

He immersed himself in Lautrec more seriously than he had studied any previous hero. Again, his Art Institute affiliation proved advantageous. The school library's Chester Dale Collection owned several Lautrec paintings, a sketchbook, and hundreds of prints. LeRoy regularly hounded Art Institute archivists to gather boxes of Lautrec lithographs from the special collections for him to pore over while wearing the obligatory white cotton gloves. His research led him to name Lautrec his "true master."[20]

Although he was forming his artistic identity in and through Chicago, Neiman's first whiffs of creative success came back in St. Paul, when had a painting accepted for inclusion in the 1949 Minnesota State Fair exhibit—an accomplishment aided by Haupers's rededication of the show to local artists during the previous decade. Neiman's relationship with Lydia also began to shift on his trips back home. His mother started to take his art seriously once she realized it could lead to a career. She even sat for a portrait when LeRoy visited during summer 1948, which took him four sessions to complete. Lydia, who

was then fifty, initially complained that the painting made her look old, and she stowed it away in her attic. But Neiman remarked that his mother had the painting proudly displayed in her living room ten years later, at which point she said, "I like it now because it makes me look so young."[21]

After LeRoy shared his newfound infatuation with Lautrec, Lydia bought him a book of the artist's prints at the Golden Rule department store in downtown St. Paul. He recalled Lydia sitting at the foot of his bed during his visits to chat late into the evenings before he dozed off. "She would be encouraging about my future as an artist. They were close talks," Neiman remembered. "She wanted me to make it."[22] Lydia teamed up with Haupers to place Neiman's work in St. Paul galleries and exhibits while LeRoy was in Chicago. Haupers wrote her a letter of introduction to the owner of St. Paul's Beard Gallery in advance of Lydia successfully convincing them to take three of LeRoy's works on consignment. Lydia finally understood that her son's aspirations were more than a diversion, and she found small ways to help launch him as a professional artist. She was also proud of LeRoy's success and enjoyed the status that came along with being the mother of a known artist.

* * *

After graduating from the School of the Art Institute in 1950, LeRoy followed his instructors' advice and Lautrec's inspiration by accepting a position at the Hoskinson & Rohloff commercial art studio, just down the street from the SAIC. It was one of several downtown Chicago art studios that filled its entry-level jobs with recent SAIC graduates. Hoskinson & Rohloff mostly did work for local advertising agencies and department stores like Carson Pirie Scott, Marshall Field, and Blum's-Vogue. Neiman was paid $65 a week to produce fashion illustrations, and he contributed to ads that appeared in magazines such as *Vogue, Harper's Bazaar*, and *Brides*. He soon established himself as one of the firm's most reliable illustrators, and his elegant draftsmanship prompted several Hoskinson & Rohloff clients to request

him by name. Neiman would often sign his illustrations with a curling "LeRoy"—an uncommon practice in the profession but one that shows his early attempts to establish a distinctive brand.

While Lautrec's fashion illustrations initially made Neiman optimistic about entering the field, the work at Hoskinson & Rohloff lacked the playfulness, wit, and individuality that marked his idol's oeuvre. Neiman began to resent the "drudgery" of sitting at a drawing board from nine to five drafting wedding gowns, pencil skirts, and pumps. He described the job as "tense, overworked, and mindless," and he grew disdainful of his senior colleagues, who he felt had abandoned whatever creative goals might have originally prompted them to pursue a career in art. "I was an arrogant upstart on his way, well, to something better," he wrote. "I had nothing but contempt for the lifers." LeRoy promised himself that the illustrating job would be only a temporary measure to pay the bills until he could find something more interesting.

The greenhorn illustrator worked hard despite the monotony, and he tried to use his uninteresting assignments as creative outlets. LeRoy recalls treating "women's millinery like still-life painting with berries, straw, fruit, flowers, ribbons."[23] The job, however, had its perks. He enjoyed interacting with the female models hired to wear the products he drew, and he even convinced a few of them to pose for his own paintings after hours. But he was generally let down by the lack of creative freedom in illustration. Neiman reached his goal of making a living by creating art, but it was an art form that prohibited him from exercising the expression that drew him to the field. Working at Hoskinson & Rohloff was ultimately not too different from making boxes at Waldorf.

Neiman was pleasantly surprised when the SAIC's dean Hubert Ropp asked him to teach a summer illustration course soon after he graduated. It was not uncommon for the school's graduates to teach a class in their area of expertise—particularly in the evenings or on the weekends. But the offer caught Neiman off guard, particularly since Ropp had once expressed distaste for his use of color. But Ropp also thought Neiman's affability, work ethic, and relative maturity—

all of which were clearly registered in his evaluations—might make him a good teacher, at least for a lower-stakes summer course. LeRoy accepted the position on the spot. Although it was only a single class and the pay was low, the prestige attached to teaching at the Art Institute—to being a *professor*—made it well worth his time. Continuing to act as Neiman's unofficial St. Paul press agent, Lydia placed an announcement in a local paper along with a headshot of her son. There was no such pronouncement published when Neiman joined Hoskinson & Rohloff. The commercial art studio was a job; teaching composed an identity.

LeRoy wound up teaching at the SAIC part-time through the 1950s. He mainly offered fashion illustration or advertising illustration classes in the evenings and on weekends; and he never worked with longer than a one-year contract. His courses, like those Haupers taught in St. Paul, served a combination of hobbyists and people who sought to expand their professional horizons. They were a popular moneymaker for the SAIC that kept classrooms full into the night all week and were staffed by teachers who earned appreciably less than the school's permanent faculty. A November 1952 *Chicago Sun-Times* article titled "Anyone Can Paint, These Happy Amateurs Say," reported on the sorts of night courses Neiman taught. "Hundreds of Chicagoans who, without any previous art training, are spending their after-work hours with brushes and canvas," it reported. A photo of Neiman instructing several attentive female students accompanies the article. Neiman, looking professorial in a suit and tie, leans over a student's easel to offer tips as she gazes toward a model posing on a stage in front of the classroom.[24] LeRoy faces away from the model and toward the camera to ensure the photographer gets a good shot of the intent young pedagogue in action.

Esther Penn, who took LeRoy's fashion illustration course soon after graduating from high school and became his lifelong friend, described Neiman as "a big personality" in the classroom. "He was very inspiring, always very creative," Penn commented. Another former student, Rita Marsh, claimed that LeRoy's pupils held him in such high esteem that the charismatic teacher "could say that sky was

green and everyone would agree." Like Haupers, Neiman socialized with students after class let out—often at an on-campus lounge nicknamed the "Snake Pit." Penn would sometimes attend local exhibits with Neiman on weekends, and she suspected that he liked playing the role of knowledgeable mentor as much as she appreciated his guidance.[25] Neiman so enjoyed his work in the classroom that he considered shifting entirely to a career as a full-time teacher, which required a year of liberal arts training in addition to his SAIC degree. He took sundry courses at Wright Junior College, DePaul University, Roosevelt University, and the University of Illinois's Chicago campus. But ultimately he never pursued teaching as his principal occupation.

Although Neiman inspired students like Penn and Marsh, his official teaching observations—conducted by his SAIC colleagues—show mixed reviews. The painter Edithe Jane Cassady began her evaluation politely by calling LeRoy "a very nice person." She then wondered: "Is he interested in teaching? Frankly, I can't figure it out." Nelli Bar, a sculptor, issued a similarly ambivalent report. She remarked on LeRoy's kindness with students and noted that he "was successful in his teaching." Bar balanced this compliment by observing that Neiman sometimes seemed aloof; he "has yet to realize that young people need somewhat more constant alertness of the instructor." It is likely that Neiman was more alert when interacting with young female students like Penn and Marsh. He also might have been more enthusiastic about his teaching had he been able to offer courses beyond commercial art, an opportunity he hoped his additional education might eventually provide.[26] But much like the SAIC tracked him into illustration when he was a student, the school limited Neiman's teaching assignments to the less glamorous part of its curriculum.

Regardless of the coldness he felt toward his work at Hoskinson & Rohloff, LeRoy was doing well in illustration. A drawing he produced for Marshall Field earned a 1952 Chicago Art Directors prize. Such accolades, however, made him only more desirable as an instructor of fashion illustration, and they limited his prospects outside of the specialty he was establishing. Neiman applied for a Fulbright scholarship to study painting shortly after winning the Art Directors award.

His letter of recommendation from the SAIC—a requirement for the application—lauded LeRoy's "character and personal qualities" but claimed, "It is difficult to give an evaluation of his aesthetic understanding" since "most of his work has been in the commercial field."[27] Meanwhile, Neiman's Hoskinson & Rohloff colleagues did not take his creative ambitions seriously and sometimes even mocked his dream to make it as a fine artist. "They were more amused by him than anything," observed Penn, whom Neiman helped to get a job as an assistant at Hoskinson & Rohloff. "He always thought of himself as an artist," Penn added. "And *commercial*, he didn't like that word at all."[28] Quitting his job, however, was out of the question for the artist, who had no other way to make a living and could not survive by teaching alone.

LeRoy balanced his uninspiring professional life by inhabiting a bohemian identity outside of work. He moved into a small basement apartment at 745 North Wabash. The flat's downtown location—just a short walk from the many hot spots on Rush and Clark Streets—made its leaky ceiling, poor lighting, and cockroaches tolerable. The bachelor luxuriated in his role as a starving artist who slept on a natty innerspring mattress without a frame and hung his clothes on exposed overhead pipes. "It was really kind of a dump," Penn remembered of the apartment. The cement-floor basement, which also housed the building's boiler, doubled as LeRoy's studio and was littered with canvases, Masonite wallboards, and supplies he used on the paintings to which he still devoted himself when he was not illustrating or teaching. For an easel he used an old upright piano, whose keys gradually fused together as they became caked with paint drippings. He frequently hosted parties alongside a life-size cardboard cutout of Toulouse-Lautrec, which he lifted from the 1949 Art Institute exhibition. The icon served as a mascot for the hedonistic subterranean scene on Wabash. LeRoy would pose with his arm around Lautrec or put a drink in front of him to suggest the artist's spirit was present and participating in the debauchery. Neiman also took perverse enjoyment from the fact that Holy Name Cathedral sat just across the street from his quarters. The church's early Sunday service often began

around the time that LeRoy's gatherings let up. The lapsed Catholic became friendly with a priest he encountered on the street during smoke breaks, and one day he invited the cleric to see a Titian-inspired painting he had completed of Christ being taken off the cross. The priest had little interest and said it looked more "like a guy slipping on a bar of soap" than Jesus before the Resurrection. But Neiman delighted at the discomfort the pastor showed when glancing at the many nude portraits surrounding the Crucifixion scene in his apartment. "For him, I guess, it was like a step into hell," laughed LeRoy, who reveled in his role as a provocateur.[29]

LeRoy was entering paintings like his Crucifixion into contests around Chicago with little luck. "I was all over the arts scene," he said. "But I wanted recognition in the official art world too—the world of exhibitions, juried competitions, shows in galleries and museums."[30] He thought he might gain an edge by lying about his age so that he could qualify for an exhibition of emerging artists, which had an age limit of twenty-five. The skillful illustrator easily changed the birthdate on his driver's license from 1921 to 1927 in an ultimately fruitless effort to win the award. But Neiman stuck with the invented birthdate until he was eighty, when he no longer had anything to gain from being younger.

The charm, confidence, and toughness Neiman projected in public masked moody fits of self-doubt, illness, and depression. Penn recalls that LeRoy was "grandiose when the situation called for it." When it came to business, for instance, "he would just go after whatever it was that he was looking for." But Neiman was "emotionally vulnerable" and often childish in private. He once refused to talk to Penn for several weeks when she declined to accompany him to a friend's wedding in Canada. "You could hurt his feelings very easily," she said. Penn also recalled an event when the artist Claes Oldenburg—an SAIC graduate who also dabbled in illustration but was rapidly establishing himself as a notable fine artist in the 1950s—once dismissed LeRoy as "just an illustrator" while gossiping at a party.[31] She never repeated the remark to Neiman, knowing that he was envious of Oldenburg's success and

would have been distressed by the slight from his more renowned peer.

In early 1952 LeRoy penned a short poem to express some of the dejection he faced alongside his hardships:

Yesterday I should have wept here
Where I cry today
Somewhere else I shall cry tomorrow
Crying so much may be a sin
But no-one can see me
Because I cry within.[32]

He maintained a brave and often rather perky face amid the inner misery. His classmate Thomas Kapsalis described Neiman as "happy-go-lucky." "He was always optimistic," Kapsalis recalled. "No gloom and doom."[33] But as Neiman's poem indicates, he tended to suppress the dreariness that often threatened to overtake him.

* * *

LeRoy's spirits began to rise when he met the copywriter Janet Byrne. Janet worked at the Carson Pirie Scott department store on the corner of State and Madison, across the street from Hoskinson & Rohloff. She regularly contracted the art studio to create ads for the store. Hoskinson & Rohloff had assistants like Esther Penn who acted as couriers between the studio and its many nearby clients. But Neiman started to deliver his drawings personally after meeting Janet— a reserved but witty young woman who shared his interest in art that went beyond the commercial fare that brought them together.

Neiman started lingering around Carson Pirie Scott and entertained Janet with wisecracks and exaggerated stories about his hijinks. He also got to know her colleague Hugh Hefner, who might have hated his life as a nine-to-fiver even more than Neiman and would soon quit the department store's advertising division to join *Esquire* magazine. Janet continued to hire LeRoy after she left Carson Pirie

Scott to work as the creative director for Emporium World Millinery Company, which was also in the downtown Loop. Their conversations soon stretched into happy hour cocktails. She eventually agreed to model for some of his sketches—one of Neiman's favorite pickup techniques—and they evolved into a romantic item.

Born and raised in Chicago, Janet was the oldest of Jeannette and Willard Byrne's three children. Her childhood shared a great deal in common with LeRoy's upbringing—she had a largely absent and alcoholic father, was raised mainly by an overworked single mother, practiced Catholicism, and spent extensive time with her maternal grandparents. But Janet was a quiet and responsible kid—more like Earl than LeRoy. She had no interest in carousing with neighborhood hooligans, and her mother and grandparents would not have tolerated such behavior even if she were inclined to act up. Her brother Bill described Janet as a "Goody Two-Shoes" who excelled at school, followed the rules, and set the bar high for her younger brothers.[34] Janet spent most of her downtime drawing, making paper dolls, and practicing piano. She was one of the top students in her graduating class at Loretto Academy and was listed among the standout achievers across all Chicago-area Catholic schools in 1942. Like LeRoy, she put her creative skills to use by making posters for high school events. This was about the only similarity that ran across Janet and LeRoy's early academic experiences.[35] Janet's high marks earned her a partial scholarship to Mundelein College, a Catholic school for women on the city's North Side. But she could not afford the tuition even with the assistance and enrolled in Chicago Teachers College, which was free for anyone with the grades to be admitted.

Although Janet entered college immediately after high school, she did not envision a permanent future in the workforce. She planned to settle down with her neighborhood sweetheart, Jack Emmett, once he returned from his World War II service in the US Army Air Forces. Jack proposed right before reporting for duty. Unlike LeRoy, with his hasty prewar engagement to Lorayne, Janet took her betrothal seriously and had every intention of marrying her fiancé once he returned. She bided her time while he served in Europe by taking

courses at Teachers College, working part-time as a soda jerk, writing Jack letters about their plans, and eagerly waiting for his correspondences to arrive. Jack's letters suddenly stopped in spring 1945, when the second lieutenant's B-24 went missing over the Atlantic. He was pronounced dead by the War Department on May 25. Janet was devastated, and she held out desperate hope that Jack had somehow survived and was stranded on an island or being held prisoner. But Jack's family finally held a memorial service on September 19, which would have been his twenty-second birthday. Jack's mother gave Janet his army-issued wings.[36]

Janet faced the tragedy with stoicism and endured despite the heartache. She completed her teaching degree but opted to pursue a career in copywriting instead—perhaps an effort to impress her absent father, who had once worked in the field. Moreover, the world of advertising, which was then booming in Chicago, offered a more urbane and exciting option than teaching for the young, educated, and creative single woman. The profession was relatively welcoming to women who sought entry into the workplace, and it provided opportunities for Janet to meet like-minded folks close to her own age and to mingle with flirty artists like LeRoy.

Janet first introduced LeRoy to her family when she invited him to join them for Thanksgiving dinner in 1952. Neiman immediately made an impression, and according to Janet's brother Bill, the artist was striving to be memorable. "He was different from the other guys," Bill remembered. "He placed himself at the center of the event." LeRoy even brought his sketching materials to show off his talents at the feast. He proved sufficiently entertaining for the evening, but Janet's family was surprised that she continued dating the boastful artist. Her friends were similarly perplexed. "You wondered how they ever came together," Penn said.[37] But Janet was impressed by LeRoy's place in the local art scene, however negligible it was at the time. And LeRoy's grandstanding balanced her reserve. "She allowed him to take all the attention," Bill said. It was an arrangement that, at least initially, seemed to satisfy them both. Janet loved art, and she took evening courses in painting and dressmaking. She became a proficient enough

FIGURE 13. LeRoy Neiman and Janet Byrne Neiman in Saugatuck, Michigan, n.d.
Courtesy of the LeRoy Neiman and Janet Byrne Neiman Foundation.

seamstress, in fact, to make her own wedding dress. But Janet was not interested in pursuing a career in art. LeRoy gave her limited access to that world, one into which he was still striving to integrate more fully. She modeled for Neiman's fashion illustration courses and helped him to frame and install his paintings at the exhibitions that accepted his work. An article on Neiman published in *Chicago's American* depicts the artist and Janet readying one of his pieces for a show. LeRoy, with a cigar dangling out of his mouth, holds a hammer in his right hand as Janet, with her long obsidian hair pulled back in a ponytail, helps him align the painting with the frame.[38] She was content to remain in LeRoy's shadow, where she largely stayed for the rest of his life.

Neiman took advantage of the uneven power dynamic that characterized their relationship. He did as he pleased from the beginning, and he recognized in Janet someone who would tolerate behavior that others might forbid. Friends, however, suggest that Janet was pained by Neiman's many affairs, as well as his tendency to brag about the exploits. LeRoy justified his behavior by claiming that he "rescued" Janet from "a dull life" by bringing her into the glitzy world he inhabited.[39] But his lifestyle was far from glamorous when they began dating, and even when they married in 1957. There was no indication then that LeRoy was destined for wealth and notoriety. He was a middling illustrator and adjunct teacher living in a dingy apartment. Janet, in other words, did not join with LeRoy in search of recognition or money. In fact, she helped to support him through most of the 1950s.

While Neiman's personal life brightened once he met Janet, he confessed, "I hadn't yet figured out who I was as a painter" during his sessions at the apartment. He was still largely emulating Anisfeld, with heady, dark, and religiously tinged work like his Crucifixions.[40] His sketchbook drawings from the time range from realistic depictions of urban life suitable for fashion ads to surreal dreamscapes that resembled the work of his Monster Roster acquaintances (plate 2).

But LeRoy experienced a creative breakthrough when the maintenance man at his building offered him a wheelbarrow filled with cans of enamel paint that he had been using to spruce up some unoccupied units. The janitor knew that Neiman was an artist, and he figured the

tenant might want the leftover material. He did not realize that most artists, including Neiman at the time, tended to work with viscous acrylics and oils. LeRoy, however, had become fascinated by the more liquid medium since learning that Jackson Pollock used enamel in his action paintings.[41] Beyond allowing Neiman to connect with Pollock's hip style, enamel's liquidity necessitated rapid brushstrokes, which created an illusion of movement that complimented his Anisfeld-ian interest in using color to create depth. The enamel, which LeRoy would pour straight from the can, gave his work a newfound sense of vitality. But he spread the material onto his surfaces in a more deliber-ate and measured way than Pollock, maintaining some of action paint-ing's spontaneity while avoiding its more chaotic drips and splashes. Neiman used this enamel-based approach for his underpaintings and then added his figures from sketches with oil acrylics. The approach resulted in works that reference abstract expressionism's kinetic and improvisational energy while maintaining a primary focus on legible figures. "It works," LeRoy said of the method later in his career. "I haven't grown since."[42] Beyond aligning with currents in contem-porary art, Neiman's commitment to enamel linked his style to the populist identity he eventually formed as an accessible and unpreten-tious artist who gave his audience what it wanted. He used the same paint that anyone could purchase at the hardware store, albeit with idiosyncratic color combinations that ventured beyond paint compa-nies' standard-issue palettes.

His new approach got off to an auspicious beginning with *Idle Boats* (1953), the first painting LeRoy completed using enamels (plate 3). The 39½″ × 42½″ piece offered a colorful landscape of small wood-framed boats docked in the yacht basin of Belmont Harbor, north of down-town Chicago. The water's transition from dark blue at the margins to gray-blue, with flashes of white toward the center suggesting the reflection of city lights at night. The boats are rendered in an impres-sionistic style that gestures toward their perpetual undulation as they float atop the water. Neiman's breakthrough painting combined his principal influences. It melds Haupers's interest in landscape with Anisfeld's bold color and Toulouse-Lautrec's focus on leisure. It also

resembles the Fauvist André Derain's *Fishing Boats, Collioure* (1905). But rather than simply reproducing these influences, *Idle Boats* found Neiman fusing them into something that was his own.

LeRoy sensed that he had hit on something as soon as he finished *Idle Boats*. "Everyone had a response to it," he recalled.[43] The priest across the street even liked it. Neiman conscripted Lydia to help him enter *Idle Boats* for consideration in the Minneapolis Institute of Art's 1953 local artists exhibition. It won first prize in the oil category, and the institute purchased the painting as part of the award. Neiman was invigorated by the positive attention *Idle Boats* received, and he wanted more of it. He had long been willing and able to adjust his work to give audiences what they liked—from the army officers to his clients at Hoskinson & Rohloff. *Idle Boats* provided him a template for continued success and recognition, which excited him at least as much as the practice of producing art. So, he immediately produced *Men, Boats, and the Sea* (1954)—a similar painting that won second place at the 1954 Minnesota State Fair's art exhibition and was later shown at the Walker Arts Center. "That's when I hit my stride," Neiman said of his enamel-based boat paintings.[44] While he was still struggling to gain recognition in Chicago, his confidence was growing along with his new style.

5

A Reporter Type of Painter

Idle Boats did not depict classical themes like the Crucifixion but the everyday sights Neiman encountered while wandering around Chicago. He endeavored to build on its success by digging deeper into Chicago leisure culture. "When I got out of art school at the Chicago Institute, I was in the so-called serious-artist bag," LeRoy said. "It was a life of seriousness and introspection and sadness in your work, with the artist enjoying himself only away from his work at periodic sordid parties with wild models, narcotics and all the underground things then considered chic. Eventually I left that to paint things that I enjoyed as a kid; races and games and public places and things." Neiman began referring to himself as a "reporter type of painter" whose often sardonic takes on city life owed a debt to Toulouse-Lautrec as well as the American social realists and English satirists. He styled himself as an American flaneur, an update of Charles Baudelaire's "Painter of Modern Life" who recorded his impressions as he strolled about Chicago's humming streets and into its glitziest and grimiest establishments. "All my subject matter is here," he said of the city. "All the action is here."[1]

He took his sketchbook to jazz clubs, boxing gyms, and horseracing tracks. LeRoy frequented posh taverns like the Palmer House's Empire Room and the Pump Room at the nearby Ambassador Hotel, as well as seedier locales such as Clark Street's Playhouse and Gigi Club. Neiman generally did not drink when he visited the sites— a dual effort to save money and focus on his work without dulling his senses. Bouncers sometimes forced the stingy and abstemious artist to

leave since he was taking up space without spending money. Neiman's sketches composed starting points for paintings he later executed in his apartment. He included dates and scribbled important details that he could reference when he got around to transforming the drawings into paintings. But he would often be so exhilarated by a sketch completed in a dimly lit club that he would rush home to start a painting immediately and work until sunrise.

The sporting spaces LeRoy visited, which were accustomed to having reporters and photographers milling about, tended to let him hang around if he stayed out of the way. He especially gravitated toward boxing and horse racing, "the two sports where," as he put it, "the entire social structure merges." In those sports, LeRoy continued, "you see not only the rich and privileged, you also see the guy with holes in his socks and run-down heels. Along with the blue-bloods, you see the bustout fat guy with the battered cigar." Neiman encountered many of the same characters across Chicago's different sporting venues, and he became fascinated by the environments' ability to attract communities that otherwise rarely commingled: "The hoods, the dum-dums, the fringe people. They were at the track, clocking the horses working out in the dawn, at the fight gyms, the massage parlors, at the dives and bars in the evening. They all had the same look, all talked the same jargon." LeRoy understood the bristly patois, which brought him back to his days loitering at Gibbons Brothers Gym and attending races with Uncle John. While his Art Institute training thrust him into the educated professional class, Neiman still felt most at home among the so-called hoods and dum-dums. "I'd come out of that same jungle," he said. "I knew all about it. So, it was only natural that I started drawing it, painting it."[2] LeRoy sought recognition from the serious art world, but he was increasingly drawn to these relatively unserious subjects. He thought he might be able to gain critical acclaim and indulge his creative interests by branding himself as an updated version of Toulouse-Lautrec for postwar Chicago.

The ever-canny LeRoy steadily found ways to become an asset to the establishments he frequented. The presence of an artist suggested that the events he sketched were important, and even spectacular.

Chicago Bears security, for instance, was perplexed when they first saw Neiman pacing the sidelines of Wrigley Field while scribbling in his tablet. LeRoy sneaked in by posing as a journalist—he put a dry-cleaning tag that read "Press" into his hat band and sauntered in like he belonged there. The guards were not fooled for long, however, and were escorting LeRoy out of the stadium when the Bears' owner and coach George Halas intervened. Impressed by Neiman's drawings, Halas decided to let the artist stick around. He sensed that LeRoy's conspicuous presence and art might help to publicize his football team. Like a street performer, Neiman would jovially interact with observers and his subjects as he worked. As Esther Penn, who accompanied him on many sketching escapades, put it, "He seemed to create some kind of electricity around him."[3] Although he described himself as a reporter, Neiman was no fly on the wall. He realized that his persona usefully augmented his art, and he gradually transformed from simply documenting scenes to placing himself at the center of them. Much like Lautrec, Neiman's art was inseparable from his image, which became increasingly outlandish once he realized it could help him to market and sell his work.

* * *

Neiman's interest in urban life was also informed by intellectual discussions emerging in the 1950s to make sense of postwar American culture. Chicago—and the University of Chicago in particular— became an epicenter for sociological inquiries into America's increasing affluence, bureaucratization, mass mediation, suburbanization, and consumerism. LeRoy regularly rode the train down to the university to attend talks by Mortimer Adler and Robert Hutchins. He treated the presentations much like the sporting events and nightclubs. Neiman carted his sketchbook into the lecture halls, which sometimes helped him to secure better seats from unwitting ushers who figured he was on assignment for a newspaper or magazine.

While perhaps an odd pairing with the strip clubs, bars, and gyms, the lectures helped Neiman to gain a firmer understanding of the leisure culture to which he was dedicating his creative energies.

The Lonely Crowd: A Study of the Changing American Character (1950), by the University of Chicago sociologist David Riesman, especially resonated with LeRoy. The *Lonely Crowd* identified a shift separating twentieth-century Americans from their nineteenth-century predecessors. It posits that nineteenth-century Americans were "inner-directed" and guided by a stable sense of self. Their twentieth-century progeny, in contrast, formed identities through bending to external social pressures. These "other-directed" folks sought membership into groups and adjusted to suit expectations. Other direction was especially noticeable among the newly affluent urban middle class— people Neiman was observing as they flocked to bars and racetracks to spend money in pursuit of pleasure. "The American is said to be shallower, freer with his money, friendlier, more uncertain of himself and his values," Riesman observed. "While all people want and need to be liked by some of the people some of the time," he continued, "it is only the modern other-directed types who make this their chief source of direction and chief area of sensitivity."[4] This conformism left the other-directed person devoid of individual purpose—hence the paradox of the book's title that propelled it into one of those rare academic tomes that attracted mainstream readers eager to give a name to the widespread condition it diagnosed.

Other direction was performed primarily through consumption guided by the sorts of corporate advertising Neiman helped to create at Hoskinson & Rohloff. Moreover, other-directed Americans, according to Riesman, demonstrated an increasingly blurred boundary separating labor and play through the networking and deal making that had become characteristic of corporate business culture, much of which was done in the taverns and restaurants where Neiman sketched. A smattering of scholars and critics expanded on the *Lonely Crowd* to explore, critique, and satirize the changed society it dissected, such as C. Wright Mills in *White Collar* (1951), David M. Potter in *People of Plenty* (1954), William Whyte Jr. in *The Organization Man* (1956), John Kenneth Galbraith in *The Affluent Society* (1958), and Sloan Wilson in the novel *The Man in the Gray Flannel Suit* (1955). American men increasingly built their identities and formed social bonds through the

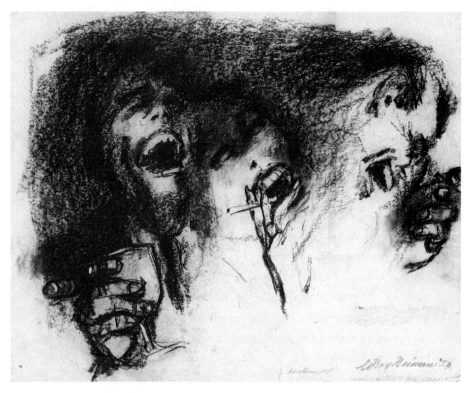

FIGURE 14. LeRoy Neiman, *Advertising People Laughing in a Bar*, 1950.
© 2023 LeRoy Neiman and Janet Byrne Neiman Foundation / Artists Rights Society
(ARS), NY.

companies that employed them, the brands they consumed, and the
places where their work and consumption collided.

Neiman participated in these assessments of other-directed life.
The charcoal sketch *Advertising People Laughing in a Bar* (1950) takes
aim at the professional colleagues who contracted LeRoy's fashion
illustrations. It presents three disembodied faces cackling with their
eyes closed and mouths agape. Reflections from patrons' gleaming
teeth provide some of the only points of illumination in the darkened
saloon they occupy. Their heads bleed together, and each face is paired
with a single hand holding a drink, cigar, or cigarette near its opened
mouth. Neiman reduces the advertising professionals to the maniacal
mouths and hands that enact the pleasure they blindly consume. The

sketch offers an ironic and cutting take on those who are in the business of exploiting the leisure they exhibit.

The artwork LeRoy made of the Chicago bar scene—which some critics identified as revivals of American saloon paintings, like John Greenwood's *Sea Captains Carousing in Surinam* (1755) and John Sloan's *McSorley's Bar* (1912)—added symbolic coloration to his sketches while maintaining the darker tones and social commentary of the Ashcan school. Neiman attempted to convey the dizzying experience of walking into a dark, smoky, and cramped tavern from the street. "As the eye becomes accustomed, everything falls into place," he said of his works. "It becomes logical and you become comfortable and continue to make new discoveries right along after you are familiar." LeRoy specifically highlighted the churning decadence of people in motion gathering to drink, smoke, flirt, and do business. "It is a throbbing inferno," he said of his bar scenes.[5] *Pump Room Bar* (1956)—an homage to Édouard Manet's *Bar at the Folies-Bergère* (1882)—depicts the tavern in the Ambassador Hotel on Chicago's Gold Coast (plate 4).[6] The painting focuses on the establishment's massive, multitiered bar filled with liquor bottles of every stripe. The bottles compose a multicolored mosaic in the otherwise dimmed room. Off to the right, the bartender bows in seeming genuflection to the urbane altar. *Mixologist* (1957) offers a similar depiction of an unnamed establishment. It again focuses on the bar, but it places a large red cash register front and center as the barkeep prepares cocktails to the side. The register functions as a debauched hearth, a center of gravity that anchors and fuels the acquisitive world Neiman emphasizes.

Like *Advertising People Laughing in a Bar*, Neiman's tavern customers are indistinct and muted. They fade into the background and melt into one another. In contrast, the brands and logos on the liquor bottles—Johnny Walker, Jack Daniels, Dewar's, and so on—are easily recognizable and colorful. The corporate emblems have more personality than the patrons and compose instruments through which the interchangeable customers form their identities. While Neiman is not typically considered a pop artist, these worked coincided with

early pop art's appropriation of corporate symbols to comment on consumer culture.

Cigarette Girl (1959) expands on Neiman's social commentary with *Pump Room* and *Mixologist* by showcasing a barely dressed waitress circulating through a group of male customers. She stands facing away from the viewer and in the middle of four reveling businessmen; they are situated in each corner of the frame laughing, drinking, and smoking. They tilt out of their seats as they chortle, with limbs flailing in varied directions to accent their inebriated mirth. Their positioning creates a menacing swirl around the cigarette girl, whose pink and deliberately exposed backside composes the painting's focal point. One of the patrons pets the woman's shoulder with his left ring finger—a gesture toward his likely status as a married professional seeking some titillation outside of the home with his buddies after work. Another man's hand seems to graze along her posterior, a perspective aided by the movement and depth that Neiman's coloration highlights. The patrons have the waitress trapped inside their lustful perimeter. Their toothsome grins and freely groping hands underscore that these men in gray flannel suits are consuming her as well as their drinks, and that she is selling a glimpse at her shapely body in addition to the cigarettes in her case. The painting comments on and participates in her objectification. The cigarette girl's facial expression is not visible, but her upright posture indicates a businesslike contrast to the unwinding businessmen. She is clearly not gaining the same enjoyment from her labor that her male customers extract from it.

Some Chicago commentators identified Neiman's bar paintings as part of the critical conversation about consumer culture that Riesman and others initiated. Meyer Levin, of *Chicago's American*, said that Neiman's bar paintings "had the lonely crowd feeling" with their anonymous patrons seeking pleasure amid a dark and alienating urban tableau. "Neiman catches the gay high-life note in his nightclub paintings," Levin wrote, "as well as the empty laughter, the macabre grimness, and loneliness beneath the mask of conviviality." The *Chicago Daily News's* Barnard K. Leitner suggested, "If LeRoy Neiman ever grows tired of painting he might find a new career in sociology."[7]

But Neiman already considered his reportorial painting to be animated by a kind of sociological analysis. The artwork added to such inquiries by applying his class-conscious credo to Chicago leisure culture. LeRoy called himself "a sociological authority not by education but simply that of an observer of human behavior. A product of the lower classes, I feel confident of understanding my lower-class background." His work on Chicago included that often-ignored community, a segment of society largely glossed over by the influential studies that focused primarily on the middle and upper middle classes. Neiman also pointed out the dignity that the working class maintained as the wealthier customers cut loose and overindulged. "In so many of my pictures the rich people are all drunk and messed up," he observed. Meanwhile, those serving the moneyed classes "keep their elegance."[8] The men in *Cigarette Girl*, for instance, consume wildly while the nameless woman remains poised and graceful amid the dehumanizing work environment. She is a descendant of *Song of the Lark*'s agrarian heroine, applied to the lonely crowd era. But she is also, of course, eye candy for viewers who identify with the partying patrons. Neiman leaves open the possibility for either interpretation. But his many works that blatantly objectified women overshadow any gendered critique implicit in *Cigarette Girl*.

Neiman described his work on the urban scene as "underworld paintings" that exposed a seedy side of Chicago. "I wanted to paint that rude, roiling, teeming world and bring it into the well-behaved art galleries and fancy living rooms of Chicago's elite," he maintained. He presents the works as unsettling "takes on the lower depths" along the lines of the writer Nelson Algren's contemporary explorations of the Windy City. Algren shared Neiman's fascination with Chicago's bars, nightclubs, gyms, and racetracks, and he used those places as backdrops for much of his work. He published the lyrical essay *Chicago: City on the Make* (1951) as Neiman was developing his aesthetic and the local sociologists were publishing their insights. The piece celebrated Chicago as "the very toughest sort of town" and likened Algren's affection for the city to "loving a woman with a broken nose. You may well find lovelier lovelies. But never a lovely so real."[9] Like

Neiman, Algren was ambivalent about the shifts that accompanied postwar consumer culture. "It's still an outlaw's capital," Algren wrote of Chicago. "But of an outlawry whose colors, once crimson as the old Sauganash whiskey-dye, have been washed down by many prairie rains, to the colorless grey of the self-made executive type playing the percentages from the inside."[10] Algren feared that Chicago was losing its edge along with the proliferation of anonymous businessmen eager to purchase their way into belonging and women striving to resemble the models in the ads that sold them clothes and beauty products.

Algren's written works posed more pugnacious challenges than Neiman's comparatively understated visual commentaries on 1950s Chicago. Algren viewed the city as a synecdoche for a ruined nation: "In no other country is such great wealth, acquired so purposefully, put to such small purpose."[11] He showed the despondence beneath the surface of postwar affluence through Chicago characters like *The Man with the Golden Arm*'s (1949) protagonist Frankie Machine, a drug-addled jazz drummer who winds up hanging himself in a filthy flophouse. Algren humanized the invisible Midwesterners and used them to indict an unfair establishment.

Neiman's Chicago had grit, but the struggling artist tended to gloss over the barbs that Algren underscored. He ensured that his depictions of Chicago's realness were lovely enough for people to purchase and display in their homes without scaring off any guests. While his art championed the working class, it did not condemn the upper class or the broader system that enabled and fortified these hierarchies. "I'm interested in people and the way they spend their money. But it doesn't bother me that they have it to spend or that they spend it the way they do," he said. "I don't paint the world in general," he continued. "I never wanted to paint the troubles of the world or the troubles of the artist." LeRoy justified this position through his claims to be a reporter rather than a reformer. "I paint truthfully," he asserted, "not critically."[12] While Neiman's paintings offered some commentary, they were not defiant. He sought to maintain a degree of social criticism without alienating the moneyed public, which at once composed his target in works like *Advertising People* and was the community most

likely to buy his art. Neiman's critiques gradually softened (but never completely disappeared) in the interest of ensuring his artworks' salability.

Increasingly, Neiman depicted winners, not the losers who inspired Algren. This tendency came into focus with LeRoy's work on athletes, which privileged noteworthy figures whose established celebrity helped to sell his work. His 1957 sketch of the jockey Bill Hartack, done in a combination of marker and pen, has the rider posing in the Silk Room at the Arlington Park racetrack at the northwestern outskirts of Chicago. Hartack is seated on a stool in the bottom left and looks straight ahead as the colorful silk jerseys occupy most of the piece. Echoing the bartenders in *Pump Room* and *Mixologist*, Hartack is positioned alongside the leisurely spectacle that his labor provides. The silks resemble the shining bottles of Neiman's tavern paintings. But unlike the barkeeps, the jockey is clearly recognizable, and his identity gives the sketch its principal meaning. It is first and foremost a rendering of a famous athlete with whom Chicago-area sports fans would be familiar.

Some of Neiman's first paying customers were owners and managers who liked how he depicted their horses, teams, and boxers. The artist quickly realized that he was not going to have as much luck in the marketplace—at least not with these deep-pocketed clients—if he focused on the exploitation and dehumanization endemic to sports: the thrown fights, the debilitating injuries, the racism. Like a sportswriter, Neiman needed access to these spaces to create his work— entry that would be easier gained if he flattered the gatekeepers and inhabitants. It was the same logic that guided his strategically flattering sketches of army superiors during the war. And athletes like Hartack were more willing to grant Neiman audience, and even take some time to pose, if they were confident that he would portray them in ways that bolstered the images they sought to project and preserve.

* * *

Neiman gained some national acclaim when his work was selected for inclusion in the 1955 Carnegie International exhibit—a prestigious

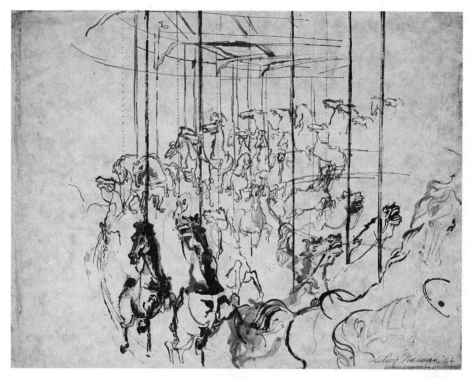

FIGURE 15. LeRoy Neiman, *Carousel*, 1954.
© 2023 LeRoy Neiman and Janet Byrne Neiman Foundation / Artists Rights Society
(ARS), NY.

annual show. But the recognition LeRoy received was mostly limited
to the city that inspired so much of his artwork. His paintings were
accepted to the annual Chicago Artists and Vicinity show from 1954
through 1960 and he regularly had pieces included in the Art Insti-
tute's yearly faculty exhibition, where they sometimes sat alongside
his former teachers' creations. The SAIC's local television show *Art-
ist's Choice* featured Neiman on a 1957 episode to discuss his art—
his first of what would be many appearances on the medium. The
local adulation tended to focus on LeRoy's most accessible work. For
instance, Neiman became fascinated by the seventy-horse carousel at
Chicago's Riverview Park, a subject that merged his interests in color,
movement, sport, and leisure. His early depictions of the carousel

sometimes included social critique by adding sketches of businessmen examining stock-market ticker tape—a suggestion that their financial activities composed a bizarre form of leisure that resonates with Algren's "self-made executive type playing the percentages from the inside." But he knew that these more obviously satirical works would not be well received, and he submitted only the less jarring carousel-themed works for local exhibition.

The carousels found enthusiastic boosters among the *Chicago Tribune's* art critics, whose populist-leaning commentaries helped middle-class locals navigate the sometimes abstruse and intimidating art world. A 1956 review by Eleanor Jewett—who was openly hostile toward the Art Institute crowd's penchant for esoterica—described a Neiman carousel as "vivid in color and rapid in action with the wooden horses riding high in an exciting vibrancy of color." Edith Weigle praised a different carousel the following year by suggesting it depicted the ride "as if all the gay, wooden horses were actually alive, full size, and stampeding." Weigle celebrated LeRoy again three months later when she wrote that his "canvases vibrate with color and movement and all, because of their subject matter, attract the attention as arrestingly as the blatant notes of a saxophone." The local critics lauded Neiman's work primarily because they found its color, style, and content to be pleasing, not because it diagnosed or investigated social problems.

Extending these reviews, Ellen Borden Stevenson's 1956 *Tribune* article "Does Modern Art Mean Anything?" expressed frustration at art's apparent disconnection from everyday people and real-world themes. "Mothered by museums and sired by the elite," she wrote, "art has lost its place as a part of everybody's life." She argued that "art with a more direct approach to life is essential" and offered a Neiman carousel as a rare example of contemporary art that resonates with commonplace interests.[13] Much like Neiman, the *Tribune* art critics would not benefit from criticizing the middle-class audience that composed their primary readership. Instead, they elevated art like Neiman's carousels, which affirmed their readers' tastes and lifestyle.

Much like he did after *Idle Boats*, Neiman responded to this positive attention and redirected his work to pursue more of it. These compromises were preferable, he figured, to continuing his work as an illustrator, where he had no say over what he created and received little public recognition apart from the signatures he sometimes wedged into the margins of his drawings. He found a particularly enthusiastic audience among the affluent middlebrow suburbanites who read the *Tribune*. LeRoy remarked that the "response to my paintings" among the "propertied class" went "beyond expectations." His first one-man show was in 1957 at the Myrtle Todes Gallery in Glencoe, twenty-five miles north of downtown Chicago, which primarily operated as a decorating business serving the community's prosperous residents. He paired this with awards from exhibits in similar suburbs like Arlington Heights and Winnetka. A *New Republic* report on Neiman's Glencoe show remarked on his artworks' particular ability to attract the men in the gallery, whose wives presumably dragged them along while shopping for home decor.[14] He gave the suburban crowd art that they enjoyed and could understand while helping to broaden the galleries' clientele to include more men.

Many of the middle-class consumers whom the *New Republic* counted among Neiman's fans were drawn to his work for the same reasons that elicited Stevenson's praise. It resembled trendier abstract works while remaining legible. Neiman's art did not disrupt suburban living rooms; it complemented them while providing a palatable hint of ab-ex's edginess. His work helped the other-directed consumers who purchased it to fit in among a postwar middle class that was increasingly using its disposable income to buy art that would broadcast their membership in that community.

Neiman, then, steadily abandoned social realism for what might be more accurately called social idealism. He remained a reportorial, bohemian sociologist. But his entrepreneurial impulses overrode the critical assessments that initially drove his interest in urban life. Building on Clement Haupers's pragmatic advice, LeRoy tweaked his art to suit market demands—a slippery slope that paved the way at once

for his commercial success and his critical dismissal as a kitsch artist. His work increasingly prioritized serving the lonely crowd over dissecting it. Neiman's ability to reflect and create postwar middlebrow taste cultures gained national prominence through his work for Hugh Hefner and *Playboy*.

PART 2

Celebrity

6

Hefner's Court Painter

Hugh Hefner ran into Neiman one evening in spring 1954 while taking a rare break from his work to grab a sandwich. Hefner had launched *Playboy* in December 1953, and the magazine's offices were a block from Neiman's apartment. The publisher remembered Neiman as "tall and heavyset, built like a boxer"—a burly contrast to the delicate and cerebral stereotypes he held about painters. The artist, who was also momentarily pausing from his creative toils, donned paint-splattered khakis and toggled a cigar between his hand and mouth. Neiman and Hefner were both weaned on newspaper comics and F. Scott Fitzgerald, loved sports, told dirty jokes, and had served in the army. But they had not maintained contact since Hefner worked with Janet at Carson Pirie Scott, when Neiman was focusing on wooing his future wife and Hefner was trying to land a better job.

After a few minutes of reacquainting chitchat, Neiman invited Hef—Hefner's preferred handle among friends—to his studio to see some recently completed paintings. "It turned out to be more basement than studio apartment," Hefner later recalled of the "classic starving artist scene" in which Neiman was residing.[1] Although Hef was a clean-cut preppy who kept his shoes polished and shirts pressed, he admired Neiman's relative bohemianism.

LeRoy enjoyed catching up with Hef, but he was skeptical of the publisher's tawdry monthly, which was already notorious around Chicago because of the nude centerfolds that were its key selling point. "At that time, I had very lofty sensibilities," Neiman reminisced.

"I was a *painter*, and I wasn't really keeping track of, you know, girlie magazines." But he found Hef's unbridled enthusiasm infectious—the publisher was even more fixated on his magazine than Neiman was on his painting. He immediately sensed that Hefner was "one of those guys who was going to do something."[2] As they continued talking, the artist and publisher realized they had far more in common than either of them had imagined. Hefner was not as smutty as Neiman supposed; and Neiman was not as pretentious as Hefner assumed.

The duo continued meeting up, often grabbing a couple of greasy hamburgers at Rush Street's Banquet on a Bun and carting the food back to LeRoy's place in time to catch NBC's *Friday Night Fights*. They huddled around Neiman's tiny TV set on folding chairs, surrounded by paintings propped up against walls and cleaned brushes set out to dry. Neiman washed his burgers down with bottles of Schlitz; Hefner preferred Pepsi. Sometimes they would venture out to see live bouts at Chicago Stadium or horse races at Arlington Park, which Neiman would sketch from the grandstands.[3] Between rounds and heats the new pals would continue their wide-ranging conversations about the good life that Hefner was exploring with *Playboy* and that Neiman was covering in his artwork.

Hefner soon decided that his friend's art could help to create the lively and cosmopolitan style he was developing for *Playboy*. "LeRoy's art packed enormous energy," he later said, "and I was certain I had discovered an amazing talent who could play an important role in my magazine." Likewise, Neiman thought Hef's editorial voice articulated many of the feelings he was attempting to express with his depictions of Chicago's nightlife and sporting scene. He also realized that *Playboy* could expose his art to a wider audience. "It was just a time for a lot of action, including sex," Neiman said. "It was still a repressed era, but there was a lot of energy waiting there right beneath the surface, waiting to break out into the open. All that was required was for someone to give it an intellectual content, to serve as a catalyst. And here was Hef leading the way."[4] LeRoy's work for *Playboy* helped to forge that path while cementing his reputation as a commercial illustrator rather than a serious artist. He later described his approach as

"made to order for Hef."[5] As *Playboy*'s "artist-in-residence," Neiman provided work that served his employer's vision. But he enjoyed significant creative leeway at *Playboy* and was able to focus on topics that held far greater interest to him than the wedding gowns and hats he drew for Hoskinson & Rohloff's clients. And it was easy for Neiman to give Hef what he wanted because their tastes and sensibilities so seamlessly aligned.

* * *

Hefner was raised in an upper-middle-class Protestant household in northwestern Chicago's Galewood neighborhood. The popular Hugh graduated forty-fifth in his class of 212 at Steinmetz College Preparatory and was voted one of the group's most likely to succeed, most artistic, and best dancers. Although Hefner's socioeconomic and academic background differs markedly from Neiman's Frogtown upbringing, the comparatively coddled Chicagoan also spent hours at the kitchen table reading and tracing many of the same syndicated comic strips that Neiman read in St. Paul. Hefner also drew his own comics—one of which featured the character "Goo Heffer," who attended "Stink-Much High." The precocious cartoonist loved the racy cartoons and illustrations that *Esquire* magazine published during his adolescence—especially the glossy cheesecake pinups by Alberto Vargas and George Petty. Hefner's otherwise prudish mother let him display the pinups on his bedroom walls to encourage his interest in art, which he developed further by working on the Steinmetz student paper.[6]

The experience on his high school paper came in handy when Hefner enlisted in the army after graduation and landed a cushy assignment clerking in recruitment offices. Like Neiman's work on the *Baptism Blade*, Hefner drew comics for various army publications. He continued writing and cartooning at the University of Illinois after his military discharge. He fashioned comics for the *Daily Illini* and established a campus humor magazine called *Shaft*, Hefner's version of the *Harvard Lampoon*, which was deeply influenced by *Esquire* and anticipated *Playboy*. Around this time, Hefner developed a fascina-

tion with Alfred Kinsey's recently published *Sexual Behavior in the Human Male* (1948), which explained Hef's long-held hunch that sex was natural and healthy. The undergraduate reviewed Kinsey's study in *Shaft* and pursued a major in psychology to dive deeper into the sexual behavior that so enthralled him.[7]

After graduating, Hefner married his longtime girlfriend Millie and set out to pursue a career as a cartoonist for one of the many publications based in Chicago. The best he could do was a position at the Chicago Carton Company—another similarity to Neiman's biography, given his work at the Waldorf Paper Company. But while Neiman was carting bales around a warehouse, the college-educated Hefner was sitting behind a desk in the personnel department.[8] Hef stayed at the job only a couple of months before pursuing a graduate degree in sociology at Northwestern, a scholarly venture that lasted just one semester until he left for the copywriting position at Carson Pirie Scott, where he originally met Janet and LeRoy.

Echoing Neiman's humdrum existence as an illustrator, Hefner quickly grew tired of penning bloodless copy shilling wing tips and fedoras. He continued drawing cartoons at night and during lunch breaks. A cluster of his art offered ribald satires of Chicago life. When the works remained unsold, Hef raised $1,000 to self-publish *That Toddlin' Town: A Rowdy Burlesque of Chicago Manners and Morals*, "a humorous poke" at Chicago, similar to Neiman's paintings. The cover featured a cartoon of a stripper that resembles the scene in LeRoy's *Cigarette Girl*.[9] Hefner, in fact, workshopped some of the comics with Neiman when the fashion illustrator dropped by Carson to hand in assignments and talk with Janet. The book sold respectably well around town, and the *Chicago Tribune* favorably compared it to *Esquire*—about as good a compliment as Hefner could hope to receive.[10] It did not do well enough, however, to land Hef a full-time cartooning position or to attract a publisher that would pay him an advance to create a second book.

But the ambitious copywriter was steadily climbing the publishing ladder. *Esquire* hired Hef away from Carson Pirie Scott to write promotions for its subscriptions department. He was initially over-

joyed to join *Esquire*, which had such a formative influence on him. Although Hefner had no passion for promotions, he figured he might eventually work his way up to a more attractive position, maybe even cartooning. But he became disenchanted by the conservative changes that *Esquire*'s editor Arnold Gingrich instituted in the 1950s. Gingrich set out to "rescue" *Esquire* from "bawditry" by replacing its pinups and suggestive cartoons—Hef's favorite parts of the publication— with higher-minded fare.[11] Hefner's dream job turned out to be a slog not too different from Carson or even the Chicago Carton Company aside from the name on the paychecks. "It was not fulfilling," Hefner said of his work at *Esquire*, "you actually had to check in and punch a clock when you came in and then left for lunch."[12]

When *Esquire* moved its offices from Chicago to New York City, the magazine offered Hefner a pay increase of $20 per week to come along. Hefner asked for $5 more—$85 a week—but the company balked, and he stayed in Chicago. Popular legend has it that *Esquire* could have saved itself from the competition *Playboy* would soon pose for a measly five bucks a week. But Hefner did not want to move east, and he quickly found a comparable position at Publishers Development Corporation.[13] He still hoped to form his own magazine, however, and he freely shared his goal around the office. Much like Neiman's Hoskinson & Rohloff colleagues, Hefner's coworkers laughed off his plans as naive and half baked. "He used to talk a lot about becoming a publisher," recalled Vince Taijiri, a Publishers Development Corporation colleague who wound up later serving as *Playboy*'s photo editor. "But I don't think anyone took much notice. I thought he was very immature for his age. He was totally unsophisticated, but he had this obsession with sex."[14]

Hef was on track to be an executive in a decade or so. But he felt himself becoming another anonymous, gray-flanneled junior executive whose vitality was slowly evaporating in a corporate world that seemed to prize conformity above all else. The twenty-seven-year-old wanted to give his dream of launching a magazine one more shot before he settled in among the lonely crowd. But Hef's gambit was not exactly a Hail Mary. He shrewdly sensed that there was a large

male audience that shared his disappointment with *Esquire*'s prim modifications and longed for a new voice to fill the void it had left—a magazine that would balance the refined and the bawdy, the serious and the cheeky. "The field was wide open for the magazine I had in mind," he later commented.[15]

Many special-interest magazines were emerging at the time to take advantage of the new lifestyles and activities that increasing postwar affluence afforded. These titles differed from "mass magazines" like *Time* and *Life* by catering to niches and selling space to advertisers that sought to capture their attention. Most men's magazines focused on hardy outdoor pursuits like hunting and fishing. Hefner wanted to do something urbane—a revival of the manicured manliness that J. C. Leyendecker's Arrow Collar Man and F. Scott Fitzgerald had embodied earlier in the century. "I'm an indoor guy and an incurable romantic," Hefner remarked, "so I decided to put together a men's magazine devoted to subjects I was interested in—the contemporary equivalent of wine, women, and song, though not necessarily in that order."[16] His publication would have the irreverent edge that *Esquire* had recently filed down, but it also would be classier than "nudie" magazines like *Adam* and *Modern Man*. He wanted to build "a younger, more virile *Esquire*" for the "city-bred guy" that would "thumb its nose at all the phony puritan values of the world in which I had grown up."[17]

The magazine that became *Playboy* was originally titled *Stag Party*, a name Hefner developed with Eldon Sellers, who served as his business manager, and Art Paul, his art director. Hef cooked up a snappy press release that marketed *Stag Party* to wholesalers by promising that the new publication was inspired by *Esquire* but would take its hidebound predecessor in exciting new directions. "It's being put together by a group of people from *Esquire* who stayed here in Chicago when that magazine moved east," the announcement stressed, "so you can imagine how good it's going to be."[18] Hefner was, in fact, the only *Stag Party* staffer who had worked at *Esquire*, and his labors at the magazine never had the slightest bearing on its editorial content.

Even before raising the money to get started, Hefner knew that he would need a gimmick to attract interest—something to set *Stag Party* apart on newsstands packed with known titles. While perusing the trade magazine *Advertising Age*, Hefner noticed ads for a calendar featuring nude photos of Marilyn Monroe—Hollywood's biggest sex symbol. Hefner bought rights to one of the photos for $500, a sizable portion of his budget. But he knew the Monroe would have the double-take-inducing effect he needed. The eventual cover of *Stag Party* announced that its pages would show "Marilyn Monroe Nude" and in "full color" for "the first time in any magazine." Hefner kept the rest of the costs down by recycling material that was already in the public domain—such as a Sherlock Holmes story and erotic snippets from Boccaccio's *Decameron*. The first issue directly aped *Esquire's* more freewheeling days with party jokes, sex-themed cartoons, and an article on jazz. This blatant imitation was especially apparent with the Monroe photo, which was soft lit in a way that resembled and was likely inspired by Vargas's pinups.[19]

Stag Party was forced to change its name only days before the first issue went to print when the publishers of *Stag*—precisely the type of hunting and fishing magazine from which Hefner sought to distinguish his new periodical—complained that their titles were too similar. When Hefner convened his staff to brainstorm alternatives, *Playboy* was the only candidate that resonated. Hef especially liked its 1920s Fitzgeraldian connotations. Paul then whipped up a logo of an anthropomorphized rabbit in a smoking jacket to replace the stag they were using, another *Esquire*-inspired touch that cribbed from the magazine's "Esky" mascot.

Playboy's first issue offered a mission statement that began to define its male reader's tastes and lifestyle: "If you're a man between the ages of 18 and 80, *Playboy* is meant for you." The copy separates *Playboy* readers from those brawny, potbellied, and tobacco-chewing guys who bought the outdoors-themed magazines. "We plan on spending most of our time inside," it admitted. "We enjoy mixing up cocktails and an *hors d'oeuvre* or two, putting a little mood music on the pho-

nograph, and inviting a female acquaintance for a quiet discussion on Picasso, Nietzsche, jazz, sex." It ends by reassuring readers who might look askance at the Nietzsche name-dropping that *Playboy* does not take itself too seriously; it is ultimately devoted to having a good time and helping its audience do the same. "Affairs of state will be out of our provenance. We don't expect to solve any world problems or prove any great moral truths."[20]

Hefner's copy struck a confident tone. But the odds were heavily stacked against his magazine's breaking into the market without ties to an established publication or deep-pocketed investors who could tolerate losing money for a while in hopes that the title would catch on. Issues first appeared on newsstands in December 1953. Hefner, however, deleted the date as insurance against slow sales. He figured vendors could keep *Playboy* on their racks for another month or two if copies did not move.[21] And he opted against putting his name on the publication, perhaps so he would not have to take responsibility for the failure *Playboy* was likely to become. This would also allow Hefner to distance himself from *Playboy* if he needed to reenter the mainstream workforce, where his experience as the publisher of a failed skin magazine might have been a professional liability.

The Monroe nude seemed to work. *Playboy* sold fifty-four thousand of the seventy thousand printed issues—a huge success for an unknown title. Hef then had the resources to continue publishing. He put dates on the issues, included a subscription blank, proudly listed himself as editor in chief on the masthead, and opened an office at 11 East Superior Street to house his expanding staff. *Playboy* did not have the money to increase its production quality by much, but it began to refine the identity Hef articulated in the first issue's mission statement. Chicago's *Saturday Review* provided precisely the response Hefner hoped his new magazine would elicit when it said the publication "makes old issues of *Esquire* in its more uninhibited days look like a trade bulletin from the Women's Christian Temperance Union."[22] *Playboy* topped a circulation of one hundred thousand and was turning a profit by the end of 1954. By comparison, *Sports*

Illustrated, which launched nine months after *Playboy*, would not be profitable until 1965.[23]

*　*　*

Hefner bumped into Neiman on the street while grabbing a sandwich as it was becoming clear that *Playboy* would survive. He wanted the magazine to have a contemporary look, and he thought Neiman could help to create that aesthetic. Art Paul agreed that Neiman's kinetic style would be a good fit, and he commissioned LeRoy to illustrate Charles Beaumont's "Black Country" for *Playboy*'s September 1954 issue. It was the first original short story that *Playboy* published, and the editors wanted to package it in a way that would present the magazine as a literary and well-designed publication that served a discerning readership. The issue was bookended with promotion for Beaumont's featured piece. Its back cover hyped "Black Country" as "the most exciting jazz story since *Young Man with a Horn*"—a 1938 Dorothy Baker novel based on Bix Beiderbecke. "Here is a story about jazz and about the people who play jazz, packed with all the power, excitement, and emotion of the music itself," the editors wrote in the Playbill section, which previewed issues. "It has been a long time since any story moved us as much as this one. Beaumont considers it to be the best story he has ever written and it is certainly one of the best we've printed to date." Beaumont, a Chicagoan renowned for offbeat fiction who eventually penned several classic *Twilight Zone* episodes, was one of the best-known contemporary writers *Playboy* had published since its launch nine months earlier.

The Playbill also mentioned Neiman, and it included a photograph of the T-shirted artist giving a moody glance—one that, like his old student photo, communicates slight annoyance at having his picture taken. "Naturally a story as special as 'Black Country' requires a special kind of illustration, so we commissioned fine artist LeRoy Neiman to do the job. Neiman teaches at the Art Institute of Chicago, and has won a number of awards for his advertising and oil painting."[24] The magazine underlined Neiman's credentials to suggest he was uniquely

positioned to accompany a tale written by someone of Beaumont's stature.

"Black Country" centers on the sort of band Neiman would see and sketch as it toured through Chicago—a group led by the obsessive and inscrutable trumpeter Spoof Collins. The story is narrated by the band's drummer, Hushup Paige, and proceeds in a fast-paced cadence that reflects the jazz-influenced Beat literature emerging at the time. Spoof is so preoccupied with his music that he leaves no time for anything else, including the affections of Rose-Ann, the band's singer who carries a torch for him. But Spoof is dying of cancer. The trumpeter kills himself in a dingy Midwestern hotel room while the band is touring rather than suffer through an illness that might rob him of the ability to perform. The band buries him in a nondescript pauper's grave outside of the undisclosed town. They inter the musician with his horn "because leaving it out would have been like leaving out Spoof's arms or his heart or his guts."[25] The first of Neiman's two illustrations is a small pen-and-ink drawing of the band huddled somberly around Spoof's gravesite in the rain. Neiman depicts the group from behind and at an elevated distance to emphasize the desolate cemetery where they laid their leader to rest before heading back on the road.

Spoof's protégé Sonny takes over as bandleader. As the reconfigured band tours, Sonny gradually adopts his mentor's characteristics. Neiman's second illustration is a full-page painting, reproduced in black and white, of Spoof, Sonny, and Rose-Ann. The trio is arranged vertically, with Spoof in the bottom foreground, Sonny at a distance on top, and Rose-Ann between the two. Spoof and Sonny are focusing on their horns while Rose-Ann extends an arm toward the audience as she belts out her lyrics. The painting slightly resembles Neiman's earlier critical depictions of nocturnal leisure and the emotional longing that accompanies it. But LeRoy's "Black Country" illustration is more deliberately legible than his noncommissioned work on Chicago's nightlife. The thickly outlined figures are stylish but not so abstract that readers would have any trouble mapping them onto Beaumont's story.

The band's fortunes rise under Sonny's leadership, and the group

is invited to play in New York. But Sonny insists that they first travel back through the Midwestern outpost where Spoof passed. They play at the same club, and Sonny stays in the hotel room where his mentor died. When the concert starts, the band is aghast to notice that Sonny is using Spoof's old horn. He had exhumed the worn-down trumpet from Spoof's grave and was murmuring messages to his deceased hero between solos. After the eerie performance, Paige claims Sonny "was putting out the kind of sound he's always wanted to."[26]

"Black Country" garnered accolades that exceeded *Playboy*'s already-high hopes. The magazine devoted most of its November 1954 Letters to *Playboy* section—a key place where the publication promoted itself and countered the ample criticism it attracted—to showing readers' admiration for Beaumont and Neiman. The letters were headlined by an appreciation from Ray Bradbury, who published a serialized version of his novel *Fahrenheit 451* in *Playboy* earlier that year: "All the way down the line, it's a better story than 'Young Man with a Horn' ever could hope to be. I'm sure it will be remembered for many years." Al Hathaway, a reader from Laguna Beach, California, reserved his praise for Neiman's illustration, which "captures beautifully the feeling of the story" and had his "feet tapping the floor" while he read. *Playboy* printed a response from Beaumont below the plaudits. The author credited *Playboy* for realizing his story's potential by dressing it up with Neiman's artwork: "The illustration is nothing short of perfect," Beaumont effused. "Neiman got across magnificently all the power and sadness—I guess dynamism is the word—that I tried to put in the story. Spoof is exactly right. Exactly. Couldn't be better. There's fury and hunger and passion—everything. It is the very heart of the story. God bless the man. I know he must have felt the story: such a picture couldn't be faked."[27] Neiman's illustrations won an award from the Chicago Art Director's Club—one of the first industry accolades *Playboy* received. The prize gave *Playboy* occasion to continue promoting "Black Country" by anthologizing it in *The Best from "Playboy" 1954*.[28]

Neiman illustrated another Beaumont story in August 1955. "A Crooked Man" depicts a dystopian society that outlawed hetero-

sexual relationships and conditioned men and women to desire part-
ners of their same sex. The protagonist is a "crooked" man in this
society who is maintaining a clandestine affair with a woman. He is
eventually busted by the secret police and institutionalized for sex-
ual reeducation. Neiman's full-page color illustration shows the man
and his lover's vexed identities in this world that stifles their desires.
The exhausted and miserable man's face occupies the foreground and
is lacerated by colorful, semiabstract lines that highlight his misera-
ble bewilderment at the hands of this society, which "repulsed him,
turned him ill, made him want to take a knife and carve unspeakable
ugliness into his own smooth ascetic face."[29] Like "Black Country,"
the provocative story and illustration—which *Playboy* cast as a par-
able about tolerance despite its reinforcement of heteronormativity—
gathered widespread acclaim. They also installed Neiman as a fea-
tured contributor to *Playboy* whose works stood among the nascent
magazine's proudest accomplishments. LeRoy reveled in the positive
attention. He woke early on the days when issues of *Playboy* were
released and waited by a newsstand for the delivery trucks to arrive
with copies.[30]

* * *

Features like "Black Country" helped to define the culture that *Play-
boy* promised readers they could enter by consuming the proper
items—from fiction to automobiles to women. "The intimate connec-
tion between capitalism and consumerism and sexuality is obvious,"
Hefner told the cultural historian Carrie Pitzulo.[31] Hef considered
Playboy a "service magazine" that composed a "veritable handbook
for the young man about town."[32] One aspired toward the *Playboy* life-
style mainly by purchasing the goods that defined it (which included
the magazine itself). As Hefner acknowledged, "*Playboy* has always
been a wish book, or a dream book" that offers a fantasy existence.
Playboy gave young men advice on how to spend their money, as well
as a glimpse of the many pleasures that free spending might yield.
Readers could imagine themselves as part of the exclusive world *Play-
boy* described if they followed the advice it offered. These tips on

clothes, food, and so forth helped readers to pursue more sex while maintaining a veneer of sophistication that offset the magazine's lewdness and suggested that its priorities spanned beyond mere titillation. *Playboy* also unsurprisingly failed to mention that the fantasy life it depicted was generally available only to those who fit the white, middle-class, and heterosexual mold through which the publication defined its reader.

The magazine balanced its consumerist instruction with an unpretentious accessibility that avoided the intellectualism of publications like *Harper's* and the *New Yorker*. Its mission to help readers become sophisticated assumed that the audience came to the magazine unpolished and in need of guidance. *Playboy* offered mentorship without making readers feel like rubes. It invited them into the taste culture it defined and strove to make them feel as if they belonged—or at least that they could belong if they followed the magazine's recommendations. "We weren't talking down to the reader," Hefner remarked. "There was no snobbism to keep him outside. I mean all the implications of a manual of living the good life would be to make a person feel at ease, so he'd know what to look for and feel confident that he was properly outfitted."[33] It helped insecure young men of the 1950s—the symbolic grandsons of Sinclair Lewis's George F. Babbitt who inherited his obsessive "love of things"—to navigate the newly affluent and consumer-driven world they occupied. The magazine, as the journalist David Halberstam put it, "midwifed the reader into a world of increasing plenty."[34] Many of these readers were, like Neiman, the first in their families to attend college and enter the professional class. Recognizing this, *Playboy* targeted college students through a network of brand ambassadors stationed at large campuses. The pliable, college-aged readers would grow into the men who bought Neiman paintings and prints once they had sufficient money to purchase the works and wall space to hang them.

Similar to Neiman's illustrations, stories like "Black Country" and "A Crooked Man" were at once stylish and comprehensible. Readers did not need a thesaurus to understand them, any symbolism was spread on thick, and literary allusions were minimized. When the

fiction editor Ray Russell published a call for submissions in *Writer's Digest*, he stressed that fiction "should be modern, aware, sophisticated, literate, but not 'literary.'"[35] Along those lines, *Playboy* encouraged art appreciation, but only to the extent that it complemented the broader lifestyle the magazine promoted. The cover of *Playboy's* August 1956 issue displays the rabbit mascot from behind looking at a wall of paintings. He clutches a museum guidebook in one hand and faces a small Mondrian-inspired piece surrounded by three paintings of curvy, seminude women. Neiman painted the nudes that Art Paul integrated into the cover design. It is impossible to tell whether the rabbit is contemplating the Mondrian or fantasizing about the women, but *Playboy* suggests that its ideal reader can appreciate both at the same time. *Playboy's* monthly nude Playmates—the magazine's undisputed focal points who were featured as centerfolds—reinforce this relative accessibility. Hef imagined the featured women as approachable and all-American girls next door, the sort one might encounter while working at the office, studying at the library, or visiting a museum. They were not unlike Millie Hefner or Janet Neiman—attractive women with familiar backstories, which *Playboy* outlined in the copy that accompanied the photo spreads. The monthly Playmates were, in short, the types of women readers might imagine meeting and impressing with the consumerist and cultural training *Playboy* imparted.

Playboy also retooled common understandings of white middle-class masculinity. It celebrated a male who lived outside of the conventional family structure. Ironically, Hefner was married with a child—a testament to the fact that the *Playboy* life was more fantasy than reality. But he abandoned the traditional role once the magazine proved successful. As part of this masculine self-interestedness, the magazine, Pitzulo explains, "prodded male readers to scrutinize themselves, and potentially each other, with a self-consciousness usually reserved for women." *Playboy* recast stereotypically effeminate activities as acceptably masculine pursuits. One could be manly and pay attention to his appearance, enjoy cooking, and appreciate literature. The nudes, the feminist critic Barbara Ehrenreich insists, helped to

deflect criticism that this new male might not be sufficiently virile or straight.[36] The *Playboy* reader was unequivocally masculine in the traditional sense. But he also knew how to eat, dress, and decorate, and he could hold an intelligent conversation about literature, music, and art. Part of asserting this manliness was making sure that all facets of this dynamic new man were coated in the prospect of heterosexual conquest.

Hefner turned to Neiman to concoct an avatar of this idealized man. Neiman would "create a new, red-hot male to symbolize the magazine's essence." The artist, who was used to placating egotistical patrons, also knew that Hef fancied himself the quintessence of the magazine's aspirational male and that whatever symbol he created should "be an homage to Hugh M. Hefner."[37] Neiman borrowed from Hollywood to develop a recipe he thought might capture what Hef was after: "I would combine the looks and manliness of two matinee idols of the day. Jeff Chandler with his fair rugged handsomeness, and the dark debonair charm of Cary Grant." He posed the fetching celebrity pastiche in the foreground of a cityscape. The square-jawed urban dweller wears a black suit and tie with wing-tip brogues and parts his hair on the side. He stands with his right foot crossed in front of his left and his weight resting on a folded umbrella that functions as a cane in his left hand. The man's tall, narrow lines reflect the buildings in the skyline behind him. But he confidently emerges from that cityscape, which Neiman renders in a spiky Gothic style. The striking bachelor is completely comfortable in this environment, and he seems equally pleased to be using the umbrella for its functional purpose or as a jaunty accessory.[38]

Playboy debuted the Neiman sketch—and the featured bachelor they nicknamed "Our Guy"—to accompany Jack J. Kessie's January 1955 fashion feature "The Well-Dressed Playboy: *Playboy*'s Position on Proper Attire." The illustration was printed as a wide-angle frieze with Our Guy dominating the first page and the cityscape background migrating onto the overleaf where Kessie's article began. Kessie was a recent graduate of Drake University in Des Moines, Iowa, whom Hef had hired to write the piece on a freelance basis. Hefner commis-

sioned Kessie primarily because he liked the young writer's sleek, Ivy League–inspired style. Kessie's articles primarily explained fashion to readers—which colors to combine, which clothes are most appropriate for which seasons, and which items to prioritize when buying on a budget. He wrote with an air of pedantic authority that suggested readers would ignore his advice at their social and sexual peril. "However well you select your head-to-toe garb," he declared in March 1957, "you'll still look like a bum or a bumpkin if you wear it—and treat it— badly."[39] But Kessie, whom Hefner promoted to associate editor in 1956, was also self-conscious about his Midwestern background. He eventually adopted the Waspy pen name "Blake Rutherford," which sounded more like a Yale fraternity brother than a recent graduate from a small college in central Iowa. The elite-sounding pseudonym added some cultural heft to Kessie's observations.

Neiman's artwork often overshadowed Kessie's advice with full-color visualizations of how the well-dressed man would look if he enacted the magazine's tips. The veteran fashion illustrator showed how trousers should hang, which accessories might best complement the featured items, and, above all, the activities such sharply attired men might enjoy while looking so good. His drawing for Kessie's May 1955 "Well-Groomed Featherweights for Spring," which focused on lightweight suits, depicted a man paying cab fare as a nearby woman steals a satisfied glance at the dashing gentleman. The illustration established a template for *Playboy*'s long-standing promotional campaign "What Sort of Man Reads *Playboy*?," which started in 1958 and included urbane men in different settings who unknowingly attract the approving gazes of women. Neiman helped to define this alluring look by putting men into the clothes Kessie discussed while helping readers to imagine themselves wearing these carefully tailored outfits. These white-collar urban dwellers had a gray flannel suit in their wardrobes, but it did not define them.

In September 1955, *Playboy* recycled Neiman's illustration of Our Guy to accompany a demographic report on the magazine's readership. *Playboy* commissioned the market research company Gould, Gleiss, and Benn to survey its readers. Their report drew some con-

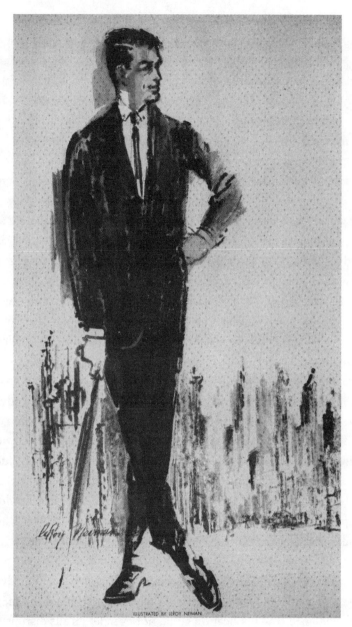

ILLUSTRATED BY LEROY NEIMAN

FIGURE 16. LeRoy Neiman, *Our Guy*, 1955.
© 2023 LeRoy Neiman and Janet Byrne Neiman Foundation / Artists Rights Society (ARS), NY.

clusions about *Playboy*'s audience that the magazine hoped might lure advertisers seeking to capitalize on men who aspired to be like the one Neiman sketched. "We've always edited *Playboy* for a particular guy: sophisticated, intelligent, urban—a young man-about-town who enjoys good, gracious living. Potential advertisers are interested in a more specific picture of a magazine's audience, however."[40] It then summarized readers' age, educational background, marital status, occupation, and hobbies. *Playboy* reported that more than 70 percent of its readers attended college and most were employed in high paying white-collar jobs. But the fashion historian Becky Conekin points out that the magazine exaggerated those educational and economic statistics to portray its readership as even more exclusive and desirable to advertisers.[41] The embellishments, in turn, urged the magazine's readers to think of themselves as part of a select community. Neiman's illustration helped *Playboy* readers form their identities and guided *Playboy* advertisers looking to target young men with money to burn.

Playboy's nude photos and overall focus on sex initially deterred big-name advertisers. But the companies could not long deny the magazine's popularity and were soon lining up to reserve ad space. Demand became so high that Hefner was able to select those advertisers that he thought best meshed with *Playboy* and sold the type of goods Our Guy might purchase. The magazine accepted ads only for items that projected a successful image. That would not include, for instance, hair restoration products or slimming aids. "Sometimes this hurt us financially," Hefner said of the policy. "But I just wouldn't compromise the appearance of the magazine to bring in dollars." These standards created a seamless flow between the magazine's advertisements and editorial content, all of which combined to create the taste culture it curated.[42] Our Guy was the image *Playboy* wanted advertisers and readers to have in mind when they envisioned the magazine's audience. The publication could not even let its ads disrupt the fantasy existence by implying that readers might be chubby, balding, or homely.

Our Guy continued to show up in and beyond *Playboy*'s fashion pieces. Neiman depicted the debonair mascot in color for Kessie's Feb-

ruary 1956 piece on loungewear, which the writer published as Blake Rutherford. The illustration shows the bachelor mascot unwinding after a long day. He wears a plaid robe and slippers while sipping a double scotch on the rocks, listening to Mozart's *Don Giovanni* on his stereo, and reading the latest *Playboy*.[43] The windows of his swanky, high-rise apartment peer out at glistening city lights. Beyond showcasing the fashionable yet cozy loungewear Rutherford discusses, Neiman shows that *Playboy* is just as much a part of Our Guy's lifestyle as the scotch he drinks and the view he enjoys.

Playboy increasingly positioned Our Guy as Hefner's alter ego, which is what the publisher wanted all along. It introduced Hef as an emblem of the magazine's signature lifestyle in a two-page June 1957 Playbill: "He likes jazz, Ivy League clothes, gin and tonic, and pretty girls—the same sort of things that *Playboy* readers like—and his approach to life is as fresh, sophisticated, and admittedly sentimental as the magazine's."[44] A full-page photograph captures Hef gazing into the camera just inside the entrance of the magazine's office building at 232 East Ohio Street, where *Playboy* had moved once it outgrew the single floor it rented on Superior Street. He projects Our Guy's cool confidence and has followed Kessie's fashion tips impeccably. A blonde woman stands behind Hefner, pushing the elevator call button as she gives the publisher an approving glance and perhaps a subtle invitation to join her wherever she is heading. The photograph reproduces the tableau of "What Sort of Man Reads *Playboy*?" Neiman's visual aids helped Hefner to mold himself into a more perfect symbol of the lifestyle his magazine defined.

The difference between Hefner and his readers, of course, was that the publisher amassed the resources to bring the fantastical *Playboy* life pretty close to reality. Hefner morphed into a Jay Gatsby for the 1950s who symbolized newly acquired wealth and exclusivity. Like Gatsby, the publisher would regularly throw lavish parties—initially at *Playboy*'s offices and eventually at the Playboy Mansion he purchased on Chicago's Gold Coast in 1959—to buttress the image. Also like Gatsby, Hefner often only briefly appeared at the parties he was ostensibly hosting. Instead of mingling, he would isolate himself in

his bedroom office to work or, just as likely, canoodle with a female guest. But Hefner was gregarious when hosting the syndicated variety show *Playboy's Penthouse* (1959–1961), another effort to tune his public identity. Shot on a set decorated to resemble Hefner's exquisite apartment, the proto-vérité-style program followed the host around as he socialized with the Playmates, intellectuals, and musicians who made his guest list.[45] Hef described the show as "a sophisticated get-together for people who we dig and who dig us." This group included Neiman, who sketched the parties as the cameras rolled and sometimes chatted with the host about his works in progress. Despite his suave reputation, Hefner was fidgety on camera. Neiman recommended that Hefner hold a pipe, which give him something to do with his hands that would make him look classy instead of tense. The prop made Hef seem more natural, and it subsequently became a signature part of his suave uniform.[46]

Playboy invested the resources from its expanding subscribership and advertising accounts to enhance its cachet. Hefner hired associate editor A. C. Spectorsky in May 1956 to lead the effort. Spectorsky— called "Spec" around the office—was a wealthy East Coaster who was born in Paris and educated at New York University and Columbia. He was the sort of person Jack Kessie was emulating when he picked the alias Blake Rutherford. Aside from some highlights like "Black Country," the stories *Playboy* published up to this point were generally mediocre and overreliant on lurid tales about sexual adventures. For instance, Ivan Gold's "Change of Air," published in February 1955 and accompanied by a Neiman drawing, focuses on a woman who had sex 160 times over seventy-two hours with members of a young men's social club. A group of men encountered the woman years later and figured they might all easily score—only to be disappointed by the fact that she had sought therapy and changed her habits. They jokingly lament that her shrink did a great disservice to the guys in the neighborhood. Gold's story, then, was an adolescent fantasy about female nymphomania. Neiman's illustration, which received an Award of Merit from the Art Director's Club of New York, emphasized the

fantasy by depicting a line of men impatiently waiting to have sex that stretches across three pages.[47]

Spectorsky urged Hefner to begin paying higher rates to lure more reputable writers, who, like the advertisers, were initially worried about associating with *Playboy*. The authors tended to change their attitude when *Playboy* started paying $2,000 for a lead piece of fiction, which dwarfed *Esquire*'s rate of $400. The magazine soon listed Budd Schulberg, Nelson Algren, and Delmore Schwartz among its contributors. *Playboy* published a statement in the opening pages of its January 1957 issue—the first year under Spec's watch—that outlined its renewed efforts to increase quality. To emphasize this initiative, the issue included a Ray Bradbury story accompanied by Pablo Picasso illustrations. "A Season of Calm Weather" centers on George Smith, an American on vacation in southwestern France who idolizes Picasso. While taking a solitary walk along the beach, Smith spots a man in the distance sketching in the sand with a stick. He realizes that the man is Picasso and his spontaneous doodles are potential masterworks that will be washed away instead of pondered and exhibited. Smith is forced to confront art's ephemerality and to consider what ultimately makes an artwork important. The Picasso illustrations that ran along the story were spare nudes that looked cubist enough to signal his style and figurative enough to be recognized as naked women. *Playboy* accompanied the feature with a photograph of a hand—presumably Picasso's hand—trailing off from the drawings to stress the artist's imprint on the magazine.[48] Picasso's appearance realized the vision Hefner articulated in the inaugural issue when listing *Playboy* readers' presumed interest in the artist. With "A Season of Calm Weather" *Playboy* was not simply a magazine that Picasso fans read but also one that published the artist's work.

The same issue that featured "A Season of Calm Weather" included a Neiman-illustrated article on the saxophonist Charlie Parker—a tortured figure not unlike Spoof Collins who likely informed Beaumont's character: "When Charlie Parker was blowing, the music spilled and tumbled out of him—abstract, brush-stroked joys and hates translated

by some mysterious process into the mathematical sense of tangible recorded sound." Neiman's drawing depicted the musician from a perspective similar to that of his award-winning painting of Collins for "Black Country." But this illustration was more abstract, to emphasize comparisons the article makes between the jazz musician and other contemporary artists, including Picasso. "As Pablo Picasso first painted in a way that pleased the academicians, grew bored and began to scatter his faces and bodies and colors in wide swaths and cubes and amorphous forms all over the canvas, so Bird [Parker] first went through a period in which he learned to swing in the old way."[49] Neiman aided *Playboy*'s efforts to put the tastes it promoted into dialogue with highbrow traditions without being esoteric. His accessible art exemplified the cultural balancing act that characterized *Playboy*'s relationship to its readers.

* * *

Neiman quit his job at Hoskinson & Rohloff to focus on his work for *Playboy*, teaching at the School of the Art Institute, and his continued efforts to exhibit and sell paintings. At *Playboy* he was part of a stylistically diverse stable of regular illustrators and cartoonists. Many of those artists, such as Harvey Kurtzman, who formerly worked at *Mad* magazine, and Jack Cole, who created the popular *Plastic Man* comic book, were well known by the time *Playboy* hired them.[50] This was especially the case with Alberto Vargas, whose career Hefner revived in 1959 by commissioning pinups done in the onetime *Esquire* artist's classic World War II–era style. Although Hefner did not have what it took to become a professional cartoonist (his fortunes may have been different had a publication like *Playboy* been around when he was starting out), he had an acute eye for talent and demanded loyalty from staffers. "Hef was not only interested in snaring you," Neiman remarked, "he was interested in tying you down." But the publisher paid well for faithfulness. *Sports Illustrated* began courting Neiman shortly after he started working for *Playboy*. It would have been a natural place for Neiman's work, given its mostly male readership

and LeRoy's established interest in sporting themes. Hefner, however, wanted Neiman to work primarily for *Playboy*, and he forced the artist to choose between them. It didn't take Neiman long to decline *Sports Illustrated*'s overtures.[51] The magazine would not guarantee him the consistent work *Playboy* offered or pay nearly as much.

The cartoonist and writer Shel Silverstein became LeRoy's closest confidant at the magazine and the social scene that grew around it. Raised in Chicago's working-class Logan Square neighborhood, Silverstein shared Neiman's and Hefner's childhood passion for cartooning. He gained notoriety with comics about army life published in *Pacific Stars and Stripes* while he served in the Korean War. Silverstein compiled his army work into the book *Take Ten* (1955), which was republished in paperback as *Grab Your Socks!* (1956) once he returned to Chicago. The collection's skewed views on military life found a substantial audience, especially among veterans. "No one had ever seen anything like that," Neiman remarked of *Grab Your Socks!*[52] *Playboy* hired Silverstein to create a series in the style of *Grab Your Socks!* in which he would travel the globe providing his off-kilter and self-deprecating impressions of the places he visited and the sticky situations that grew out of the cross-cultural exchanges.

Silverstein and Neiman—two extroverted Midwestern veterans—morphed into a slapstick comic duo. And their hijinks were accented by equally distinctive appearances—Silverstein's shorn head and dark beard complemented Neiman's abundant mustache and the cigar that always seemed to be smoldering just below it. Both added color to Hefner's soirees, which inevitably escalated with their mutual egging and efforts at one upmanship.[53] Shel and LeRoy's shenanigans rankled the *Playboy* scene's more refined members, but they charmed Hefner. Silverstein and Neiman became two of the sometimes-distant publisher's best personal friends among his coworkers. He enjoyed their goofiness and connected with them in ways that he never, for all his efforts at sophistication, totally jibed with East Coasters like Spec. The three would regularly spend time together, and Hef even trusted Silverstein and Neiman enough to show them some of the "blue" films

he made with girlfriends.[54] One of the great ironies of *Playboy*—as a wish book—is that its dream of urbane refinement was created by so many fairly unrefined Midwesterners.

With friends like Silverstein, Neiman had found his community in the *Playboy* crowd. He became as much a fixture in the social scene that orbited around the magazine as he was in its pages. Neiman fit in far better with this group than he did among his more serious SAIC colleagues. And he increasingly viewed his art as part of the larger *Playboy* lifestyle. "I was right in the middle of the whole intellectual community, faculty meetings, seminars and all that. All we ever talked about was art, painting, sculpture; I became bored," he said. "In that world everything had to be intellectual or introspective or it wasn't considered important."[55] But beyond the fun times, the folks at *Playboy* appreciated his art and took it seriously. The magazine routinely surrounded Neiman's illustrations with copy that celebrated his credentials. Hefner proudly hung *Mixologist* in his office alongside the Jackson Pollock and Willem de Kooning he owned. Hefner's walls were perhaps the only places where Neiman's work would hang in proximity to such vaunted figures.

Attesting to his admiration for Neiman's art as well as his self-importance, Hefner—who firmly believed he was helming a historic publishing empire well before *Playboy* was recognized as such—had the artist sketch what he witnessed around the magazine's offices and get-togethers. He invited Neiman to join him at Cook County's courthouse in December 1963, when *Playboy* faced obscenity charges that focused on nude photos of Jayne Mansfield.[56] Neiman functioned as a court painter who was equally tasked with documenting and glorifying Hefner's expanding kingdom. When Joe Goldberg published an authorized "inside story" of *Playboy* in 1967, Neiman painted a portrait of Hefner, flanked by adoring Playmates, for the cover.

Neiman and Janet married around the time the artist became a *Playboy* staple. They had a small wedding on June 22, 1957, at Holy Name Cathedral that drew attendees including Janet's Catholic family and LeRoy's buddies from the magazine, whose presence might have made the more traditional guests uneasy as the couple exchanged

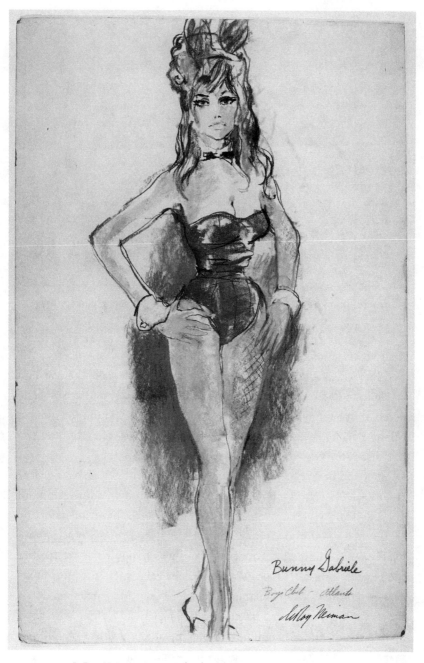

FIGURE 17. LeRoy Neiman, *Bunny Gabriele*, n.d.
© 2023 LeRoy Neiman and Janet Byrne Neiman Foundation / Artists Rights Society
(ARS), NY.

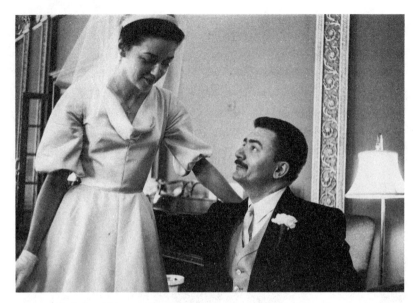

FIGURE 18. LeRoy Neiman and Janet Byrne Neiman at their wedding, June 22, 1957. Courtesy of the LeRoy Neiman and Janet Byrne Neiman Foundation.

their vows. Janet's father succumbed to tuberculosis a year before the wedding, Charlie Runquist could not be troubled to make the trip, and Uncle John had died in 1946. Hefner gifted the newlyweds an electric percolator, a fancy appliance at the time. They honeymooned in both Miami Beach and Saugatuck, Michigan, where Neiman taught at the Art Institute's Ox-Bow summer school.

Janet and LeRoy had settled into a $105-a-month flat above a grocer at 59 East Chicago Avenue, still a modest downtown address, but an upgrade from Neiman's basement with far better light for painting. While LeRoy adored Hefner, the artist ignored the warnings from his boss and friend about marriage and was happy to be wedded in the church, one of *Playboy*'s most ardent critics. He did not, however, avoid the wanton lifestyle Hefner espoused and participated in it heartily even as he settled into domestic life. Unlike Hefner, who grew up in a steady and loving family, Neiman sought both the stability of marriage and the excitement of bachelorhood—a balance he tried to maintain with varying degrees of success.

7

Playboy's Norman Rockwell

Based on the success of Neiman's early work for *Playboy*, Hefner asked the artist to start illustrating the monthly Party Jokes page in August 1955. When *Playboy* launched, the Party Jokes were framed by drawings of nude women in flirtatious poses that complemented the section's mostly sexual topics. Neiman replaced the previously rounded and cartoonish nudes with sketches in the lustrous and angular style of his fashion illustrations. LeRoy was not immediately credited as the Party Jokes artist, but avid readers would have recognized his work from Our Guy's regular appearances. One year after Neiman started illustrating the Party Jokes, *Playboy* moved the section to the opposite side of the centerfold—one of the magazine's highest traffic areas for those readers who hoped the nude photos might unexpectedly extend another page.

Hefner and Paul sought a sexy mascot that would define the Party Jokes page and encapsulate its combination of humor and titillation. "I wanted her to be something special," Neiman said, reflecting on his brainstorming sessions with the editors. "Mischievous, but respectable. Loved. Unpredictable."[1] Neiman returned mock-ups of a curvy miniature woman with coal-black hair. He accented her nudity with thigh-high stockings and elbow-length gloves. "A gremlin," the satisfied Hefner proclaimed in reaction. "Strictly feminine," Neiman rejoined. Hefner fused the remarks by naming the nymph the "Femlin."[2] The publisher later claimed that the Femlin was partly inspired by an illustration of a nude woman seated in a champagne glass that

appeared in the bartending book *Bottoms Up*. He also referenced a similarly spritely character played by Alice Faye in the 1934 musical *George White's Scandals*, when some camera trickery made it appear that she was performing the sultry tune "Oh, You Nasty Man" while perched on the rim of a martini glass.

The Femlin first appeared in July 1957 as a miniature companion to Our Guy. She poses in his ashtray, stretches out in a cocktail, and stands on his palm while he grins at her puckish antics. Like Tinker Bell's loyal infatuation with Peter Pan, Femlin adores Our Guy, who considers her a lovable but naughty pet. Hefner described the Femlin as "the personal pixie of the bachelor, similarly inclined to get into mischief."[3] She helps Our Guy keep his datebook, fastens his cuff links before he leaves for a night on the town, and puts on his slippers when he returns home. She also gets sick after taking a drag off Our Guy's cigarette and tugs at his pant leg when he neglects to give her the attention she demands. Neiman compared her to the gremlins that World War II fighter pilots would blame for mechanical troubles. The Femlin also, of course, evinces *Playboy's* general attitude toward women. She is an attractive but subservient object whose diminutiveness reflects the lack of intelligence that is laced into her identity.

Like Our Guy, Femlin became a fixture in the magazine, attracting as much interest as the jokes she adorned. Neiman eventually would sketch a year's worth of Femlins at a time and would put the character into poses that complimented the month. She hauled a sprig of mistletoe in December that, in her arms, looked like a small tree; she celebrated with New Year's party favors in January and sniffed a Valentine's Day bouquet in February. The Femlin also reinforced the taste culture that *Playboy* championed by fiddling with the gadgets it discussed, skimming through issues of the magazine that Our Guy left lying around his apartment and reading a bound copy of Hefner's rambling *Playboy Philosophy* manifesto, which she kept alongside books by Alfred Kinsey and Sigmund Freud. The Femlin morphed into a company mascot on par with the bunny and Hefner, steadily drifting beyond the Party Jokes page. *Playboy* published two standalone books of its jokes, both of which featured the Femlin on their

jacket, and she appeared on the magazine's cover eight times throughout the 1960s. When *Playboy* expanded beyond publishing and into clubs and resorts, it decorated its drinkware and ashtrays with her and sold Femlin figurines at the gift shops. Before he became famous for assassinating Lee Harvey Oswald, the Dallas nightclub owner Jack Ruby put the Femlin on his business cards (without *Playboy*'s permission).[4] With Our Guy and the Femlin, then, Neiman created two of *Playboy*'s most powerful symbols as it established itself as America's most influential men's magazine. LeRoy visualized *Playboy*'s idealized man and woman.

* * *

Playboy officially anointed Neiman as the magazine's star artist with the April 1958 profile "Painter of the Urban Scene." The article introduced Neiman as a "fashionable fine artist" and "perceptive portrayer of the sophisticated life" through color reproductions of several paintings—including *Pump Room* and *Mixologist*. The profile included a photo of Neiman at work in his studio and stressed his "mushrooming reputation" among critics. The article provided LeRoy's most visible write-up to date. *Playboy* reinforced Neiman's role as the magazine's most prominent regular artist by giving him a special place in its December 1958 five-year anniversary issue. These efforts installed Neiman as *Playboy*'s closest equivalent to the *Saturday Evening Post*'s Norman Rockwell.[5] LeRoy's aesthetic encapsulated *Playboy*'s urbane hedonism in the way that Rockwell's style typified *Saturday Evening Post*'s chaste sentimentality. In 1963, *Playboy* began publishing standalone portfolios of Neiman's and Vargas's artworks. They were the only two illustrators the magazine—which generally owned the illustrations it commissioned for publication—set apart in this way.

Shortly after installing Neiman as *Playboy*'s main artist, Hefner developed a recurring feature that put LeRoy front and center. Launched in December 1958, "Man at His Leisure extended Silverstein's comic series by having Neiman sketch and paint his impressions of exotic and exclusive locales. "You'll be *Playboy*'s man on the go," Hefner told Neiman. "You'll go out and find the hippest places,

the hottest chicks, and the finest restaurants in the world, and you'll paint them, you'll show the reader what it's like to live the kind of lifestyle he dreams of."[6] The series added travel to the multifaceted fantasy lifestyle *Playboy* curated for its readers. As the historian Elizabeth Fraterrigo puts it, *Man at His Leisure* helped the magazine endorse "the notion that a true sophisticate must, of necessity, be a cosmopolite."[7] Like Kessie's fashion tips, Neiman's series helped upwardly mobile, middle-class readers to navigate everything from the logistics of transoceanic travel to ordering wine at dinner. Neiman considered himself an ideal ambassador for readers precisely because he was an outsider in haute culture and, as a result, could adequately introduce fellow interlopers. "I didn't have any more clue than the average reader did about these rare terrains," Neiman wrote," but as a poor boy in a rich world, I was the man for the job."[8]

Neiman chose Chicago's familiar Pump Room restaurant for his first installment of *Man at His Leisure*. "For the urban man of leisure, the Pump has become *the* scene in the Midwest," the article reads. Neiman painted beautifully arranged meals, elegant diners, and assiduous wait staff onto one of the restaurant's menus. The feature introduces *Playboy* readers to what they would encounter if they managed to secure a reservation at the Pump. It also offers some implicit tips for the uninitiated on how fine dining works. The article notes that the restaurant's imperious maître d' "bows to no man" but "has a courteous inclination of the head and a smile for all patrons."[9] Aside from characterizing this colorful figure, the piece explains what maître d's are and the roles they perform for the many readers who have never visited a restaurant with anyone employed in that capacity.

The inaugural *Man at His Leisure* received enthusiastic reviews on par with Neiman's "Black Country" illustrations. "Where's it all going to lead?" gushed the Tucson-based *Playboy* reader Don Humphrey. "You have the best of everything in *Playboy*! The best writers, like Beaumont. The best cartoonists, like Silverstein. And the very best of all is your LeRoy Neiman. His recent illustrations depicting the Pump Room in Chicago have got my feet itching and my taste buds blossoming. I beg of you: don't restrain that boy: he's really great." The most

interesting bit of fan mail *Man at His Leisure* inspired came from Ralph Canterbury, of Tempe, Arizona, who saw fit to issue his tribute in verse:

> It seems there's this fellow named
> Neiman,
> An artist who paints like a demon.
> From horses and clothes
> And bar rooms he rose;
> Now why don't you let him draw
> Weemin?

The editors reminded Canterbury that Neiman drew "weemin" every month for the Party Jokes page.[10]

Man at His Leisure variously describes Neiman as *Playboy*'s "itinerant impressionist" and "boulevardier-with-brush." The series also presents him as a vigorous contrast to effeminate and sensitive artistic stereotypes. "Neiman's an artist's artist," asserts a February 1960 *Man at His Leisure*, "the master of the facets of his art, yet he is not the willowy-fingered ascetic, the aimless, soul-searching wanderer so common to literature dealing with painters. No introverted escapist, Neiman spends his days confronting life in masculine terms." Reflecting its pieces on fashion, cooking, and decorating, *Playboy* emphasized Neiman's roguish persona to assure readers that they could appreciate art without compromising their manliness and heterosexuality. Once *Man at His Leisure* took off, Neiman went from satirizing those eating out on corporate expense accounts to being the beneficiary of the ample per diem *Playboy* afforded him while he was on assignment. It was a trade he made happily. Neiman was at once a cheapskate and a libertine—a combination that was hard to achieve without someone footing the bills. "I never pick up a tab," he once boasted. "I don't believe in it."[11] *Man at His Leisure* relieved him of such inconveniences.

* * *

Neiman's relationship to academic culture grew increasingly strained as his success with *Playboy* blossomed. Plenty of SAIC faculty did

commercial work, but none was so publicly identified with a publication as controversial as *Playboy*. While *Playboy* boasted freely about Neiman's association with the Art Institute, the school left Neiman's work for *Playboy* out of the faculty biography it printed in course catalogs. This omission was conspicuous because the Institute typically listed instructors' professional highlights. Nevertheless, Neiman developed a louche reputation around the school. As he put it, "My *Playboy* connection forever sealed my fate as an artist who would not be accepted by the art establishment."[12] One time while LeRoy was chatting with a fellow instructor between classes, he recognized one of his colleague's students from her work posing nude for *Playboy* photographers. Always keen to show off, Neiman gossiped to his coworker about her modeling. The woman grew ashamed and despondent once word inevitably spread around the school. A few days later Neiman was interrupted while painting in his studio by her boyfriend pounding on the door and looking for a fight. "I hurried to the entrance before I feared he may break the door down," Neiman wrote in his journal. "Upon opening the door, there stood the wild-eyed young man, cursing and swearing both hands knotted into fists." The scandalized woman stood silently next to her beau as he accused Neiman of tarnishing her name. Neiman defused the confrontation by explaining that her photographs did not make the cut and, as a result, would not be appearing in *Playboy*.[13] LeRoy avoided a scuffle, but his identification with *Playboy* was beginning to make him seem like a slimeball among the Art Institute's more respectable folks.

Teaching at the School of the Art Institute offered Neiman the esteem that he craved. But his work for *Playboy* was yielding fame, which he desired in equal measure. Not even his most renowned SAIC colleagues would be recognized around town or have their bar tab picked up by a fan—a scenario Neiman was enjoying with increasing regularity. He was regaining the art-star status that he had not boasted since his days at Washington High or in the army. The animated and recognizable artist began getting attention from journalists. And the publicity-savvy Neiman understood that he would attract even more notice if he gave the reporters a show. When a 1959 *Chicago's Ameri-*

can article asked Neiman how he developed an interest in art, the artist cracked, "I saw my dad draw a bath." The same newspaper featured Neiman the following month to promote its relaunch as *Chicago's New American.* The advertisement asked, "Who Reads Chicago's New American?" and featured a grid of assorted Chicagoans—housewives, pastors, carpenters—explaining what draws them to the paper. Neiman, the only artist among the bunch, appears in the bottom right corner. "News coverage is masculine and hard-hitting," he says of the paper. "I like the no-holds-barred art criticism too."[14] The ad reinforces Neiman's identity as a macho, *Playboy*-style artist. He is a sophisticated working artist but also a regular guy—not too different from the cabbies and laborers surrounding him in the ad—who stands behind the quality of his work and invites whatever criticism the paper might direct his way.

LeRoy also started attracting media coverage when traveling on *Playboy's* behalf, which was aided by the magazine's publicity department. Both the *San Francisco Examiner* and the *San Francisco News* reported on Neiman's 1958 visit to make preliminary sketches for an eventual *Man at His Leisure* feature. The *San Francisco News's* Dorothy Walker reminded readers that Neiman was "a serious painter, not just a flashy illustrator." Walker also called attention to the money his work for *Playboy* was generating. "Many an artist, striving to make a living by his brush, has had to skip a meal," Walker remarked. "But LeRoy Neiman of Chicago is one artist who is putting on weight as a result of his painting."[15]

By the time Neiman started *Man at His Leisure*, Spectorsky and Hefner were routinely publishing work by big-name writers. While those folks gladly accepted *Playboy's* ample checks, they were cautious about getting too cozy with a magazine that was still primarily known for nude centerfolds. Nelson Algren, for example, bragged that he never read the magazine despite placing several stories in it. At one point, the cantankerous writer derided Hefner's company as a "high schlockhouse" of faux refinement that only further alienated the lonely crowd who looked to it for lifestyle advice. Algren, in fact, was temporarily barred from the Playboy Mansion for his remarks

and generally boorish behavior. Puzzled guests at one party spied the sloshed writer carrying on a slurred conversation with a medieval suit of armor that Hefner had on display. Algren later defended himself by saying the knight was the most interesting person at the party.[16]

In contrast, Neiman publicly defended the legitimacy of *Playboy* and stood by the work he created for it. "So many of the great moderns loved to paint the world of high fashion," he told the *San Francisco Examiner*. "Look at Manet, Degas, Dufy. Look at Americans like Sargent and Whistler. Nowadays artists think there is something immoral about painting the so-called sophisticated life. That's hooey. There's just as much significance—and more beauty of color and line—in painting a twirl of whipped cream as there is in portraying a dish of sauerkraut. I like both, and when I'm not hungry, I like abstract subjects as well." He left out the fact that most critics attacked not *Playboy*'s interest in sophistication per se but how the magazine curated a version of refinement that championed female objectification and blind materialism. LeRoy's joke about painting while hungry also suggested that artists should not be ashamed if they were lucky enough to have their work find a paying audience. His impressions of the good life for *Playboy*, he maintained, were both steeped in canonical traditions and paid better than more faddish abstract art. When *Chicago's American* asked Neiman whether he harbored any misgivings about working with *Playboy*, the artist offered an unequivocal no before asserting that features like *Man at His Leisure* are "what Lautrec would do if he were alive."[17]

As he neared forty (but admitting only to being in his early thirties), LeRoy eventually came to terms with the fact that *Playboy* was the only facet of his career paying worthwhile dividends. Accolades for his non-*Playboy* paintings were few and far between, and the Art Institute would not commit to employing him beyond the twelve-month contracts he signed each summer.[18] Neiman was set to teach in spring 1960 when Spectorsky offered him an opportunity to scout Europe for future *Man at His Leisure* features. Not wanting to miss out on the six-month trip, Neiman told his SAIC superiors that health concerns necessitated a sudden leave of absence. "I regret that you

are forced on the advice of your physician to reduce your activities making this leave necessary," read a letter from the Art Institute dean Norman B. Boothby. A separate letter confirmed that LeRoy would be able to keep his health benefits through the rest of the year.[19]

It is possible that Neiman was, in fact, ill. He suffered from a range of minor maladies throughout his life. It is far more likely, however, that taking a health-related leave would be the only way Neiman could get out of his spring teaching duties, keep his insurance, and avoid burning any professional bridges. His correspondences with the dean make no mention of the Europe trip, and it is difficult to imagine a scenario in which LeRoy would be too sick to teach but well enough to travel abroad for an extended period. As much as he enjoyed working for *Playboy*, he was employed by the magazine only on a freelance basis and did not receive health benefits. To Neiman's credit, he found the SAIC replacement instructors for the courses he was set to teach that semester. Spectorsky cut Neiman a $2,200 check to be used against the expenses the artist incurred for his work-related research and travel.[20] Janet joined LeRoy, and the pair arrived at Southampton, England, by ocean liner on March 17, 1960.

LeRoy steadily made *Playboy* his top professional priority. "My art friends warned, 'Watch out, LeRoy, that's the first step down a slippery slope. You have to decide if you want to be a serious artist or associated with tits and ass.'" Neiman chose the latter proudly and without hesitation. "I loved *Playboy*," he wrote. "If I was marginalized because of it, I didn't care." He depicted himself as a continuation of a long line of artistic iconoclasts like Toulouse-Lautrec and even Pollock. "If you're a product of the art school syndrome, it's considered a violation to go your own way," he told the *Boston Globe*. "I've violated mores. I'm different."[21] This apparent rebellion was made easier, however, by the lack of attention his work was attracting beyond *Playboy* and its readership.

But a group of clients, collectors, and galleries began showing interest in Neiman's art precisely because of his links to *Playboy* and the salability that connection guaranteed. Minneapolis's Radisson Hotel hired Neiman to paint a full-length portrait of the Danish American

cabaret singer Hildegarde for the suite it named in her honor. The hotel sought to appear like one of the hot spots Neiman depicted in *Man at His Leisure* and figured it might as well hire the artist who made the Pump Room look so elegant. Neiman's work also gained popularity among the corporate set. Executives whose businesses purchased *Playboy* ads included his art in their personal and company collections. By 1961, Pillsbury, DuPont, and Firestone all had Neimans on display at their respective headquarters.[22]

Chicago's Frank J. Oehlschlaeger took notice of LeRoy's popularity, if not prestige, and invited him to exhibit some work at his small gallery in 1959.[23] The pieces moved quickly, prompting Oehlschlaeger to stage a solo show for Neiman the following year, in which he sold fifteen of the twenty-four paintings he displayed. Oehlschlaeger Gallery became Neiman's principal home in Chicago, and it took a one-third commission from every piece it sold—a standard percentage but one that LeRoy still thought was too steep. Neiman started working with Hammer Galleries in New York one year later, which was run by the powerful Hammer Brothers. Victor Hammer directed the Fifty-Seventh Street gallery, Harry served as bookkeeper, and the enigmatic Armand handled most of the wheeling and dealing. Neiman was particularly fond of Armand, a charming and ruthless businessman who called to mind his uncle John. But LeRoy was not naive enough to trust the Hammers, and he later expressed regret at taking their deal—the first offer he received—without shopping around for a better and more prestigious gallery partner in New York.[24]

Oehlschlaeger and Hammer Galleries openly emphasized Neiman's role at *Playboy* in their publicity. Hammer Galleries maintained a general interest in "democratizing art" by including items at a range of price points. As Armand Hammer explained: "One of my pleasures in running the Hammer Galleries has been to entice into its rooms people who would normally feel out of place in snooty art galleries. I felt that the Hammer Galleries did something genuinely useful in giving ordinary people a taste of buying art works of high quality which were easy to appreciate and enjoy. They might go on with more confidence to browse in other galleries."[25] Neiman provided a suitable

entry point for these consumers who were interested in art but unacquainted with and intimidated by art culture. Underlying Hammer's benevolent claims was a diversified business model that generated more revenue than many upscale galleries by selling a greater volume of goods at lower costs per item. But Hammer's perspective reflects *Playboy's* populist consumerism. Hammer and Oehlschlaeger wanted Neiman to bring middle-class patrons, especially men, into their galleries. *Playboy*, in turn, realized that any increase in stature that Neiman enjoyed in the gallery world—even more accessible businesses like Oehlschlaeger or Hammer—would only help the magazine by aligning it with that milieu. Neiman's status as a popular artist was solidifying. He still harbored a desire to break into the world of fine art and museums—a yearning he never abandoned. But he was not going to pass up the money, celebrity, and good times that accompanied his partnership with *Playboy*.

* * *

Like its artist-in-residence, *Playboy* maintained a conflicted relationship to art culture. The magazine encouraged readers to understand and acquire art en route to achieving the lifestyle it promoted. Modern art typically hung on the bachelor pad walls depicted across its editorial content and advertising. An April 1967 installment of "What Sort of Man Reads *Playboy*?" shows an impeccably groomed man perusing an art exhibition with a blonde on his arm while an equally attractive brunette scopes him out from across the gallery.[26] Museums, the ad implies, are another place for the hip bachelor to meet women, and art appreciation composes a way to impress them. Like suits and stereos, art was a helpful asset in Our Guy's cultural portfolio.

But understanding and acquiring art was even more baffling for the uninitiated young man than deciding between pleated and nonpleated slacks or selecting the proper turntable. *Playboy* offered some general training to keep readers informed without overwhelming the bachelor's principal commitment to pleasure seeking. The magazine's features on art tended to focus on those artists with some mainstream prominence—the names most likely to crop up at a dinner party or

be featured at a major museum exhibit. *Playboy*'s casual engagements reflected a contemporary commodification of modern art in middlebrow culture that, according to the cultural historian Erika Doss, boosted its popularity by oversimplifying its nuances.[27] The magazine also generally framed its discussions of art in ways that complemented its preoccupation with women and sex. A March 1961 piece on Willem de Kooning focuses in large part on *Woman I* (1950–1952), an intentionally grotesque painting that moved against the polished feminine loveliness that *Playboy* peddled.[28] Although de Kooning's interpretation of women, beauty, and sex was different from and even critical of the images *Playboy* tended to publish, the magazine nevertheless found the painting relevant to its infatuation with the same subject matter.

Playboy showcased its participation in art culture with the September 1960 feature "Painting a Playmate," which had several artists depict the monthly centerfold Ann Davis in their respective styles. Richard Frooman contributed a low-angle Georges Seurat–esque pointillist portrait of Davis standing with her robe undone. Neiman captures her from above as she ascends a spiral staircase, which he renders in kaleidoscopic color. Loath to deny its readership nude photos, *Playboy* included stills of Davis being painted alongside reproductions of the works that the commissioned artists eventually produced. Although none of the artists ventured into the de Kooning–style grotesque or questioned the common sense that Davis should look sexy, the feature positions Playmates as worthy topics for artistic treatment and indicates that the magazine is fully capable of interpreting them in this way without compromising its masculine and heterosexual ethos. It also gives readers permission to be challenged, inspired, and turned on by art. Hefner further made the case for *Playboy*'s artistry and debt to recognized creative traditions during the 1963 obscenity trial by comparing its centerfolds to Paul Émile Chabas's once-polarizing *September Morn* (ca. 1912), a painting that depicts a solitary nude woman wading on a lakeshore. He convincingly contended that Chabas's work, which was on permanent display in the Metropolitan

Museum of Modern Art, was no more revealing than anything the magazine published.[29]

The art critic Sidney Tillum's January 1962 feature "The Fine Art of Acquiring Fine Art" explains how readers might start amassing their own collections. Tillum opens the article by asserting that nearly anyone can afford stylish art if they know where to find it. "Acquiring fine art used to be an avocation for the very, very rich," he writes. Tillum then happily reveals that "the cultural buying spree of the few has spread to the many," along with the United States' booming economy and the surging art market that catered to the nouveau riche, precisely the community Oehlschlaeger and Hammer sought to exploit when they teamed up with Neiman. Assuming no familiarity on the part of readers, Tillum explains how galleries operate and overviews the intersecting cultural and economic purposes they serve. He describes the gallery as "a cultural marketplace which selectively showcases representative products in the art world, and thus exists not only as a business venture, but as a creator of trends and an arbiter of taste as well."[30]

Photos of art in galleries, studios, and rental libraries accompany Tillum's article along with a legend that gives their title, artist, and price. The works range from a $40,000 untitled Jackson Pollock to a small John Grillo abstract priced at $150. LeRoy Neiman's $875 *Jockeys* is included among these pieces, shown on an easel next to a $6,000 Larry Rivers canvas titled *Final Veteran*, which is propped up against a studio wall. Tillum offers readers a sense of art's vast price range while scaling the included works to accommodate different budgets. He puts Neiman in dialogue with Pollock and Rivers while acknowledging that the artist-in-residence occupies a lower tier in the marketplace.

Reflecting *Playboy*'s antielitism, Tillum acknowledges the art world's endemic superficiality and the seeming arbitrariness underlying which artists are revered and how their works are priced. "Those who take a dim view of the current rush for conspicuous consumption of culture see the art world as a fattening monster engaged in dis-

pensing taste," he writes, "flattering egos and deflecting power drives while discreetly muffling the sound of purring from the counting rooms." Tillum accepts that the art world—while perhaps ultimately rooted in frivolity—wields social power that aspiring Playboys ignore "at the risk of being called a Philistine" and ostracized by those they hope to impress. Like Jack Kessie's fashion pointers, Tillum schools readers on how they can avoid the humiliation of artistic ignorance and begin collections that broadcast their membership in the urbane taste culture *Playboy* defines. He implies that Neiman might compose a realistic starting point for the budding collector who fits the *Playboy* reader's economic profile.

While *Playboy* helped readers to understand, appreciate, and acquire art, it also cautioned them against taking it too seriously and mocked those who did. Hefner had been issuing lighthearted jabs at art culture since *That Toddlin' Town*, which included a cartoon of two men at the Art Institute looking at a cubist nude. "Man—is she stacked!" one of the men says. The piece points out the silliness of someone being aroused by a cubist interpretation of the female form while perhaps lamenting the genre's lack of interest in arousal. Hefner liked the cartoon enough to adapt it for use in *Playboy*'s first issue. Such irreverent content participated in a broader takedown of modern art and the stereotypically snooty highbrows who liked it.[31] *Time* magazine, for example, referred to Pollock as "Jack the Dripper" in 1956. *Mad* lampooned abstract art by putting a finger painting executed by a chimpanzee on the cover of its March 1958 issue. Norman Rockwell even participated in these debates with *The Connoisseur* (1961), which the *Saturday Evening Post* used as its January 13, 1962, cover image. The piece depicts from behind an older man in a gray flannel suit gazing at a large abstract expressionist drip painting. Similar to *Playboy*'s August 1956 cover of its rabbit mascot visiting a gallery, Rockwell's man clutches his hat, an umbrella, and a museum program in hands clasped behind his back as he contemplates the canvas. The biographer Deborah Solomon calls *The Connoisseur* Rockwell's "masterpiece" and suggests the painting shows his appreciation for modern art.[32] But Rockwell's perspective leaves open the possibility

that the conservatively dressed gentleman, his glove-encased right hand fidgeting with his bare left hand, is also straining to understand and acclimate to this chaotic and newfangled approach that seems so at odds with his upright posture and traditional attire. *Playboy's* attitude toward modern art—displayed by the August 1956 cover—sits somewhere between *The Connoisseur's* subtle ambiguity and *Mad's* exaggerated sarcasm.

The magazine's cartoons—places where the publication was free to display its greatest irreverence—most directly targeted art-world pretentions. An August 1955 Arv Miller piece has two restorers painstakingly working on Rubens paintings. "Professor, I would appreciate your opinion on the underpainting," says one restorer, who has discovered that the masterwork is actually a paint-by-numbers. *Playboy* cartoons took special aim at abstract art. A November 1960 John Dempsey has two people contemplating a straightforward landscape on a museum wall that is otherwise dominated by drip paintings. "I don't get it," one of them remarks. A June 1960 Gardner Rea cartoon shows a painter's abstract canvas surrounded by realistic nudes. "Don't tell me you're going commercial too," a miffed colleague says to the artist. A February 1967 Francis Wilford-Smith drawing displays a less successful action painter who grows dejected when the material he hurls onto the canvas winds up creating an exact replica of Leonardo da Vinci's *Mona Lisa*, not the masterpiece he was hoping to generate.[33]

The cartoonist Jim Beamon's intermittent "*Playboy* Art Gallery" series built on the comics by offering realistic reproductions of famous paintings that he tweaked in sardonic ways. An April 1965 installment focusing on *September Morn* has a periscope peeking up from the lake's surface to spy the nude woman. Another pokes at James McNeill Whistler's 1871 *Arrangement in Grey and Black No. 1*, colloquially known as *Whistler's Mother*, which depicts a pious woman seated in profile, hands folded in her lap, and gazing toward something out of the frame. Beamon widens the perspective and inserts a television in her sight line to suggest this woman—whose pose and expression have inspired significant critical speculation—is just watching

TV. Neiman would have gotten a chuckle from Beamon's take on *The Gleaners*, which has Millet's peasant farmers golfing instead of working.[34] The series would have been comfortably at home in the pages of *Mad*.

Unsurprisingly, many of *Playboy*'s cartoons exposed the sexual dimensions bubbling beneath the surface of the art world's stereotypical solemnity. A handful featured lecherous artists, often made all the more cartoonish by berets and goatees, attempting to ogle or seduce women under the guise of having them pose nude for a portrait. "Take off your glasses so I can see what you look like," directs a lusty painter to the otherwise-nude woman posing in Misch Kohn's July 1956 comic. "How can I capture the real you when you're all bundled up like that," another portraitist asks his bikini-clad model in July 1969.[35] The cartoon scenarios reflect Neiman's admitted efforts to lure women to his apartment to pose.

Richard Taylor's March 1959 drawing shows a museum curator seated in his office, surrounded by walls filled with modern art. The curator, however, sneaks a peek at a realistic painting of a nude woman that he keeps tucked out of view. He publicly celebrates the modern works on display, but he privately prefers the curvy nude. Taylor published a similar cartoon in December 1962 that takes place in a figure-drawing class. "Now I want all of you to focus your attention on the muscles of the upper left arm," says the instructor, while pointing to a voluptuous model standing on a platform. Taylor implies that the students will be scrutinizing other parts of her anatomy. Another cartoon from 1967 shows the aftermath of an art heist that a detective calls "the most unusual robbery I can remember." The crime took place in a museum full of Boucher-like nudes. Rather than steal all the artworks, the crooks cut out the parts depicting breasts and buttocks. The caper showcases a very different understanding of the paintings' value from the logic that drove the museum to acquire them.[36]

Neiman's work at *Playboy* attested to and deepened the magazine's connections to the art world. His illustrations regularly referenced the magazine's fluency with identifiable artistic traditions by, for instance,

having the Femlin pose in the style of nudes by Poussin or Titian. But the macho artist also participates in the magazine's sarcasm. His May 1969 Party Jokes illustrations have the Femlin working on an abstract painting—an allusion to the common snipe that anyone could work in the seemingly slapdash form. The accident-prone pixie discovers it is not so simple and winds up covered in paint. Another Femlin drawing has the nymph posing for a portrait. She becomes enraged when she sees the finished painting, which is done in an abstract style that fails to showcase her sexy figure. Neiman's January 1972 *Man at His Leisure* transports readers to an art auction at Sotheby's in London. He explains the elite scene assembled at Sotheby's and the exorbitant prices that its artworks fetch. But the pleasure-seeking artist gives special attention to a young woman leaning over to inspect a painting and a man inspecting the woman. "A 19th century landscape due to go on the block is the focus of interest for one young lady, who is, in turn, of interest to the gent on her left," he writes in the copy that accompanies his sketch.[37] LeRoy shows how the man, surrounded by priceless artworks, would rather look at a woman's butt. Neiman exemplifies how *Playboy* combines its appreciation and understanding of art with an unwillingness to let this point of interest interfere with its main priorities. He helped the magazine define a taste culture that combined sophistication with sophomoric carnality.

* * *

LeRoy and Janet returned from their *Playboy*-sponsored European trip in spring 1960 in time for Neiman to resume teaching in the fall. They left again the following April, this time indefinitely. Following in Haupers's footsteps, LeRoy planned to establish a studio in Paris, which would allow him to paint the same locations Toulouse-Lautrec had captured a century earlier. It took Neiman some effort to convince Janet, who missed her family during their first trip, to join his continental artistic rite of passage. But Janet, who also still loved to paint, eventually agreed. Neiman was giddy about the relocation. "I have to get away and concentrate on my own things," he bragged to

the *Minneapolis Star Tribune* shortly before departing. "From now on, on all my commissions they'll have to agree to pay the shipping costs from Paris, too."[38]

The couple again sailed from New York to Southampton on the SS *United States*—a trip Neiman used as the backdrop for his first international *Man at His Leisure*. He showed off his impressionist skills with a colorful painting of the ship's ceremonial embarkation—with streamers flying from its many levels—that *Playboy* reproduced on a full page. The piece finally fulfilled the series' global ambitions and marked Neiman's evolution into "*Playboy*'s ambassador-at-large to the world's far-flung playgrounds."[39] The expanded scope of *Man at His Leisure* complemented Silverstein's international cartoons as well as Ian Fleming's James Bond spy stories, which *Playboy* began publishing in March 1960.

Man at His Leisure was not as silly as Silverstein's hijinks or as thrilling as Bond's adventures. But the newly international series harmonized with its kin by offering voyeuristic glimpses of exotic and taboo spaces, such as Paris's Lido Cabaret. A segment on nude beaches in Yugoslavia (now Croatia) combined Neiman's artwork with photos of him drawing naked, a sketchbook strategically positioned over his lap. A December 1961 installment focused on Maxim's restaurant in Paris. The article described Neiman's experience dining with his "date." This guest may have been Janet, but *Playboy* preferred to create the impression that Neiman was a bachelor, which would be more consistent with the swinging lifestyle it presented. *Playboy* expanded on *Man at His Leisure* by curating branded travel packages. It decorated promotions for the Playboy Tours with Neiman sketches of global landmarks and sophisticates kicking back. Our Guy shows up in one of the illustrations with a pipe dangling out of his mouth as he helps a female traveling companion to her seat at a café.

When he was not on assignment for *Playboy* Neiman worked in rented studios in the Passy section of central Paris's Eighth Arrondissement and on Brompton Street in London. He spent most of his time in Paris, where he reconnected with former SAIC schoolmates like Leon Golub and Seymour Rosofsky, who had relocated to France. He

became acquainted with other expatriates, including the painter Bob Thompson and the writer James Baldwin, who took a liking to Neiman and opened the *Playboy* artist's eyes to racism in America and the far more tolerant treatment Black Americans encountered abroad.[40] Neiman sketched Baldwin twice during their conversations, and he returned to the United States with a renewed interest in race relations that would begin to shape his work, especially his explorations of sports. He also took side trips with Janet to visit museums, sketch landmarks, and scout places that might eventually be suitable for *Man at His Leisure*. While in Rome Neiman used his *Playboy* credentials to access the set of Federico Fellini's *8½* (1963), where he sketched as the filmmaker worked. Despite his incessant travels, LeRoy enjoyed a period of immense productivity during his time in Europe and received a Gold Medal Award for work he entered the Salon d'Art Moderne's 1961 contest.

The award led to two exhibits the following year. The first, at London's O'Hana Gallery in March 1962, included forty-one paintings, most of which Neiman completed in Paris. The works extended his worldly image by comparing French and English culture through their respective renditions of the twist dance craze. LeRoy hammed it up at the opening by doing the twist himself—at one point with the Duchess of Bedford's daughter. Neiman sold seventeen of the paintings and drew generally positive, but by no means rave, reviews. "His technical accomplishment is adequate to the aims he has set for himself and in one or two paintings his colour composition is far better than it has a right to be," a critic for *Topic Magazine* backhandedly reported. London's *Daily Mail* found Neiman's focus on the twist to be blatantly opportunistic and called him "one of the most dedicated men out— dedicated to money, that is."[41] Neiman's exhibition at Paris's Galerie O. Bosc seven months later was more enthusiastically received. The *New York Herald Tribune*'s French edition likened Neiman to Delacroix, Degas, and Toulouse-Lautrec before calling him "one of the most talented artists in our midst."[42]

The European exhibits combined with the recently globalized *Man at His Leisure* to establish Neiman as an indisputably interna-

tional artist. When the Morgan Coal Company commissioned LeRoy to paint the 1962 Indianapolis 500 auto race, the *Indianapolis News* referred to him as an "eminent French artist" instead of a fellow Midwesterner—a typo he surely savored.[43] As he bragged before leaving the country, Morgan Coal would have to pay the shipping costs from Paris, where he would complete the works after it flew him out to sketch the event. This is precisely the sort of reinvention that Neiman hoped the extended trip would provide.

When he decided it was time to leave Europe in early 1963, Neiman surmised that his professional prospects would be best served by settling in New York instead of returning to Chicago. The choice upset Janet, who was under the impression that they would eventually come back home. Their traditionalist marriage, however, gave her little choice in the matter, and she joined her husband, who no longer wanted to be stigmatized as a provincial Chicagoan. "For any artist, the target is New York," he later said. "If you come to New York from Chicago, you'll always be a Chicago artist, like [the boxer] Tony Zale was always from Gary, Indiana." It was even better, he wrote in his journal, to settle in New York from Paris. "You are then international," he stated.[44]

Playboy, despite its proud Chicago roots, also benefited from the cachet its artist-in-residence gained from becoming a New Yorker. The magazine expanded its collaboration by commissioning Neiman to help decorate the Playboy Clubs it started opening in 1960. Between 1960 and 1970, Neiman completed more than one hundred paintings and two murals for eighteen Playboy Clubs and two resorts. He created the seventy-two-foot *Hunt of the Unicorn* mural for *Playboy*'s hotel and resort in Lake Geneva, Wisconsin. At first glance, the peculiar piece, which is based on a series of early Renaissance Dutch tapestries, looks like a fox hunt. But the mounted hunters and their dogs are pursuing a white unicorn that is galloping out of the frame. LeRoy also occasionally ran workshops at the *Playboy* resorts for those guests who wanted to learn how to paint in his increasingly popular style.

Earl Neiman helped his brother and Janet secure housing in the

Hotel des Artistes at 1 West Sixty-Seventh Street—where he and Marlys lived in a studio apartment. LeRoy's brother and sister-in-law had been in New York for the previous couple of years. Marlys was working as a secretary for the Metropolitan Museum of Modern Art. Earl had developed a specialty in stained glass and occasionally did work for local churches, including New York University's chapel.[45] Marlys's salary mainly paid their rent at the Hotel des Artistes, an eighteen-story, Gothic-style cooperative built in 1917. As its name suggests, the apartments were initially meant to serve artists of one form or another. Tenants included the actor Rudolph Valentino, the dancer Isadora Duncan, the writer Fannie Hearst, and illustrators such as Charles Dana Gibson and Norman Rockwell. Many of the structure's units feature double-height windows to maximize the natural light that visual artists need to work. Because of its height, the apartment building also had to function as a hotel. As a result, it includes a ballroom, swimming pool, and a restaurant, the Café des Artistes. West Sixty-Seventh Street came to be known as "Artist's Row" because of the hotel and the famous people who lived there.[46]

The fact that Earl and Marlys already resided in the Hotel des Artistes made the move convenient for LeRoy and Janet. But Neiman was also attracted to the conspicuous address, which would amplify his newly acquired status as a New York artist who once kept a studio in Paris. LeRoy and Janet eventually purchased ten units in the building, but they initially lived in a small one-bedroom. To reflect his paint-encrusted upright piano on Wabash Street, LeRoy used an old pool table as an easel. They decorated the walls with tapestries procured in Europe, some of LeRoy's paintings he did not want to sell, and, in the living room, a portrait of Neiman painted by Clement Haupers in the late 1940s. They were not yet rich, but the new residence aided LeRoy's tireless efforts to sculpt his image. How could he be anything but an *artiste* now that he lived in the Hotel des Artistes?

Hammer Galleries held Neiman's first solo show at its East Fifty-Seventh Street galleries on October 8–19, 1963. The exhibit included sixty-six paintings, almost all of which LeRoy completed while in Europe. Hammer's press release emphasized Neiman's focus on leisure

FIGURE 19. LeRoy in his studio at the Hotel des Artistes, 1969.
Courtesy of the LeRoy Neiman and Janet Byrne Neiman Foundation.

culture through combining abstract and figurative approaches. "Neiman builds his figures with flickering dabs, daubs, and rapid veils of paint, with an intelligently fauvist practice in color—light, vivid, and gay. However, this dashing surface treatment is given a firm basis of reality by Neiman's thorough sense of structure and anatomy." The publicity sheet also maintains that Neiman's visually engaging canvases offer "trenchant social commentaries." These observations, Hammer insists, are made even more poignant by "Neiman's own background among the unwashed, unwatched, and unwanted"—qualities that the press sheet suggests gave LeRoy a particularly authentic perspective on the subject matter he depicts and dissects.[47] The *New Republic's* Frank Getlein, who reviewed a 1957 Neiman exhibit in Chicago, noted some creative development since the artist's voyage abroad. "He has lost nothing in the years since [the 1957 show] and possibly gained a little elegance from his French studies," Getlein observed."[48]

LeRoy sent Clement Haupers an announcement for his Hammer exhibit. He included a letter that updated his old teacher, with whom he had been out of touch, on his recent adventures and relocation to New York. "Thought I'd enclose a press release sent out in regard to my exhibition to give you some idea what I've been up to in the past decade or so," Neiman wrote. "It doesn't take much examination to conclude that I've been busy." LeRoy balanced the proud announcements with affectionate comments that explained the deep influence Haupers had on him as he grew into a professional artist. He thought Haupers would enjoy knowing that Victor Hammer owned a landscape by his Parisian mentor André Lhote that includes "many of the early principles of painting you taught me." LeRoy also told Haupers that he and Janet had the portrait the teacher painted on display in their apartment. "I love it for several reasons, but it annoys me too because it makes a couple of things of mine in the same room look bad," Neiman said of the painting Haupers gifted him. "You are in my mind more often than not as I go about this great trade and passion we both share," LeRoy told his mentor in closing. "It's all your fault," he wrote, adding some levity to his sincere appreciation.[49] Neiman

gave Haupers credit for his success while also making it clear that they had become peers.

As intended, the move to New York enhanced Neiman's profile and broadened his professional network. The boxing trainer Angelo Dundee visited the Hammer show. Dundee thought Neiman's colorful style and association with *Playboy* might be a clever way to showcase his up-and-coming fighter Cassius Clay, whom LeRoy had briefly encountered and sketched the previous year. While Neiman's scenes of urban leisure helped Hefner to realize his editorial vision, his work for *Playboy* built a foundation from which he would help to fashion athletes like Clay into a new breed of celebrity icon.

8

The Sports Artist

LeRoy briefly visited New York from Paris in May 1962 to check in with the Hammers. While in town, he caught a Saturday evening fight card at St. Nicholas Arena on West Sixty-Sixth Street—not far from the apartment building where he and Janet would be living less than a year later. The main event was a heavyweight bout between Cassius Clay and Billy Daniels. Like most fight fans, Neiman had heard of Clay, an up-and-comer out of Louisville who won a gold medal at the 1960 Rome Summer Olympics. But few, including Neiman, thought the captivating boxer was a legitimate contender. Clay, in fact, was making more waves with his mouth than his fists. The "Louisville Lip" demonstrated a visionary understanding of publicity with witty and rhymed lines that touted his greatness and taunted his opponents. Neiman was partly drawn to the fight at St. Nick's because of the barbs Clay had slung at Daniels before their encounter, which ABC television would broadcast live on *Fight of the Week*.[1]

Neiman was chatting with the press at ringside when he ran into the sportscaster Jack Drees, an acquaintance from his Chicago days. Drees was gushing about Clay and told Neiman he needed to meet the vivacious young heavyweight, who had bulked up and improved since Rome.[2] LeRoy stopped sketching and followed Drees into the bowels of St. Nick's to Clay's dressing room, where the boxer sat on a training table as his hands were being wrapped. Although terrifically cocky when he had an audience, the fighter was fidgety and nervous in the quiet, private moments before bouts. He welcomed distraction from reporters and photographers, which allowed him to slip back

into the register of a confident showman. And Clay was intrigued by Neiman's unusual request to sketch him.

As LeRoy drew Clay, who was shirtless and kneading the just-applied tape into his knuckles, he was struck by the fighter's exceptional physical beauty. "He was golden," Neiman recalled, "no hair on his body, just beautiful. He looked like a piece of sculpture, with no flaw or imperfection. His features and limbs were perfectly proportioned."[3] LeRoy wholeheartedly agreed with Clay's frequent proclamations that he was "so pretty." And the former fashion illustrator and *Playboy* artist knew masculine beauty when he saw it. He captured Clay in profile sitting on the table. After inspecting LeRoy's sketch, the impressed Clay borrowed the artist's pen to make some of his own drawings alongside the piece. The boxer casually doodled during his spare time—his father was a sign painter and occasional muralist. Athletes frequently asked to keep Neiman's sketches—requests he often granted—but none had wanted to take his own turn drawing.

Clay filled the vacant bottom right corner of LeRoy's sketch pad with a cartoonlike adaptation of his self-aggrandizing statements. He first drew his bust in profile—a rough contrast to Neiman's delicate sketch. Clay surrounded his face with a rocket zooming into the sky to the left and a Cadillac speeding down the road below. He signed it:

By the Great Cassius Clay
Next Champ by 1963

The doodle depicts Clay as a fighter on the rise. He is a spaceship blasting into the atmosphere and a luxury car zipping toward a bright and prosperous future. The vehicles are heading out of the picture, indicating that Clay would not be contained by any prescriptive framework. As Clay worked on the picture, a member of the boxing commission summoned him to the ring for his match. "Wait a minute," the fighter said without looking up. "I'm not finished with this drawing." The flustered official left and returned moments later to insist that the boxer approach the ring.[4] Clay put the final touches on his artwork,

returned Neiman's pen and sketch pad, and proceeded to beat Daniels with a seventh-round technical knockout.

Neiman was more interested in the boxer's showmanship, self-assurance, and looks than his performance in the ring. He sensed that Clay was a new sort of athlete who carefully tended to his image, not too different from *Playboy*'s Our Guy. Clay viewed himself as equal parts athlete and entertainer, and he knew how to play the media to ensure his name circulated far and wide. "I don't feel I'm in boxing anymore," he told the writer Tom Wolfe in 1963. "It's show business."[5] The pioneering self-promoter trained in T-shirts that bore his name—a first in sports—and traveled in a personalized bus with "The World's Most Colorful Fighter" painted on the side in a prismatic combination of letters.

LeRoy's vivid, kinetic, and promotionally friendly art complemented Clay's style and savvy. Clay and his management figured that the increasingly popular *Playboy* artist could publicize the boxer in a new way while tapping into the magazine's large audience of sports fans. Neiman's work—and the art Clay made with LeRoy's coaching—added a visual element to the fighter's well-documented gift of gab. Aligning with Clay also helped Neiman to expand his growing image. He parlayed his work at *Playboy* to become the signature artist for the new era of athlete-entertainers that Clay ushered in.

* * *

After the Daniels match, Neiman did not see Clay again until relocating to New York the following winter. He attended the first Clay fight he could, a March 1963 bout against Doug Jones at Madison Square Garden, and used the occasion as the subject for a *Man at His Leisure*. LeRoy had done several sports-themed installments of the series—such as the exclusive West Side Tennis Club in the Bronx and the Winter Olympics in Squaw Valley, California—but he had not yet covered his beloved boxing for *Playboy*. Most prizefighting venues at the time were rough and grimy—hardly appropriate for *Man at His Leisure*. But Manhattan's Madison Square Garden, a mul-

tipurpose venue where celebrities flocked both to watch events and to be written up by the society columnists who spotted them, was an appropriately luxurious setting.

Clay's antics intensified the Garden's electric atmosphere by helping to generate the venue's first sellout in thirteen years. "I'll shut the door on Jones in four," he guaranteed before winning by an unexciting decision. "They came to see the destruction of the Louisville Lip, and they didn't," Clay crowed of the packed house.[6] The publicity teed Clay up for a championship shot against Sonny Liston, a title few thought he stood a chance to win.

Neiman's *Man at His Leisure* feature did not appear until December 1963—nine months after Clay-Jones. *Playboy* packaged the painting as a foldout printed on heavy matte paper that stood out among the magazine's thin and glossy pages. A Vargas pinup of a curvy blonde lounging on pink satin sheets was printed on the opposite side. The double-sided foldout invited readers to remove and display the piece, and it gave them decorative options depending on the brand of manliness they preferred to showcase. It also further reinforced the status of Neiman and Vargas as the magazine's marquee artists.

The Madison Square Garden painting combined pen and watercolor to depict a panoramic view of the storied arena as Clay and Jones were introduced. The luminescent white ring is surrounded by a darkened and smoky mass of spectators, staff, and security guards that Neiman highlights with oranges and yellows. "Madison Square Garden," explains the text accompanying LeRoy's piece, "means but one thing to the professional prize fighter: the ultimate arena."[7] Neiman does not explicitly identify the fighters or offer the date of the match. The name on the back of Jones's golden robe is vaguely legible; and Clay stands in the opposite corner wearing a white robe with red trim. Boxing fans would be able to decipher the specific fight. But, in keeping with the focus of *Man at His Leisure*, the scene at the Garden, which Neiman describes as a "vast, dark bowl in a pyramid of stark white light," composes the main subject. Some of this was practical. It was entirely possible that Clay might have slipped in prominence in the nine months between the fight and the time LeRoy's feature

went to print, making the painting less relevant. The Garden, by contrast, was a monument of prizefighting culture, the sort of macho and sophisticated place where *Playboy* readers could fantasize about dressing up and visiting. But Neiman's painting would be one of the last depictions of a match featuring Clay in which the heavyweight was not the main attraction.

Clay was scheduled to fight Liston for the championship in February 1964—two months after the publication of Neiman's *Man at His Leisure*. Despite Clay's undefeated professional record, boxing experts were not taking him seriously.[8] *Playboy* repeatedly doubted him. In a 1963 article, the magazine's resident prizefighting maven, Budd Schulberg, recounted meeting Clay at a party. The precocious boxer pressed a note into the writer's hand with a self-aggrandizing poem that he signed "the next champion of the world." Schulberg was charmed by Clay's pluck, but he maintained that the young fighter would have to "grow up and wait for Liston to grow old" before he might win the title.[9] *Playboy* profiled Clay in July 1963. The article called the young pugilist's rhymes "trite" and credited his "flamboyant egotism" with setting in motion an undeservedly rapid rise through the heavyweight ranks.[10]

Angelo Dundee invited Neiman to Miami to sketch at the Fifth Street Gym, where Clay was training. "The Dundee camp adopted me," LeRoy recalled, "and I was soon folded into the Cassius Clay road show."[11] Clay kept an entourage of family, friends, and hangers-on who loitered around the gym, ran errands, and kept him company when he was not training. The diverse community featured sparring partners, journalists, personal photographer Howard Bingham, hype man Drew Bundini Brown, and Malcolm X, with whom Clay had developed a friendship that led to his eventual religious conversion to Islam. Neiman enjoyed being part of the crew—a decidedly rougher community than the one at the Playboy Mansion that reminded him of his days back in Frogtown.

The artist would sketch with Clay early in the mornings after the contender finished his daily roadwork. Unlike many in the entourage, Neiman was not on Clay's payroll. But he was a not journalist either.

He was a fan, but not a flunky. Clay's relationship to the press orbiting him in Miami was growing increasingly tense as the fight neared and few picked him to win. "It's your last chance to get on the bandwagon," he said to reporters. "I'm keeping a list of all you people."[12] Neiman had been on the bandwagon since the dressing room at St. Nick's. But his support for Clay was not driven simply by his affection for the boxer. As with Hefner, LeRoy saw in the fighter a magnetic rising star who could enhance his own notoriety.

LeRoy's sketches centered on Clay's preparations and the scene that grew around him. One drawing showcases the exterior of the Fifth Street Gym, which was in a modest building above a shoe-repair store in a run-down section of Miami Beach. Several men idly hang around the entrance between a shoeshine stand and a sandwich board advertising Clay's presence at the gym. The drawing depicts Clay as a man of the people—"the people's champ," as the fighter often called himself—who trains upstairs as a cobbler labors on the ground floor and others socialize on the sidewalk. Neiman underscored the drawings' documentary qualities by including dates, time stamps, captions, and even objects from the fight that he pasted onto his sketch pad. He depicted the pre-fight weigh-in on the official instruction sheet that the boxing commission provided competitors before the match. He glued a press pass for the weigh-in next to the instructions and drew on top of it as well. "At last, the fight fraternity assembles at the scale," Neiman writes in the lower left margin. The fighters are surrounded by reporters and television cameras from ABC and CBS. Liston stands on the scale expressionless while Clay needles him from behind. "You're no champ—you're a chump!" the challenger hollers in a speech bubble. The notes and collage elements provided context and a sense of atmosphere that would inform any future paintings Neiman completed of the event.

Other sketches offered more straightforward celebrations of Clay. A drawing dated February 19—less than a week before the match—depicts Clay from behind entering the gym as fellow Fifth Street boxer Luis Rodríguez jumps rope. Clay is facing a poster for his upcoming match, one of many affixed to the walls. This announcement clearly

lists him as the challenger; his name is below and slightly smaller than Liston's. But Clay walks confidently into the room and toward the poster, confronting the challenge like the symbolic rocket and Cadillac he drew for LeRoy in 1962. Neiman depicts the boxer shirtless, lean, and upright with proportions that resemble his fashion illustrations. He elongates Clay's torso to make the boxer appear slightly less muscular and more in line with the male models the artist sketched for *Playboy*. And he cleverly stresses Clay's beauty by including Rodríguez in the frame, whose nickname was El Feo, or "the Ugly One."

Neiman also sketched Liston in Miami. But he got off to a stormy start with the mercurial champion, who had little use for someone milling about with a sketch pad while he trained. At one point Liston grew irritated when he saw Neiman at ringside with a cigar wiggling in his mouth as he drew. "Hey artist, get rid of the cigar," Liston reportedly said. Neiman protested that his stogie was unlit. "Get rid of it. I don't care if it's cold," the champion seethed. LeRoy moved away from the ring to a corner of the gym out of Liston's view and continued sketching, with his cigar. Liston eventually warmed to the idea of being drawn and the benefits it might present. But he did not want to be sketched while he was working out. Instead, Liston invited Neiman to visit him during the evening at the home he was renting in Miami. The champion, an ex-convict and former mob enforcer, was dogged by his checkered past. Liston thought Neiman, who was known for drawing the classiest subjects, might help to soften his frightful image. "I don't want you to paint me as a fighter," he told LeRoy. "I want you to paint me as a gentleman."[13] Liston thought that perhaps Neiman could spark an image makeover that would align him with the sophisticated style the artist helped to create for *Playboy*.

But the painting Neiman fashioned only enhanced Liston's menace. He depicted the champion as a faceless animal with an entirely red body on a black background—a beast charging out of the darkness (plate 7). While the artist stretched Clay to emphasize his regal beauty, Neiman compresses Liston into monstrous proportions. He gives the fighter a boulderlike chest with shoulders and arms poised for confrontation. Liston's tree-trunk forearms are the same width as his

boxing gloves, which appear more like permanent appendages than removable equipment. He is a terrifying and rage-fueled ogre who seems set on dispensing punishment. Liston, as Neiman represents him, was as repellent as Clay was attractive.

After his unexpected victory over Liston, Clay immediately confronted the press that doubted him. "Eat your words!" he hollered to the ringside reporters before declaring that he had "shocked the world!" Two days later, the new champ further stunned the public by announcing his conversion to Islam and name change to Cassius X, which he switched to Muhammad Ali the following month. Suddenly, Ali had transformed from a harmless windbag into an ominous threat. With the metamorphosis, Ali revealed himself to be far more complicated than most critics had assumed. Even astute commentators like Schulberg, as it turns out, did not understand the fighter very well at all. Regardless of his motives, Neiman was one of the few who had taken Ali seriously. This early support gave LeRoy privileged access to Ali for the rest of the boxer's storied career.

The journalist and *Paris Review* editor George Plimpton, a sports fan who became enchanted by Clay while in Miami for the Liston match, published excerpts from his notebook in *Harper's* magazine that sought to explain boxing's enigmatic new titleholder. Relying heavily on interviews with Malcolm X, Plimpton offered a less caricatured exploration of Ali and his beliefs for a public still largely unfamiliar with the Nation of Islam. Neiman provided the illustrations for Plimpton, two sketches that show Ali's dual role as an unbridled braggart and a devout Muslim. The first depicts Ali predicting that he will finish his next opponent in eight rounds by extending eight fingers. He hollers the prophecy with his mouth agape, his head cocked back, and his eyes closed to muster the loudest possible proclamation. Ali's screaming mouth occupies a disproportionate part of his face to emphasize the fighter's exceptional volubility. He is all bluster—a surge of emotion and sound. The second sketch shows Ali with his head bowed in solemn prayer. The hands that were aggressively predicting his victory in the previous drawing are extended from his

waist with their palms raised in a worshipful gesture. His eyes are still closed but in meditative devotion rather than a strained effort to amplify his screams. Neiman's illustrations punctuate the textured portrait Plimpton offers by demonstrating Ali as a rare amalgamation of flamboyance, thoughtfulness, and piety. The sketches, the first of which includes Neiman's signature, also exposed LeRoy's artwork to *Harper's* readership, a stereotypically more learned and diverse group than *Playboy's* audience.

Neiman further elaborated on Ali's complexity with a sketch of the fighter and Malcolm X that was not included in Plimpton's article. He depicts the faces of Ali and X—Ali from the side in the foreground and X in partial profile behind him. Ali issues a full-throated holler, again with his mouth open impossibly wide, while X gazes sternly ahead. Neiman presents them as a two-headed being and implies that Malcolm X's ideas power Ali's performances—another indication that there is a calculated method underlying the boxer's strategic madness. Neiman's drawing explores a mysterious element of Ali that made many uneasy. The artist was comfortable probing Ali's relationship to Islam, and he offered a respectful depiction of the fighter's religion rather than dismissing him as an ignorant fanatic. With these sketches, Neiman allied with and even anticipated a growing community of liberal intellectuals like Plimpton who identified Ali as a powerful symbol of the intensifying cultural frictions in 1960s America.

Publications like *Playboy* could no longer afford to disregard Ali by the time he earned the title. As Ali told the magazine in 1964, "Being a Muslim moved me from the sports pages to the front pages." Hefner's passion for both boxing and the First Amendment made Ali an obvious choice for one of the extended interviews *Playboy* began publishing in 1962. Ali was the first athlete included in the series—a feature in which *Playboy* strove to achieve the sort of thoughtfulness more typically associated with magazines like *Harper's*. Alex Haley, who interviewed Malcolm X for the magazine in 1963, directed *Playboy's* "candid conversation" with the new champ. During the wide-ranging conversation, Ali explained the racism he repeatedly faced and vowed

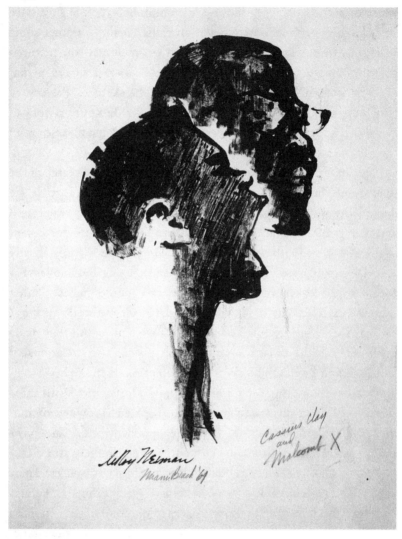

FIGURE 20. LeRoy Neiman, *Muhammad Ali and Malcolm X*, 1964.
© 2023 LeRoy Neiman and Janet Byrne Neiman Foundation / Artists Rights Society
(ARS), NY.

to use his platform to wage a broader fight against inequality in the
United States. "Maybe God got me here for a sacrifice," Ali said,
a statement that seems prophetic given his suspension and the revo-
cation of his title in 1967 for refusing military enlistment on religious
grounds.[14] The interview also put Ali into dialogue with the eclectic

slate of people *Playboy* had interviewed—a roster that included Henry Miller, Jawaharlal Nehru, Salvador Dalí, Ayn Rand, and Frank Sinatra. Neiman's artwork helped to broker Ali's entrance into this rarefied cultural milieu where artists, thinkers, and entertainers intermingled.

* * *

Ali's broadening cultural relevance inspired Broadway producer Hillard Elkins's 1964 musical reboot of Clifford Odets's 1937 boxing-themed play *Golden Boy*. The production starred Sammy Davis Jr. and premiered at the Majestic Theater in October 1964—the same month that Ali's *Playboy* interview went to print. Odets's original melodrama focused on Joe Bonaparte, an Italian American who uses prizefighting to rise out of poverty. Elkins reimagined *Golden Boy* as a tale about Joe Wellington, a Black fighter from Harlem. But Wellington must battle against racism as well as poverty—a shift that, according to the trade publication *Billboard*, added "breadth and bite to the tragedy" at the center of the original play.[15] A musical number titled "Don't Forget 127th Street" focused on Wellington's simultaneous love for his Harlem neighborhood and his hope to escape it. The lyrics mention Malcolm X to characterize its setting.[16]

Muhammad Ali's struggles with racial discrimination and his out-spokenness about civil rights gave *Golden Boy* the relevance that *Billboard* lauded. The real-life fighter, who was living in Harlem at the time, attended the musical and visited with Sammy Davis Jr. backstage after the show. Neiman sketched the production and painted a portrait of Davis, as Wellington, for its Playbill. The piece depicts the protagonist in a golden robe evocative of the play's title and raising his arms victoriously at Madison Square Garden. But Wellington looks exhausted and despondent; his chin sinks into his chest and he seems barely able raise his arms. The pose gestures toward the challenges that weigh on the fighter within and outside of the ring. Neiman was hired to paint Davis based on his work with Ali, and his portrait put *Golden Boy* into dialogue with the controversial boxer and the politics he embodied. Simultaneously, Neiman's work with Davis connects Ali to the entertainer. The artist links athletics, entertainment, and cul-

ture while joining Ali to establish a new context where these spheres explicitly overlap.

The Hammer Brothers, despite their money-hungry reputation, did not initially approve of Neiman's increasing interest in Ali and sports. They were averse to Ali's politics and generally uncomfortable with the interracial scenarios that sports so often involved.[17] The Hammers, of course, were not alone in their antipathy toward Ali—the boxer's politics and religion rankled both white and Black Americans. Neiman kept painting Ali despite the Hammers' racist discouragement. He also continued working with the Hammers, who could not dictate what the artist painted, only what they chose to stock at their gallery. He did not agree with their views, but he was not about to give up their patronage.

As Ali began defending his title, he and Neiman collaborated on predictive sketches that supplemented his famous rhymed prophesies. Neiman called the drawings "voodoo doodles" and claimed that Ali had "convinced himself that if you made a drawing of an opponent lying face down on the canvas, that it would come true."[18] Ali's sketch of his 1965 rematch against Liston—which he won by knockout in the first round with a mysterious "phantom punch"—shows him blasting the former champion clear out of the ring. It also embraces Ali's villainous image. Tears stream from the referee's face, who screams, "Stop. He is finish'ed champ." Ali writes "facing reality" above the packed crowd of spectators, which he depicts as a quilt of frowning faces. Several of the faces are captioned as judges to indicate that the sporting establishment, like most of the fans at that point, hopes to see Ali lose. But three smiling faces are clustered among the otherwise despondent crowd. One of them has a long black mustache and is captioned as "LeRoy." Aside from Neiman, Ali drew in the artist's assistant and girlfriend Linda Moreno, a Mexican American woman from Houston who started traveling with LeRoy in 1964. He also includes an unnamed Black Muslim. He shades both Linda's and the Muslim's faces to make them the only nonwhite people in the crowd. This makes LeRoy the sole white person in attendance who is pleased

with Ali's victory. The drawing, which Ali gifted to Neiman, demonstrates the artist's position as a rare friend to Ali among a mostly hostile white public.

Ali's subsequent voodoo doodles experimented with different genres and media. For his 1966 match against Cleveland Williams, Ali poked fun at the challenger's "Big Cat" nickname by sketching his prediction in the form of a two-panel comic titled *House Cat in the Astrodome*. The first panel has Williams's head on the body of a cat. His gloves are raised and he growls ferociously. The second shows Ali entering the frame from the left to swat away Williams, who takes cover under a stool like a proverbial scaredy cat.[19] Ali painted a watercolor and marker prediction before his 1967 match against Zora Folley in Madison Square Garden—the champ's last fight before his suspension. According to Neiman, who praised the watercolor as Ali's most ambitious work to that point, the boxer took about four hours to complete the piece and worked on it late into the night before the match.[20] The painting shows a packed house in Madison Square Garden, with a TV camera capturing the spectacle from a platform high in the stands. Ali performs his signature "Ali shuffle"—a technique Neiman depicts by drawing several sets of legs to suggest the boxer's feet in rapid motion. The disorienting move apparently works, and he sends Folley sailing toward the ropes with a left hook. Like his drawing of the Liston rematch, the crowd members are faceless apart from LeRoy and Linda, who grin as they watch from a few rows back.

Ali's predictive sketches have received only cursory mention in the many volumes devoted to the boxer's life and career. But they show Ali's expansive stylistic repertoire and the role Neiman played in helping to build it. Likewise, Ali helped Neiman develop into an entertainer as well as an artist. Neiman had always loved attention. But it was not until after he participated in Ali's transformation into one of the world's biggest celebrities that LeRoy began to understand the true power of publicity. Neiman began to grow his mustache out beyond the corners of his mouth, wear loud outfits, and travel with Linda or another alluring female assistant. The World's Most Color-

ful Fighter inspired Neiman to stake his claim as the World's Most Colorful Painter.

* * *

Neiman's association with Ali catalyzed his transformation from the *Playboy* artist known primarily for the Femlin and *Man at His Leisure* into a sports artist. More of his commissions concerned sporting themes, and he received a flood of invitations to attend and sketch events. LeRoy no longer had to ask for credentials or even flash his *Playboy* business card to scrounge complimentary tickets. He was an asset who enhanced events and could be introduced before competitions or during a lull in the action. As the heavyweight boxer Ken Norton once said when he saw LeRoy doodling before a match: "Jesus, LeRoy's here. It must be a big fight."[21] Neiman became a signature feature of marquee sporting events that attested to and amplified their exceptional status.

Taking a page from Ali's promotional book, Neiman claimed that he was the United States' first and most influential sports artist. "There hasn't been any sports art to speak of," he remarked to the *Christian Science Monitor*, "so I've had the field pretty much to myself." Even more brashly, he told *New Times* magazine that "before me, sports art was not even considered art."[22] Neiman was fully aware of, and even influenced by, the sports-themed artwork that George Bellows, Thomas Eakins, Frederic Remington, Elaine de Kooning, and others had produced before him. He was also privy to contemporary illustrators who specialized in sports, such as Robert Riger, Harvey Schmidt, Jim Jonson, Howard Brodie, and Merv Corning. But none of the other illustrators had Neiman's established brand, memorable persona, or distinct style. LeRoy had learned from Ali that an important step on the way to being recognized as the greatest was declaring oneself the best—the louder the better. And to his mind he was the only artist specializing in sport whose work transcended illustration. Neiman repeatedly claimed that he produced commissions on a "take it or leave it" basis—another major overstatement—unlike professional illustrators, who tweak their work until employers are satisfied.[23]

Although this policy generally held true for his private commissions, Neiman would make revisions for high-profile clients.

An economic, technological, and visual sea change in sports coincided with and boosted Neiman's ascendence as America's best-known sports artist. Sports were beginning to explode in popularity, along with the establishment of national publications like *Sports Illustrated* and especially sports television. Sporting events proved effective vehicles for advertisers to attract young and moneyed men—a demographic that overlapped almost exactly with *Playboy*'s readership. In fact, sports broadcasts drew many of the same upscale advertisers that shopped their wares in Hefner's pages. By the 1960s, television was driving the business of big-time sports and influencing the shape that sporting events took—from the times when they were staged to implementations like the TV time-out. Neiman noticed this shift while working at events, and he did what he could to position himself in locations that might attract a couple seconds of valuable airtime—exposure that could lead to his next job. At boxing matches, for instance, he would often rest his sketch pad on the ring's apron or gallantly help the high-heel-wearing ring card girls into and out of the squared circle between rounds.

As the market for sports media boomed, individual media outlets set out to distinguish their products with stylized representations. ABC Sports producer Roone Arledge led this creative charge. Arledge considered himself an artist in a profession filled with technicians, and he believed that sports TV had not yet realized its creative potential. He endeavored to "add show business to sports" through an aesthetic he nicknamed "up close and personal."[24] Arledge, in fact, was deeply influenced by *Playboy*. Before joining ABC in 1960, he created a pilot for a variety show modeled on Hefner's magazine called *For Men Only*.[25] ABC Sports' flagship Saturday-afternoon show *Wide World of Sports*, which launched in 1961, was the main laboratory for Arledge's approach. The globetrotting program combined sports coverage with documentary travelogues to explore the often-exotic locations where sporting events took place and the vibrant cultures they revealed, such as surfing in Hawaii or baseball in Japan. Demonstrating the cre-

ative debt Arledge owed to *Playboy* and Neiman, *Wide World* mostly showed men at leisure around the globe.

Neiman's vibrant art helped to develop the aesthetics of commercial sports culture during the 1960s, especially as network TV started transitioning to color broadcasts. Magazines and TV networks regularly augmented the photography and video footage they primarily relied on with drawings and paintings. But they tended to maintain realistic fidelity to the people and events they depicted. As *Sports Illustrated*'s managing editor John Tibby explained: "In a magazine like ours, paintings are an ideal counterpoint to four-color photos—provided the artist doesn't go too far north. We don't want the reader to wonder if we printed the page upside down or sideways."[26] As Neiman's star rose, *Sports Illustrated* began featuring covers that resembled his work by Frank Mullins, R. T. Handville, and Francis Golden, who illustrated the ubiquitous Pee-Chee school folders. A Mullins drawing of Liston before his 1965 rematch against Ali includes Neimanesque accents like brushstrokes around the arms and gloves with errant streaks to suggest movement.[27] But following Tibby's conservative editorial directives, Mullins offered a toned-down approach that stuck to accurate colors and lifelike depictions of Liston's facial features and bodily proportions that was nothing like Neiman's monstrous painting of the fighter.

The photographer and artist Robert Riger—who briefly presented some of his sketches on Arledge's *For Men Only* pilot—provided illustrations for both *Sports Illustrated* and ABC Sports. His graphite drawings were rooted in a photographic and even forensic sensibility. Riger's sketches of Clay and Liston's first match for a *Wide World of Sports Yearbook* broke down what he called "the indelible image of the fight" by demonstrating how he believed Clay got the upper hand that led to his victory.[28] Beyond their documentary function, Riger's pencil drawings, with their soft lines and two-tone palette, express nostalgia for a less technologized past as sport was becoming more colorful and faster paced. Neiman, in contrast, was better suited to sport's commercialized transformation. Like Arledge, he was invested in adding show business to sports by amplifying its energy and drama.

LeRoy's promotionally minded approach seamlessly complemented sports media's increasingly commercial priorities. "I will not draw an athlete in a humiliating position," he unapologetically wrote. "I do not care to capture them picking their noses on the bench, tripping or falling or scratching themselves. My intent is to catch them at their best or noblest, in their clearest possible form." Neiman maintained his artistic independence despite his unwaveringly optimistic method— and even claimed that his rose-tinted view demonstrated his creative autonomy: "To point out how the strong man stumbled, or how an athlete might have succeeded but didn't, is outside my appetite."[29]

* * *

When Madison Square Garden's president Irving Felt wanted to update the arena's decor, he hired Neiman to create works that would celebrate the venue's heritage while aligning it with 1960s sports culture. Felt ordered a 6′ × 8′ portrait of Sugar Ray Robinson to honor the middleweight's many fights at the arena. He also paid Neiman $18,000 to create *Introduction of the Champions*, a 6′ × 10′ mural that would hang in the Garden's VIP lounge.[30] Completed across 1964 and 1965, *Introduction* depicts the Garden from a panoramic perspective similar to LeRoy's 1963 *Man at His Leisure* painting of the arena, but with recognizable figures sprinkled in the ring and crowd. It focuses on the commonplace ritual of acknowledging former champions before a marquee fight—a ceremony that suggests the impending bout is steeped in the tradition the honorees represent. Jack Dempsey, Joe Louis, Archie Moore, and Sugar Ray Robinson stand in the ring and wave to the audience. Ali is in the crowd to the right of the ring, pointing toward and hollering at the champions of old. Neiman emphasizes the spectacle by surrounding the ring with writers, photographers, and an ABC camera—a brand-conscious gesture toward the network that would ingratiate the artist to Arledge and eventually lead to commissions. LeRoy also fills the crowd with glamorous fans like Frank Sinatra and Ava Gardner. He even gave Janet and his brother Earl cameos.[31]

When Felt scanned the completed mural he noticed that Neiman

had included the gangster Frankie Carbo among the spectators. Carbo was a known fight fan. But Felt worried the mobster's presence might sully the Garden's image. "I took his signature hat off," Neiman said of the Carbo avatar, "made one stroke of color on the face 1½ inches high and it became [New York City] Mayor Wagner."[32] Felt so admired the final version, that the following year he commissioned Neiman to create a 47½" × 43" painting of the birthday party Madison Square Garden hosted for John F. Kennedy in 1962, when Marilyn Monroe famously serenaded the *Playboy*-friendly president. The paintings connect Madison Square Garden's history—in and beyond sport—to Neiman's style.

A wave of sports-related commissions followed Neiman's work for the Garden. He did boxing posters, fight programs, and cover illustrations for *Ring* magazine, several of which featured Ali. *Time* magazine hired LeRoy to paint a portrait of the hockey player Bobby Hull for its March 1968 cover. Those perusing newsstands that month could see Neiman's work on the cover of both *Ring* and *Time*, as well his regular Femlin drawings in *Playboy*. The *Time* cover, for which Neiman collected a $2,000 fee, was the artist's most visible illustration yet. But LeRoy said he was more excited to have made the cover of *Ring*, despite the comparatively meager $50 it paid, because of his sentimental attachment to the "Bible of Boxing," which he had been reading since his days loitering in the Gibbons Brothers Gym back in St. Paul.[33]

Sports fans started to recognize Neiman's promotional art as valuable memorabilia that warranted preservation and display. LeRoy's poster for a 1968 match between Jimmy Ellis and Jerry Quarry replaced the conventional black-and-white photographs of boxers with close-up drawings accented by colorful brushstrokes and shading. "Boxing has gone high-tone," the *Chicago Tribune* said in response to the Ellis-Quarry poster, which it viewed as a "modernistic" contrast to "those garish old billboard posters that customarily advertise championship matches." The International Boxing Club's Murray Goodman predicted that "someday these posters will be collector's items."[34] LeRoy continued producing promotional art for film and theater alongside his principal work in sports. He illustrated a poster for

the satirical spy movie *Casino Royale* (1967), and he made programs and sets for the plays *Borstal Boy* (1967), *Whores, Wars, and Tin Pan Alley* (1969), and *Oh, Calcutta!* (1969), which was helmed by *Golden Boy* producer Hillard Elkins. *Oh, Calcutta!* featured an all-nude cast, and Elkins figured that Neiman's experience at *Playboy* qualified him to complete the artwork for its program.

Neiman's combined work in sports and entertainment led to a 1967 gig sketching Frank Sinatra—one of the only celebrities bigger than Muhammad Ali or Sammy Davis Jr. Reflecting Neiman's visit to the Fifth Street Gym three years prior, the artist shadowed Sinatra in Miami while the entertainer filmed the crime drama *Tony Rome* during the day and performed at the Fontainebleau hotel in the evening. He then joined Sinatra and his entourage for drinks and card games that often stretched until sunrise. At one point, an especially tough-looking member of Sinatra's crew caught Neiman's attention. The man noticed LeRoy sketching him and demanded the drawing. "Fuck you!" Neiman reportedly snapped at the thug. "I'm not going to give that to you." A few minutes later, Sinatra quietly pulled Neiman aside and advised the artist that he better give up the picture.[35] The man was Joseph Fischetti, a Chicago mobster and cousin of Al Capone. LeRoy was not stupid enough to tangle with Fischetti. But he was nonetheless angry at being humiliated in front of Sinatra, a paragon of cool whose admiration he desperately sought.

Neiman noticed considerable similarities between Sinatra and Ali when he sketched the singer. He compared Sinatra to an athlete on several occasions, and he used the performer to explain the degree to which athletes had become stars just like musicians or actors. "People are more themselves in leisure than in work," he told *Jock* magazine. "But athletes, performers, are more themselves at work. [Willie] Shoemaker is Shoemaker on a horse. [Mickey] Mantle is Mantle at the plate. Sinatra is Sinatra singing."[36] An ardent fight fan, Sinatra liked Neiman because the artist represented him in the same heroic register that he used to depict Ali and Sugar Ray Robinson. LeRoy's drawings for *Tony Rome* showed a slim Sinatra who looked more like the 1950s-era swinger than the puffy middle-aged crooner

he had become by the late 1960s. "He trusts me," Neiman explained of Sinatra, who was often hostile toward the press that constantly hounded him.[37]

LeRoy's perpetual travels and presence at events put him in daily contact with journalists, whom he often charmed into giving him some exposure. "He liked to see his name in print," said Nick Gage, a friend who wrote for the *Wall Street Journal*.[38] Neiman served as a confidential source for a front-page investigative article of August 19, 1968, that Gage wrote on Sinatra's associations with mobsters.[39] These friendships were well known and mostly overlooked until Sinatra became involved in politics during John F. Kennedy's presidential campaign. Speculation arose that Sinatra might compose a link between the politicians he supported and his underworld buddies. Sinatra was supporting Hubert Humphrey's presidential bid when Gage published the article. Neiman provided the reporter with information about Sinatra's relationship to Fischetti, whom the Fontainebleau put on its payroll while the singer worked at the hotel. The article did not hinge on the tips Neiman offered, but those details helped to flesh it out. LeRoy enjoyed displaying his knowledge of Sinatra's tight-knit inner circle, trusted Gage's journalistic scruples, and wanted to get back at Fischetti in some small way—even if it meant embarrassing Sinatra. The article was indeed a public relations catastrophe for Sinatra, who denied links to the several prominent mafioso Gage mentioned. But the damage was done. Shortly thereafter, Humphrey's campaign quietly severed ties with the singer. While Neiman venerated Sinatra, he needed to salvage some dignity. "He thought he was as important in his field as Sinatra was in his," Gage speculated about the reasons his chatty friend offered information about the famed entertainer's seedy pals.[40]

Neiman's growing ego was not unwarranted—he was becoming a known quantity in 1960s popular culture and one of only a handful of artists who might be recognized in public. Increasingly, works that were once displayed freely alongside the event they promoted started to go missing. Columbia Pictures offered a $500 reward for the return of an artwork Neiman created for *Casino Royale* that was sto-

len from the lobby of New York City's Capitol Theatre on the night of the film's premiere. Playboy Clubs began bolting down their original Neimans—a security measure they did not need to take with other decorations.[41] The Hammers eventually stopped pestering Neiman about his popular sports art and began to put it in the gallery, where it sold quickly. The brothers' quest for profits ultimately outweighed their retrograde social values. Oehlschlaeger Galleries sent LeRoy repeated letters reporting that it could not keep his work in stock and asking for more inventory. And other galleries across the country regularly inquired about the possibility of serving as vendors.[42] Neiman's work was virtually everywhere by the end of the 1960s, and his aesthetic came to signal not just sports but also popular entertainment culture—from big fights to Broadway plays to crooners. His branded art helped to build and visualize a male-oriented, postwar, middlebrow taste culture that combined the pursuit of sex with leisure activities like sport and music. Neiman became the preferred artist for those who identified with this pleasure-seeking lifestyle.

9

At the Hotel des Artistes

The celebrity Neiman enjoyed was defined primarily by his proximity to major stars like Hefner, Ali, and Sinatra. He was a sideshow, never the main event. Even his exhibitions mostly featured works that traded on the well-known subjects they displayed. This secondary status was difficult for someone with Neiman's vanity to accept. He created his own domain at the Hotel des Artistes.

When he was not on the road, Neiman worked in his studio to transform sketches into paintings and complete whatever commissions were in his queue. He rose around seven thirty in the morning seven days a week, no matter the time he retired the previous evening, and worked until about six in the evening. LeRoy broke only for lunch, which he scheduled to coincide with the CBS soap opera *As the World Turns* on weekdays.[1] He usually went out for dinner and then met with assistants and business associates in the evenings to plan for the following day, discuss upcoming travel, and handle bookkeeping. The diligent artist maintained a regimented schedule not too different from the hours he worked at the Frogtown box factory and in the military. "He painted every minute of every day," his niece Heather Long remembers.[2]

Even when Neiman dined out, he would bring six-inch-by-eight-inch pieces of white cardboard and sketch—usually the friends or business associates accompanying him, but sometimes a pretty woman or fellow celebrity he spotted across the room. When he forgot his cardboard, he would doodle on menus in a style similar to his first couple of *Man at His Leisure* features. "That was his parlor trick,"

remembered his friend Joan Gage. "He'd just sit there and draw you while sitting at the table and then he'd sign it with his name and the date and the place." It was also a way for LeRoy to transform meals into public demonstrations of his ability. "Everybody loved it," Gage added. "And he did draw people better than they actually looked."[3]

As LeRoy started making serious money, he and Janet steadily purchased additional Hotel des Artistes properties. They owned ten units when Neiman passed away in 2012. LeRoy filled the apartments with an often-warring conglomeration of parties who sometimes made his world in the building resemble the melodramatic plotlines he watched on TV every afternoon. His girlfriend and assistant Linda, whom he later described as a "fiery Tex-Mex with suicidal tendencies," resided in the maid's quarters on the second floor and spent much of the workday with LeRoy in his studio.[4] Janet handled many of LeRoy's business affairs. But she detested Linda and kept her distance from the studio during the day, typically retreating to their ninth-floor apartment, where she worked on her own art. Earl and Marlys, who also disliked Linda, lived down the hall on the third floor in a smaller version of LeRoy and Janet's apartment. Earl needed his younger brother's financial support, but he resented the power dynamic it created between them. LeRoy thought his older brother was a deadbeat and made sure that Earl knew who was in charge at his residence. His mother, Lydia, alone since Ernst's death in 1962, also frequently visited and would watch *As the World Turns* with LeRoy and buzz around the studio. Lydia got along well with Janet and Marlys, but she thought Linda was a housekeeper, which peeved LeRoy's girlfriend and assistant.[5] Lydia's presence also made it easier for Earl and LeRoy to lapse back into petty sibling bickering. Despite the familial and romantic tensions, the hotel was indisputably LeRoy's kingdom. It was a marked contrast to the households of his childhood, over which he had no control.

The hotel became Neiman's miniature version of Hefner's Playboy Mansion, where he was the star. LeRoy entertained regularly and annually threw himself an all-female birthday celebration. But his get-togethers were not the sorts of glamorous events he might be paid to

sketch. He preferred to hang around with other artists, writers, and folks from his Chicago days who also had migrated to New York.[6] Neiman both enjoyed a low-key, unpretentious crowd and wanted to be the most famous person at the party. He hosted in a style reminiscent of Hefner's sometimes-shadowy presence at his *Playboy* soirees. "He wasn't a guy who would run through the room seeing if all the guests were OK," recalled Nick Gage. "He would usually sit somewhere, and people would come by and drift away." Neiman would even momentarily slink away from his gatherings and into the studio to tweak a painting in progress if he got a sudden idea. Janet seldom attended the happenings. When she did, she tended to stay in the background rather than mingle. Joan Gage recalled attending many of LeRoy's parties over the years and never once meeting Janet.[7]

Continuing the social dynamics established during their childhood, Earl was not a part of LeRoy's inner circle, despite the close quarters they kept at the Hotel des Artistes. Earl—who wore a goatee and horn-rimmed glasses—was scholarly and romantic with a mystical streak that prompted him to experiment with a variety of religions. "I went through a long business about the wisdom of the East," Earl told *ARTnews*. "I studied yoga, I had a guru."[8] He practiced Hinduism for a while but eventually returned to the Catholic Church into which he was raised. Earl gravitated toward leftist and radical Catholics who were involved in the growing civil rights movement and influenced by the renegade priest Ivan Illich. Like LeRoy, Earl also regularly threw parties at the Hotel des Artistes. But his smaller functions were more like salons. On Saturday afternoons, he would hire models and invite a group of artists, priests, nuns, Black Panthers, and other like-minded people to come by and sketch. LeRoy rarely showed, and it is unclear whether he was welcome.

Earl did not make enough money to live off the religious art he was mostly commissioned to create, but his work gained notoriety within the niche community it attracted. *Catholic World* magazine anointed him a "great religious artist."[9] Earl maintained that he did not identify any difference between religious and secular art. All art, he claimed, was sacred. And he cited a broad range of influences, some of which

intersected with his famous brother's work. He described a mural he painted on the interior dome of St. Leo's Church in Baltimore as "a Tiepolo kind of thing" and likened the flying angels it included to "sports figures in action." Also like LeRoy, Earl was a wily opportunist who admitted to letting his professional prospects influence his religious beliefs. He recalled that he kept getting work from the Catholic Church while he was sampling different religions. "They were good patrons," Earl said, "and I finally realized, what the hell difference does it make? . . . So that's what brought me back into the Church, really. I found out it's as good as any other."[10] Ultimately, Catholicism was the most rewarding religion for him on several levels.

Esther Penn describes Earl and LeRoy's relationship as a "love hate kind of thing." "They got along much better when they were living in different countries," she said with a laugh. Nick Gage, who was friends with both brothers, observed that "LeRoy was supportive, but wanted to make clear that he was in a class way above Earl as an artist."[11] Neiman would sometimes half jokingly tell friends that Lydia named her sons LeRoy and Earl because of her fascination with royalty.[12] LeRoy was "the king," and Earl was not quite so special. Lydia had no such interest in royalty, and Earl was, of course, named after the decidedly common Charles Runquist Sr. When LeRoy and Janet visited the Vatican in 1967, LeRoy sent Earl a postcard of the pope's massive throne because he liked how it was arranged in the frame. "No, I'm not thinking of doing the Pope's throne," he wrote to his brother, who was looking after the apartment while they were away.[13] It is a cordial note—and it demonstrates that LeRoy respected Earl's artistic know-how enough to share an image that he found interesting. But LeRoy was also boasting about the great time he and Janet were having to his brother, who specialized in Catholic art but lacked the means to take international vacations and was instead stuck at home collecting his famous brother's mail.

With LeRoy's support Earl eventually did begin traveling to Italy, where he acquired some of the materials for his work in stained glass. While abroad, he met and fell in love with a younger sculptor from Venezuela named María. Earl and Marlys divorced in March 1974. He

married María and moved to Italy shortly thereafter. Neiman was furious at his brother, which was deeply ironic given his own promiscuity.[14] But the same rules did not apply to the king. Penn suspects that LeRoy was bothered not so much by Earl's infidelity, but because he thought his older brother was trying to imitate him by consorting with a younger and exotic woman. And LeRoy was angered that Earl would leave Marlys, especially after the boys lived through the hardships that Charlie's absence created. But he let Marlys continue living at the apartment in the Hotel des Artistes after she and Earl split up. "He sort of took Marlys under his wing for a while," Penn remembers. "If only to vilify Earl."[15] LeRoy and Earl's relationship started to resemble that of John and Charlie Runquist. Neiman supported, was often disappointed by, and freely cast judgment upon his less successful brother. But LeRoy also retained some of his roustabout father's characteristics.

Janet resented LeRoy's philandering, which likely accounted for her infrequent presence at his parties, where she would have to endure the humiliation of interacting with her husband's girlfriends in front of guests. The couple started sleeping in different rooms only a few years after moving to New York City. But Janet, possibly because of her Catholic upbringing, did not want a divorce. LeRoy was not interested in a divorce either—just a marriage in which he could do as he pleased.

Publicly, Janet was willing to play role of a happy and doting wife who tended to her quirky artist husband—a performance that both helped her to salvage some dignity and benefited LeRoy's business prospects. In 1965, the *Chicago Tribune* published a short profile on Janet in conjunction with LeRoy's exhibition at the Astor Tower Hotel. The article focused mostly on how Janet kept house and cleaned up after her lovably messy spouse. But Janet insisted that the "excitement and satisfactions of a life with never a dull moment" overshadowed and "more than compensate[d] for any housekeeping problems" her eccentric husband presented.[16] The *Indianapolis Star* published a similar article two years later. It also centered on how Janet supported her flighty husband and the professional sacrifices she made to aid

his aspirations. "My career has been more or less helping LeRoy with his," she says. "Every year, I say, 'This is the year I'm going to take up art again.' But I'm easily distracted. I have many interests. I take ballet lessons—I'm a perpetual student." According to the profiles, Janet was perfectly fulfilled. But Janet had little to do with LeRoy's artwork by this time, and she seldom entered his studio during the day, when his girlfriend-assistants would be around. Like her husband, Janet understood the value of cultivating a favorable image.

LeRoy echoed Janet's contentment to the *Indianapolis Star*. "The lucky artist is one who finds an 'artist's wife,'" he said. "An artist's wife has to treat her husband like a child."[17] In his personal notes, Neiman penned a poem titled "The Artist's Wife" that honored Janet:

> You are a support system
> A mentor
> A package of memories
> Consciously and unconsciously each day
> You anticipate changes
> You never discourage—never lacking
> in understanding
> You and I are part of each other
> Never to part
> Your presence in my life has become
> part of my personal history
> Our special relationship
> Special and unique
> There is only one of you.

In a November 1971 diary entry LeRoy tenderly wrote: "Janet departs for Chicago. I really love Janet. There is no one I miss like her. She is so good."[18] LeRoy expressed overflowing admiration for Janet so long as she played the role of the obedient and content wife.

And Neiman did not simply have secret trysts on the side; he publicly showcased and bragged about his girlfriends. He wore them like any other accessory. When a reporter from the *Honolulu Advertiser*

asked if there were any women in his life, Neiman chirped, "Lots of 'em." At one point in the 1970s he took to wearing a golden stud medallion that dangled above the thatch of black chest hair where his shirt was perpetually unbuttoned. The charm, he pointed out, was a gift from a Venetian girlfriend.[19] Even when his exclusively female companions were strictly assistants, Neiman always dangled the possibility that they were his romantic partners as well—not unlike the bunnies who accompanied Hefner around his mansion. Linda was his main girlfriend-assistant from 1964 through 1977—and she was the only one who ever lived at the Hotel des Artistes. But there were others, such as a woman named Lucette, and also Gina Byrams, who worked at Baltimore's Playboy Club and won the first ever Bunny of the Year competition. "LeRoy has nothing but the look of love in his eyes for the swinging Gina," reported *Chicago Defender* gossip columnist Cherokee Charlie after he spotted the couple frolicking around Chicago in 1969.[20]

LeRoy insisted that Janet did not envy his many girlfriends and happily accepted his lifestyle. Janet "understands I am an artist and that I live life a certain way," he remarked. "I tell her what my buddy Hugh Hefner tells his girlfriends, 'If you want to hang in there, that's the way it is.'"[21] He gave Janet privileged status among his lovers, none of whom would ever graduate to the level of a spouse. "She isn't jealous of my girlfriends," he said. "But they are of her." Although LeRoy's women had to tolerate his need for variety, the artist expected fidelity from them all.[22]

Janet endured the humiliation. But Linda—who was both affectionately and dismissively called "Bonehead" or "Bone" around the studio—eventually could not handle her lesser role. She was deeply in love with LeRoy and sometimes signed notes "your one and only" in a hopeful attempt to solidify her always-tenuous status in his life. Linda came from a family of housekeepers and was enchanted by the wealthy world into which Neiman brought her. But despite the glamour Linda enjoyed with LeRoy, she was ultimately a second-class citizen confined to maid's quarters that were not too different from where she grew up. "Linda was a real problem," remembered Esther

Penn. "She was the one who was jealous, not Janet. She would get into fights with LeRoy walking down Fifth Avenue. If she thought that he looked at some other woman or had gotten involved with some other woman she would become furious." LeRoy took Linda along on work trips, but he vacationed with Janet. In these cases, Penn recalls, Linda threw fits. "She would take drugs and jump on the table and use a knife on herself."[23] LeRoy's datebooks are filled with reports of Linda's breakdowns, several of which required stays at drug and mental health rehabilitation centers. A breaking point finally occurred when Linda bit Janet's finger so viciously that she needed a tetanus shot.[24] Neiman fired Linda and moved her back to Houston, where he purchased her a condominium. While LeRoy seemed to love Linda in his own way, he also exploited her vulnerability and devotion, which likely exacerbated her emotional instability.

Janet found small ways to get back at her husband and assert what limited agency she possessed. LeRoy sometimes felt guilty about his behavior and would try to make it up to Janet with extravagant gifts. In such instances, she would often return or throw away the expensive items. "It was her way of giving him a slap in the face," Penn says. Janet refused to wear a Cartier ring and fur coat Neiman bought her to make sure her husband knew the lavish presents did not result in forgiveness.[25] Neiman created a Hefnerian world at the Hotel des Artistes that gave him the freedom of bachelorhood and the stability of family. But he seemed to be the only one who was satisfied with the arrangement.

10

The Heavyweight Champion of Art

Sonny Werblin, co-owner of the New York Jets, was a Neiman admirer who had purchased several paintings from Hammer Galleries. The Jets were New York City's second professional football club after the Giants and had to conjure ways to compete with the better-known team. Beyond the context of football, the Jets' survival depended on finding a niche in a city with more entertainment options than anywhere else. Unlike many of his peers in football, Werblin, who formerly worked as president of the Music Corporation of America's television department, viewed sports like any other entertainment property. "My dad used to say sports is the new Broadway," explained Werblin's son Tom.[1] The Jets, for instance, briefly had Sammy Kaye's jazz band perform at their games instead of the standard marching bands. Building on those efforts, Werblin hired Neiman to serve as the team's artist-in-residence starting in 1967. No professional football team had ever employed an artist in this capacity, and Werblin hoped the novelty might get his franchise more attention. "LeRoy was an entrée into an additional audience," Tom Werblin said.

As artist-in-residence, Neiman had full access to the Jets—from pregame prayers to travels on the team plane. A Neil Leifer photograph shows a row of bulky players seated on the bench in their muddied green-and-white uniforms. Neiman sits among them donning a turtleneck sweater, mustard slacks, and an overcoat. A sketch pad rests on his lap, and a batonlike cigar dangles out of fingers encased in leather gloves. "Neiman is allowed to roam free by the Jets because he is not a threat to embarrass them or expose their military secrets

in tomorrow's newspapers," wrote *Jock* magazine's Larry Merchant. "What he sees and hears comes out vaguely on a one-of-a-kind canvas, an image they feel is less a revelation of their private selves than a glamorization of their heroic selves." The Jets' public relations director Frank Ramos remembers the Jets players enjoying Neiman's presence. Some went out of their way to get his attention in hopes that they might end up in a sketch or painting. Neiman described Jets guard Bob Talamini as "the kind of guy who, if he was knocked flat and saw me drawing him, would extend his prone position" so the artist could get a better look.[2]

Neiman became a sort of mascot for the Jets. He sometimes spread out a picnic blanket on the sideline and sketched with an assistant lounging by his side. When the Jets were doing poorly fans would yell, "Send in LeRoy!"[3] But Neiman grated on Coach Weeb Ewbank, a traditionalist who saw the artist as one of many unnecessary distractions that the publicity-hungry owners had imposed on the team. During one game, LeRoy's sketch pad was knocked into the mud by a player who tumbled out of bounds. "You know something, LeRoy? I think your work is actually improving," joked Ewbank as Neiman scrambled to collect his scattered materials.[4] Outside of documenting the competitions, Neiman presented his sketches on the weekly WNBC-TV show *Jets Huddle*, and his paintings were used to decorate the team's game programs. Hammer Galleries organized an entire exhibition of LeRoy's Jets artwork in late 1968 to capitalize on the local interest in the team.

Jets quarterback "Broadway" Joe Namath received a disproportionate amount of LeRoy's attention. The quarterback seemed to jump out of the pages of *Playboy* and, as his nickname suggests, embodied the glamour of New York City in ways that complemented the glossy brand the Jets were building. "His rakish smile could be used to sell just about anything," wrote Namath's biographer Mark Kriegel.[5] When the quarterback arrived in New York, he was talented, handsome, and wealthy thanks to his record-breaking rookie contract. But he was also an unsophisticated country boy from Beaver Falls, Pennsylvania, via Tuscaloosa, Alabama. Neiman immediately saw through

Namath's cosmopolitan facade. "He was wearing an I.D. bracelet, and he was dressed like a used car salesman," LeRoy reflected. "He was drinking beer with a go-go dancer." But with some help from Neiman and the Jets' other promotional staff, Namath quickly transformed into a model of stylish bachelorhood whom LeRoy described as "the first real *Playboy* athlete of his generation."[6] Who better to depict the *Playboy* quarterback than *Playboy*'s artist?

Neiman saw Broadway Joe as an intoxicating admixture of rebelliousness, daring, and charm. "Joe is a symbol of nonconformity—his slouch anti-military, his whole bearing anti-authority," LeRoy told the NFL's *Pro!* Magazine. "He's aware of his glamor," Neiman said to New York's *Daily News*. "He knows what he's got going for him and acts like a star but doesn't take himself seriously except on the field. That's where he knows it counts."[7] Neiman's sketches emphasized the contrast between Namath's casual coolness and competitive precision. He depicted Broadway Joe as a heroic slacker who endured tremendous pain at play while performing with seemingly effortless grace. One illustration shows Namath shaving his legs—without shaving cream, Neiman points out—so his legendarily brittle knees could be treated. The sketch simultaneously displays the physical sacrifice Namath makes and demonstrates the matinee idol quarterback primping like a showgirl before a performance. Another drawing depicts Namath being taped up before a game. Again, the illustration gestures toward the quarterback's bravery while posing Namath like *Playboy*'s Our Guy being fitted for a suit. Neiman's sketches of Namath also hinted at sexiness—a rarely explicit quality in pro football that the marketable athlete was infusing into the conservative game. Neiman's drawings of Namath showed that even football players, those muscular beacons of hypermasculinity, could strive to look good without sacrificing their manliness.

When bragging to the *Houston Post* that he would be attending a postgame party at Namath's apartment, Neiman caught himself referring to the sporting event as a *show*. "I said show," he laughed. "I meant game. But it really is a show actually."[8] And Namath realized that Neiman could help burnish his showmanship. He indulged

FIGURE 21. LeRoy Neiman and Joe Namath, n.d.
LeRoy Neiman Papers, Smithsonian Institute, Archives of American Art, Washington, DC.

LeRoy's occasional requests to pose so the artist could be sure that he sufficiently captured a motion or gesture. The quarterback also mugged for a photo with LeRoy, who had a cigar clenched firmly in his mouth while crouching over a football as if he were playing center and about to snap it to Namath. Broadway Joe stood behind LeRoy waiting for the ball. Neiman gleefully hams it up for the pho-

tographer. Namath, however, musters only an unenthusiastic grin. But Broadway Joe was game to play his starring role in the Jets' show and tolerated the gimmicks that supported it, including the team's artist-in-residence.

Namath represented an odd fusion of Hugh Hefner and Muhammad Ali in 1960s popular culture. He was countercultural, but only within the traditional world of football. Broadway Joe was more of an individualistic rebel who did not seriously engage with the bigger social issues that preoccupied Ali. Like Hefner, he was ultimately devoted to having a good time and he believed people should be left alone to seek pleasure however they liked. "I believe in letting a guy live the way he wants to if he doesn't hurt anyone," Namath told *Sports Illustrated* in 1966.[9] But Ali informed Broadway Joe's penchant for self-aggrandizement and attention to his looks. The quarterback playfully titled his 1969 memoir *I Can't Wait until Tomorrow . . . 'cause I Get Better-Looking Every Day*. It might as well have been called *I'm So Pretty*.[10] Namath's audacious guarantee of victory before the 1969 Super Bowl reflected Ali's poetic predictions. And his triumphant raised finger after the Jets fulfilled his prophecy—an assertion that he and the Jets were "number one"—mirrored Ali proclaiming himself to be the greatest. Neiman recognized the parallels and articulated them in his sketches of the similarly ostentatious and magnetic athlete.

As with Ali and Sinatra, Neiman followed Namath down to Miami for Super Bowl III in January 1969. He provided illustrations that accompanied *New York Times* writer Dave Anderson's dispatches from Florida. The *Times*' sports editor James Roach was so pleased with LeRoy's work that he sent the artist a note thanking him for "adding a touch of class to our pages."[11] Neiman also illustrated Anderson's subsequent book *Countdown to the Super Bowl*, which offers an insider's view of the ten days leading to the big game. Many of Neiman's Super Bowl drawings would have been appropriate for a *Man at His Leisure* feature. One has Jets players lounging poolside at the Fort Lauderdale hotel where they stayed prior to the championship. Another shows Namath at the same pool chatting with a gaggle of bikini-clad female admirers. One of the women shoots the dashing quarterback a lusty

glance. The poolside tableau mimics the "What Sort of Man Reads *Playboy?*" advertisements Neiman had created for Hefner.[12]

The Jets' victory occurred while the NFL was rebranding its championship as the Super Bowl to emphasize the game's status as a singular spectacle that transcended football, and even sport. Neiman's artwork helped to inflate the game's importance and became its signature look. At their victory parade, the Jets presented New York City mayor John V. Lindsay with a framed Neiman painting of Namath, who reportedly owned $75,000 worth of Neimans—mostly of himself. The Jets decorated their offices and practice facilities with Neimans and hired LeRoy to make their annual holiday cards. LeRoy even gradually won over Ewbank, who displayed two Neimans in his living room.[13]

Joe Namath's celebrity surged after the Super Bowl victory he so brashly guaranteed. Like Ali, he was famous within and beyond his sport. Namath parlayed his notoriety into a job cohosting the *Joe Namath Show* with the sportswriter Dick Schaap. The unexceptional weekly television talk show launched in October 1969 and lasted only thirteen episodes. But it was novel in pairing guests from sports and entertainment. One episode featured the figure skater Peggy Fleming and the singer Paul Anka. Another had the actor Yaphet Kotto alongside the New York Mets pitcher Tom Seaver. Neiman painted the set for the *Joe Namath Show*. He created two large black-and-white drawings of Namath on panels erected behind the stage where Broadway Joe and Schaap interviewed guests. Each panel depicted a different version of Namath in profile, emphasizing his iconic slouch. On the left, the quarterback wears his Jets uniform. On the right, he dons a suit and tie. The paintings emphasized Namath's status as a *Playboy*-style athlete. They show a new type of sophisticated sporting man for whom work and play blend.

Muhammad Ali appeared on the *Joe Namath Show*'s second episode. Namath opened the interview with some blithe joshing. "Really, in all seriousness, how does it feel to be with a star?" he asked one of the only athletes more famous than himself. "I like you because you talk a lot," Ali told Namath in reference to their similarly boastful

reputations. The actor George Segal joined the group after a commercial break. Segal plugged his upcoming film *The Owl and the Pussycat* before Ali interjected to mention that he was about to star in the Broadway play *Buck White*. Namath would act in his first film, *Norwood*, the following year. Though mostly unrevealing, the conversation among athletes and actors—on a stage in front of Neiman's depictions of Namath at work and in leisure—demonstrated the melding of sports and entertainment culture that Ali and Namath instigated. In fact, a January 1971 article in *Time* credited Ali and Namath with transforming athletes into performative and self-promotional "peacocks" who shared more in common with entertainers like Segal than traditional sports figures.[14]

"It was a new thing in sports," Neiman said, "the loudmouth or the extrovert or confident person. As Ali kept getting bigger—and Joe [Namath] did—their performances improved because of the conditions they created. And I sort of felt my work—because it was getting conspicuous—it had to be better, it had to measure up in some way."[15] Like his subjects, LeRoy was a peacock who not only admired celebrity culture but also sought to become a part of it. "There is no such thing as an artist being over-exposed any more. He can only be mass-exposed," he said with a Warholesque flourish while covering the Jets.[16] Neiman occasionally appeared on episodes of *Playboy after Dark*—a reinvention of *Playboy's Penthouse* that ran from 1969 to 1970—and Dewar's White Label scotch featured him in a 1970 installment of its Dewar's Profiles national advertising campaign. But LeRoy and his work were pervasive in sports culture. He augmented the steady stream of commissioned posters and programs with cover art for LPs like *The Heavyweights* (1969) and *The Fighting Irish of Notre Dame* (1969) and for books such as Sugar Ray Robinson's *Sugar Ray* (1970), Pete Axthelm's *The City Game* (1970), Major League Baseball's *This Great Game* (1971), Jose Torres's *Sting Like a Bee: The Muhammad Ali Story* (1971), and Gale Sayers's *I Am Third* (1970). The National Football League decorated the walls of its Park Avenue offices with Neimans, and the boxing promoter Don King outfitted his nearby office similarly. New York City restaurants that catered to a sporting crowd,

such as Toot's Shoors and the Iron Horse, increasingly commissioned or bought Neimans to fill their walls. By 1968, Al Schact's East Fifty-Second Street steakhouse displayed forty Neiman originals. Neiman's work became the preferred wallpaper for sports culture.

* * *

Neiman was happy to glorify Namath for the Jets, and he benefited tremendously from associating with the quarterback. But he preferred Ali's socially conscious substance to Namath's blind self-interest, and he respected the boxer's willingness to sacrifice economic gain for his beliefs. Moreover, Neiman realized that Namath's star power was premised upon his whiteness, and he understood the role that racism played in making Ali and Broadway Joe—despite their many similarities—very different sports celebrities in the public imagination.[17] LeRoy also identified how these attitudes impacted his own livelihood. "Black athletes don't sell well," Neiman candidly told *New Times* magazine.[18] A disproportionate number of LeRoy's sports commissions requested that he depict white athletes like Namath. LeRoy did not decline the jobs, but he started to explore the racial dynamics of sports in his noncommissioned works. "I love to study the intimate interaction between a black man and white man," he said. "In a painting of a boxing match, I might have a Negro manager telling a white fighter what to do in the next round or vice versa."[19] The 1973 painting *Black Break*, for example, depicts a Black man about to take a break shot to start a billiards game (plate 9). An all-white group of competitors and spectators looks on as the pool shark leans over the green-felt table in concentration. The painting gestures toward the unnamed player's position as a rare Black man breaking into the mainly white world of professional billiards. While far from revolutionary, such works reveal Neiman's awareness of structural racism in sport—inequalities that he both benefited from and pushed against. They also demonstrate his willingness to engage with the racial politics of sport during a time when few in commercial sports culture would give the issues even the most superficial attention.

Neiman's political views, though always liberal, became increas-

ingly progressive as the 1960s wore on. He found opportunities outside of sport to put his work to explicit political use in ways that his commissions typically did not allow and despite the possibility that this work might alienate fans, galleries, or potential clients. For instance, he illustrated Almena Lomax's story "In the Faraway Country of Montgomery" for *Harper's* in 1968. The tale centers on a Black woman who launches a newspaper in Tuskegee, Alabama, and endures varying degrees of racism while running her business. Neiman's illustration captures the indignities of racial segregation by depicting four Black children walking by signs designating "Colored" and "White" spaces. That same year, LeRoy provided sketches for Robert F. Kennedy's presidential campaign and for David Halberstam's article on the candidate, which was also published in *Harper's* only days before Kennedy's assassination. He later redid the sketch—a simple pencil drawing of Kennedy's face—by surrounding the fallen politician's visage with quotes from his speeches. Neiman produced a similar sketch of fellow Minnesotan Hubert Humphrey for use in his campaign after he won the democratic presidential nomination.

Humphrey secured the nomination at the infamous 1968 Democratic National Convention in Chicago. The event attracted thousands of protesters, who were violently muzzled by police and national guardsmen in a quasi-totalitarian show of force sanctioned by Chicago's mayor Richard J. Daley. The American Civil Liberties Union published the pamphlet *Law & Disorder* after the convention to document and repudiate Chicago's sudden transformation into a police state. The publication included photographs of the protests as well as essays by Nelson Algren, Arthur Miller, and Hefner—who was whacked with a nightstick during the protests when he refused to leave the street outside of his mansion.[20] Neiman illustrated Studs Terkel's caustic article on Daley with a splotchy ink portrait of the mayor's face in front of the Chicago city seal, which hovers above his head like a demonic halo. The mayor resembles a ghoulish and imperious Rorschach blot. Terkel used Neiman's drawing to set his article in motion. "Study the portrait of Mayor Richard J. Daley as you would a Rembrandt or a Goya. It's awesome, his startling resemblance to the Buddha. A touch

of Gaelic, perhaps, but godlike nonetheless. It bears a religious signif-
icance." Terkel continued with a stinging rebuke of Daley and those
who enabled his abuse of power. He finished the diatribe by returning
to the Neiman-inspired theme that opened it. "Study the portrait of
Mayor Richard J. Daley as you would a Rembrandt or a Goya. Who
painted it? Who created it? Who is responsible?"[21] Neiman's haunting
depiction of Daley anchored Terkel's unflinching observations. The
drawing showed LeRoy's willingness to politicize his art under cer-
tain circumstances. And Neiman was surely pleased that Terkel sug-
gested his drawing deserved the same consideration as a Rembrandt
or a Goya.

Neiman also began participating in art education and outreach after
taking a trip to Atlanta with some friends who were involved in the
city's antipoverty efforts. "I came out of poverty," he said, "and when
you're from poverty you learn you have to depend on yourself and you
have to use all of your experience."[22] Art gave LeRoy a purpose when
he was a kid, and he thought he might be able to inspire young people
with similar creative inclinations. In 1968 he teamed with Economic
Opportunity Atlanta to provide free art lessons and equipment to
needy kids. He visited from New York three times a month and lever-
aged his contacts to recruit athletes like Hank Aaron, Juan Marichal,
Satchel Paige, and Jose Torres to pose for his classes. Local Black activ-
ists Martin Luther King Sr. and Julian Bond also visited his courses.
The Atlanta program was short lived, but it set in motion Neiman's
sustained involvement in art education for underprivileged youth.
Muhammad Ali's commitment to charity work partly inspired Nei-
man's outreach. Coincidentally, Ali and Neiman reunited in Atlanta in
October 1970, when the boxer received a license to fight Jerry Quarry
after more than three years of banishment.

* * *

Neiman joined Ali at his training camp in the countryside just beyond
Atlanta's city limits. Reprising their activities in Miami six years ear-
lier, LeRoy and Ali would draw together—often *en plein air*—when
the boxer was between workouts. Ali had become more interested

in art during his suspension. He bought a personalized art case and was beginning to experiment with color and landscapes. "I've got to get more serious about my painting," Ali told the *Louisville Courier Journal's* Dean Eagle. "I'll open a gallery and show my work. Everybody will want paintings by me, and I'll make a fortune."[23] The fighter produced a crayon and marker drawing for LeRoy at this time that depicted a boat sailing between two islands. He wrote, "To LeRoy Neiman, From Muhammad Ali" and drew two hearts between their names to suggest his affection for his friend and drawing coach. Neiman acknowledged that Ali could likely capitalize on his artwork. "Someday this work of Ali's may be very valuable," he correctly speculated in an interview with the *Boston Globe*. "I suppose the art critics would call the watercolors of this triple threat artist (poet-painter-prizefighter) primitives. But Grandma Moses painted primitives, too, and she didn't have nearly as good a right hand as Ali." While he recognized Ali's talent and progress, Neiman was not ready to call his friend a great artist. "Ali is definitely improving," he said. "But as a painter he is still a great fighter."[24]

Ali's father, Cassius Clay Sr., believed that he himself would have had a successful career in art were it not for the racism he faced in Louisville, which forced him to make a living painting signs.[25] Cassius Sr. shared his son's brashness, and he did not hesitate to let LeRoy know how little he thought of his work. Neiman laughed off Clay's verbal jabs, but Ali saw the bickering as an opportunity to stage a contest between the two at the kitchen table of the cottage they were renting during training. They would each compose a landscape and Ali would serve as judge. LeRoy sketched a scene out of the cottage's window. Cassius Sr. worked from his imagination to create a Technicolor creek running along a hillside with purple accents. Ali stopped the competition about ten minutes after it began to declare LeRoy the winner by an apparent aesthetic knockout. "No contest!" Ali hollered. "LeRoy is the Heavyweight Champion of Art!" Neiman praised Cassius Sr.'s bright landscape after the duel. But Clay was peeved by the defeat, refused to shake LeRoy's hand, and "stomped out of the room."[26] Dean Eagle witnessed the battle as well. The Louisville-based

sports reporter was not partial to either painting. "Frankly, I thought Clay's dad did as well as the *Playboy* artist," he wrote. "Both pictures were equally unimpressive."[27]

Georgia's governor Lester Maddox, who was elected on a segregationist platform, staunchly disapproved of Ali's return bout because of the boxer's Muslim faith and stance on Vietnam. Maddox did not have the authority to stop the match, but he declared an unofficial "day of mourning" on the date of the bout and called for similarly outraged Georgians to boycott it.[28] The controversy provided wonderful marketing for the interracial battle between Quarry and Ali. Neiman's poster for the match shows Ali standing tall in the right foreground with gloved hands at his side. Quarry, in contrast, is depicted from the shoulders up in a compact fighter's pose. Neiman shades Quarry with green to emphasize his "Irish" nickname—a common practice in boxing used to advertise a boxer's whiteness. While Neiman's poster exploits the bout's racial dynamics, it represents Quarry as a fighter and Ali as a god. The Ali sketch closely resembles a separate drawing Neiman did of the fighter for the *New York Times* in 1974 that was based on a seven-foot-tall marble statue of the Greek god Hermes.[29] His depiction of Ali for the 1970 poster worked from the same classical model.

In documenting the fight, Neiman continued to position Ali as the heroic protagonist. A sketch of the pre-bout weigh-in showed Ali on the scale with dozens of reporters, camera operators, and others crowding around and straining for a glimpse. Quarry is off to the side, an afterthought to the assembled onlookers. The scale on which Ali stands functions like a pedestal that emphasizes his statuesque majesty. Neiman's drawings of the match itself, which Ali easily won with a third-round technical knockout, similarly push Quarry to the margins in favor of celebrating Ali's long-awaited return to the ring. Quarry is a foil in the sketches who serves mainly to stress Ali's comparative greatness.

Ali's return was a major economic success and a boost to a sport that had dipped in popularity while its biggest star was suspended. Ali participated in the usual pre-fight publicity, but he did not make

a prediction. "I don't need the old image, I won't be bragging all the time," he said prior to the match. "No more poems and no more predicting the rounds I'll be knocking people out. All that was for promotion."[30] But in the post-fight press conference Ali could not resist showing that he had, in fact, foretold his victory—privately to Neiman with a painting dated two days earlier. The artwork, which he displayed to the assembled reporters, was a watercolor of the ring surrounded by faces shaded in different hues to suggest the exceptionally diverse crowd that the fight attracted. More of the faces—even many of the white people—are smiling than in Ali's earlier depictions of the unfriendly spectators he attracted. A mustachioed white face that must be Neiman beams from the second row. Quarry is seeing stars in the middle of the ring as the referee ends the fight. "Stop Ali. It's all over—go to your corner now," he commands, as Ali struts away victorious. Lester Maddox sprints down the aisle toward the ring screaming "Stop that fight!" But the governor is too late. The artwork prophesied Ali's victory in the ring as well as his triumph over Maddox's racist efforts to maintain his banishment.

Ali won another tune-up in December 1970 against Oscar Bonavena before finally getting a championship fight against Joe Frazier—the bout that would offer Ali the opportunity to regain the title he never lost in the ring. The March 8, 1971, match at Madison Square Garden was billed as the Fight of the Century by promoter Jerry Perenchio, a marketing whiz out of the Sonny Werblin mold. Ali and Frazier would each receive $2.5 million—the biggest fight purse ever to that point and a key storyline in the match's hyperbole-laden promotion. "This transcends boxing—it's a show business spectacular," exclaimed Perenchio. "You've got to throw away the book on this fight. It's potentially the single greatest grosser in the history of the world." Live closed-circuit broadcasts were exhibited in fifty countries and featured the Hollywood actor Burt Lancaster as color commentator. *Life* magazine hired Frank Sinatra to photograph the event from ringside.[31]

Neiman hyped the Fight of the Century from start to finish. The *Boston Globe*'s John Crittenden recalled Neiman rushing into the Fifth Street Gym directly after arriving in Miami to document Ali's train-

ing. "Instead of taking his luggage to the hotel, he had come directly from the airport to the gymnasium as if he were afraid that he might miss something vital. He unsheathed his oversized pad and perched on the edge of the ring, sketching furiously."[32] LeRoy created the official program and poster, as well as the cover art for a *New York Times Magazine* issue published before the match. Neiman's poster, done in watercolor and marker, shows Ali and Frazier staring each other down in profile. Ali is on the right with a bare fist raised toward Frazier. His head is bowed slightly in a pose that is at once aggressive and beatific. It would not be obvious that Ali was a boxer were the image extracted from the poster. He could be preaching, praying, or protesting. Frazier, in contrast, wears gloves raised just under his chin and looks ready to spar. Neiman depicts the comparatively establishmentarian Frazier's body and face with precise lines that detail his features. He uses watercolors to contour Ali's face, which creates a murkier portrait that emphasizes the recently reinstated boxer's inscrutability. Reflecting the Ali-Quarry poster, Neiman's Fight of the Century announcement represents Frazier as a boxer and Ali as a perplexing legend. Neiman's illustration participates in the debates surrounding Ali by suggesting that the polarizing fighter merits more complex creative treatment than his rival (plate 10).

The documentary sketches Neiman created for the Fight of the Century focused mostly on Ali, who was the main attraction despite his status as challenger. Moreover, Frazier's camp would not grant LeRoy access. Frazier's manager Yank Durham kicked Neiman out of a training session when he showed up to sketch. "I don't give a fuck who he is. I don't want him here," Durham snapped after someone told him about LeRoy.[33] But Neiman produced plenty of drawings of Frazier during the grueling fifteen-round fight, which he won by unanimous decision. An estimated three hundred million watched the bout on closed-circuit broadcasts around the world, and Madison Square Garden was brimming over with stars that included Hefner, Sammy Davis Jr., Hubert Humphrey, Barbra Streisand, Aretha Franklin, Miles Davis, Diana Ross, and Bob Dylan. President Richard Nixon, no fan of Ali, had a special television line installed at the White House

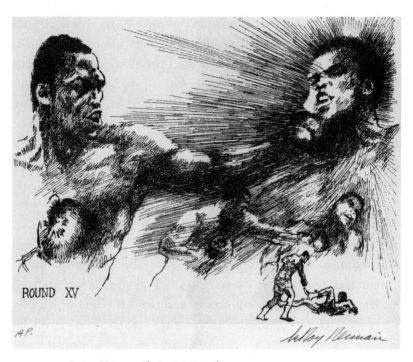

FIGURE 22. LeRoy Neiman, *Ali-Frazier, Round 15*, 1971.
© 2023 LeRoy Neiman and Janet Byrne Neiman Foundation / Artists Rights Society
(ARS), NY.

so he would not miss out. According to the *Boston Globe*, "In size of
money outlay and spectator interest, the attraction dwarfs such spec-
tacles as the Super Bowl football game, and baseball World Series in
the United States, the World Cup soccer and even the colorful Olym-
pic Games."[34] The Fight of the Century somehow lived up to Peren-
chio's grandiose projections. It rode Ali's fame and infamy to become a
historic sports spectacle with ripple effects throughout entertainment
culture. As with the Super Bowl, Neiman helped it to achieve this
exceptional status and spark a broader era of hypermediated, mega-
sporting events.

Neiman made round-by-round sketches of the match that high-
lighted its key moments. His other drawings explored the glitzy scene
at Madison Square Garden. LeRoy focused on the many Black spec-
tators in attendance, most of whom were rooting for Ali to retake his
title. Neiman was especially captivated by the flashy outfits many of

PLATE 1. LeRoy Neiman, Portrait of Lydia Hoelscher, 1949.
© 2023 LeRoy Neiman and Janet Byrne Neiman Foundation / Artists Rights Society
(ARS), NY.

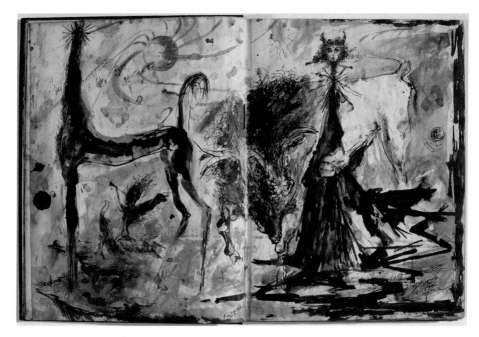

PLATE 2. LeRoy Neiman, surreal sketch, ca. 1952.
© 2023 LeRoy Neiman and Janet Byrne Neiman Foundation / Artists Rights Society
(ARS), NY.

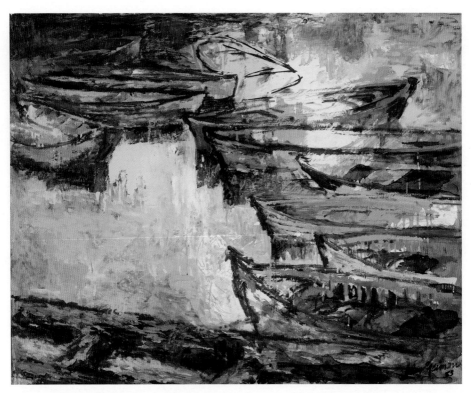

PLATE 3. LeRoy Neiman, *Idle Boats*, 1953.
© 2023 LeRoy Neiman and Janet Byrne Neiman Foundation / Artists Rights Society
(ARS), NY. Photo, Minneapolis Institute of Art.

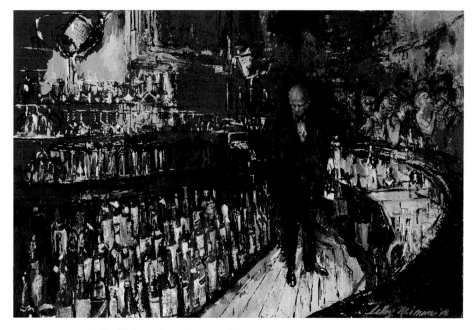

PLATE 4. LeRoy Neiman, *Pump Room*, 1958.
© 2023 LeRoy Neiman and Janet Byrne Neiman Foundation / Artists Rights Society (ARS), NY.

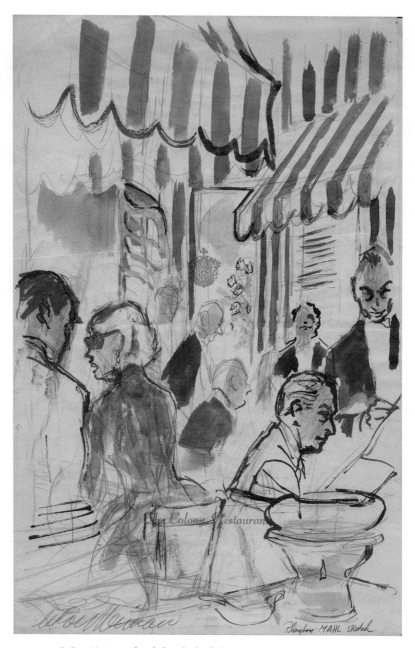

PLATE 5. LeRoy Neiman, Sketch for *Playboy*'s "Man at His Leisure," n.d.
© 2023 LeRoy Neiman and Janet Byrne Neiman Foundation / Artists Rights Society
(ARS), NY.

PLATE 6. LeRoy Neiman, sketch of Woody Allen performing at the London Playboy Club, 1966.
© 2023 LeRoy Neiman and Janet Byrne Neiman Foundation / Artists Rights Society (ARS), NY.

PLATE 7. LeRoy Neiman, *Sonny Liston*, 1964.
© 2023 LeRoy Neiman and Janet Byrne Neiman Foundation / Artists Rights Society
(ARS), NY.

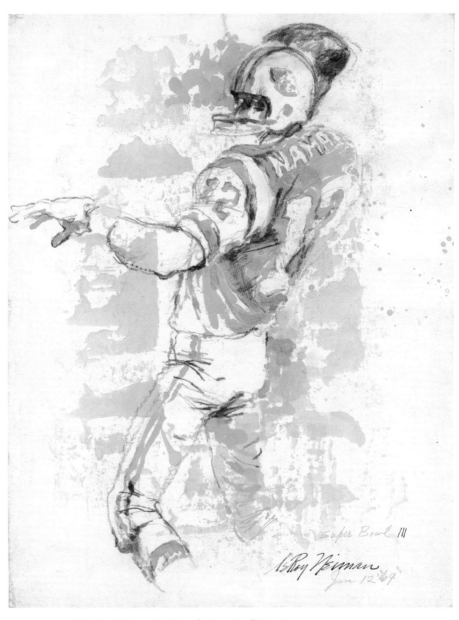

PLATE 8. LeRoy Neiman, *Joe Namath, Super Bowl III*, 1969.
© 2023 LeRoy Neiman and Janet Byrne Neiman Foundation / Artists Rights Society
(ARS), NY.

PLATE 9. LeRoy Neiman, *Black Break*, 1973.
© 2023 LeRoy Neiman and Janet Byrne Neiman Foundation / Artists Rights Society
(ARS), NY.

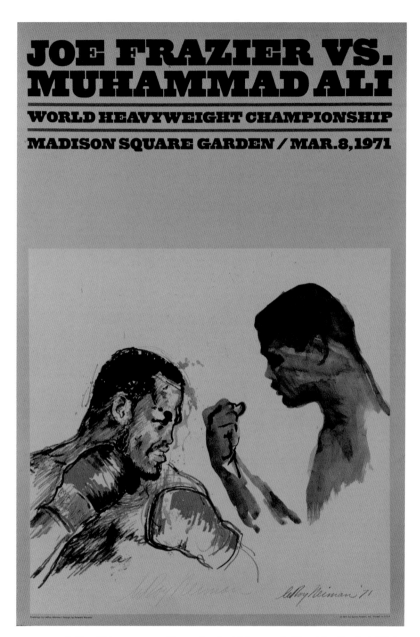

PLATE 10. LeRoy Neiman, poster illustration for Muhammad Ali and Joe Frazier's "Fight of the Century," 1971.
© 2023 LeRoy Neiman and Janet Byrne Neiman Foundation / Artists Rights Society (ARS), NY.

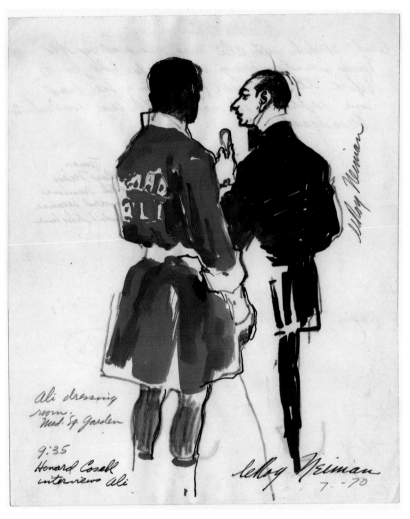

PLATE 11. LeRoy Neiman, *Howard Cosell Interviews Ali*, 1970.
© 2023 LeRoy Neiman and Janet Byrne Neiman Foundation / Artists Rights Society
(ARS), NY.

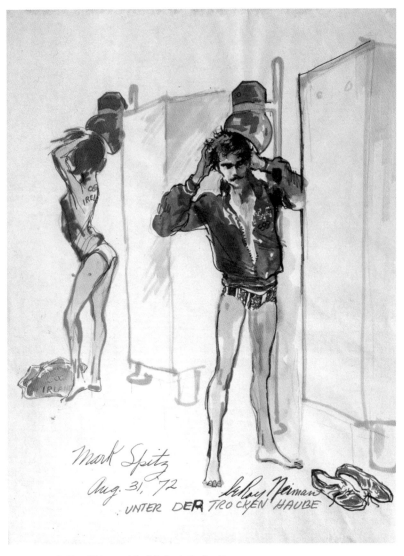

PLATE 12. LeRoy Neiman, *Mark Spitz in Locker Room*, 1972.
© 2023 LeRoy Neiman and Janet Byrne Neiman Foundation / Artists Rights Society
(ARS), NY.

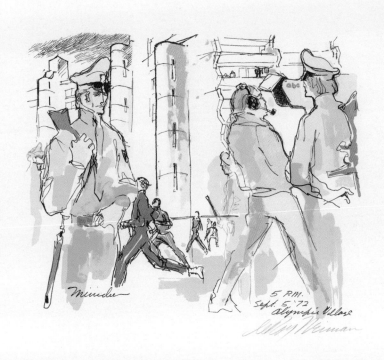

PLATE 13. LeRoy Neiman, *Munich, September 5, 5pm*, 1972.
© 2023 LeRoy Neiman and Janet Byrne Neiman Foundation / Artists Rights Society
(ARS), NY.

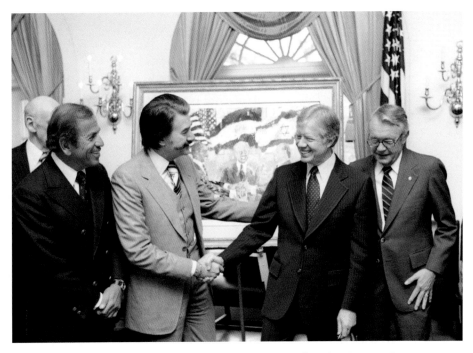

PLATE 14. LeRoy Neiman with President Jimmy Carter at the White House, 1980.
Courtesy of the Jimmy Carter Presidential Library.

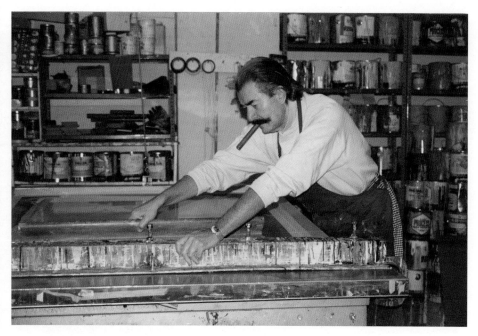

PLATE 15. LeRoy Neiman working on a screen print, 1991.
Photo by Lynn Quayle. Courtesy of the LeRoy Neiman and Janet Byrne Neiman
Foundation.

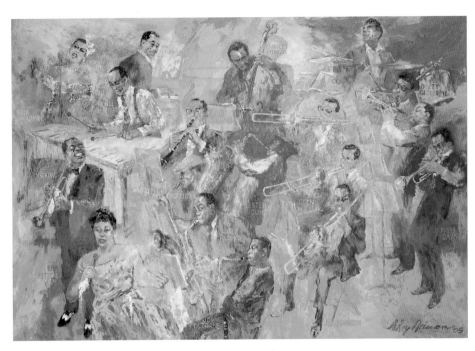

PLATE 16. LeRoy Neiman, *LeRoy Neiman's Big Band*, 2005.

FIGURE 23. LeRoy Neiman, *Black Style*, 1971.
© 2023 LeRoy Neiman and Janet Byrne Neiman Foundation / Artists Rights Society
(ARS), NY.

these fans wore to the event—contrasts to the more subdued attire
he traditionally witnessed at big matches. Aretha Franklin appeared
in a full-length fur coat and a sequined hat that extended into a foot-
long curved cone. NFL defensive end Carl Eller wore a plaid suit with
knickers and knee-length leather boots. Eller topped the outfit off
with a camel-colored wolf coat and matching hat. Other spectators
donned similarly inventive regalia that included multicolored bell-
bottoms, platform shoes, butterfly collars, feather boas, wide-brim
hats, and sparkling medallions. "Their clothes were a knockout,"
remembered ABC's Howard Cosell, "the costumes so garish, so color-
ful, that the artist LeRoy Neiman had a field day. It was like Van Gogh
discovering the vineyards."[35]

Cosell was correct. The onetime fashion illustrator loved the wild
outfits and the lively palette they presented. Neiman also identified
the clothes as expressions of the Black pride that Ali's return inspired.
"The magnitude of the event merits dressing to the fullest homage to

Ali," he said.[36] "Big fights, classically, have been populated by screen stars, business tycoons, underworld figures with flashy blondes," he wrote.[37] Marquee matches, Neiman suggests, are decadent but typically white events like the scene at Madison Square Garden that he depicted in *Introduction of the Champions*. The Fight of the Century was a different sort of spectacle—and the styles that Black attendees showcased emphasized the cultural shift. The costumes were not simply ostentatious exhibitions but ways of aligning with the flamboyant Black style that Ali represented—a style that had been officially suppressed for three years but had finally returned to the biggest stage in entertainment. Neiman's sketches of the snazzy spectators—some of which he eventually turned into stand-alone pieces with lamentable titles like *Blacks Blackin' It* and *A Player and His Lady*—emphasize the audacious, racialized, and political attitude that the clothing helped to convey. And Neiman, who wore a red-velvet suit and golden tie, was dressed as hot as the Black spectators he sketched to demonstrate his connection to that community. The drawings make novel points about Ali's expansive cultural significance as a boxer and a showman that LeRoy—given his experience in fashion, sport, and entertainment— was uniquely equipped to articulate. These perceptive works separate Neiman from the sports illustrators with which he was loath to identify and align him with an intelligentsia that was growing increasingly reluctant to claim the artist as one of its own.

11

TV Artist in a Xerox Society

Since its launch in 1961, ABC's *Wide World of Sports* had aired high-lights of nearly every major boxing match. The program planned to continue this tradition with Ali and Frazier's Fight of the Century. But ABC balked when promoter Jerry Perenchio demanded $750,000 to license the footage.[1] The bout was such a spectacle that films of it were exhibited in theaters for several weeks after the big event—a far more lucrative opportunity than the one ABC presented.

Instead of the footage, *Wide World* staged a conversation between Ali, Frazier, and Howard Cosell in ABC's Manhattan studio, which was just across West Sixty-Seventh Street from the Hotel des Artistes. Frazier, however, suddenly canceled. The fighter claimed to be suffering from the flu. It was later revealed that Frazier's manager did not want his boxer to be made to look a fool by the quick-witted Ali, who delighted in needling his rival.[2] So it was only Cosell and Ali, whose swollen jaw did not prevent the loquacious former champion from berating Frazier and charging that the fight was fixed. ABC augmented the conversation with a combination of photographs and Neiman's ringside sketches, to which the artist added color in the five days between the fight and *Wide World*'s Saturday afternoon episode.[3] Similar to the *Joe Namath Show*, Neiman's poster for the match served as a background for the stage on which Ali and Cosell sat. His artworks spiced up the visually staid interview in lieu of fight footage.

The next year, *Wide World* was covering the World Chess Championship between the brusque American wunderkind Bobby Fischer and the Russian champion Boris Spassky at Reykjavik's Laugardalschöll

arena. The championship consisted of twenty-one games stretching across July and August 1972. Few events are less TV-friendly than chess. Not even *Wide World*, which televised barrel jumping and log-rolling, had covered a chess match. But Fischer-Spassky became a curiosity for Fischer's quirks and the match's potential to be exploited as a Cold War showdown between the United States and Russia. Taking a page from Ali's playbook, Fischer was a bombastic rarity in chess. He publicly criticized opponents and had a pattern of withdrawing from competitions if his sometimes-odd requests were not granted. The behaviors peeved his competitors but provided great copy that stoked unusual interest in the championship. Promoters marketed Fischer-Spassky as the Match of the Century—the chess equivalent to Ali and Frazier's big fight. ABC paid $125,000 for broadcast rights and would show weekly clips of the matches on *Wide World*.[4]

Fischer craved the exposure and money that came with television. But the cameras and equipment made the hypersensitive grand master anxious. He insisted that any cameras be silent and out of sight. ABC met the demands and positioned its cameras so that only their lenses were visible through holes drilled into walls. The network's crew was directed not to wear shoes, carry coins in their pockets, or make any other unnecessary noise.[5] Fischer nevertheless charged that the cameras were distracting. He ordered their removal and, when the match organizers refused, forfeited a game to Spassky in protest.[6] The controversy, of course, sparked only more interest in the match.

"I definitely want it filmed," Fischer told ABC Sports amid his tantrum, "but I cannot have it filmed when it bothers me." ABC eventually negotiated what it thought was a satisfactory arrangement that put the cameras further out of view and earshot. The network showed twenty minutes of footage on the following weekend's episode of *Wide World*. But Fischer erupted with anger after the program and claimed that he was not aware the game was filmed. ABC finally gave up on the prospect of recording the Fischer-Spassky matches and instead featured re-creations of their games on *Wide World* with analysis from the American grand master Larry Evans.[7]

But ABC Sports still wanted some visual record of the champion-

ship it paid to cover. So Roone Arledge invited Neiman to Iceland in hopes that the artist might sketch the matches. "We need you here, pronto!" Arledge said to Neiman. "Get yourself on the next plane to Reykjavik. Fischer's just canned the crew from the match. No cameras. No glaring lights. We need to get you over here to document the damn thing!" Neiman caught a cab to La Guardia Airport. "I hope he's not distracted by my working," the artist told a reporter of Fischer before boarding the jetliner. "I don't want to start a whole new round of postponements."[8]

Once he arrived in Iceland, Neiman was immediately struck by Fischer's peculiarities. "I could see right away that he was a rare bird," he recalled of the jumpy savant. Apart from the idiosyncrasies, Neiman saw in Fischer similarities to Ali and the other celebrities he specialized in sketching. "He has the manner of a prize fighter on his way to the arena except without the fear," Neiman wrote. "Fischer is the first chess player with that contemporary, sports-star attitude."[9] LeRoy was excited to draw the star but wary of unnerving him. Neiman initially went to work with his preferred implement, a Rapidograph pen. The instrument's scratching noise irritated Fischer, who shot the artist a piercing gaze until he stowed the bothersome tool. Neiman then began drawing with a felt-tip marker. The smell, however, piqued Fischer. "Like a predatory creature in the wilds, he began furiously sniffing the air," LeRoy recalled. Finally, the artist produced a silent, odorless graphite pencil. He sketched the rest of the event without incident and presented his work on the following week's edition of *Wide World*, where his art illustrated the match in place of the video footage ABC could not collect. In one piece, a harried and unkempt Fischer seems to be biting his fingernails as he leans over the board in tightly coiled concentration. Spassky sits across from the American—a stoic and coifed contrast to his twitchy competitor. The drawing has the two chess powerhouses facing off in a pose that reflects Neiman's poster for Ali and Frazier's blockbuster match.

Because of their successful collaborations, Arledge hired Neiman to work as a special correspondent for ABC Sports' coverage of the 1972 Summer Olympics in Munich, which began shortly after the Fischer-

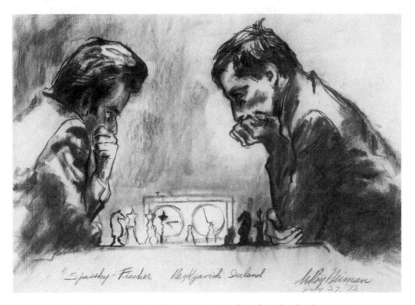

FIGURE 24. LeRoy Neiman, *Spassky-Fischer in Reykjavik, Iceland*, July 27, 1972.
© 2023 LeRoy Neiman and Janet Byrne Neiman Foundation / Artists Rights Society
(ARS), NY.

Spassky matches. Neiman's work for ABC—especially its popular
Olympics broadcasts—made him a hot property for sports television.
His recognizable presence on air not only signaled an event's status
but also helped to sculpt the standing of the media outlet that deliv-
ered it.

More generally, Neiman's small-screen appearances illustrate TV
and art's sporadic intersections. As the media historian Lynn Spigel
explains, networks during the 1950s and 1960s used modern art to
counteract television's stereotypically lowbrow repute and to "per-
suade the public there was something interesting to watch on TV"
beyond the programs that led Federal Communications Commission
chair Newton Minow to call the medium a "vast wasteland" in his
1961 address to the National Association of Broadcasters. Television
networks performed this aesthetic and cultural work mainly through
their design departments. Artists including Andy Warhol and Ben
Shahn made illustrations for CBS, the most aggressively stylish major

network. These efforts strove to attract an affluent and discerning "class" audience. They also muddied the boundaries that traditionally separated TV and modern art. Spigel, in fact, cites *Playboy*'s syndicated programs—shows on which Neiman occasionally appeared and sketched—as exemplars of this convergence through their engagements with music, fashion, and art.[10] Such examples reveal a mostly overlooked alliance between broadcast-era television and modern art that indicates TV was more artful and that modern art was more quotidian than has been previously imagined.

Neiman's work on television shows the intersection of art and TV occurring in the unlikely context of sports coverage. The artist helped ABC to build an exceptionally sophisticated brand within sports television and to create mega-events like the Olympics. His appearances forged a populist and televisual artfulness that was careful not to alienate the middlebrow and mostly male consumers that sports TV tended to attract. Sports television, in turn, informed Neiman's colorful, fast-moving, and promotionally minded work. TV made Neiman into America's most popular artist as the medium was becoming what the media scholar Horace Newcomb described as "the most popular art."[11] Neiman TV-driven fame created unprecedented demand for his artwork that he exploited through mass-produced prints. More than his association with *Playboy* and sports, LeRoy's identification with TV and prints established his notorious reputation as an overexposed exemplar of commercialized kitsch.

* * *

ABC first covered the Olympics with the 1964 Winter Games in Innsbruck, Austria. It then televised all but two of the subsequent Summer and Winter Olympics through 1988.[12] Arledge used the quadrennial event as a showcase for the practices *Wide World* workshopped on Saturday afternoons throughout the year. ABC started marketing itself as the "Network of the Olympics" before its coverage of the 1968 Summer Games from Mexico City. The ratings and accolades ABC attracted with Mexico City saw the traditionally last-place network—

which industry insiders jokingly called the "Almost Broadcasting Company"—begin to improve its lowly status on the strength of its exceptional sports department.

The 1972 Munich Games built on Mexico City and the recent success ABC had migrating sports programming into prime time with the launch of *Monday Night Football* in 1970. ABC paid a record $13.5 million for Munich's broadcast rights—$8 million more than it spent to cover Mexico City. Arledge envisioned an extravagant broadcast that would do justice to the historic investment. He amassed a 330-person team and planned 66.5 total hours of coverage—47 of which would be scheduled during prime-time hours. ABC Sports augmented its event coverage with the series "Up Close and Personal," documentary profiles on notable athletes. The vignettes introduced viewers to select competitors and built dramatic subplots that might entice the audience to follow the featured athletes as the Olympics progressed.[13]

Neiman would help to create the intimate viewing experience ABC hoped to furnish. He was a special correspondent along with Erich Segal, author of the bestselling romance novel *Love Story* (1970). Neiman sketched events and Segal, an ardent distance runner, shared his insights. The International Olympic Committee's (IOC's) charter stipulates that cultural events should accompany the sporting competitions, and organizers routinely commission artists to help celebrate and sell the Olympic Games. The graphic artist Lance Wyman designed logos for the 1968 Mexico City Olympics, which combined hypnotic and psychedelic patterning with Mexican folk art. Leni Riefenstahl's *Olympia* (1938) and Kon Ichikawa's *Tokyo Olympiad* (1965) expanded documentary film's aesthetic horizons with their respective memorials of the 1936 and 1964 Summer Games. Arledge sought to place ABC Sports into the tradition that Wyman, Riefenstahl, and Ichikawa represent. He cited documentarians as inspiration for many of his broadcasting innovations.[14] And Arledge periodically commissioned illustrators like Robert Riger and the more stylish Roy Carruthers, who created a painting for ABC Sports' 1972 programming lineup that featured a group of bulbous male figures wearing uniforms representing the sports that the network televised.

But Arledge had never hired an artist to work on camera as part of ABC's Olympics coverage. Neiman wasted no time making his presence known once arriving in Munich. An ABC Sports staff photo snapped before the Games began—taken from a crane to capture the network's massive team—shows LeRoy up front between Arledge and main studio host Jim McKay.[15] Just like he would at a championship match, Neiman placed himself in the center of the action.

Once the Olympic Games started, Neiman transformed into a sporting flaneur who roamed the Olympic Village observing, schmoozing, and sketching. "I was just turned loose," he remembered.[16] ABC intermittently checked in with the artist to see what he had been drawing—usually through interviews with correspondent Peter Jennings, a young newsman at the time who specialized in the Middle East but was helping in Munich. Neiman was at ease on camera and his celebratory approach jibed with ABC's promotional ethos. He even used Arledge's vernacular when describing his method: "My commitment to my work requires that I have access and mobility to get *up close, personal*." Neiman's art promoted the star athletes ABC was emphasizing in its coverage and exposed viewers to others the network may have overlooked. The artist was famous enough at this point that the athletes recognized the benefits of getting the Neiman treatment. The American distance runner Steve Prefontaine consented to run past Neiman in slow motion several times so the artist could accurately capture his winning stride.[17]

Although Neiman complemented ABC's aesthetic, he carried a different creative approach. "I tried to take a look at the things TV cameras were not always zooming in on," he said. "I felt like I was on a special mission," Neiman continued. "I was the artist and everything else was the cameras."[18] His independent wanderings led him to the Russian gymnast Olga Korbut, who captured his attention while she was practicing. Neiman lacked the expertise to evaluate Korbut's athletic talents, but he identified "something special" in the gymnast and sketched her several times before she emerged as the Olympics' biggest female draw. He saw in Korbut's joy and spriteliness a magnetism on par with Ali, Namath, and Sinatra.

Unlike Korbut, the American swimmer Mark Spitz was a main attraction leading to Munich. Neiman added new elements to the ample attention Spitz received. In particular, LeRoy used his privileged status as artist-in-residence to follow Spitz into a locker room where photographers were prohibited. He captured the hunky swimmer drying his hair after a workout, getting his look just right before emerging from the sequestered area to face the journalists who shadowed him throughout the games. Neiman's sketch relays Spitz's status as an image-conscious sex symbol out of the Joe Namath mold. It underscores this persona by depicting Spitz next to an attractive female athlete who is also drying her hair. The champion swimmer, Neiman suggests, tends to his appearance just as meticulously as a gorgeous woman (plate 12).

Several of the artist's other drawings focus on male athletes' sexuality and appearance. He sketched the American wrestler Sergio Gonzalez nude on a scale from behind. Desperate to make weight, Gonzalez has a trainer cut what Neiman described as his "mod-long hair," which the artist shows piled on the floor. LeRoy struck an ironic note by sketching the four-hundred-pound American wrestler Chris Taylor—not a conventional sex symbol—lounging in a cheesecake pose as if he were a *Playboy* centerfold. Neiman also captured a group of Italy's male athletes sauntering around the Olympic Village whistling at and trying to pick up women. "The Italian team finished in 10th place in the Games but retained their number one spot in girl-watching," Neiman drolly explained in a book of his Munich sketches.[19]

Aside from the men, Neiman maintained his usual focus on attractive women who fit the *Playboy* ideal. "There were so many good-looking, healthy people in one place," he said. "The girl athletes were especially attractive. They were not the heavy, muscular type but sexy broads."[20] Neiman consciously objectified the few female athletes he depicted. He gave the swimmer preening alongside Spitz a slight yet curvy physique that looks more like that of a model than an Olympic athlete. Neiman's sometimes leering sketches of Munich's women complemented ABC Sports' general sexism. The network's coverage—like most sports television, then and now—gave women athletes little

attention. When it did cover women, it generally focused on those who fulfilled conventional standards of beauty. Among its many stylistic hallmarks, ABC Sports developed the "honey shot"—a cutaway from event coverage to an attractive female fan—that became a standard convention in sports television designed to satisfy the genre's primarily male audience.[21] Neiman's sketches amplified ABC Sports' tendency to cater to the heterosexual male gaze.

The Munich Games were disrupted on September 5, when the Palestinian terrorist group Black September took hostage and eventually killed eleven members of Israel's team. ABC Sports immediately transformed into a de facto news unit and became the main source of TV coverage on the crisis as it unfolded. Neiman sketched the standoff between German authorities and the terrorists, who were holed up in the Olympic Village for most of the day before a fatal shootout. LeRoy's sketches of the emergency offered darker-toned contrasts to the light and hopeful colors that his other Olympics drawings displayed. He captured the frenzied situation by depicting police patrolling, athletes milling about, and ABC Sports unwaveringly recording the scene. While Neiman's drawings rendered the authorities, athletes, and camera operators without distinct facial features or markers of national origin, they deliberately included ABC logos on the cameras. The brand placements stressed ABC Sports' centrality to the globally significant event and its coverage. They also showed Neiman's commitment to promoting his employer even amid a deadly tragedy (plate 13).

Neiman's Munich artwork composed a minor part of ABC's coverage. But it helped to make Munich the biggest and most celebrated sports TV spectacle ever to that point and to buttress ABC's self-designation as "The Network of the Olympics." The *New York Times* called ABC's coverage an "electronic marathon" of "superb" television, and *Variety* lauded it as "the video hit of the summer" and a turning point in ABC's overall status as a network.[22] The award-winning broadcasts proved for the first time that sports television could offer valuable cultural and aesthetic contributions.

Accolades for LeRoy followed. The American marathoner Frank

Shorter, who won a gold medal in Munich, wrote Neiman to see whether he could acquire a sketch. "A copy of the drawing you did of me is one of the few things I would want to hang on my wall to remind me of what happened," Shorter remarked. LeRoy replied that the piece was tied up in an exhibition at Hammer Galleries but that it might be available afterward if it did not sell.[23] Beyond the Hammer exhibit, the Indianapolis Museum of Art organized a show of Neiman's Olympics works that ran from November 22, 1972, through January 7, 1973. ABC received a barrage of inquiries from people wondering how they might obtain a Neiman.[24]

The praise moved Arledge to intensify ABC Sports' partnership with Neiman. Following the New York Jets, Arledge commissioned LeRoy to produce holiday cards for his network division. The 1973 card shows Santa Claus perched atop Earth wearing a *Wide World of Sports* patch on his signature red coat and speaking into an ABC camera like a sportscaster.[25] Neiman's card depicts St. Nick globetrotting in ways that reflect *Wide World*'s touring format and diplomatic pretensions. The cards also solidified Neiman's role as ABC's artist-in-residence. Neiman, however, was not exclusive to ABC, and the artist's work for the network put him in high demand from other media outlets looking to make their own mark in sports broadcasting.

"When I returned, I realized a lot of people had looked on that stuff," Neiman said of his work in Munich. "I experienced a wave of popularity."[26] He was hired to appear on NBC's World Series coverage in October 1972—one month after Munich. The next month, he joined the Independent Television Network's broadcast of the International Horse Race in Washington, DC. NBC again had Neiman participate in its January 1973 coverage of Super Bowl VII, and *TV Guide* commissioned him to paint a cover for its issue of September 15, 1973, which previewed the professional football games scheduled to air that fall. "The exposure," LeRoy said of his newfound association with television, "was mind-boggling."[27]

Less than a week after his *TV Guide* cover went to print, LeRoy was back to work for ABC Sports to sketch on its broadcast of the Battle of the Sexes exhibition tennis match between Billie Jean King and Bobby

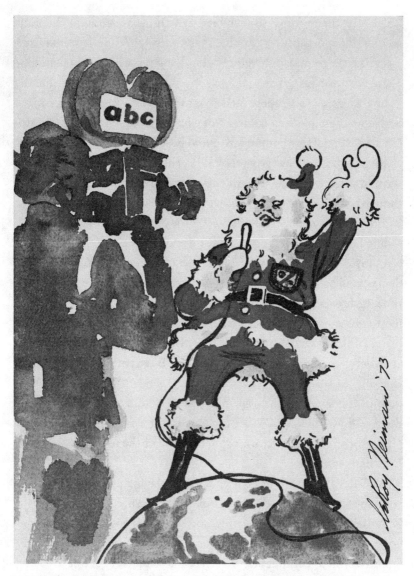

FIGURE 25. LeRoy Neiman, Christmas card sketch for Roone Arledge and ABC, 1973. LeRoy Neiman Papers, Smithsonian Institute, Archives of American Art, Washington, DC.

Riggs. The made-for-TV spectacle—which became one of the most memorable sporting events of the 1970s—exploited controversies surrounding the feminist movement that King represented by matching her against the fifty-five-year-old retired professional-turned-hustler Bobby Riggs. A self-proclaimed "chauvinist pig," Riggs claimed that women had no place in sports. Not even a championship female athlete like King, Riggs contended, could beat him.

Riggs, whose jabs were as rooted in economic opportunism as they were in sincere bigotry, caught the attention of Jerry Perenchio, who thought he could market the event as a spectacle on par with the Fight of the Century by pitting a *Playboy*-style sexist against a crusading feminist. He arranged for King and Riggs to compete in Houston's massive Astrodome for a $100,000 winner-take-all prize. ABC Sports paid $750,000 to license the match and air it live during prime time. Its broadcasters stressed the event's exceptional import by wearing tuxedos like they would when covering a championship boxing match. The *New York Times* called Battle of the Sexes "an unholy alliance between Miss America and the Rose Bowl parade." "One cannot describe it primarily as a sports contest," echoed the *Atlanta Constitution*, "It is show business sprinkled with Hollywood gimmickry." As the ABC host Howard Cosell proclaimed when the broadcast opened: "It's not the usual tennis atmosphere, and not the usual tennis event. It's a happening!"[28]

ABC devoted much of its broadcast to playing up the man-versus-woman storyline of Battle of the Sexes. The hosts continually praised King, who dominated the match and won in straight sets. But they couched the celebrations in language that reminded viewers of the feminist athlete's desirability. Cosell called her a "very attractive lady" as she entered the sold-out arena—on a throne carried by shirtless men dressed as Egyptian slaves. "You get the feeling that if she ever let her hair down to her shoulders, took her glasses off, you'd have somebody vying for a Hollywood screen test," the sportscaster observed later in the match. Neiman's sketches maintained this emphasis by capturing King scrutinizing her appearance in a 180-degree mirror before the match as her husband Larry looked on approvingly. Nei-

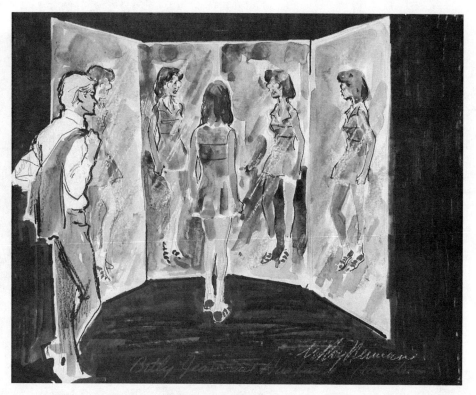

FIGURE 26. LeRoy Neiman, *Billie Jean King*, 1973.
© 2023 LeRoy Neiman and Janet Byrne Neiman Foundation / Artists Rights Society
(ARS), NY.

man appeared on camera only briefly toward the end of the presenta-
tion when the sideline reporter Frank Gifford looked in on his work.
"I'm enjoying the girls out here," LeRoy said. He then showed Gifford
several sketches of women present at the match. He drew a female
photographer he spotted as well as a portrait of Billie Jean King's
mother, who was watching her daughter compete from the stands.
Neiman gave special attention to a lineswoman whose backside he had
been ogling. "And here we got the lineswoman, another beauty," he
told Gifford with a devilish grin. "This is an angle I've had all night and
it's been a little distracting for me." Gifford nodded uncomfortably
before sending it back to Cosell in the main studio. Neiman's appear-
ance at Battle of the Sexes, which attracted more than fifty million
viewers, cemented his role as a staple of sports TV that accentuated

marquee broadcasts.[29] It also reinforced his tendency to depict sport as a male domain in which women—even those giving historic and dominant athletic performances—are best appreciated as sexualized objects.

* * *

Neiman increasingly described his work in terms of television as he became identified with the medium. He claimed that TV had ushered an "age of multiples and clones, a society of multiple copies and instant replays" that he dubbed a hyperreal "Xerox society." His colorful, kinetic, and commercial work grew out of the mass-mediated world TV created and hastened the stereotypically unrefined medium's transformation into an art form. "I seek to make the task of the spectator increasingly difficult," he said when describing his artwork's combination of the figurative and abstract. "I set traps for him. Modeling takes place where emphasis does not lie; accents are subordinated; foreground and background merge up close, and then expand with distance. As one advances on my painting it becomes more abstract, more fluid. And as one moves away it falls into focus and is realistic."[30]

The aesthetic challenges that his work offers, Neiman suggests, lay in their resemblance to what Marshall McLuhan described as the "cool" low-definition TV image: it is discernible from a distance but fuzzy up close.[31] Neiman's TV-inspired artwork, the artist contends, is legible but also demands and rewards meticulous scrutiny. In this sense, LeRoy insisted that his work integrated exceptional artistic value onto the medium. His vibrant creations specifically showcased color TV's aesthetic potential. In doing so, they complemented the media historian Susan Murray's analysis of how nascent color television was marketed as a "more immersive, expansive" viewing experience than black and white that "stimulated an especially engaged and responsive form of attentiveness."[32] Neiman implied that his televised artwork deepened this absorption by joining color TV with vivid painting. "Television, especially color television with its wild colors and textures, has done a lot for art," he remarked. "People sit back and see it as someone's creative experience, just as they do my paintings."[33]

The combination of color television with the creative innovations that producers like Arledge developed sparked a growing demand for sports art during the 1960s and 1970s. "Media has created the market for sports art," said Merv Corning, an illustrator who worked in a realist style and was regularly commissioned by the NFL. "In the old days, football players and other athletes in team games were just a mob of guys; but today, instant replays and freeze scenes show you how graceful and pictorial athletes really are—especially in living color. More and more collectors want scenes like that on their walls."[34] These collectors especially coveted Neimans because of his association with big events and TV. Thanks to television, LeRoy was a name brand whose signature style most powerfully signaled sports art in popular culture. "Neimans" thus carried greater value within this context than works made by less visible and conspicuous sports artists like Corning. LeRoy's originals could no longer satisfy the surging interest in his art. This demand was especially high among sports television's mainly middle-class audience, which generally could not afford original works but would pay for less expensive print reproductions.

Art prints, like television, occupy a relatively low position in traditional aesthetic hierarchies. Despite the money to be made on Neiman's prints, Armand Hammer was wary of associating with the medium for fear of further sullying his gallery's already-questionable reputation. Hammer strove to improve his status by acquiring Knoedler Gallery in 1971, which he bought along with Maury Leibovitz. Founded in 1946, Knoedler was one of the United States' oldest and most prestigious galleries. Its inventory included works by Bonard, Degas, Manet, Renoir, and Velazquez. But Knoedler had fallen on hard times, could not pay its bills, and, as a result, lost big-name clients like Willem de Kooning and Henry Moore. Hammer and Leibovitz had the capital and business acumen to turn Knoedler around. But they did not have the reputation to maintain Knoedler's esteemed brand. "Knoedler represented everything Hammer did not, with old-fashioned ways of doing business that usually excluded hype," wrote Armand Hammer's biographer Steve Weinberg.[35] Hammer provided Knoedler with

financial and administrative support while Knoedler gave Hammer cultural clout, which the businessman wielded by keeping the legacy brand intact despite the organizational overhaul.[36]

Hammer initially distanced Neiman from Knoedler for fear that the celebrity artist might compromise the status he was striving to build and the new audience he was attempting to attract. This irked Neiman, who also craved the prestige that an affiliation with Knoedler would give him. But LeRoy was pragmatic enough to recognize that it was better in the long run to stick with Hammer. He respected and identified with Armand Hammer's position as a guileful art world outsider who was strategizing ways to gain respectability—even if those efforts sometimes worked to LeRoy's disadvantage. While the image-conscious Hammer was not going to bankroll or sell Neiman's prints, he also could not and would not prevent the artist from partnering with others to work in the medium and capitalize on the new revenue streams it presented. Hammer also realized that Neiman's prints would likely help to publicize the originals he stocked.

Limited-edition serigraphs—that is, silkscreen prints—enabled Neiman to reap the benefits of selling in volume while separating his prints from the medium's commercial reputation. An eventual compendium of Neiman's prints emphasized this point by including language from the scholar Fritz Eichenberg explaining serigraphy's distinction from run-of-the-mill posters.[37] The serigraphs approximated the texture of paintings by layering ink in various consistencies. Neiman oversaw the printing runs, which were generally limited to three hundred copies. He then signed and numbered each copy—in pencil to reduce the risk of piracy. LeRoy's direct involvement imparted the serigraphs with a semblance of the authorial "aura" that is allegedly lost in mechanical reproduction—one of the elements informing print's degraded status. At the time, a Neiman original—depending on the size and subject matter—could fetch about $25,000. A serigraph, priced between $150 and $300, generated up to $90,000 if all copies sold. The limited print runs created a sense of artificial scarcity that allowed the serigraphs to be priced relatively high despite their low production costs. Neiman's main market for the prints consisted

of upwardly mobile, middle-class consumers eager to showcase their cultural standing by displaying art that would be easily recognized as such by peers who saw it in their homes or offices. But beyond the serigraphs, Neiman licensed his work for poster-grade reproductions with which he had comparatively little involvement and that nearly anyone could afford.

Neiman described print dealers as mercenary "mutations of the turn-of-the-century Parisian art merchants." But he also appreciated how the print industry democratized art collecting and bypassed traditional gatekeepers—one of the key features informing the medium's degraded reputation. "I was aware that the virgin-buying public fancied Neimans, and this multiples market perfectly served my desire to reach as broad a range of eyes as possible," he wrote. "It fed my notion that art could and should be shared without compromising quality."[38] Neiman carefully frames his involvement in the print business as an anti-elitist undertaking aimed at serving a community that the traditional art market ignored, and even looked down upon. The way Neiman tells it, he realized that he was going into business with sharks, but the need to satisfy his adoring public made the gambit worth the risk. This posturing allowed him to benefit from the tremendous profits that prints presented while maintaining that he was not simply in it for the money.

The ostentatious New York City print dealer Felicie Schumsky, who ran Felicie Incorporated, earned Neiman's trust by insistently separating herself from her less scrupulous peers. Schumsky handled the prints of Salvador Dalí, who developed a suspicious reputation because of his general overexposure and association with posters. Schumsky broadcast her partnership with a banner on Felice Inc.'s letterhead that read "Specializing in the World of Salvador Dalí." Schumsky thought Neiman's prints could be even more popular than Dalí's given his renown among *Playboy* readers and sports fans. She sent LeRoy an impassioned proposal to represent his print interests: "My main function will be to act as a central business control for you in order to insure that your interests are always protected, that your integrity as an artist is maintained, that your output is handled at the

highest level of quality, that your works are at a consistent price level in the market and generally that you are treated as an artist rather than a commodity." Schumsky's pitch shrewdly tapped into LeRoy's desire to make as much money as possible while being perceived as an artist unconcerned with commercial gain. Neiman signed a five-year deal with Felicie in March 1971 that gave her exclusive rights to act as his agent for "the complete production of his graphic works."[39] Their agreement stipulated that Neiman would oversee all printing and have final say on any advertising Felicie created to market his work.

Felicie Inc. first published a series of three Neiman sports posters that depicted Joe Namath, baseball player Johnny Bench, and the jockey Bill Hartack. The prints sold for $10 each and were marketed as "Neiman Super Stars." Neiman earned a dollar for each poster that sold.[40] Felicie Inc. planned for the inaugural posters to be the first of an ongoing series of sports celebrity prints. It did not take long, however, for the athletes to request a cut of the profits that Felicie Inc. and Neiman were making off their likenesses. LeRoy had no set policies regarding payments made to the athletes featured in his prints. If they asked, he typically gave them a percentage of his take, signed prints, or some combination of the two. "I always have to get the most money," he later said.[41] On the basis of those experiences, Neiman started producing more generic sports prints that did not depict famous individuals or other licensed properties, such as the serigraphs *Red Boxers*, *Soccer*, or the hockey-focused *Ice Men*. As Schumsky predicted, Neiman's serigraphs and posters sold as well as Dalí's prints. Felicie Inc. underscored Neiman's importance to the company by adjusting its letterhead shortly after their partnership began: "Publishers and Distributors of Salvador Dalí and LeRoy Neiman Graphics." The company gave LeRoy top billing along with the superstar artist who influenced his look and persona.

"The action started after the Olympics, really," Neiman reflected of the demand for his prints. "Everybody wanted to get in on my notoriety." Galleries across the United States were soon awash in Neimans, which, similar to other collectibles (e.g., Hummel figurines, Beanie Babies), were sold by select dealers to create the impression of scar-

city and inflate their value.[42] But the overexposure prompted Shirley Percival, a gallery owner out of Des Moines, Iowa, to write Schumsky a concerned letter suggesting that her company was flooding the market, which would eventually lower the value of Neiman's work and diminish his stature. "I feel that LeRoy is doing himself irreparable damage by joining the Dalí-type print category," Percival wrote. "If LeRoy were limited in artistic output it would be excusable. However, the magnitude of conception is so great that he is passing up an opportunity to become a very important artist in time."[43] Neiman, Percival suggested, was beginning to seem like a hack who was more interested in short-term profits than in building a lasting artistic legacy. While Schumsky promised Neiman that she was principally committed to protecting his artistic integrity, the publisher, who worked for a percentage, had an interest in encouraging her star client to churn out as much volume as possible. Felicie Inc. extended Neiman's output beyond prints by publishing *Art & Lifestyle* in 1974, a coffee-table book that combined reproductions of his work with autobiographical reflections on his life, process, and point of view.

Felicie paid LeRoy a $22,500 advance for *Art & Lifestyle*, which retailed for $35—significantly less than a serigraph but more than a print. Neiman gave $10,000 of his advance to Mickey Herskowitz, a journalist from Houston who agreed to ghostwrite. Neiman stipulated that Herskowitz's name would appear only in the acknowledgments, in order to give the impression that he wrote the book himself. Felicie published the oversize volume leading up to the holidays alongside Pablo Picasso's *Picasso* and Dalí's surrealist cookbook *Les Diners de Gala*.[44] A newsletter directed at booksellers by the publisher's representative Thomas C. Brown recommended LeRoy's book above Felicie's Picasso and Dalí titles "because [Neiman] is the 'in' artist of the day."[45]

A Felicie Inc. press release described *Art & Lifestyle* as "an unforgettable journey through Neimanland with LeRoy Neiman as guide." The book presents LeRoy as a dapper figure who boldly forged an unconventional path to art stardom. The first page offers a dedication to Janet. The next displays a photo of Neiman cuddling with

another woman while enjoying a Venetian gondola ride—his shirt unbuttoned to the navel and his golden stud charm sparkling in the Italian sun. Building on these first pages, *Art & Lifestyle* delivers a heartily embellished version of Neiman's story. He narrates himself as a convention-flouting original who strikes a rare balance between jet-setting elegance and easygoing relatability. "I once traded a painting to a plumber in return for a sink that he installed in my studio," LeRoy says in the introduction. "Fair exchange, my art for his."[46] While his autobiographical remembrances consist mostly of self-aggrandizing fluff, *Art & Lifestyle* does offer some thoughtful observations about what makes Neiman's approach unique. One page combines sketches of a gentleman sliding into a formal topcoat, a boxing trainer putting a robe on a fighter, a baseball player pulling on a jacket, and a stripper draping her bare shoulders in a shawl. Another page juxtaposes sketches of Muhammad Ali with drawings of the trickster-like Harlequin from the commedia dell'arte. Such moments show Neiman's capacity to put different spheres of popular culture into illuminating dialogue that demonstrate the aesthetic borders sport, fashion, sex, and entertainment share while combining these spheres to articulate a middlebrow taste culture.

Art & Lifestyle also gave Neiman an opportunity to cite television as "the most important single development" in his career and a turning point in art history. "Television has the capacity to deliver a drawing or a painting to an audience that, at any moment, might number 50 or more millions of people," he wrote. "Television came along to circulate my work to more people than the Old Masters knew existed." Neiman described art on TV as "the ultimate visual use" and located himself as the creative revolutionary at the center of this multimedia aesthetic sea change.[47] "There was a day when the king's court, the church and the academics had power over art and artists," LeRoy asserted. "Television and the mass media have wiped all that out. Now the people can see an artist's work on TV or in a magazine and decide for themselves if the work is any good."[48]

To complement and solidify his identification with sports media, Neiman used his sketchbook to flatter some of the industry's key gate-

keepers. He composed a stately sketch of Roone Arledge with the words "Responsibility, Integrity, Truth, and Beauty" alongside the TV executive's visage. Howard Cosell proudly displayed a Neiman portrait in his apartment next to a framed jacket of his 1973 book, *Cosell*, which was published by Playboy Press.[49] Neiman met the star *Sports Illustrated* photographer Neil Leifer while they were both covering the Jets. Often working the same events, Leifer and Neiman eventually became friends and started swapping sketches for photos. In January 1973, the two were at Joe Frazier and George Foreman's "Sunshine Showdown" bout in Kingston, Jamaica. When Neiman returned to New York to start a commissioned painting that would be reproduced as a serigraph, the artist realized that he had neglected to record some details necessary to make the piece accurate. He called Leifer to see if the photographer could spare a shot that might help fill in these particulars. "I need a picture from this angle that's going to show me what that place looked like, exactly, in color," LeRoy said to Leifer. The photographer could not give Neiman anything *Sports Illustrated* might want to publish, but he found a shot from the perspective LeRoy sought that was out of focus. "I gave the picture to LeRoy and said you can do anything you want with it," Leifer recalled.[50] But he stipulated that Neiman had to paint him into a copy of the serigraph. LeRoy agreed and created a personalized version by sketching Leifer's face onto the body of a ringside photographer that was visible through Frazier's legs. Neiman continued his lifelong tendency to use his art to secure favorable treatment from influential figures.

By the mid-1970s, Neiman estimated that he devoted roughly half of his time to prints, which had become pervasive to the point of near disposability.[51] A 1974 Major League Baseball sweepstakes provided a trip to the World Series as its first prize. It awarded one thousand sets of four Neiman posters as third prize. A gallery in Allentown, Pennsylvania, handed out a free Neiman print with any purchase over $15. And LeRoy was inclined to pursue the many opportunities to make money—in and beyond prints—that arose alongside his fame. In 1975 he collaborated with the oceanographer and TV star Jacques Cousteau on a 1,500-edition publication of Herman Melville's *Moby Dick*. Cous-

teau penned an introduction and Neiman illustrated the book, which retailed for a princely $450. Contrasting that boutique effort, LeRoy licensed his work for reproduction on commemorative plates, drinkware, jigsaw puzzles, and even a rayon men's dress shirt.[52]

Neiman was a prudent businessman despite his seeming willingness to accept any moneymaking opportunity that came along. He unceremoniously dismissed Felicie Schumsky in 1975 after determining that she was not living up to the terms of their agreement. LeRoy sued Felice Inc. on the grounds that it was financially mismanaged and owed him over $200,000 in back payments. The company, he charged, had been producing shoddy prints, selling his work at discounted rates to substandard galleries, and putting too much inventory into circulation.[53] LeRoy was perhaps most offended that Felicie started representing Wayland Moore, a blatant Neiman imitator out of Florida who also specialized in colorful sports scenes, immediately after he severed ties with the company. Felicie denied wrongdoing and issued a countersuit that claimed Neiman had betrayed their agreement by refusing to sign several serigraphs.[54] The legal battle stretched into 1978 until the parties finally settled.

Neiman transformed a deposition he gave against Felicie Inc. into a performance that rivaled his best TV appearances. He did not bring a sketch pad to the courtroom. But he invited along his assistant Lucette, whom Felicie's lawyer asked to leave before they proceeded. Neiman expressed little patience for the legal process and the attorneys' detail-oriented questions. "You guys better get along or I'll split," he said at one point when the lawyers' debate became heated. Neiman later asked if he could "go out and have a drink"—and he did leave for a moment while the attorneys waded through a series of questions, objections, and modified queries that were important for the deposition but that the restless artist could not stomach. LeRoy's own lawyer seemed to get irritated with his client, whose impatience made him only moderately helpful when they were piecing together the facts surrounding his history with Felicie. "I don't know," Neiman said to his attorney after one question, "that's not my bag to keep records of when the dates were or the times."[55]

But LeRoy's attentiveness and recall miraculously improved when he was asked about Schumsky's integrity. He became truculent and accused his former publisher of professional incompetence and emotionally instability. "We'd scream at each other on the phone," Neiman said. "I'd scream too, the only thing I don't do is cry, she cries, she is always one up on me." LeRoy steadily became angrier as he recounted their falling out. "Everything got all fucked up, for the record. It's about time we used this language because it's so ridiculous to do this kind of stuff," he said. "I'm the unique person here, my work is unique and I could have anybody distribute or publish my prints," he insisted. "You don't find LeRoy Neiman every day, she was easily replaced."[56] Felicie, he coldly maintained, was a bungling crook.

As Neiman started making money with Felicie, Hammer was having trouble resisting the profitable opportunities that his prints offered. It collaborated with Felicie Inc. by publishing several FKH (Felicie Knoedler Hammer) print editions of Neiman's work in 1973 and 1974. The FKH brand maintained a tenuous and symbolic fence between Hammer-Knoedler and the print medium. But Maury Leibovitz officially took over management of Neiman's print interests after the artist fired Schumsky. Shortly thereafter, Hammer established the permanent subsidiary Hammer Graphics, which handled Neiman and a stable of other print clients that included Dalí and Gloria Vanderbilt. Despite the new print division, Neiman insisted that his work be attached to the more prestigious Knoedler brand. Hammer cleverly indulged the request by connecting LeRoy to Knoedler Publishing, which was separate from Knoedler Gallery but shared its coveted name.[57] Neiman would be attached to Knoedler—albeit in a slightly adulterated form—and Hammer would be able to profit from the artist's prints without compromising the Knoedler Gallery's reputation.

Leibovitz set out to correct Felicie Inc.'s many missteps. He limited Neiman's serigraph output to about ten a year and exerted firmer control over their distribution and pricing. Leibovitz also authorized select galleries in different regions—such as Franklin Bowles in San Francisco—to carry the new serigraphs. Unaffiliated galleries, of course, could sell whatever they pleased on the secondary mar-

ket. But only the certified businesses could stock Neiman's newest prints. The partner galleries, much like collectibles dealers, committed to purchasing a set number of serigraphs and selling them at a specific rate. "We don't like to see LeRoy Neimans hanging in just any mom-and-pop incidental store," commented Knoedler's Marc Rosenbaum. "The galleries where LeRoy Neimans hang are the galleries that exhibit works by Miró, Dalí. It could be Picasso, perhaps. You know, the high-ticket items."[58] The stability Leibovitz and Knoedler brought to the Neiman market also enabled steady price increases. Within a year of beginning to work with Neiman, Leibovitz estimated that his client was worth about $30 million and had "sold more art than any painter in the history of the world," because of his prints and the exposure his identification with sports and television gave them. Neiman coolly claimed he did not know how much he made—only that it was "a lot."[59]

12

Middle America's Michelangelo

Neiman's fame and fortune drew praise and criticism in equal measure. In 1975, St. Paul's Minnesota Museum of Art staged a Neiman retrospective to coincide with its Bicentennial celebration. As part of the honor, it commissioned Neiman to create a painting for its official poster. The work he produced, *Baghdad of the Midwest*, centers on the golden horses featured in Daniel Chester French and Samuel Potter's *Progress of the State* sculpture that sits atop the state capitol—a piece Neiman would gaze upon while traipsing around town as a kid. The retrospective, the first serious honor LeRoy received from his hometown, put Neiman into dialogue with F. Scott Fitzgerald as one of the city's great artists. But it also made important distinctions between the two. As the museum director Malcolm Lein wrote in the catalog for Neiman's retrospective: "Both were performers caught up in the whirlpool of their respective worlds. But whereas Fitzgerald was dizzied by success and embittered by failure, Neiman remains sufficiently aloof to survive the exposure, the affluence, the publicity."[1] Neiman, Lein observes, was both successful and able to navigate the challenges that accompany fame—obstacles that plagued Fitzgerald. The painter was a more authentic Midwesterner who possessed a grittiness that Fitzgerald lacked.

The *Minneapolis Tribune* critic Mike Steele, who specialized in theater and dance, took issue with St. Paul's willingness to compare Neiman with an artist of Fitzgerald's caliber. He charged that the chronically cash-strapped Minnesota Museum of Art was trying to make a splash by pandering to popular tastes. "Pity the poor museums,"

Steele wrote, "under the financial gun, under pressure to do popular shows while talking about esthetics and education." He called Neiman "a third-rate illustrator" and pointed out that his works "have created little talk in the art world." The retrospective, he charged, makes a mockery of "a supposedly serious museum with beautiful gallery space that could have done any artist proud." The Neiman paintings on display "teach us nothing about perception. Their outlook is mundane and obvious. They're facile and vulgar, heavy-handed and glub [sic]. As illustrations they call attention only to themselves."[2]

A letter to the *Minneapolis Tribune* editor from Ray Johnson, of Edina, Minnesota, issued an ardent defense of Neiman against Steele's invective. Sarcastically parroting Steele's prose, Johnson called the journalist a "third-rate art critic, who, under pressure to obtain reader attention, must run down the works of Neiman." He continued by maintaining that Steele's elitism neglected his primary responsibilities to the *Tribune's* readership. "Critics must not forget, in their scramble for readable writings, that their first responsibility is still to art itself: to bring an interested public to art by the written word and to aid in the evaluation of modern artists' works by the test of time."[3] Johnson's heartfelt rebuttal hinged on an appeal to the popularity that Steele found so repellant. These very different reactions to Neiman's success illustrate the main poles between which public reception of his work tended to oscillate after he established his identity as the artist on TV.

Steele was correct that Neiman had not yet received much attention from professional art critics. LeRoy's work, though undeniably pervasive, rarely circulated in the galleries or museums that attracted critical commentary. Art critics were not particularly hostile toward his work to this point because they generally ignored it. Instead, some of Neiman's most aggressive detractors during the mid-1970s represented middlebrow sites wary of being identified with an artist they considered unrefined. *Sports Illustrated's* Pat Jordan, for instance, published a vitriolic article on Neiman in January 1975. Jordan was a contract writer for the magazine who specialized in baseball. He had taken some art courses in college, but otherwise had no formal training on the subject or experience writing about it.[4] He neverthe-

less delivered a scathing attack that cast LeRoy as tacky, obnoxious, and technically inept. "His personal flamboyance obscures deficiencies in his art," Jordan wrote of Neiman. "At best, he is only an adequate draftsman." Neiman, Jordan argued, was a talented showman but a terrible artist. Jordan also accused the artist of never graduating beyond the simplistic fashion illustrations he began his career producing, especially when depicting women.[5]

Jordan's critiques—particularly his observations about Neiman's reliance on fashion illustration tropes and his depictions of women—have merit. But it is telling that *Sports Illustrated*, like the *Minneapolis Tribune*, was comfortable publishing such a cutting story on art written by someone who was not an art critic. Neiman's work, these publications implied, did not require or deserve expert consideration. Jordan's article complemented *Sports Illustrated*'s broader efforts to separate itself from Neiman, who was often mistakenly connected to the magazine by commentators who assumed it published his work. *Sports Illustrated* editors loathed these associations, which they feared might undermine the magazine's literary ambitions. At the time, the publication purchased nearly $100,000 worth of sports art each year to decorate its offices. But the managing editor John Tibby smugly told the *Los Angeles Times* that his weekly "never asked Neiman for a nickel's worth" of his work.[6] *Sports Illustrated*'s attitude toward Neiman shows the popular magazine serving as an unlikely gatekeeper in middlebrow culture. It sought a popular readership, to be sure; but its editors found Neiman to be overly simplistic and commercial. *Sports Illustrated* imagined an audience, to use Jordan's words, that would see through Neiman's flamboyance and be unmoved by his work.

Neiman defended himself as a legitimate and sincere artist amid the rising swell of criticism. "I'm not a phony, I'm a classically trained, scholarly, hard-working, in-the-middle-of-things kind of artist. There's not a bit of phoniness in me." He mainly used populist rationales to defend his work. As he remarked about his style, "the idea is not to be unclear, but to make clarity seem accidental." LeRoy sought to challenge viewers, but not to the extent that his art would confuse, alienate, or fail to entertain. And he was unapologetically committed to

painting whichever figures captured the public interest. "If a guy gets hot, I'll do him," he told the *Detroit Free Press*. Neiman insisted that he was not pandering, but rather bringing art to those who might normally be intimidated by it through depicting subject matter they enjoyed. And his populism was not boundless. LeRoy staunchly separated himself from those artists whom he deemed shoddy or derivative, such as Wayland Moore or Walter Keane, who took credit for the paintings of teary-eyed waifs that his wife Margaret Keane produced. "They treat me like I'm some kind of Keane painter," Neiman groused of his critics. "Well, I'm no hack like Keane. I'm a real artist."[7] While he shared Keane's popularity, Neiman maintained that his art held up a probing and instructive mirror to American culture in ways that Keane's treacly work did not. His work celebrated and capitalized on sports, sex, and leisure; but it also provided opportunities for audiences to contemplate these complex facets of society. Such defenses, of course, also served as canny marketing that reassured Neiman's fans that they were purchasing legitimate and tasteful art despite what they might read about the celebrity artist in the *Minneapolis Tribune* or *Sports Illustrated*.

"I struck a chord," Neiman told the *New York Times*. "History will rate me with Andy Warhol, Norman Rockwell, and Walt Disney."[8] Neiman never hesitated to put himself into prominent company—however outrageous the parallels might seem. But his self-comparison to Rockwell was especially apt. By the 1970s, Neiman had become a sort of Rockwell for the television era who updated the homespun *Saturday Evening Post* artist's mass-mediated, commercial, and accessible approach with a faster-paced vision of Americana. Galleries frequently packaged Neiman and Rockwell together because of their overlapping audiences and significant print inventory. In 1976, the *Saturday Evening Post* hired Neiman to create a painting of the tennis star Chris Evert that would appear on the cover of its May–June issue. His illustration captures a Rockwellian wholesomeness by depicting Evert in a white tennis skirt with her golden tresses held back by a delicate pink ribbon. But Neiman's painting also accentuates the twenty-two-year-old's sexiness by showing her skirt flying skyward

while she is in action. Neiman overlays Evert's innocence with the allure of *Playboy*'s Playmates. His *Saturday Evening Post* cover fused Rockwellian sentimentality with Hefnerian titillation.

* * *

Roone Arledge reinforced Neiman's Rockwellian status by granting the artist a more prominent role in ABC's coverage of the 1976 Summer Olympic Games in Montreal than he enjoyed in Munich. With Montreal, Arledge sought to outdo Munich on all fronts. The network paid $25 million for rights and intended to air most of its seventy-four hours of coverage during prime time. By the 1976 Olympics, ABC had worked its way into first place among the United States' major networks. Montreal would help to maintain this position both by attracting viewers and, just as important, promoting ABC's other programming.[9]

Neiman again served as a special correspondent. But this time, he painted an 8′ × 12′ mural of the event in ABC's main studio as the Olympics proceeded. At a press conference, Arledge explained Neiman's role while the artist sat next to him sketching. Both brandished unlit cigars on the dais, and Neiman sported a paint-splattered shirt. When Arledge finished his announcement, Neiman previewed the mural as "a panorama of the Olympic Games in my most emotional colors" and claimed that it would constitute the "most noble, challenging effort" of his career.[10]

ABC outfitted Neiman in a custom pair of canary yellow coveralls—which became increasingly saturated with colorful splotches as the Games wore on—that matched its commentators' blazers. As in Munich, Neiman wandered around and sketched events during the day. He then painted next to Jim McKay's anchor desk at the ABC Sports studio in downtown Montreal's Cité du Havre district. Each evening Neiman offered a live update on his work in progress. McKay underscored the painting's Olympian significance by introducing Neiman as the "most famous sports artist in the world" and proclaiming that "never before have 50 million or more people, night after night, watched an artist create a great painting." Neiman dubbed the mural

Olympic Ring, a dual evocation of the Olympics' interlocking rings logo and the German composer Richard Wagner's Ring Cycle (*Der Ring des Nibelungen*) that shared his references' epic connotations.

He described the mural as a "circular composition of interlocking stories" structured around a collection of flags in the center of the canvas. The Olympics flag sits prominently in the center and is wreathed by overlapping banners from the United States, Soviet Union, Canada, and other easily recognizable countries. "The flags were the core of the painting," Neiman explained, "and all the events that would happen in these remaining weeks would fan out from these representatives of the competing nations." Sporting scenes swirl counterclockwise around the flags. A bike race in the top right corner curves toward the upper middle of the canvas; the top left corner features a diver with her back arched toward the lower left, which guides the viewer's eye toward group of runners gliding across the bottom toward the center. Neiman unsurprisingly featured a disproportionate number of American athletes to reflect ABC's US-centric coverage. Neiman also made additions and alterations as the Games developed. "In keeping with the way I work, there was no pre-plan, just be open to whatever happens," he explained. LeRoy originally reserved a space in the lower middle of the canvas for the marathoner Frank Shorter, who was expected to repeat as champion. But he decided to omit the distance runner when Shorter earned only a silver medal. "I'm disappointed Frank didn't win," Neiman told McKay during a broadcast while pointing to the location where he originally intended to paint the runner. "I'm putting the US rowers in this space."[11]

Neiman got the most out of his time on camera by sprinkling his appearances with wisecracks and stunts. At one point he sat on the American shot-putter Brian Oldfield's shoulder, using the mammoth athlete as a ladder to reach the top of his canvas. When the erudite and often-pretentious Howard Cosell stopped by the studio to ask Neiman how he might classify his creative approach, the artist quipped that his singular style could be described only as "Neimanism." LeRoy's brief segments, as one ABC publicist put it, provided "a great time-filler" for the network's coverage.[12] They were events

within an event that ABC promoted surrounding commercial breaks and used to comment on those sports and athletes Neiman included in—and excluded from—the mural.

"Did you see the photographers at the Games? There were thousands of them," Neiman said to stress his originality among the throngs of media professionals in Montreal. "They marched them into the stadium like foot soldiers. Painting on the other hand is a unique thing. It's real. The artist seeks an image that can be achieved in no other way." ABC even positioned Neiman's work as a sort of sporting feat. At one point, McKay asked the artist if his completion of an 8′ × 12′ mural in eighteen days was a personal record. Neiman responded that the task demanded "total dedication" and claimed he was "giving as much as the athletes" to complete it by the time the Games ended. "For an artist to paint the Olympics is as powerful as it was for Michelangelo to paint the Sistine Chapel," Neiman gloated. More than likening himself to the Renaissance master, Neiman claimed he was freer to follow his inspiration than his artistic ancestor. "The courts and the Pope told [Michelangelo] what to do," he said. "But I was responsible to no one but myself. Roone visited the set frequently during the Games. But at no time did he tell me what to do."[13]

Regardless of Neiman's apparent creative license, critics found his *Olympic Ring* to be a simplistic reflection of television's tendency to prioritize marketability over substance. The *Detroit Free Press*'s Bettelou Peterson praised most of ABC's Montreal coverage but insisted that "less, in fact, nothing of LeRoy Neiman and his mural would be an improvement."[14] The arts and culture magazine *New West* panned Neiman's work as a "debacle" and "sports-art fiasco." Neiman's mural, the magazine's Peter Plagens and Walter Gabrielson chided, "turned out to be just a mildly graphic, slapdash canvas about winners, flags, and winning—which is probably what ABC wanted anyway." Neiman, for instance, positioned the United States' flag most conspicuously among the national banners in the center of his mural. He also exploited Cold War sentiments by putting the US flag directly above and partially over the Soviet Union's flag—even though the United States finished third in the medal count behind Russia and East

Germany. The perceptive Cosell asked the artist whether there was "some motivation of the hammer and the sickle directly beneath the American flag." "I think it's deliberate, yeah," LeRoy casually replied. Neiman did not elaborate on his motives, but he acknowledged that some degree of nationalism informed the shape his mural took. Like Arledge, Neiman was building a narrative that would please ABC's viewership and the advertisers that sought to reach it.

ABC was pleased with Neiman's contribution to its coverage, which successfully maintained its top position among networks. Neiman's mural stressed the Games' fabled qualities and the role ABC Sports played in realizing them. Comparisons to Michelangelo were clearly overblown, but the *Olympic Ring* offered a novel combination of corporate advertising and public art that used television to become one of the most widely and collectively experienced paintings ever. "While it is not a completely realized piece," commented *Arts Magazine*'s Therese Schwartz, "it was a first: and for better or worse, millions saw an artist at work."[15]

As with Munich, requests for prints of the *Olympic Ring* flooded ABC. The network anticipated the inquiries this time and arranged with Neiman to have prints processed immediately after he completed the mural. The prints—both serigraphs and posters—were released in concert with an exhibition of Neiman's Montreal works at Hammer Graphics' gallery. Before the show, ABC contacted Leibovitz with a request to alter some promotional materials to make clear that the network owned the copyright to Neiman's mural. "Contractually, ABC owns the mural," Neiman said of his arrangement with ABC. "But artistically, I still own it. After all, Michelangelo still owns the Sistine Chapel." A Hammer Graphics advertisement marketed the *Olympic Ring* serigraphs by appealing to their "as seen on TV" status—an unusual way to promote art at the time but one that would more effectively reach Neiman's main audience than emphasizing his SAIC pedigree.[16]

A simultaneous partnership with Burger King increased the attention Neiman received during the Olympics. He contracted with the fast-food restaurant to produce four sports paintings that would be

reproduced as posters and given away during the Olympics. As one announcement said: "Buy any sandwich at Burger King from now until August 5th and you'll get a free sports print created especially for Burger King by LeRoy Neiman, the world famous sports artist. There's track, swimming, gymnastics and basketball. Every week you get a different print. Free (while supplies last) So have it your way . . . and get a Neiman." Burger King gestured toward the posters' artfulness by partnering with a company that would frame the pictures for those who planned to preserve and display their Neimans.[17] The promotion was mainly targeted at kids. Burger King even augmented the prints with free book covers that combined Neiman's sports art with a table of weights and measures and other learning aids to ensure their circulation among the school-age set.

As with most of his partnerships, Neiman maintained approval rights over any advertising Burger King used for the collaboration. He signed off on one promotion that ran in a national television campaign but exploded with anger when a print ad using the same concept was set to run in *Sports Illustrated*—a seemingly reasonable place given the magazine's subject matter and audience. His displeasure was directed not at the content of the advertisement but at its presence in *Sports Illustrated*, which had upset him with the Pat Jordan piece it published the previous year. Jose Alberni, Burger King's director of divisional marketing, attempted to calm Neiman with a flattering letter. "This ad was conceived by BBDO [Advertising Company] and presented to us," he wrote remorsefully. "This assumption was made because we (Burger King and BBDO) had already gone through the process of approval on the TV commercial." The Burger King executive apologizes for Neiman's disappointment but explains the understandable rationale behind their plan to place the ad in *Sports Illustrated*. Alberni ended his message on an obsequious note:

> In closing, let me say that we at Burger King are very proud of this promotion and feel that we will enjoy a significant reputation for having done it. I hope you too feel proud about it. Putting everything else aside and setting what we have done in its proper perspective—we

have given millions, who could never have afforded it the opportunity to own and appreciate 'art' at its best, and that fact that the 'art' is a Neiman makes it even more significant to us, to those receiving it, and I think to you, because after we are through we can all safely assume that you will be more widely known, owned, and admired than any other artist ever.[18]

Although clearly designed to pacify the thin-skinned Neiman, Alberni's flowery statement was not complete hyperbole. At the time, Neiman was simultaneously appearing on prime-time network television and serving as the face of a nationwide fast-food promotion that put hundreds of thousands of his prints into circulation. Not even Rockwell enjoyed that kind of visibility or reach. Neiman's work with Burger King cemented the identification he established with mass culture by appearing on television and making prints to satisfy the demand his TV work created.

Neiman described the Montreal Olympics "as the height of [my] exposure" and admitted that he "shamelessly basked in this windfall of notoriety." "I tapped into a new kind of audience, people who didn't know much about art, and had little interest in it," LeRoy maintained. "Watching my drawings come to life on TV helped them feel part of the action. This was not art tucked away in some exclusive gallery or imposing museum, this was art in real time."[19] Affirming his exceptional fame, a December 1976 episode of the short-lived NBC variety show *Van Dyke & Company* offered a lighthearted send-up of Neiman's performance in Montreal. "I'm sure most of you saw the beautiful paintings that the artist LeRoy Neiman did during this year's Olympics," host Dick Van Dyke said during the program's opening. "Well, our show's not as special as the Olympics, of course, but nevertheless, we're borrowing from that idea tonight and we've invited a famous painter to come here and paint our show." Rubber-faced Sid Caesar plays the fictional artist Werner Von Schloppa, a cartoonish amalgam of painterly stereotypes with a thick German accent who seems more interested in maximizing his time on camera than producing the mural. Von Schloppa, like Neiman in Montreal,

wears paint-saturated yellow coveralls. The NBC program uses Von Schloppa to roast Neiman's contribution to the excesses that marked its competitor's Olympics coverage. When Van Dyke checks on Von Schloppa at the end of the show the artist reveals a massive portrait of his own face—a playful poke at Neiman's tendency to hog the limelight. The parody attested to LeRoy's recognizability among the network audience *Van Dyke & Company* attracted. The Von Schloppa gag would land, of course, only if viewers were well aware of Neiman and his work for ABC.

* * *

As a result of Neiman's rising celebrity and occasional work for other media outlets, ABC signed him to a one-year exclusive deal in 1977— its first such agreement and the first time a sports television outlet had an artist on retainer. The contract stipulated that he would sketch ten events of ABC's choosing for $2,500 per appearance.[20] Neiman would own the originals he produced on camera and receive a cut of whatever proceeds ABC made on prints of his "as seen on TV" works.

Neiman's exclusivity with ABC covered only appearances on sports television. The roving artist would often appear on local TV news and talk shows in whatever town he passed through. He would generally sketch the hosts and guests while espousing his leisure-loving worldview and promoting the serigraphs that were most recently on the market. In 1977, for instance, he visited a special episode of Dinah Shore's talk show *Dinah!* that was taped at the San Diego Zoo. Like his sports television cameos, Neiman drew select animals as the show progressed (he was especially enamored by the tigers) and intermittently displayed his work to the host.

Various television programs and films requested use of Neiman's art or to feature him on camera in some capacity. The NBC daytime soap opera *The Doctors* included several Neiman reproductions as part of its set design. "I think this is a first in Daytime Television to be featuring an artist's work as an integral part of the sets," wrote *The Doctors* producer Chuck Weiss to Neiman's management in 1978. "As you know, he [Neiman] is reaching an audience of approximately 14 mil-

lion viewers, most of whom are women which might in the end give Mr. Neiman a new group of admirers."[21] Neiman's success in prime time during the Olympics made NBC confident that the artist's work might also enhance its daytime soap opera.

Neiman was also involved in proposals for shows centered entirely on him. In 1976, he contracted with the production company Laureate II to develop a one-hour, made-for-TV documentary that would provide "a definitive statement on Neiman." A separate effort saw LeRoy collaborate on a treatment for a talk show titled *Neiman's New York*. Neiman would host the program from his home studio and sketch guests while they waxed about the good life. The proposal surmised that *Neiman's New York* would "appeal to a wide range of audience tastes; from blue-collar sports celebrity buffs to white-collar art lovers; from talk show enthusiasts to the affluent young sophisticates who make it a point to stay au courant with trends and people in the news."[22] Beyond attracting advertisers looking to reach those audiences, the program would promote prints of the drawings Neiman completed during the episodes. Neither show moved into production. But Neiman was happy to attach his name to both while they developed.

The overexposed artist also finally started getting the attention of those renowned critics who had previously ignored his work—but not in the way he would have liked. While writing a short profile on Neiman, Rogers Worthington polled the *New York Times*' Vivien Raynor and the *Chicago Tribune*'s Alan Artner on LeRoy's work and its importance. Raynor thought it ridiculous even to mention Neiman in a serious conversation about art. "I don't see the point in figuring out why he isn't taken more seriously," she told Worthington matter-of-factly. "I know that he doesn't rate high in the fine arts world, and that he is considered a hack by some, and I would agree with that." Artner was similarly unenthusiastic but a little more specific. "The longer you have a picture of his, the less and less it reveals," he said. "Neiman gives it to you all at once. There is color, movement, excitement in what he does. But he is more concerned with a decorative effect, a bold statement that grabs your eye. What he lacks is that

extra dimension."[23] When these notable critics finally mentioned Neiman, they did so only in the most dismissive terms.

In February 1979, the *New Yorker* published "Worldwide Recognition in His Own Lifetime," a short article on Neiman that opens with several paragraphs listing the many places where the always-moving artist had traveled to work—from Yugoslavian nudist colonies to the Mercantile National Bank, of Hammond, Indiana, where he was commissioned to paint an 8′ × 56′ mural titled *Summertime along the Indiana Dunes* in 1965. The article transitions to a series of quotes that its unnamed author "overheard at the opening reception for a show of serigraphs, etchings, and drawings by LeRoy Neiman at the Hammer Graphics Gallery." Eavesdropped fragments of mostly snide comments follow, such as "That would look perfect in my parents' house in Florida" and "The project was a commission."[24] The *New Yorker* piece suggests that those who attended Neiman's exhibition were nevertheless self-conscious about being perceived as fans of his work. The comments distinguish these folks from the taste culture and social class that Neiman's fans represented. These reviews dismiss LeRoy's art on the grounds that it demonstrates kitsch's tendency to pose as legitimate art. It thereby does violence to "real" art and dulls the sensitivity such authentic work might instill in the apparently crude folks who are enamored of Neiman's superficial output.

The *Los Angeles Times*' Harper Hilliard linked Neiman's ignominious reputation to his TV-friendliness: "Neiman's paintings require no work from viewers. Like TV, they provide a passive kind of enjoyment. They do not provide visual nourishment. Caveat emptor. These twinkies of painting may induce visual madness." The *New Times*' Robert Ward reinforced this elitist disdain for the TV-watching and fast-food-eating public Neiman attracted. "Since his appearance on television during the 1976 Montreal Olympics," he wrote, "LeRoy has become, arguably, America's best-known artist. I don't mean in the Art World, which doesn't exist outside of New York, anyway, but in Kansas. Call up someone in Kansas and ask him what painters he knows, he's going to say LeRoy Neiman. After all, they eat Burger King out there."[25] Neiman, Ward charges, was a junk-food shill and

creature of the idiot box whose art was as trashy as the products he endorsed and the medium on which he appeared.

Ward ties his disregard for Neiman's fans to stereotypes of the Midwest as an unrefined cultural wasteland located somewhere between New York and Los Angeles. Other critics echoed that sentiment by tying Neiman's questionable repute to his appeal among Midwesterners. *Art News* called his works "paragons of Middle Americanism" and *Sports Illustrated* referred to LeRoy as "Middle America's own Michelangelo."[26] Neiman's work did take on special resonance in Middle America among a grassroots group of art enthusiasts who called themselves "Picture Ladies." The Picture Lady program, a nationwide effort that was especially popular in the Midwest, was designed to introduce kids to art despite shrinking budgets for arts education in public schools. Neiman was a common choice for the program given students' familiarity with the ABC and Burger King partnerships. "We know that because of your appearance at the Summer Olympics the children will better relate to you than the others," wrote Sally Russell, a Picture Lady from Hutchinson, Kansas, who contacted Neiman to request background materials to help with her lesson. The amateur educators also appreciated that Neiman's work, largely because of the Burger King promotion, was accessible and affordable. "On our PTA budget, we get prints wherever we can!" wrote the thankful Nancy Muzzy, a Picture Lady from Aurora, Illinois.[27]

In a request for background information, Muzzy informed Neiman that she planned to discuss the basketball print he produced for Burger King. LeRoy wrote Muzzy a lengthy reply that praised her volunteer efforts. He then contextualized the basketball painting she selected and explained another recent piece on the sport that he completed in "homage to the great black basketball players over the years." He mentioned what he viewed as "an El Greco-like quality in these basketball paintings above others I do—because of the elongated figures and the soaring upward quality."[28] Neiman's thoughtful response aided Muzzy's lesson planning by describing his artwork's engagement with contemporary society and the inspiration it took from his creative predecessors. It is reasonable to assume that he saw the Midwestern

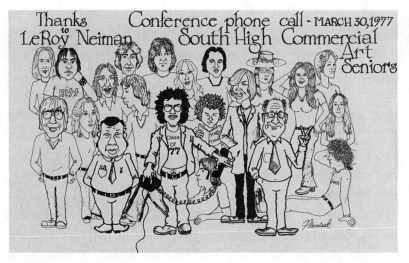

FIGURE 27. Thank-you note to Neiman from a commercial art course at South High School in suburban Cleveland that he visited by telephone in 1977. LeRoy Neiman Papers, Smithsonian Institute, Archives of American Art, Washington, D.C.

Picture Ladies as a continuation of the inspiring female teachers he encountered as a child back in St. Paul.

Complementing his outreach with the Picture Ladies, Neiman participated in a 1977 conference call with a commercial art course from South High School in suburban Cleveland. The students thanked Neiman with a homemade illustration of their class—a motley crew that resembles the cast of ABC's *Welcome Back, Kotter*. The group includes an angsty boy sporting a Kiss shirt and studded cuff, a busty girl wearing a pot-leaf necklace, and another uninterested teen with his nose buried in an issue of *High Times*. Their teacher, Don Terry, added a note to tell Neiman that he was a longtime *Playboy* subscriber and devoted fan. The illustration features Terry up front wearing a shirt with a *Playboy* insignia on the chest.[29] This Midwestern crowd cherished Neiman's approachability, was not concerned with the opinions of critics like Vivian Raynor or Alan Artner, and preferred *High Times* and *Playboy* to the *New Yorker*. Neiman gave the public school students—who otherwise had limited access to art education— artwork that they were capable of appreciating. Moreover, LeRoy's

references to forbears like El Greco at once show him stressing his connection to canonical traditions while suggesting his work offers a suitable entry point into studying art.

Neiman made light of the derision his work for Burger King attracted in an interview on WOR-TV's *Joe Franklin Show*. He joked that Burger King promised him a lifetime hamburger credit, but the gourmet and former army cook then confessed that he had never actually eaten at the restaurant. LeRoy was uncomfortable whole-heartedly identifying with Burger King and justified the collaboration by celebrating how it brought art to the masses. "It was good exposure because I did it for the kids. And I've got a following of kids now that's just enormous," he said. "We've got part of the studio that's just answering the kids." One school kid named Jeff Korbman invited the artist to watch (and presumably sketch) his kickball game at the Hebrew Youth Academy in South Orange, New Jersey. LeRoy explained that he was traveling and could not make the game, but he sent Korbman an autograph. After Montreal, a boy named Lee Maddox from Warner Robbins, Georgia, sent Neiman a note of appreciation and mentioned that "my sisters think your [*sic*] cute." "You are probly [*sic*] the best artist ever and will be remembered forever!" wrote Greg Small from Teaneck, New Jersey, after being similarly dazzled by Neiman's work in Montreal.[30]

Part of the reason Neiman was so loathed by the critics who were beginning to remark upon his ubiquitous work was because of the passionate following he attracted among the unschooled—kids like Greg Small and even the Picture Ladies, who loved art but had little formal knowledge. Clement Greenberg would have counted these folks among the "insensitive" who drive the market for kitsch.[31] Neiman gave these rubes artistic equivalents to TV and fast food. But his work also eroded the cultural boundaries separating the learned and uneducated—barriers that art and knowledge of it help to fortify. "Television watchers not previously exposed to art suddenly discovered it, and Neiman's paintings, drawings and prints became desirable to a vast following of admiring new collectors who would have responded with a blank stare to the names of a dozen leading

artists working today," wrote the *Des Moines Register*'s Nick Baldwin. "People who wouldn't blink an eyelash at Van Gogh like and appreciate Neiman paintings," observed Ward Bushee of the *Salinas Californian*. The *Los Angeles Times* art critic Robert McDonald noted that "there is satisfaction for viewers in being able to explain 'Ah, a Neiman!' as they might also for 'a Dali,' 'a Wyeth,' or 'a Norman Rockwell.'" Neiman's work both pleased his audience and helped them begin to feel comfortable in art culture.[32] LeRoy's art signaled his fans' membership in an alcove of art culture from which the so-called serious art world and its representatives staunchly separated themselves to assert and maintain their status as cultural elites.

As the Picture Ladies recognized, Neiman provided a gateway into art appreciation for many who were not routinely exposed to art or able to procure it. Chip Bodanski, a middle schooler from Ridgefield, New Jersey, wrote Neiman to say that his work in Montreal inspired him to "take any art programs I can" once he began high school the following year. And Stan Bell from Salt Lake City thanked the artist for producing relatively affordable prints. "As one who will never be able to afford a Neiman original, I would like to say thank you for your use of the serigraph medium. These reproductions lend themselves so well to your style it is pure pleasure to say that I own a 'Neiman.'"[33]

And LeRoy's passionate fans treated the artist with a kind of zeal normally reserved for athletes and pop stars. Autograph hounds flooded his mailbox with requests for a signature or sketch. The art dealer Robert Grenon recalls women lining up outside of the Franklin Bowles Gallery in San Francisco before Neiman's promotional appearances and squealing with excitement once they finally caught a glimpse of their favorite artist. The longtime Hotel des Artistes doorman Joe Gonzalez remembered fans waiting outside of the apartment building for hours just to request an autograph or photo.[34] And fans were attracted to Neiman not simply because they admired his art but also because he was a celebrity—the sort of famous-for-being-famous figure that fascinated his contemporary Andy Warhol.

Neiman loved the attention. "Garbage collectors would shout out from the trucks, street workers would call from manholes," LeRoy

recalled. He also took pride in the fact that his most devoted fans tended to represent a workaday segment of society. As he recounted in his journal, "One summer day crossing Central Park a city employee spearing litter with his hook shouted, 'I've got Neimans!'" When Neiman asked the man which pieces he owned, he listed prints of *Bar 21* and *The Super Bowl*. They were "all posters," Neiman affectionately reminisced, "but he was proud of his collection. I bellowed back 'Good eye!' as he waved." "They *love* me," LeRoy said of his fans in 1978. "They don't just admire me. They *love* me. It's a different thing, from being a celebrity. All sorts of people—kids, old people, bums, intellectuals, world leaders, celebrities, rich people, middle class. In the last ten years, I've run into a public that *loves* me."[35]

Neiman handled criticism differently depending on his mood and the source of the derision. Esther Penn recalls Neiman furiously storming out of the room when a fellow artist mocked his collaboration with Burger King. LeRoy saved the negative press he received and kept track of the journalists who slighted him.[36] But he also sometimes seemed mildly entertained by the disparagement, which was perhaps a defense mechanism to suggest the jabs did not bother him. LeRoy's nephew Richard Byrne recalls his uncle referring to himself as "The Artist" in an ironically haughty tone that suggested he did not buy into the cultural authority the title carried. When Robert Ward visited Neiman's apartment to interview him for his 1978 *New Times* profile—a write-up that would ultimately depict the artist as a shallow phony—LeRoy answered the door wearing a robe that Muhammad Ali gave him. Neiman successfully baited Ward, who mentioned the outfit in his article when characterizing the artist as a vain and insecure attention seeker. LeRoy sensed that Ward sought to depict him as a buffoon and made sure the journalist would at least do so on his terms. "When I read unfavorable comments," LeRoy once said, "they're always well written"—a flip suggestion that critics were literate but otherwise make few lasting contributions to public discourse.[37]

But the self-aware Neiman undercut any irony he sought to convey with the crude and intolerant rationale he gave Ward for his critical

dismissal. He managed to exhibit several forms of bigotry within a couple of breaths when discussing his outsider status. "You've got to have some kind of lobbyist group," he said. "You remember what I was telling you about the Jews? Well, the Jewish critics support their own." When their conversation turned to Andy Warhol, Neiman chalked up much of the pop artist's success to the fact that he "has the homosexual mafia behind him. You see, they are another taste-making clique, but if you quote me on this please don't make it sound as if I'm anti-gay, because I'm not . . . But ask around," he continued, "any honest person will tell you that there are a large number of gay critics and painters who support one another. I don't fit into any of these molds."[38] Although Neiman reassured Ward that he was not anti-Semitic or homophobic, he made clear that his position as a straight white man whose work mainly attracted other straight white men did him no favors in the art world. Such gripes dovetailed with more general reactionary complaints about white male victimhood that were gaining currency in the 1970s. Neiman surely realized that such retrograde sentiments would make him only less appealing within the mostly progressive art world. He also likely understood that his comments might resonate with his principal audience of middle-class *Playboy* readers and sports fans.

* * *

Recognizing Neiman's sustained popularity, in 1978 the US Olympic Committee named him its official artist for the Winter and Summer 1980 Olympics. But Arledge lost interest in Neiman shortly after Montreal. ABC Sports barely used the artist in 1977 despite their exclusive contract. "I felt neglected," Neiman recalled of the suddenly dormant partnership, "month after month passed with no communication." Arledge did not respond to Neiman's many queries and never commented on why ABC Sports stopped using LeRoy. But it seems safe to assume that the novelty had worn off as the artist became more visible and divisive post-Montreal. Neiman finally got Arledge's attention when he signed a one-year deal with CBS Sports in 1978. According

to LeRoy, Arledge called him "disloyal" and vowed he would "never be used again" on ABC—a guarantee on which the powerful executive delivered.[39]

CBS conscripted Neiman to aid its ongoing efforts to compete with ABC. The centerpiece of the deal was an appearance on the January 15, 1978, Super Bowl XII broadcast, for which it paid Neiman $10,000.[40] CBS spent a record $4.5 million on rights to televise the Super Bowl from New Orleans's Superdome. It scheduled the game during prime-time hours for the first time and sought to recoup the expenditure by charging $325,000 for a minute of advertising, another record. Like ABC, CBS Sports had Neiman sketch the game on camera. But he produced his art on an experimental Electronic Palette, a product of CBS and the Ampex Corporation that was developed to aid the network's news coverage. The Electronic Palette allowed artists to "paint" with a stylus onto a tablet that fed into a computer memory and was displayed on a monitor. Artists could choose from a 256-color inventory, control saturation-levels, and simulate a variety of techniques that included watercolor, oil, and pen and ink. "Paintings can be executed quickly," reported the television trade publication *Back Stage*, "with errors corrected simply and precisely with electronic erasures." CBS billed the newfangled gadget as having the ability to foster "impressionistic" work comparable to Neiman's paintings.[41]

While promoting the Super Bowl coverage, CBS Sports' president Robert J. Wussler predicted that Neiman's work on the Electronic Palette would spark a new era in the aesthetics of television. "For years, we have felt that the marriage of computers and graphic design would be ideally suited for the medium of television," he said. "Finally, the Electronic Palette has brought us out of the dark ages and into something very special that all our viewers will appreciate. In ten years, this technology will be second nature." As Joseph Flaherty, CBS's vice president of Engineering and Development, added, "Traditional television graphics systems limit the artist's images to fairly simple geometric shapes, while the Electronic Palette actually expands the artist's horizons."[42] The venture marked the beginnings of networks

using Super Bowl broadcasts to debut eye-catching new technologies, which is now a staple ingredient of the annual sports media ritual.

Neiman said that he traveled to Ampex's Silicon Valley headquarters several times in advance of the Super Bowl to get a feel for the Electronic Palette. He promoted his work on the contraption with the same gusto as his Montreal mural by saying his efforts would revive what had become an "antiseptic" medium. "Without question, I call this the art form of the future," he enthused at a Super Bowl pregame party.[43]

When the game began, Neiman and his assistant Lucette were perched in a Superdome luxury box overlooking the field. Neiman donned a yellow shirt and a sparkling gold vest. Lucette wore a turquoise gown, feather boa, and sun hat. CBS periodically cut to Neiman's electronic sketches throughout the game—especially during interstitial moments when it had a few seconds to spare. It displayed his impressions of the starting lineups as the announcers introduced the Dallas Cowboys and Denver Broncos. As the broadcast segued into halftime, CBS showed Neiman's drawing of a key play from the first half. LeRoy's signature emerged on the lower-right margin of the artwork to suggest he was putting the finishing touches on the digital piece in real time. The coverage ended with a montage of highlights from the game, which the Cowboys won, as Frank Sinatra's song "Winners" rang out. The montage closes with video footage of the victorious Cowboys coach Tom Landry being carted off the field, which transitions to Neiman's depiction of the coach. The cut from video to the electronic drawing suggests that CBS's coverage aligns with Neiman's artful and innovative approach.

Neiman's Electronic Palette sketches were perhaps the only truly experimental art of his career. But the work he produced for CBS was difficult to decipher and appeared smudgy with dull coloring. It lacked both the punch of his usual color palette and the precision of his action sketches. Reviewers held little back when assessing the works. The *Baltimore Sun* compared Neiman's electronic drawings to "one of your kid's rejects from kindergarten." As the *Boston Globe's*

Jack Craig lamented, "whatever was the significance of artist LeRoy Neiman's conversion to an electronic palette as he sketched Super Bowl personalities, he could not explain it to the TV audience, much as he tried." The *Philadelphia Daily News* offered a more direct but equally damning response: "LeRoy Neiman was awful."[44]

Even CBS play-by-play announcer Pat Summerall and color commentator Tom Brookshier seemed puzzled by Neiman's role on the broadcast and unsure about how they might weave him into the coverage. At one point, Brookshier mocked Neiman's gaudy appearance when the camera cut to the artist sketching next to Lucette. "And there's Mr. Neiman . . . the one on the right," Brookshier said through a chuckle that implied the dandy artist was out of place in the macho world of football. "That's what it looks like to LeRoy Neiman," Summerall remarked when the telecast displayed Neiman's sketch of a first quarter touchdown play, "a blur." A few minutes later, Brookshier cracked that the Electronic Palette "sounds like something in your mouth" and the commentator could not help but mention that Tom Landry "looked better live" when CBS showed Neiman's drawing of the coach. In a postgame interview, Brookshier admitted that he thought the broadcast's stylistic flourishes were overblown. "It was really show business," he offered.[45] Neiman's over-the-top electronic artwork typified the Super Bowl broadcast's permanent transformation into a prime-time corporate spectacle defined as much by its excesses as by the game itself.

But more people watched CBS's Super Bowl XII broadcast than any program in the history of television—sports or not. The CBS executive Craig K. Tanner sent Neiman a note of appreciation shortly after the game to praise his work on camera and perhaps to balance the criticism it attracted. "I'd like to take this opportunity to congratulate you on your contribution to the Super Bowl broadcast," Tanner wrote. "I have heard many enthusiastic comments about your work with the Electronic Palette, indicating that your paintings greatly enhanced the on-air presentation of that game for the millions who were watching. An exacting task well accomplished." Neiman later expressed befuddlement at why the Electronic Palette was not more widely

adopted after Super Bowl XII. "Computer painting is a problem, and it hasn't been totally accepted," he said in a 1980 interview with Lezly Garrett. "It's just a mistake on the part of the networks not to use it as they should." *Broadcasting*'s Het Vennenbos hazarded that the Electronic Palette's association with Neiman, whom he affirmed was "not thought of as in the first rank of illustrators," may have stalled its adoption by suggesting that the gadget "encouraged somewhat primitive work."[46] While the Electronic Palette did not catch on, Neiman's on-air work with the technology did anticipate the Telestrator, a similar but more explanatory digital tool that CBS debuted for its 1982 Super Bowl XVI broadcast. The Telestrator became a commonplace feature in sports TV—as well as a staple of weather programming—shortly after the CBS broadcast introduced it to a mass audience.

CBS Sports signed Neiman to another one-year contract in 1979. The agreement stipulated that he would have at least six appearances on camera and be paid $10,000 for each.[47] The deal also allowed CBS to use LeRoy's artwork for introductory sequences and bumpers that bookend commercial breaks. The network principally relied on Neiman for *CBS Sports Spectacular*, a weekend anthology program scheduled against ABC's *Wide World of Sports*. The show's introduction features a fast-paced montage of sundry sporting events as a modernized and guitar-heavy adaptation of Aaron Copland's "Fanfare for the Common Man" plays in the background. The video footage transforms into Neiman paintings of the same sporting events along with cuts to a human eye and CBS's eye logo. The opening montage insinuates that CBS offers a humanized and inventive way of seeing sports that is only otherwise witnessed in artwork—and Neiman's art in particular. At the end of the sixty-second sequence, Neiman's signature appears on the bottom right of corner of the frame. CBS Sports' flagship show pins its entire identity on Neiman's aesthetic—a demonstration of the artist's unusual clout in network sports television during this moment.

Aside from featuring Neiman's work in its introduction, *CBS Sports Spectacular* sometimes accompanied its event coverage with travelogue features in which the artist offered his thoughts on and sketches of the places where the program traveled. He appeared on its coverage

of the 1979 Royal Ascot horse race in England. The posh event was ideal for Neiman—who had devoted a July 1966 installment of *Man at His Leisure* to it—because of the tuxedos and gowns attendees showed off while watching the race. "This event was just made for your style, wasn't it?" CBS Sports host Dick Stockton asks Neiman during the prerace coverage. Stockton wears the standard-issue CBS blazer. Neiman, in contrast, dons a gray tuxedo, top hat, and ascot tie—the signature costume for gentlemen in attendance. "Well, I'm attired for the occasion, I'll tell you that," Neiman responds. "If you want to flaunt your art on television, you got to meet the occasion." The program then cuts to Neiman's segment, which is driven by a voice-over the artist wrote and performed. Footage of Neiman sketching the fancy scene is interspersed with shots of his drawings as the song "Ascot-Gavotte" from *My Fair Lady* plays. The song's lyrics—which include the lines "everyone who should be here is here"—underscore the exclusivity of the race.

Neiman's commentary and sketches focus on Ascot's pomp and circumstance. "In the Royal Enclosure, Ascot people are in the custom of high occasion," he announces with the enthusiasm of a carnival barker. He peppers this reportage with commentary on the superficialities that characterize this "British Halloween" by noting the many "snobs" in attendance. Ascot, Neiman contends, is not simply a sporting event, but a powerful stage on which the well-heeled flaunt and fake their social status. "At Ascot, the rich are more anxious to be gentlemen than the gentlemen are to be rich. But all told, the snubbable outnumber the snubbers," he concludes. Neiman's commentary offers cultural context for CBS's primarily American viewership while reflecting the wry populism that animates much of his work and point of view.

A separate 1979 *CBS Sports Spectacular* segment features Neiman prancing around Tokyo. It begins with footage of the city's bright lights that is edited to keep pace with an upbeat Japanese pop song. Eschewing voice-over, it adopts the format of a music video that shows Neiman luxuriating in Tokyo's dizzying nightlife with a group of young women as the song pulses. LeRoy and his playmates toast

with sake, eat sushi, and dance at a night club while his sketches—all of beautiful Japanese ladies like those who escort him—intermittently appear on the screen. At one point, Neiman exits a restaurant with two women clinging to his arms. Another woman approaches the trio, kisses LeRoy, and happily joins the group as they trot off toward their next adventure. The segment never mentions sport or the events CBS traveled to Japan to cover (baseball, boxing, and skiing). Instead, CBS uses the globetrotting Neiman to offer an introduction to Japanese leisure culture while suggesting that its viewers belong to a cosmopolitan taste culture not too different from the one LeRoy helped *Playboy* build with *Man at His Leisure*.

* * *

Neiman's partnership with CBS Sports ended after 1979 for undisclosed reasons.[48] But sports media properties outside of network TV continued to hire him to help build and signal their legitimacy. Sylvester Stallone invited LeRoy to the set of *Rocky II* (1979) and gave the artist a cameo in the film. Neiman sketches Rocky Balboa antagonist Apollo Creed while the boxer was training for the movie's climactic match. Creed jumps rope while LeRoy, wearing an all-white suit, leans against a boxing ring and works the sketch pad. Stallone includes an over-the-shoulder shot of Neiman's drawing in progress. Creed, a character based on Muhammad Ali, was the sort of dazzling boxer Neiman would sketch were he real. LeRoy appeared in every subsequent Rocky film until he died, and *Rocky III* (1982) ends with a shot of Neiman's painting of Balboa and Creed squaring off. Stallone used the artist to help emphasize the event status of the fictional matches that take place in the movies and to align those contests with the actual sporting world.[49]

Not long after the release of *Rocky III*, Stallone ventured beyond film and into actual boxing promotions by staging a tournament called Night of the Tigers. The gimmicky event, which featured a slate of obscure fighters, took its name from the *Rocky* theme song "Eye of the Tiger." It leveraged the Rocky myth to build an audience by dangling the possibility that a real-life Balboa may be competing among

the unknown pugs. Night of the Tigers used a Neiman painting of Rocky Balboa to advertise the event, which the upstart cable sports channel ESPN contracted to televise.

ESPN built on Night of the Tigers by collaborating with Neiman to sell prints of an altered version of *Football Star Constellation* (1978), a painting he completed after Super Bowl XII. The piece commented on the increasingly technologized and mediated sport by showing football players competing in orbit. "Television makes football more than an air-and-ground game," Neiman said of the painting. "It becomes stratospheric . . . The pass rides on the roar of the crowd, literally off the Super Bowl field, and projects the players into outer space, feeding the audio and video to satellites, then bouncing them back to Earth." ESPN offered to market a print of the painting over its airwaves if Neiman added the channel's SATCOM 1 satellite.[50] Neiman—at this point no stranger to making alterations to appease clients—happily obliged. The print would be exposed to a captive audience of sports fans who overlapped with the general market for Neiman's work. ESPN, in turn, would gain some legitimacy by getting the Neiman treatment that the artist had previously applied to ABC, CBS, and the *Rocky* films. The collaboration occurred as ESPN was still selling cable providers and consumers on the idea of around-the-clock sports television. Aligning with Neiman—like securing the rights to a popular event—helped to this end.

Save the ESPN collaboration, Neiman's work on sports television mostly dried up by the end of the 1970s.[51] The artist later claimed that Arledge's betrayal was a blessing in disguise. Otherwise, LeRoy speculated that he might have become a full-fledged "TV personality" and turned away from his art. But Neiman continued to integrate TV, and even ABC, into his artwork as he saw fit.[52] In 1982, the National Bowling Hall of Fame in St. Louis commissioned Neiman to paint the champion bowler Earl Anthony. Neiman's painting, *Million Dollar Strike*, includes in the background ABC Sports' broadcast team covering the event for *Pro Bowlers Tour*, which aired on Saturday afternoons after *Wide World of Sports*. And Neiman attempted to reunite with ABC for its coverage of the 1984 Summer Olympics in Los Angeles—

for which he was already serving as the US Olympic Committee's official artist. Leibovitz sent Arledge an autographed copy of Neiman's *Winners* (1983)—a coffee-table book like *Art & Lifestyle* that focused on sports—along with a note suggesting that his client would love to be part of ABC's broadcast. "I know that LeRoy is proud of having been part of the ABC team on those great and memorable Olympics," he wrote. Leibovitz sent a more direct entreaty to ABC executive Jim Duffy. "I think it would be good for ABC, as well as LeRoy Neiman, If we can get over some prior misunderstandings and have LeRoy do his thing with ABC for the 1984 Olympics."[53] ABC passed on the offer.

By the time LeRoy's work on television fizzled, sports TV had attained the cultural legitimacy and economic power that it originally hired Neiman to help establish. Sports TV enjoyed a robust viewership, committed advertisers, and mature technological accoutrements like the Telestrator. Neiman played a small but important role in helping sports TV to develop into an economic force as well as a site of middlebrow cultural production capable of creating art. In fact, the annual Sports Emmy awards launched in 1979—shortly after Neiman's work for ABC and amid his contract with CBS—to recognize exceptional creative accomplishments in the genre and to suggest that sports TV was capable of such achievement.

And America's most popular medium made Neiman its most popular artist. By 1982, Maury Leibovitz was boasting to *Forbes* magazine about a survey that showed "37 percent of teenagers recognized Neiman's name—an exceptional figure for a living artist." That same year, the critic Robert Hughes called Neiman the second most famous artist in the world, after Andrew Wyeth.[54] LeRoy largely had television to thank for this recognition, as well as the reputation that seemed to dip lower as his media-driven popularity rose higher.

PART 3

Outcast

13

Bringing Disease to the Hospital

In May 1985, LeRoy was invited to participate in a group installation at Area—a trendy Manhattan nightclub frequented by artists and celebrities. Area set itself apart from other local hotspots by changing its theme every six weeks. The transformations featured complete redesigns with different exhibits and performances. Area's May 1985 motif was art, and Neiman agreed to supply works along with Andy Warhol, Jean-Michel Basquiat, Keith Haring, and Robert Mapplethorpe.[1]

Area's co-owner Eric Goode gathered Art's high-profile contributors at Mr. Chow's restaurant on East Fifty-Seventh Street—another hangout popular among the artsy set—for a dinner celebrating the upcoming theme change. Goode agonized over how to seat the assembled artists, many of whom had tense relationships. He wound up assigning LeRoy to a table with Warhol and Basquiat. Neiman recalls Mr. Chow's eponymous owner Michael Chow working to document the occasion by passing a sketchbook around to the artists as they ate and mingled. LeRoy affably provided a doodle and then passed the book to Basquiat, who made a far more audacious statement by slamming his plate of food onto it.[2]

Goode also hired the photographer Michael Halsband to take a group portrait that would serve as part of the invitation for Area's reopening. Halsband corralled the artists and some hangers-on into a corner and climbed a ladder so he could fit the conglomeration of twenty-eight into a single frame.[3] Even in this colorful crowd LeRoy found a way to stick out. He stands in the back row between David

Hockney and Dennis Oppenheim while raising a champagne flute to toast the occasion—a pose that continues his long history of celebrating fine dining and high society. Neiman is just behind Warhol, whose pale and expressionless face is partially obscured by the brim of the sculptor John Chamberlain's fedora. Basquiat is front and center, staring directly into Halsband's lens.

Neiman was an odd member of the vaunted assembly. He was the most widely known artist present that evening, and probably the only one aside from Warhol who would be recognized on the street outside of New York City. Yet he did not belong among the Basquiats and Hockneys. As the musician and painter John Lurie later recalled of the event, LeRoy "had no idea what he was doing there."[4] But Neiman gladly accepted Goode's invitation to briefly share the stage with his less popular but more respected colleagues.

The same year as Area's exhibit, an East Hartford, Connecticut, Chevrolet dealership partnered with LeRoy to produce a limited-edition Neiman-designed Corvette and sell his serigraphs out of its showroom. There was enough demand for Neiman's work that it could be peddled at a suburban car dealership. It is difficult to imagine Mapplethorpes being sold in that environment—or for Robert Mapplethorpe to allow his art to be hawked alongside sedans and station wagons. These wide-ranging activities made the 1980s the period during which Neiman achieved his greatest fame and infamy. He became ubiquitous in popular culture and enjoyed the tremendous material benefits that came along with this visibility. But Neiman's popularity—coupled with his seeming willingness to accept nearly any moneymaking opportunity that presented itself—solidified his reputation as an artist whose work attracted those who were incapable of appreciating genuine art.

* * *

LeRoy received his first invitation to the White House in the summer of 1978. President Jimmy Carter was hosting a concert on the South Lawn to celebrate the Newport Jazz Festival's twenty-fifth anniversary. Over eight hundred guests attended performances by Dizzy

Gillespie, Dexter Gordon, Sonny Rollins, Mary Lou Williams, Cecil Taylor, and others. Neiman had been illustrating Newport's posters for several years at that point, and he was brought in by the festival's organizer George Wein to document the special offshoot event.

Neiman returned to the White House six months later with Maury Leibovitz to present Carter with a signed poster of the painting he created for the concert. The duo was unable to get on the president's schedule that day, but they met with his assistant Richard Harden and gave him the artwork instead. "I presented your poster to the President," Harden wrote LeRoy, "and he was delighted to receive a work on a subject so dear to his heart." Carter's secretary Susan Clough reiterated the appreciation. "If a Presidential library is built in the future, your inscribed work will be placed there."[5] While Neiman and Leibovitz did not get a chance to meet Carter, they discussed the possibility of future collaborations with Harden, who thought the president might be able to use LeRoy's services for his Council on Physical Fitness and Sports or another suitable endeavor he needed to publicize.

Carter had previously hired artists to help with his campaigns and fundraising. Warhol created a portrait of Carter that was used during his 1976 presidential campaign. And Carter hired five well-known artists—Jacob Lawrence, Roy Lichtenstein, Robert Rauschenberg, Jamie Wyeth, and Warhol again—to paint their impressions of his inauguration on January 20, 1977.[6] Neiman was not included in those efforts, but Harden believed the popular artist and registered democrat could make an impactful contribution. Neiman and Leibovitz sent Harden a signed poster of the golfer Arnold Palmer to ensure that the bureaucrat would remember his promise to connect LeRoy with Carter.[7]

The president's office quickly found use for Neiman by hiring him to commemorate the March 1979 signing of the Egypt-Israel peace treaty. Carter brokered the treaty after hosting Egyptian president Anwar Sadat and Israeli prime minister Menachem Begin at Camp David for thirteen days of intense negotiations in September 1978. The treaty, which biographer Jonathan Alter called "the most impor-

tant and durable peace treaty anywhere in the world since the end of World War II," became the crowning achievement of Carter's presidency.[8] Sadat and Begin jointly received the Nobel Peace Prize as a result of the watershed diplomatic achievement. Carter wanted the treaty's eventual signing to be memorialized by an artist who would do justice to its colossal significance.

Neiman brought his sketch pad to the March 26, 1979 ceremony on the South Lawn—the same spot where he drew Dizzy Gillespie and Mary Lou Williams less than a year earlier. As always, he marched to the front of the crowd. While he sidled into position, Neiman caught eyes with Lillian Carter, the president's irreverent and folksy mother who had established herself as a quotable celebrity and her son's greatest booster. The omnipresent Neiman had previously met, sketched, and mingled with Miss Lillian. She recognized LeRoy as he approached and invited him to join her in the front row. Neiman sat on the ground at the feet of the First Mother and her granddaughter Amy—a location he knew would attract the attention of photographers. One photo shows Neiman sitting in the grass while wearing an unusually subdued beige overcoat. The crowd behind him is mostly peering up at the platform where Carter is making the landmark treaty official. Lillian's gaze, however, is focused on Neiman's feverish drawing. She seems more fascinated by Neiman's sketch in progress than the historic occasion he is documenting.

The painting Neiman produced has the American, Egyptian, and Israeli flags billowing perfectly in the background—not unlike his *Olympic Ring* mural. Sadat and Begin cordially shake hands in the foreground. Carter stands between the two and, with a satisfied grin, encases their clasped hands in his own. The powerful Middle Eastern leaders resemble the champion boxers Neiman had depicted so often, while Carter is the referee who has ensured a clean match. The painting shows the triumph of sportsmanlike diplomacy among big political egos unaccustomed to compromise. "It's not a publicity piece," Neiman said of his work. "It means something. It grasps the seriousness, the significance, and the intelligence of whatever they were going through."[9] The president benefited from Neiman's flat-

FIGURE 28. Neiman sketches a ceremony celebrating the Egypt-Israel Peace Treaty on the White House South Lawn as Lillian Carter looks on, March 26, 1979.
Courtesy of the Jimmy Carter Presidential Library.

tering hand, which depicted a dashing and Kennedyesque version of Carter on the South Lawn. LeRoy later recalled being surprised by the president's lack of vanity when Carter told Neiman that the painting ignored his sagging neck—a feature other artists often emphasized to caricatured proportions.[10] But Neiman was so used to making egotistical clients look good at that point that he could not bring himself to depict the president any other way.

Neiman's painting was transformed into three hundred signed prints, which sold for $3,000 each to raise funds for the Democratic National Committee.[11] But it took LeRoy until January 30, 1980, to get on Carter's schedule so he could personally give the president one of the twenty-five artist proofs he created. He and Leibovitz again trekked to Washington for a ten-minute appointment with Carter at quarter to eleven in the White House Cabinet Room. The New Jersey

senator Bill Bradley, a former professional basketball player for whom LeRoy had created campaign posters, opened the short ceremony by introducing Neiman and commending his fundraising efforts on behalf of the democratic party. Neiman then gave Carter his print and made small talk while they signed the artwork and took a few pictures until the president carried on with his crowded itinerary (plate 14).[12]

Two days after their meeting, Carter wrote LeRoy a thank-you note for the serigraph, which he called "inspiring" and had hung in his study. Neiman kept the original painting and twenty-one of the twenty-five artist's proofs. The other four proofs were reserved for Carter, Begin, Sadat, and Miss Lillian, who personally delivered Begin and Sadat their prints while on a Middle Eastern tour later in the year. She joked to Sadat that he could sell his serigraph if he ever went broke.[13]

Later in 1980, Neiman attended Lillian Carter's birthday party in New York, which was coincidentally held during the Democratic National Convention. LeRoy sketched Lillian while she chatted with the journalist Barbara Walters. He then crossed paths with Andy Warhol, who was taking photos and recording the event on audiotape. Neiman and Warhol were casual acquaintances at that point and had socialized on a few occasions. LeRoy even visited Warhol's infamous Factory once, but found its amphetamine-laden, queer, and glittery scene to be a discomfiting contrast to the martini-heavy and heterosexual *Playboy*-style environment he preferred. But the famous artists got on well and bonded over their working-class Catholic roots, close relationships with their mothers, obsession with celebrity, and daily addiction to *As the World Turns*. When the evening wound down, Lillian asked Warhol and Neiman if they would like to share her car—complete with a Secret Service detail. Warhol and Neiman had both socialized with the world's hottest celebrities, but each was amazed at the crowds Lillian Carter attracted. Neiman likened her magnetism to that of Muhammad Ali.[14]

Once the trio arrived at Lillian's hotel, the First Mother invited Warhol and Neiman to her suite for a nightcap. In his diaries, Warhol cattily recalled LeRoy "drawing those terrible drawings of his"

while they gossiped and drank in Lillian's quarters. Warhol also was delighted by Neiman's willingness to tell Lillian dirty jokes, which the president' mother enjoyed and matched with some of her own bawdy yarns. One of LeRoy's wisecracks, Warhol recalled, involved "a bear using a rabbit after every crap to wipe himself." Neiman later confessed that he was able to talk so freely with Lillian because she reminded him of his similarly saucy mother, Lydia. Warhol would have captured the discussion on tape, but he later discovered that his recorder had stopped working—a malfunction the paranoid pop artist blamed on the Secret Service agents hovering nearby.[15] But Warhol was so impressed by the conversation that he suggested LeRoy work for him at *Interview* magazine. Neiman never took Warhol up on his offer, which may or may not have been sincere. But the two artists participated in a different sort of collaboration the following year.

* * *

Two months after the Democratic National Convention, the Los Angeles Institute of Contemporary Art's (LAICA) director Robert A. Smith pitched Neiman and Warhol on a joint exhibition of their sports-themed works. Established in 1971, LAICA prided itself on offering a "program reflecting many concepts of high artistic achievement." Smith elaborated on the mission statement by describing LAICA as "an institution that functions as a laboratory for new ideas, a place where experimental and untested work is seen publicly for the first time."[16]

But LAICA was not drawing nearly the volume of visitors Smith hoped to attract. Smith recalled that one LAICA show received a glowing review in the *Los Angeles Times*—a publication with a circulation of approximately 1.2 million. The high-profile write-up, however, resulted in only about two hundred visitors over the exhibit's six-week run. "The LAICA's audience," Smith frustratedly observed, "was obviously so small that is had to be considered almost nonexistent. What had developed was a symbiotic dialogue between small groups—LAICA, artists, dealers and collectors." Not long after this deflating realization, Smith visited the Centre Pompidou in Paris,

which was holding a massive Salvador Dalí retrospective that ran from December 1979 through April 1980. The show was a blockbuster, and Smith witnessed crowds stuffing into the museum late into the evening. "Who were these people?" he asked of the flocks lined up to see Dalí's work: "They were not the cognoscenti; they'd probably never heard of Daniel Buren, France's foremost contemporary artist. How could LAICA attract, even contract, their American counterparts, the vast audience with no knowledge of contemporary art? Doing a Dalí retrospective was out of the question; I thought, 'No self-respecting American museum would be caught dead validating such a crassly commercial artist.' But if Dalí works for the French, who are his American equivalents?"[17]

Andy Warhol and LeRoy Neiman instantly came to mind as brand-name artists who might lure large audiences like those Dalí drove to the Pompidou. And Warhol's then-recent *Athletes* (1977) portrait series gave Smith a distinct and marketable theme around which he could curate the joint exhibit.

The show Smith envisioned would make a provocative splash among the art world, attract visitors from communities that did not generally patronize museums, and kindle a reconsideration of traditional aesthetic hierarchies. As Smith wrote to Neiman and Leibovitz in October 1980 when he was initially presenting them with the idea, "Even though Neiman and Warhol have common origins in illustration and commercial art, one has developed a popular reputation through the media (magazines and television) while the other has been validated by the world of high art." The Neiman-Warhol exhibit, he continued, "will seek to explore some of the more outdated values upon which the art world is dependent. By juxtaposing these two very prominent and popular artists, I hope to draw attention to the lack of an aesthetic rationale of the 'chosen' and 'reviled' within contemporary art."[18] LeRoy immediately agreed to be involved—despite his status as a representation of "the reviled"—and loaned Smith transparencies to help him begin organizing the show.

Smith marketed the undertaking as a bold endeavor that would unapologetically ruffle a complacent and sometimes hypocritical

art establishment. He claimed the exhibit would constitute an especially daring move for Warhol—despite his established willingness to engage with popular culture—and had his dealers worried that the show might lower the value of his art by putting it into proximity with Neiman. Smith also penned an advance open letter requesting that critics "suppress your immediate impulse to either laugh or to scream" at the unconventional show.[19] *Neiman-Warhol* gained another layer of controversy when the Playboy Foundation awarded LAICA a $45,000 grant to support the exhibit. A *Playboy* spokesperson praised Smith's show as a complement to the magazine's irreverent ethos and interest in art.[20]

Despite their very different reputations, Neiman and Warhol expressed mutual admiration. Neiman included a subtle homage to Warhol in *Toots Shor's* (1975)—a colorful tavern painting. The bar at the center of the piece includes Neiman's usual array of recognizable liquor bottles—from Cutty Sark to Jack Daniels. A collection of mixers sits in a cooler beneath the bar. Several cans of Campbell's tomato soup are arranged next to bottles of Schweppes tonic. Neiman replaced the tomato juice commonly used by bartenders with cans of the tomato soup Warhol reproduced in the 1962 silkscreens that helped launch the pop art movement. Neiman used *Toots Shor's* to demonstrate his familiarity with and appreciation for Warhol's groundbreaking work.

It is difficult to determine precisely what the habitually equivocal and ironic Warhol thought about anything—let alone Neiman. He once called LeRoy the only other artist he enjoyed being around.[21] Warhol surely would have envied Neiman's work on television. He listed the prospect of having a TV program as "the great unfulfilled ambition of my life" in *The Philosophy of Andy Warhol* and admitted to being "really jealous of everybody who got their own show on television."[22] When Warhol finally did get a program in 1979, he created a very different style of show from the straightforward sports broadcasts and talk shows on which Neiman appeared. Warhol's projects— which included *Fashion* (1979–1980), *Andy Warhol's TV* (1980–1983), and *Andy Warhol's Fifteen Minutes* (1985–1987)—subverted commer-

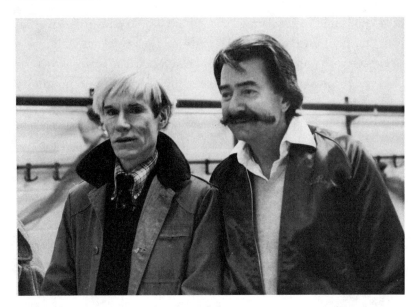

FIGURE 29. LeRoy Neiman and Andy Warhol, 1981.
Photo by Maria Del Greco. Courtesy of the LeRoy Neiman and Janet Byrne Neiman
Foundation.

cial television's typical patterns with prolonged moments of silence, nonsensical tangents, and celebrations of banality. According to Lynn Spigel, Warhol's unusual television shows were rare instances of "queer visibility" on the medium and "became a means of derailing TV's stock roles and for making the 'other's' everyday visible to national audiences."[23] Warhol's television work contrasted Neiman's performance of cocky heterosexuality, which LeRoy often accentuated by openly gawking at women on camera.

Prior to *Athletes*, Warhol's artistic engagements with sports were mainly incidental. Some of his early advertising illustrations, for instance, landed in *Sports Illustrated*. He also debuted the photo silkscreen technique that eventually became one of his preferred approaches with *Baseball* (1962). But Warhol had no real interest in sport. He manufactured his highbrow artistic persona in part by deliberately separating himself from sports culture and the normative manliness that accompanies it. A 1974 advertisement for Pioneer stereos used Warhol's professed lack of sports know-how to market its high-

end equipment. "Andy Warhol doesn't play second base for the Chicago Cubs," the ad reads atop a photo of the platinum-wigged Warhol resting his elbow against a shiny Pioneer receiver. "He doesn't even know who does," the advertisement continues before informing consumers that the famous artist and onetime Velvet Underground manager does know music and prefers listening to it on Pioneer stereos. Pioneer uses Warhol's utter unfamiliarity with mainstream sports to stress his cultural taste and reach out to the similarly refined consumers it seeks to attract. Warhol was a fish out of water in sports culture, which was Neiman's native habitat.

Regardless of Warhol's general lack of interest in sports, the financier Richard L. Weisman thought a series of athlete portraits would be a natural, and profitable, extension of the Polaroid Big Shot society photographs that had commanded most of Warhol's attention during the 1970s. "Andy didn't really know the difference between a football and golf ball," Weisman admitted. But the artist nonetheless recognized athletes as a powerful genre of celebrity he had yet to explore. "The sports stars of today are the movie stars of yesterday," Warhol observed while starting the project. He also implied that Neiman's work for ABC in Montreal, which he watched nightly during the 1976 Olympics, influenced his willingness to take on a sports-themed project.[24]

Weisman paid Warhol $800,000 to produce eight sets of ten 40″ × 40″ portraits of famous sports stars. Many of the athletes Weisman approached were initially reluctant. But once Muhammad Ali signed on, he recalled that "everyone wanted to join in."[25] Warhol's portraits depicted the athletes with the glamour and sexiness he brought to his other celebrity snapshots. The artist maintained his oblivious posture toward sport when discussing the project in public. "I still don't know how to pronounce the name at the end, what was his name?" he said of basketball player Kareem Abdul-Jabbar. "I could walk through his legs, he was just so tall. . . . But they were all so sweet." In a separate conversation with the New York Times, Warhol described the jockey Willie Shoemaker as "so cute, like a doll. A perfect little doll." Warhol's observations undercut commonplace sports discourse, especially

when applied to the men. His work and words sparked a mystified dismissal from the *Times'* sportswriter Tony Kornheiser, who suggested the awkward artist was out of his element.[26] Despite Warhol's feigned ignorance, his portraits commented on the beauty and desirability that informed sporting celebrity—a dimension of sport culture that even astute journalists like Kornheiser tended to ignore.

Privately, Warhol confessed that he found many of the athletes to be uninteresting, ignorant, and entitled. Warhol reserved a particular distaste for Ali—a star whom Neiman confessed to idolizing.[27] He photographed Ali in August 1977 at the boxer's training camp in Deer Lake, Pennsylvania. Three years earlier, LeRoy had painted an oversize fresco of Ali on the wood-paneled wall of the camp's gym, which used a knothole for one of the fighter's eyes. Warhol sat Ali in front of a white bedsheet next to Neiman's painting. "I hoped mine would come out as good," Warhol commented of Neiman's portrait while he started snapping pictures of the shirtless boxer.[28]

Ali, however, would not sit still long enough for Warhol to capture the poses he wanted. Instead, the prizefighter recited polemical snippets from a lecture he had recently given about the many problems facing American society. The social ills he rattled off included drugs, prostitution, and homosexuality, which rankled Warhol. "Muhammad was just talking. I think he was torturing us," Warhol recalled of the photoshoot. "I mean, how can he preach like that? It's so crazy, I think he's a male chauvinist pig, right?"[29] Andy had to interrupt what he called the boxer's "Alilogue" several times so he could get him to stop moving. But Warhol could not deny that Ali was a gorgeous subject—and that the fighter's famous prettiness afforded him considerable behavioral leeway. "He can say the things that he can because he's so good looking," the artist bluntly observed. "He has the most beautiful voice, the most beautiful hands, and the most beautiful face. And he can use all three at the same time. That's why people will listen to him."[30] As far as Warhol was concerned, Ali was a dumb but handsome jock.[31]

Athletes opened in December 1977 at New York City's Coe Kerr Gallery on East Eighty-Seventh Street. The show underwhelmed both

Warhol aficionados and sports enthusiasts. It was emblematic of the 1970s era that many critics rate as a self-satisfied and overly commercialized period of Warhol's career.[32] Part of the reason Warhol opted to participate in the LAICA exhibition, according to *Interview*'s editor Bob Colacello, was to help Weisman recoup some of the money he lost on *Athletes*. While Warhol agreed to be part of the joint show with Neiman, he laughed it off in his diaries as a lark and suggested he would not attend it.[33]

The LAICA exhibit ran from November 17, 1981, through January 9, 1982. Warhol opted out of the preshow publicity, but Neiman arrived in Los Angeles a full week before the opening to help spread the word. He autographed a Sunset Strip billboard for the show and appeared on a segment of *Entertainment Tonight* with baseball player Steve Garvey, figure skater Dorothy Hamill, and *Playboy*'s Miss November Shannon Tweed, whom LeRoy sketched on camera. Warhol did make it to the VIP and press reception, which was jointly hosted by Muhammad Ali's wife Veronica Porché Ali, the art collector Joan Agajanian Quinn, and Sylvester Stallone—an amateur painter himself who had separately commissioned both Neiman and Warhol to do his portrait.[34] Once *Neiman-Warhol* opened, LAICA expanded its hours to accommodate the larger crowds Smith expected to draw.[35] And the audience at *Neiman-Warhol* did differ from those at previous LAICA programs. Hefner showed up to the reception with Tweed on his arm. While making some remarks on behalf of the sponsoring Playboy Foundation, Hefner benignly joked that Neiman and Warhol should sketch each other's portraits. "Only if we do them nude," Warhol replied in deadpan. Warhol's quip was met with confused silence and awkward smiles among the assembled guests—precisely the effect he likely sought from a group that was far more mainstream than his usual social circle.[36]

The works on display at *Neiman-Warhol*—which included several juxtapositions of each artist's impression of the same athlete—invited comparisons between Neiman and Warhol. Neiman's portraits showed the athletes full bodied, in motion, and practicing the vocation that made them famous. Warhol, in contrast, froze the athletes

in glamorous poses and, like his other Polaroids, captured them from the shoulders up. Warhol's athletes were not feverishly competing but intentionally posing for the camera. Accentuated by solid white backgrounds, their facial expressions offered softer, relaxed, and even seductive counters to the strained and focused looks typical of action shots. Warhol's subjects were marked as athletes only because of the sporting equipment they held in the frame. Abdul-Jabbar, for instance, rested a basketball on his right shoulder. When positioned in that way, the featured sporting equipment took on the appearance of merchandise being sold with the help of an attractive model. *Athletes* may be only a footnote in Warhol's eclectic oeuvre, but the artist's "sportraits" pushed further Neiman's explorations of the intersections across sport, commerce, fashion, and sex.

The colorful brushstrokes and drawing that Warhol added to his athlete portraits—a convention he included in most of his commissioned Polaroids—gave his works an unusual resemblance to Neiman's approach. The biographer Blake Gopnik locates Warhol's addition of paint to the photographic portraits as "a knowing comment on brushwork." Warhol claimed that he preferred his Polaroids without paint or drawing. "But people expect just a little bit more. That's why I put in the drawing." He jested that the streaks and squiggles put the "art" in his portraits and made them "come off as more intellectual."[37] The added ornamentation knowingly pandered to audiences who could not imagine an artwork existing without some painting or drawing present. In doing so, they exploited the middlebrow market for sports art while commenting on the more predictable artworks Neiman specialized in creating. Warhol's deft ability to participate in popular commercial culture while also criticizing it marks one of the key differences that separate his celebrated art from LeRoy's more straightforward and less acclaimed work.

Neiman-Warhol did not attract the throngs that Salvador Dalí's retrospective drew to the Pompidou. But Smith got the attention he was seeking. Commentators, however, were unwilling to indulge the LAICA director's hope that *Neiman-Warhol* might prompt a rethinking of artistic boundaries. As the *Los Angeles Times'* Suzanne Muchnic

observed, "No assembly of mere paintings could possibly embody all the gossip, rancor, righteous indignation and venom that preceded the current exhibition of LeRoy Neiman and Andy Warhol's portraits." Several critics panned the show as no more than a cynical attempt to fundraise after the Reagan administration cut federal arts funding, which forced LAICA to close its secondary gallery space earlier in the year. The *Los Angeles Times* critic William Wilson charged LAICA with trading "its respectability for money and bad art" in an effort to "please corporate sponsors and attract big crowds." Smith penned a rebuttal that insisted the show was already in the works before the LAICA lost its governmental support. But the *LA Weekly's* Emily Hicks pointed out that LAICA had, in fact, issued a press release shortly before the exhibit stating that it would be selling *Neiman-Warhol* posters "to offset the loss of funds due to recent federal budget cuts," which made Smith's claims hard to believe.[38]

Critics pulled few punches when reviewing *Neiman-Warhol*. "Pundits have likened the exercise to selling drugs at Synanon or bringing disease to the hospital," Muchnic offered. The exhibit only intensified the snide dismissals Neiman had grown accustomed to absorbing.[39] In a blistering feature for the *Village Voice*, Peter Schjeldahl berated Los Angeles's art culture as vapid. "There is nowhere to learn about art except superficially in this town," he wrote.[40] Schjeldahl cited *Neiman-Warhol* as evidence to support his takedown of LA as a cultural backwater.

LAICA unsurprisingly took umbrage at Schjeldahl's screed. It published a response on behalf of Los Angeles by Peter Plagens, who was eventually named to its board of directors.[41] Plagens was happy to defend Los Angeles and LAICA. But he did not extend his sympathies to *Neiman-Warhol*. In the March 1982 issue of *Art in America*, Plagens delivered the most damning condemnation the exhibit received. He called the show "a product of conditions, most notably that we are living in a period of decadent artistic exhaustion when proprietors of contemporary galleries must grope deeper and deeper in the realm of the specious to pull out vulgar shows which will attract any financial backing and press coverage." The critic specifically targeted

LeRoy and wrote that "anyone with a semester of art appreciation who looked carefully at a typical Neiman will conclude that it is a B+ illustration of a cliched pose carried out with considerably facility, a little garishness and absolutely no profundity." Exhibiting Neiman, Plagens suggested, represented an unforgivable degree of commercialized vulgarity that outweighed any of LAICA's stated efforts to rethink established cultural hierarchies.[42]

Warhol also took his share of abuse for *Neiman-Warhol*. The biographer Victor Bockris called the show a "low point" of his career. Writing for the *New York Review of Books*, Robert Hughes claimed the exhibit was indicative of the pop artist's steady decline and suggested the formerly confounding Warhol was finally all out of tricks. "It was a promotional stunt," Hughes said of the show. The gimmickry did not trouble Hughes. But the critic maintained that the gambit "backfired, raising the unintended possibility that Warhol was down there with Neiman. The Warhol of yore would not have let himself in for a fiasco like the LAICA show."[43] Teaming up with Neiman, Hughes implied, was a bridge too far. The *Los Angeles Herald-Examiner*'s Christopher Knight called the show "a flop" and an "exercise in obfuscation" that drew false equivalences between radically different artists. As *Art Week*'s Neil Menzies commented, "The ultimate, unhappy result of the exhibition is that, financial gain aside, the LAICA as well as the public—highbrow or lowbrow—loses. Bad art is not good for anyone."[44] The commentators suggested that any short-term benefits LAICA enjoyed from *Neiman-Warhol* were ultimately not worth the compromises it made by permitting LeRoy's work to enter and evidently infect its previously vaunted domain. By the time the show ended and the reviews were published, Neiman's reputation among critics was arguably lower than it had been before his collaboration with Warhol.

14

The LeRoy Neiman of . . .

The disastrous *Neiman-Warhol* exhibit did not have an impact on LeRoy's standing among his primary audience, or on the US Olympic Committee. The USOC enthusiastically rehired Neiman to serve as its official artist for the 1984 Winter Games in Sarajevo and the Summer Games in Los Angeles, which were branded as LA84 and poised to be the grandest sporting event ever staged on American soil. The USOC's executive director Don Miller praised Neiman as an obvious choice for the Games because of his unquestioned status as "the best and most highly respected sports artist in our country." Neiman and Knoedler Publishing forged an agreement with the USOC that allowed the artist to use the Olympics' interlocking rings logo in exchange for 20 percent of whatever proceeds his Olympics-themed works generated on the first $1.5 million they earned, and 15 percent after that benchmark. Knoedler framed the deal as a donation, but the contract more closely resembled a licensing fee, with Neiman and Knoedler paying to use the USOC's authenticating trademark.[1]

"I am hopeful and possibly idealistic that the upcoming Olympic Games will help assure world peace," Neiman said before the Los Angeles Games began. "It is an honor to again be a part of the US Olympic team." But LeRoy's work in LA focused less on diplomacy than his usual chestnuts. "I'll be looking at the women," he told *Good Morning America*'s Joan Lunden. He even set up a studio at the nearby Playboy Mansion, where he would turn his sketches into paintings. "It's not a bad duty at all," he bragged to the *Hollywood Reporter* of his temporary workspace. "I'll be painting out by the pool and the scen-

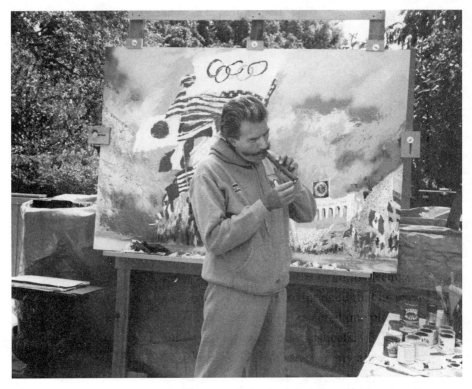

FIGURE 30. LeRoy Neiman working on a painting for the 1984 Summer Olympics, 1984. Photo by Lynn Quayle. Courtesy of the LeRoy Neiman and Janet Byrne Neiman Foundation.

ery around Hef's place isn't too shabby."[2] Neiman had a separate studio at the Neiman-Marcus department store in Beverly Hills, where he reimagined his performance for ABC in Montreal by painting in a roped-off area as customers watched: "If the athletes can perform in front of that many people, I can paint in front of a live audience." The stunt was part of a larger deal to begin stocking LeRoy's prints at Neiman-Marcus stores across the country.[3]

Befitting their outsized scope, the Los Angeles Olympics was a multifaceted event with several entities beyond the USOC involved in staging their many interrelated parts. The other organizations had slightly differing visions for LA84, and some were uninterested in working with Neiman despite—and also because of—his enduring association with the Games. The Los Angeles Olympic Organizing

Committee (LAOOC), for instance, named Ernie Barnes its official artist. Barnes was an African American former professional football player who specialized in elongated and muscular Black bodies in motion. Notably, his painting *The Sugar Shack* was used as the cover art for the soul singer Marvin Gaye's 1976 album *I Want You*.

The Olympic Arts Festival more insistently and explicitly separated itself from Neiman. The IOC requires hosts to stage cultural and arts programming that is "of an equal standard" to the sporting events. While the required cultural programming is less visible and popular than its athletic counterpart, the Los Angeles Olympics sought to make a daring artistic statement on par with the 1984 Games' generally spectacular ambitions. California Institute of Arts' president Robert Fitzpatrick was hired to direct the Olympic Arts Festival, which, like the Games, would take place at various venues across the sprawling Los Angeles region. Fitzpatrick immediately distanced his festival from the sporting event and distinguished himself from sports administrators. "I don't know much about the Olympics. I'm a notorious non-jock. By and large, as a spectator, most sports bore me to the point of exquisite pain," he said, before admitting that he actually signed a petition against the Olympics coming to Los Angeles before he was recruited to oversee the accompanying arts festival.[4] Like Andy Warhol's Pioneer advertisement, Fitzpatrick underlined his highbrow cultural credentials by professing ignorance about—and even mild hostility toward—sports and the popular tastes it represents.

Thanks to funding from the Times Mirror Company—the parent organization of the *Los Angeles Times*—Fitzpatrick had an unusually large budget to create what he promised would be "the largest cultural festival ever held in the United States." The ten-week event, most of which ran before the sporting competitions commenced, included art exhibits, film screenings, and four hundred performances by 145 theater and dance companies. Because of the Times Mirror Company's support, which reflected a larger corporate presence in the 1984 Games that was used to offset public expenditures, Fitzpatrick was sensitive to suspicions that the Olympic Arts Festival might be overly commercial and sanitized by sponsors' demands. He insisted on "abso-

lute artistic freedom" and maintained that the privately funded event would allow greater experimentation than its predecessors. "Previous cultural programs had all had an organizing committee that was part of the government, and therefore there was a great deal more reticence about taking risks," he said. "This is a festival that is going to take risks. Some things probably won't be accepted by the public, either at the box office or critically. That's fine. That's part of the excitement."[5]

Fitzpatrick also sought to use the festival to showcase Los Angeles as a city with a vibrant arts culture—an effort that complemented his work at Cal Arts. "We're trying to use the festival to bring things to Los Angeles that wouldn't get here without the leverage the Olympics offers," he told the *Los Angeles Times*. "One of the things I hope Olympic Arts will do is have people see Los Angeles in the '80s as Paris was in the '20s and '30s," he continued. "If you were a great painter, musician, writer, or photographer, you couldn't not spend time in Paris in those years. I think we have much the same potential here." Fitzpatrick imagined Olympic Arts as a powerful rebuttal to those like Peter Schjeldahl who viewed Los Angeles as a second-class city destined to remain forever in New York's cultural shadow. "It's our coming of age," Fitzpatrick proclaimed. "Our artist mitzvah."[6]

Olympics Arts managed to bring together performers representing countries with frigid diplomatic relations. The well-connected Fitzpatrick enlisted the help of Armand Hammer to secure the participation of Soviet artists despite the Soviet Union's decision to boycott the Olympics' sporting events.[7] The festival staged the exhibit *A Day in the Country: Impressionism and the French Landscape* at the Los Angeles County Museum of Art, which required an unprecedented loan from the Louvre, and it marked the US debut of German choreographer Pina Bausch's Tanztheater Wuppertal. It left a permanent monument with the *Olympic Gateway* statue Robert Graham installed at the front entrance of the Los Angeles Memorial Coliseum, where many of the athletic competitions were held.

To complement the performances and exhibits, Olympics Arts commissioned a series of fifteen posters by artists ranging from recog-

nizable stars like Roy Lichtenstein and Richard Diebenkorn to comparatively obscure figures with a novel point of view, such as April Grieman and Jayme Odgers. The posters promised to continue Olympic Arts' inventive approach. "Mostly the Olympics have relied on graphic designers for their posters," said LAOOC vice president Hope Tschopik. "We could have gone out and gotten such designers, but we wanted this to be a truly cultural event." Fitzpatrick refused to give the artists any directives and he deliberately excluded Neiman. "The posters didn't need to relate to sports and could be serious or whimsical," he said, "but I wanted the artists to keep in mind that they were creating posters, not just works that would be transferred to posters. The images ought to be provocative and interesting enough that after six months or a year, people would still find them intriguing."[8]

Olympic Arts certainly could have afforded to commission Neiman, but Fitzpatrick wanted the artist's absence to help define the sort of festival he aimed to create. On several occasions, he explicitly used Neiman to describe what he wanted to avoid. "Olympics in the past have used artists like LeRoy Neiman, whom I consider a great embarrassment for those who have vision, for those who have eyes. It's second-rate schlock art." Neiman, he suggested, was the sort of artist whom unschooled "government bureaucrats" like Don Miller would hire to appease mainstream tastes. "There will be none of LeRoy Neiman's 'jock art' at the festival," he guaranteed. Fitzpatrick sought to attract a different audience; one that, like him, might normally view sports culture as pedestrian and degrading. Fitzpatrick's outspoken antipathy for Neiman compelled Mark Donnelly from Studio City, California, to write a letter to the *Los Angeles Times*' editor in praise of the director's scruples. "The fact that Robert Fitzpatrick dislikes the work of LeRoy Neiman so intensely does more to give me hope about the Olympic Arts Festival than any other statement he could possibly have made," Donnelly wrote.[9] Omitting and disparaging Neiman composed as powerful a statement about Olympic Arts' ambitions as booking Pina Bausch's dance troupe.

Hammer organized an exhibit of Neiman's Olympics-themed work to coincide with LA84. Rather than argue against Fitzpatrick and

his ilk, Hammer used their snobbery as an endorsement that might further endear Neiman to popular audiences turned off by elitism. A press release for the show pointed out that Neiman is "as loved as he is detested." It then quotes several disparaging reviews to position LeRoy as an art-world iconoclast who is not out to please highfalutin critics and is untroubled by their trifling digs.[10] Interviewing Neiman prior to the Los Angeles Games, ESPN's Roy Firestone asked the artist whether he was bothered by the seemingly unceasing stream of criticism. LeRoy shrugged, let out a long thoughtful exhale, and said he did not let it get to him. He then compared himself to Ronald Reagan—whose political views he never respected but whom he admired for remaining outwardly cool despite whatever controversies surrounded him.[11]

Neiman's affinity for Reagan's polished unflappability is telling. Despite LeRoy's progressive political leanings, his macho demeanor, heterosexuality, business-friendliness, and patriotic themes made him an artist whom conservatives and anti-intellectuals embraced. While Neiman and Leibovitz had to lobby for Jimmy Carter's attention, LeRoy was the Reagan administration's preferred artist. Reagan twice invited Neiman to the White House in 1981—once to sketch his inauguration and another time for a ceremony recognizing sporting greats. As part of his budget-slashing conservative agenda, Reagan instituted widespread reductions to federal arts funding that imperiled organizations like LAICA.[12] Reagan would have appreciated that Neiman's popular work was market supported and did not require governmental largesse. LeRoy, in this case, was a friend to an enemy of the arts.

* * *

Opinionated gatekeepers like Fitzpatrick had no discernible impact on Neiman's overall popularity during the 1980s. LeRoy mostly worked on commissions during this era to celebrate sporting events, athletic milestones, or just popular stars. Clients would generally pay him a flat fee for the commission of, say, an athlete who recently broke a record. They would then finance a poster run and assume the risk

of selling those prints. Neiman was paid regardless of the print sales, but all parties generally came out on top. In fact, prices for his work surged during the 1980s. Shortly before the 1985 Super Bowl, three Japanese businessmen agreed to pay Neiman $50,000 for a painting of the game. Later that same evening, the investors sold the yet-to-be-completed artwork for $90,000.[13]

The commissions extended beyond Neiman's sporting specialty—sometimes to unexpected lengths. In 1982, the children's restaurant Chuck E. Cheese hired LeRoy to help observe its fifth anniversary with a painting of its mouse mascot. That same year, the Arizona Heart Institute in Phoenix paid Neiman $50,000 to complete a 4' × 5' painting of Dr. Ted Dietrich and his team performing an open-heart surgery. LeRoy spent a week at the institute observing and sketching surgeries from the medical theater. The painting—which Neiman compared to Rembrandt's *The Anatomy Lesson of Dr. Nicolaes Tulp* (1632) and Thomas Eakins's *The Gross Clinic* (1875) with his usual immodesty—offers a characteristically colorful bird's-eye-view of the painstaking procedure.[14] Like Neiman's sports art, it depicts the surgery as an intense collaborative feat worthy of commemoration.

Companies including Coca-Cola, Wheaties, AMF sporting goods, Caesar's Palace, the Tropicana Hotel, United Airlines, and Continental Airlines got in on the Neimanmania by hiring him to produce work for their advertising. LeRoy continued appearing in Stallone's *Rocky* films as a ring announcer, and his artwork showed up as part of the set design in the short-lived TV sitcom *The New Odd Couple* (1982) and the action film *Tango & Cash* (1989)—both of which used his prints to build a manly ambiance.[15] A New Orleans restaurant saw an opportunity to capitalize on Neiman's popularity and arranged to use his work on its signage, decor, and menus in exchange for 1 percent of its gross revenues.[16]

Other clients employed Neiman as a recognizable pitchman who glamorized their products. In 1986, Arrow Shirts hired LeRoy to update the Arrow Collar Man advertisement that J. C. Leyendecker established for the company in 1905. A print ad juxtaposed a classic Leyendecker illustration of Arrow's shirts with Neiman's modernized

interpretation of them. The following year, Sharp hired LeRoy to star in a commercial that claimed the company's copiers made prints that were as vibrant as his paintings.[17] In 1984, General Electric paid Neiman $15,000 to appear in a commercial for its car phone. The ad shows a white Corvette with a Neiman illustration of three sprinters racing on its hood. A suave LeRoy waits as the freshly painted sports car slowly runs through a blazing drying line. "This is a Neiman," LeRoy says after the custom Corvette emerges from the oven. The phone then rings from inside the car and Neiman answers the call—an indication that the luxury product can withstand the most extreme conditions.[18]

In East Hartford, Connecticut, the Chevrolet dealer Harvey Lipman caught wind of the car Neiman painted for GE's commercial and convinced LeRoy to create a series of custom Corvettes that would be sold exclusively out of his dealership. "I told him we had done a number of special edition cars in the past," Lipman said, "but an artist has never been involved." Neiman and Lipman planned to manufacture twenty-five of the white and gold sports cars. They retailed for $50,000—roughly twice the price of a regular Corvette at the time. The specialized editions featured LeRoy's self-portrait on the roof supports, his signature on their left headlight cover, and another autograph in gold leaf on the white leather headrests. The interior of each door included an illuminated color slide of Neiman's painting *Rendezvous a Corvette*, which depicted a similar white-and-gold Corvette parked outside of a fox hunt. But Lipman and Neiman created only nine special editions because of low demand. Lipman discontinued the project and instead began selling Neiman prints out of a gallery connected to his showroom called Auto Graphics, which he publicized as "the official central Connecticut gallery of the art of LeRoy Neiman."[19]

Regardless of his pervasiveness, Neiman maintained that he would not simply take any job that was offered. He rejected one pitch from a company that wanted to use his work on bedsheets. "Bedsheets? Never!" he huffed. "I don't want people to sleep on my art!" Richard Perry, who ran Merrill Chase Gallery in Chicago, also noted that Neiman declined several offers from clients who sought his rendition of

pornographic content—unsurprising requests given his alliance with *Playboy* and general interest in sex.[20] But LeRoy's "standards" did not prevent him from allowing his art to be pasted onto rayon shirts or from contributing a painting that was used by the company Creative Fragrances to sell a perfume commemorating the fiftieth anniversary of the film *Gone with the Wind*. Neither did they stop LeRoy from taking the $350,000 that the Mustang Ranch Bordello paid him in 1988 to illustrate the certificates that stockholders would receive when the company went public. He reserved the right to say no to any offer but did not seem to turn much down.[21]

Dealers often brokered Neiman commissions from buyers who already owned some of his work but wanted a customized piece. "He was a good businessman. Very direct," recalls the Minnesota-based art dealer Robert Varner. "I had a client who wanted a fairly good-sized original of golfers, something that was unique. So, I called LeRoy and told him what the guy was looking for. And he said: 'What course do you want? What hole do you want? Who do you want playing? Seventy-five grand.' And that was the end of the conversation." Richard Perry recounted a separate instance when a client who owned a banana plantation sought a 10′ × 8′ painting of bananas. "Eventually, I talked him into doing the painting," Perry remembered of Neiman's initially unenthusiastic response to the job. "He was a little ashamed of it, but he got it done."[22]

Neiman kept hundreds of unsold paintings, sketches, and prints at his studio. The prolific artist took creative measures to control this artwork's value and circulation. He often donated pieces that did not sell to charity auctions, which allowed him to write off the value of that work on his taxes. Neiman also used loose art as a sort of currency. Varner remembers connecting LeRoy with a buyer who was interested in baseball. Neiman invited the buyer to his studio office, opened a file drawer full of baseball sketches, gave the man a price, and told him to pick five. He then signed the sketches the customer selected, took the payment, and sent him on his way. On many other occasions, Neiman informally traded sketches for free drinks while holding court at a bar. He dined for free at Tavern on the Green—

just one block east of his apartment—in exchange for a large work he produced for the restaurant. LeRoy was sentimentally attached to some of his art and would not sell it for any price. But he viewed most of his works as tradable commodities. And informally selling or trading his art allowed Neiman to recoup a greater share of profits by not paying taxes or involving dealers. LeRoy, though, balanced his shrewdness with generosity. He turned down few requests for donations and indulged so many autograph requests from collectors and fans that Knoedler asked him to start sending an unsigned glossy head shot instead for fear that the value of his signature would decline on account of market saturation.[23]

At a certain point, Neiman's work became so commonplace that it bordered on generic. When Harper & Row published the sportswriter Roger Kahn's 1977 book *A Season in the Sun*, it mislabeled a colorful cover illustration by Bernie Fuchs as a Neiman.[24] Whoever made the mistake likely assumed the illustration was just one more Neiman in a sports landscape overflowing with them. And LeRoy continued spawning imitators even more brazen than Wayland Moore that included Mark King, Harry Schaare, Tony Kees, and Timothy Spindler. Neiman kept tabs on these artists, whom he believed were cashing in on the booming market he created with inferior imitations. LeRoy was most troubled by Robert Bennett Neiman, who worked in a similar style but with brighter backgrounds and photorealist figures. Like LeRoy, Robert Bennett Neiman was a World War II army veteran who served in France. And his given surname actually was Neiman. Consequently, LeRoy could not stop him from using the moniker on his work and in the marketing for it. But the opportunistic Robert Bennett Neiman was clearly taking advantage of LeRoy's name recognition. His autograph—which read "R. Neiman"—closely resembled LeRoy's signature by combining an oversized capital "R" like the one LeRoy used to write his first name along with a similar rendering of their last name. And Robert Bennett Neiman's marketing materials emphasized only the part of his name that he shared with the famous LeRoy. An ad exclaimed that "sports enthusiasts naturally would like to own a 'Neiman' original full color painting." The

promotion ended with a note from the artist that proclaimed, "Call me . . . Neiman."[25] The misleading but brilliant promotion exploits the name's obvious association with LeRoy and his sports-themed work. It almost seems to taunt LeRoy, who was legally powerless to stop the impostor. But it also shows that LeRoy had created a market for colorful sports-themed artwork that could support several working artists—and two Neimans.

The predictability and pervasiveness of Neiman's work by the 1980s made it easier for imitators to thrive. He almost exclusively worked on commissions from clients who wanted him to reproduce the sort of art that put him on the map. He was no longer collaborating with culturally transformative figures like Muhammad Ali or Joe Namath. Nor was he participating in Roone Arledge's reimagining of sports television at ABC or weird but inventive ventures like CBS's Electronic Palette. Even his work for *Playboy* waned. He stopped doing *Man at His Leisure* in 1973 and was mainly contributing Femlin sketches for the Party Jokes page. And *Playboy*'s profits and relevance were plummeting during the 1980s—a topic to which *Newsweek* devoted an August 1986 cover story.[26] The brand of swinging masculinity it traditionally peddled was increasingly viewed as misogynistic and, with the rising HIV and AIDS epidemic, even dangerously irresponsible.

Hefner's diversified company was forced to shed assets to weather its sink in popularity. By the end of 1986, it closed all Playboy Club locations. As a result, it planned to sell off the Neimans that decorated the shuttered nightclubs, further flooding the market for LeRoy's work. In 1989, *Playboy* struck a $2.1 million deal with Dyansen— a retail art vendor that bought the originals and the rights to reproduce them as prints. *Playboy* framed the deal as an exciting new venture rather than a desperate attempt to evade bankruptcy.[27] Neiman, however, was infuriated by the arrangement. He viewed Dyansen as a purveyor of chintzy mall art that lacked the integrity of the approved galleries that typically sold his work. "Dyansen would never be my choice to represent my work and it is a serious disservice to my career and standing for some source other than myself to determine who handles my work," Neiman angrily wrote to Hefner. "What a shame

that after all these years such a durable and personal friendship as ours and the special longlasting relationship with *Playboy* has to be affected." Hefner responded with a calm and sympathetic letter that suggested *Playboy* would have preferred to strike a deal with Hammer, but Neiman's usual gallery was uninterested in purchasing the paintings.[28] Neiman and his artworks were becoming relics of *Playboy*'s past during a time when the company was eager to reinvent itself.

LeRoy did occasionally experiment with new themes and media. In 1988, he created the limited-edition bronze sculpture *Defiant*, a thirteen-inch-tall horse on its hindlegs reminiscent of Frederic Remington's famous *Bronco Buster* (1895) statuette that, like Neiman's paintings, had become a decorative staple in dens and executive office suites. Neiman later expressed passing interest in what he described "soft art"—a method that "involves cutting pieces of modacrylic fabric and sewing them in layers onto a canvas."[29] But Neiman did not stick with sculpture, and there is no indication that he completed any works of soft art. Instead, he mainly waited for commissions from clients who wanted art with his characteristic look and themes. It was easy money as the artist neared the age when most professionals are ready to retire.

* * *

Neiman had been conspicuous enough to inspire parodies since his appearances on prime-time TV in the 1970s. But as his visibility swelled into the 1980s, LeRoy became a commonplace shorthand for kitsch in middlebrow culture—an easy target comparable to the flamboyant pianist Liberace and the syrupy poet Rod McKuen who produced work akin to velvet Elvis tapestries and prints of dogs playing poker. Neiman composed a safe and legible object of criticism for those who sought to separate themselves from the mainstream predictability he represented and the groups that enjoyed it. His status as a cultural punching bag, of course, was possible only because of his pervasiveness, which ensured that audiences understood the frequent references. Although sometimes playful and sometimes cutting, the

critiques and parodies hinged on a shared common sense that Neiman made bad art for people who did not know any better.

A February 5, 1981, installment of Garry Trudeau's comic strip *Doonesbury* commented on the Iranian hostage crisis shortly after the American prisoners were set free. It did so by depicting the erratic Hunter S. Thompson–inspired character Uncle Duke as a hostage. Duke became squirrelly at one point during his detention and asked his captors to change the decor in his room. "Get me something classy, okay. You know, like a LeRoy Neiman sporting print," Duke hollers at the guard. Trudeau uses Duke's taste in art to illustrate the general coarseness that makes him laughable.[30] The 1984 spy spoof *Top Secret*—which centers on an American rock star Nick Rivers (played by Val Kilmer) who travels to East Germany on a goodwill tour and is unwittingly embroiled in a military coup—expanded on Trudeau's joke. At one point, the East German army captures Rivers and stages an interrogation to extract sensitive information he does not actually possess. The stone-faced guards become frustrated when their efforts are fruitless and consider torturing their prisoner. "He won't break. We've tried everything!" reports one of the guards to his commanding officer. "Do you want me to bring out the LeRoy Neiman paintings?" "No," the miffed officer responds after giving the suggestion some thought. "We cannot risk violating the Geneva Convention." A few years after *Top Secret*, the *Chicago Tribune* critic Terry Clifford bemoaned a spate of television remakes of notable films. "Surely, if there is fairness in life, there must be some kind of Dante-like place for those TV producers who persist in remaking motion pictures, classic or otherwise," he wrote. "Perhaps a room filled with nothing but LeRoy Neiman paintings."[31]

To call someone "The LeRoy Neiman of . . ." their specific field was to designate them a well-known but trashy hack. *Saturday Night Live* availed itself of Neiman's punchline status in a sketch on November 5, 1988, which aired just before that year's presidential election. "Dukakis after Dark" features Jon Lovitz as Democratic candidate Michael Dukakis, who at that point in the campaign had all but conceded defeat to George H. W. Bush. Dukakis, complete with a smoking

jacket, is hosting a late-night program modeled on *Playboy after Dark*. He mingles around a swanky penthouse à la Hefner and pauses to chat with several guests. He eventually encounters LeRoy Neiman (played by Kevin Nealon) painting at an easel. When Dukakis asks about the work in progress, Neiman replies, "Governor, I call this 'What Might Have Been.' It shows the nuclear aircraft carrier Nimitz after its conversion into a floating shelter for the homeless." The joke lampoons the liberal agenda that turned many voters away from Dukakis. "It's beautiful, LeRoy," Dukakis replies. "I think it's right up there with the Olympic moments series that you did for Burger King." The sketch suggests Dukakis's poor taste in art reflects his political naivete.

Paramount Pictures released *Scrooged* two weeks after *Saturday Night Live* aired "Dukakis after Dark." The holiday film—an adaptation of Charles Dickens's *A Christmas Carol*—stars Bill Murray as Frank Cross, a blindly materialistic TV executive. At one point, the main character discusses a television special that is sure to be a ratings blockbuster. The program will have Neiman painting the Berlin Wall and the pope blessing the entire Zulu nation. LeRoy fits seamlessly into the cynical executive's exploitative TV event. Shortly thereafter, *The Encyclopedia of Bad Taste* canonized Neiman as an exemplar of vulgarity alongside shag rugs, mood rings, the televangelist Tammy Faye Bakker, and Spam. The only other artists included in the sarcastic reference book were Margaret and Walter Keane and Morris Katz, who holds the Guinness World Record as the world's fastest painter and executed his rapid-fire artworks with an unorthodox combination of palette knives and toilet paper.[32]

Many of the jokes were made in good fun, and Neiman took them in stride as inevitable accompaniments to fame. He even expressed appreciation for a comic simulation of his work in *Playbore*, a 1983 send-up of *Playboy*. LeRoy could not help comparing the *Playbore* parody to the work of folks like Wayland Moore and Robert Bennett Neiman. "Whoever did this could probably make a few bucks if he kept imitating me," LeRoy chuckled.[33] While he was never above playful self-deprecation in private, Neiman would also sometimes publicly joke about his over-the-top persona—as long as the jests were

issued on his own terms. He briefly appeared in the 1982 made-for-TV movie *Rooster* as the sleazy painter Elroy Marcus, a character that made obvious reference to Neiman. In the scene, Marcus paints the beautiful Bunny Richter as she lounges in a bathing suit on the patio of a posh villa. An insurance detective interrupts the intimate portrait session. When the investigator asks Marcus his name, the artist condescendingly snaps, "I'm a famous painter. You've undoubtedly heard of me." Neiman's campy performance as Elroy Marcus, which he punctuates with icy glares and extended pauses, shows his willingness to have fun with the flashy identity he so carefully constructed.

On February 11, 1986, *Late Night with David Letterman* invited Neiman to participate in its absurdist Harmon Killebrew Night—a faux event sardonically billed as a momentous occasion in broadcast TV. Host David Letterman, a master of droll comedy, memorialized the evening in his opening monologue by giving out commemorative ice scrapers for the men in the audience and rain bonnets for the women. The program further amplified the evening by hiring LeRoy to paint on camera. "To commemorate a special night. Not just a special night but a special career and a special man, we've asked world famous artist LeRoy Neiman to be here tonight," Letterman announced. "And during the show he's going to be capturing all the magic of Harmon Killebrew Night on canvas." The broadcast then cut to LeRoy, who was already at work on his 8′ × 10′ canvas.

No stranger to appearing on talk shows, Neiman exhibited good rapport with Letterman. But unlike most of his TV appearances—on which he would agreeably yuk it up with hosts and share his work—here Neiman played the comic role of an inconvenienced straight man focused on completing his painting and mildly irritated by Letterman's periodic interruptions. At the beginning of the show, Letterman asked LeRoy if Killebrew could have the painting when it was finished. Neiman replied with a stern and definitive no before chomping down on his cigar with a knowing smirk and turning away to continue working. Later on, Letterman asked Neiman what the piece might fetch on the open market. "Two hundred fifty grand, and it's all yours," LeRoy curtly responded, again with a sly grin that cut his

serious tone. "Apparently, the fumes are getting to LeRoy," Letterman retorted with an eye roll.

Complementing Neiman's presence, the farcical episode included an appearance by Liberace, who did not seem to be familiar with Killebrew but was happy to clown around for a few minutes anyhow, and a visit by the country singer Charley Pride, who performed his song "Mountain of Love" over the telephone because he was unable to make it to New York for the show. The *Late Night* special shared more in common with Andy Warhol's experimental television programs than the sports broadcasts that helped to make Neiman a celebrity. It also demonstrated LeRoy's willingness to play along with a bit that satirized his frequently televised sports commemorations, and even his reputation. He realized that the appearance would only solidify his status as a punchline, but he could not pass up the exposure. And Neiman's impressive comic timing, which effortlessly kept pace with Letterman, demonstrated his comfort on the medium after two decades of TV appearances. "I like being outrageous," he told *Esquire* two years before his Letterman guest spot. "It's the worst possible thing for my income and standing in the art community, but I can't care. Why should I behave myself now, after all these years?"[34]

LeRoy realized that lashing out at his critics would only amplify their comments, make him seem petty, and probably invite additional scorn. In a 1986 response to a fan who asked how he dealt with the negative remarks, Neiman claimed to value the role critics play in the art world without taking their slights to heart. "The artist is, in any case, on his own, certainly not oblivious of the critic but also not creating for him," he wrote.[35] But he could not help but point out what he viewed as the hypocrisy of critics who berated his commercialism while ignoring the economic forces that drive the art world—business interests that their writings help to fuel through the promotion they offer for artists, dealers, and exhibitions. "I'd love to hang out with the critics who don't like what I do," he later told the *New York Times*. "But there are some things that are out of the question. You can't let it get to you."[36]

But the criticism did get to him. In fact, Neiman and his busi-

ness associates sometimes took measures to prevent the denunciations from reaching the public. In 1980, Knoedler's lawyers scared the *Saturday Review* into killing a largely negative profile on Neiman written by the freelancer Deborah Solomon, who eventually became an esteemed art critic and biographer. The attorneys argued that Solomon's article was journalistically irresponsible to the point of being potentially defamatory. It also charged that someone from the *Saturday Review* posing as Solomon had called Neiman's office to conduct follow-up interviews.[37]

LeRoy would have liked to kill a short *Sports Illustrated* profile published five years later by Franz Lidz. Neiman participated only reluctantly because of his contentious relationship with the magazine. While the article itself was not particularly mean spirited, it was overwhelmed by a series of pull quotes from Neiman haters. Most of the statements were from known art critics like Peter Plagens and Franz Schulze, who sniped: "Neiman is no fool. While he may be a bad painter, he is not a mediocre one." But the article also clumsily quoted an unnamed "noted magazine designer" who said, "What Howard Johnson's is to taste buds, LeRoy Neiman is to the eyes."[38] Lidz was enraged by the piece that eventually went to print, and he accused his editors of altering the profile beyond his intent. He took specific issue with their addition of the quip from the magazine editor and alleged that this anonymous source had to be a Neiman enemy from within *Sports Illustrated*. Lidz charged that his superiors transformed the article into an ethically negligent hatchet job. He gave LeRoy a copy of the heated letter he issued to the editorial staff and sent the artist a separate apology. "I should have known better," he wrote. "Sorry."[39] LeRoy had warned him that the magazine's hostile editors would use the opportunity to take whatever cheap shots they could. "It really pissed me off," Lidz remembers of the liberties *Sports Illustrated* took with his article. "It was just dumb and unprofessional."[40]

While he was never happy about his reputation, Neiman was fully aware of his role as an exemplar of bad art among the literati. In 1984, a recent Northern Illinois University graduate named David L. Gould asked Neiman to write him a recommendation letter for an

application to Yale University's graduate program in art. After scrutinizing the slides Gould sent along, LeRoy generously responded that he would happily provide a positive evaluation. But he then felt obligated to tell Gould that his endorsement might be a detriment at a prestigious Ivy League institution like Yale. "I hesitate to lend my opinion to your evaluation submission because of how Yale might rate my work," he wrote. "It is wise to go with people who are positively strong in that arena."[41]

Neiman maintained some healthy perspective on his status by reminding himself of how far he had come since his rough-hewn childhood in Frogtown and his days ladling soup in the army. When the journalist Debbie Sorrentino asked him about the common charges that his work was unrefined, Neiman responded, "This has got to be true since I was born and raised in the elements of the poor, working class, uninitiated into the dictates of the tastemakers." Despite his sociocultural disadvantages, LeRoy proudly maintained, "I have exceeded my expectations of what I could do."[42] He realized that most artists, even relatively successful ones, never achieve fame or wealth. LeRoy wanted the respect of critics, curators, and dealers. And he believed that he deserved their admiration despite his commercial bent and the middlebrow audience he mainly served. But Neiman had also experienced poverty firsthand. If he had to choose, he would take the fame and wealth—even if accompanied by a steady stream of derision.

15

The Price and Cost of Legitimacy

Neiman battled against the widespread criticism he faced during the 1980s by investing greater resources to shape his image and legacy. He established the LeRoy Neiman Foundation in 1986, a nonprofit that aligned his charitable activities with his image management. He also began to compile an inventory of his work and papers, a project that eventually employed several staff and culminated in 2005 when the materials were deposited at the Smithsonian's Archives of American Art. "I've got an archivist," Neiman later told the *Philadelphia Inquirer*. "We keep all reviews, everything, records. It's an expenditure I feel is necessary."[1] Neiman believed he was a historically important figure and that his materials should be available for future study—just like the Toulouse-Lautrec lithographs he perused during his time at the SAIC. He also hoped the archived materials would enable an eventual reconsideration of his place in art and cultural history.

LeRoy underscored his significance and celebrity by sometimes giving himself cameos in those paintings that depicted elegant scenes and notable establishments—especially bars and casinos. In *P. J. Clarke's* (1978), LeRoy sits at a table drinking and chatting with the famous guests the New York City tavern attracts, a group that includes Frank Sinatra in the bottom left corner and Jacqueline Kennedy Onassis in the bottom right. In *F. X. McRory's* (1980), a similar commissioned piece of the Seattle whiskey bar, Neiman placed his visage in the foreground stooped over a sketch pad while documenting the lively scene swirling around him. The paintings position these scenes as Neiman's element and insinuate that the locales would not

enjoy their tony status without LeRoy's combined roles as a celebrity and chronicler.

During the mid-1980s, Neiman expanded on the in-painting appearances by starring in a series of promotional video documentaries that offered his point of view on paintings that were about to hit the market as serigraphs. Produced in collaboration with Knoedler, the peculiar and genre-defying videos welded the travelogue, essay film, historical documentary, and infomercial. They were mainly vanity projects that never aired theatrically or on TV and, as a result, were seen by very few. But the videos were distributed to approved Neiman dealers who might wish to exhibit them in their establishments—in the same way department stores sometimes play infomercials on a loop as part of a display for featured items.

The twelve-minute video *Napoleon at Waterloo* from 1988 focuses on Neiman's identically titled painting, which was released as a print that same year. LeRoy conscripted Edmund Levy to direct, an established filmmaker who won an Academy Award in 1966 for his work on the short documentary *A Year toward Tomorrow*. The video opens with a shot of Neiman's paint-soiled studio floor that pans backward to an overhead view of the artist entering his creative sanctuary in similarly splattered coveralls. He strides past two easels that display his portraits of Napoleon Bonaparte and the Duke of Wellington, then pauses to light a cigar before approaching his featured opus, *Napoleon at Waterloo*, a massive canvas that depicts Neiman's interpretation of the famous 1815 battle. Resembling the opening sequence of PBS's *Masterpiece Theater*, the introductory footage is soundtracked by a grand orchestral march from the Napoleonic era.

This introduction is followed by Neiman's explanation of the creative inspiration he took from Napoleon and his ill-fated battle against Wellington. The painting, he notes, was completed over three years during the height of the Vietnam—a military effort that Waterloo helped the World War II veteran to put in perspective through his art. More specifically, Neiman explains his fascination with Napoleon's vanity and flair for publicity, which was mainly communicated through the portraits he commissioned. "In Napoleon's time, paint-

ing was like a photo opportunity," LeRoy states. "Napoleon was constantly posing for artists. He loved art. He must have—he stole it everywhere," Neiman adds with a playful grin. The video cuts to the site of the Waterloo battle, which LeRoy tours with his usual cigar and sketch pad. He recounts Wellington's victory at Waterloo but ends the piece by maintaining that Napoleon's glamour ultimately made the Frenchman a more enduring historical figure than his victorious adversary. He proves his point by ordering a Napoleon Brandy at a Parisian bistro. "See what I mean," he says with a satisfied nod. "How many of us could meet our Waterloo and come back?" Neiman then raises his snifter to the camera, gives a wink, and toasts his muse before the credits roll atop his artistic tribute to Napoleon and Waterloo.

The President's Birthday Party, a 1989 video based on LeRoy's painting of the same name, offers a similar survey of the artist's creative interests and process. The artwork provides Neiman's interpretation of John F. Kennedy's 1962 birthday party at Madison Square Garden, with a focus on Marilyn Monroe's memorably sultry serenade to the commander in chief. Neiman shows the golden-haired Monroe in the foreground singing "Happy Birthday" to JFK, who is surrounded by recognizable figures, including his brothers Ted and Robert, New York City's mayor Robert Wagner, and Vice President Lyndon B. Johnson. The painting's inclusion of so many identifiable people reflects *Introduction of the Champions* (1965), the boxing-themed piece that is also set at and owned by Madison Square Garden.

While Madison Square Garden owns the painting, Neiman held the rights to its reproduction. The video, also directed by Edmund Levy, was produced to coincide with the release of six hundred signed and numbered serigraphs. An uncredited narrator celebrates the painting as a nostalgic masterwork that "captures an era of promise and sweetness before a time of war and bitterness." It then cuts to Neiman in his studio, who explains his love for Kennedy in aesthetic terms. "I remember Kennedy from the debates with Nixon. The first one was in Chicago, a few blocks from my studio," he reflects. "I watched the man, and I liked what I saw. Among other things, Kennedy was

a master of style. He started the dry look in men's hair. . . . His ora-
tory was tough, lean poetry." Kennedy, Neiman asserts, embodied
the *Playboy* ethos of heterosexual manliness and fashion conscious-
ness—a lifestyle that his encounter with Monroe, the original Play-
mate and a rumored lover, encapsulates. The video then mourns Ken-
nedy's assassination just eighteen months after the carefree festivities
Neiman captures and laments the tumultuous decade that ensued. It
concludes back at Neiman's studio, where the artist approaches the
painting and pours himself a drink. "But on this night the president
did have a good time," he says while fixing his beverage. "In fact,
I think he had a hell of a good time. Happy Birthday, Mr. President,"
Neiman says while raising his glass to the painting. As in *Napoleon at
Waterloo*, the artist signs off with a toast to the distinctive and style-
conscious version of history that his artwork offers.

The videos reflect Neiman's consistent publication of books that
compile reproductions of themed works, such as *Horses* (1979) and
An American in Paris (1994). Like the videos, these volumes frame
their topics through LeRoy's point of view on the subject matter
and use that perspective to emphasize his artistic originality and sta-
tus. But LeRoy ventured into the realm of fiction with *Monte Carlo
Chase* (1988), an international adventure tale set in Monaco. The book
begins with an illustrated story about a vigilante artist. The Artist—
who remains nameless but appears identical to LeRoy—travels to the
French Rivera to gamble and hunt down a wily and crooked art dealer
named Renard, the Fox. Like LeRoy, the Artist is accompanied by
a beautiful assistant named Lydia, an homage to Neiman's mother,
who passed away in 1985. "There is no dossier on M. Renard," the art-
ist explains. "He is known only as an art-market publisher who went
AWOL after duping dozens of galleries with his bogus prints."[2] Monte
Carlo's luxurious casinos and restaurants compose the backdrop for
the Artist's fox hunt.

Renard turned to forgery after an unsuccessful attempt to become
a legitimate painter. The Artist first learned about Renard when he
discovered that the scoundrel was counterfeiting one of his popular
prints. "It never wears well when an artist discovers someone toying

with his art. So, it goes without saying that I'm out to get this cul-
prit."[3] The Artist maintains that he is most offended by Renard's will-
ingness to swindle the relatively normal folks who purchase prints.
"The affluent don't usually invest in popular multiples. So [Renard's]
breed sells to the general public, seeking out new, untested collec-
tors and Ma-and-Pa galleries." A rise in counterfeit prints was occur-
ring while Neiman was writing *Monte Carlo Chase*. According to
a *Los Angeles Times* report, "Dealers say the demand for art is so great
these days that most people never take the time to demand proof of
authenticity."[4] Neiman's work—along with that of similarly popular
artists like Dalí and Wyeth—was regularly forged and sold to unwit-
ting customers. The Artist's dogged hunt for Renard was partly moti-
vated by an effort to protect the relatively workaday community that
buys prints.

After some reconnaissance, the Artist and Lydia discover that
Renard is registered in the same hotel where they are staying under
the pseudonym O. Serline—another tribute to Neiman's maternal lin-
eage. But they still must find the disguised miscreant among Monte
Carlo's luxuriating throngs. The Artist fashions his own costume to
avoid being spotted by his quarry. He inexplicably opts to affect a
limp and dress like an elderly Orthodox Jewish man, complete with
a long beard and yarmulke: "I'll take his measure one on one, in dis-
guise, with a style equaling his own savoir faire and when I pull off
his apprehension single-handedly, I'll see the respect in his eyes, his
appreciation of my performance."[5]

The cloak-and-dagger hunt climaxes with a confrontation and car
chase through Monte Carlo's winding seaside roads—the same path
that the city's Grand Prix auto race uses. Within a couple of miles,
Renard loses control of his Rolls Royce and careens into Monaco Har-
bor. Rather than let the Fox drown, the Artist decides to rescue his
adversary. "For me, the real fun in fishing has always been the catch.
Now that I've caught him, hooked him, he's of no further use to me.
My instinct is to toss him back into the water like an ugly, sharp-
toothed dog fish. Instead, fighting my initial impulse, I pull him to
his feet and confront him." The hero forces Renard to face the humil-

iation of being outmaneuvered by the very artist he had been imitating and swindling. "And then this usurper, this purveyor of fake art, making no effort to disguise his amazement and with no trepidation, looks me up and down, gazing at his nemesis, the real thing, the actual artist standing before him." The Artist effectively outfoxed the Fox. "I should have known," admits the conquered Fox when he realizes his pursuer was the Artist—a defeated refrain akin to those of the captured villains in so many crime melodramas and *Scooby-Doo* episodes. Rather than turn Renard in to the authorities, the Artist is satisfied with his gentlemanly victory and decides to let the dishonored rogue free, with the knowledge that he will never be able to match his adversary's creative ability or wit. "In this mecca of chance, I have performed my task to my own artistic satisfaction, nonviolently overtaking this contemptible rascal and beating him at his own game."[6] The Artist has proved, once and for all, that he is the genuine article. Renard, in contrast, is a cheap imitator whose intelligence and masculinity are as decrepit as his artistic talents.

Similar to Neiman's videos, *Monte Carlo Chase* offers an amateurish narrative rife with clichés from the thriller genre—from the disguises to the climactic car chase to the sexy female consort. "Neiman's story trundles along with the suspense of a second-grade spelling test," declared an unsparing review in *People* magazine. "This is a work that is beyond interpretation, not to mention repair."[7] The illustrated tale is followed by sixty plates of Neiman's Monte Carlo–themed works that have no direct connection to the fictional adventure beyond their setting. The paintings include a disproportionate number of topless sunbathers luxuriating in the permissive vacation spot. The story of the chase, however, frames the larger project through an argument about Neiman's status as an authentic and clever Artist who defends his customers against the likes of Renard and other phony ne'er-do-wells. The book ends with a short essay by LeRoy that positions himself as heir to a tradition of canonical artists who took inspiration from southern France—a group that includes Cézanne, van Gogh, Renoir, Dufy, Matisse, and Bonnard. It is hard to view the videos and *Monte Carlo Chase* as anything more than self-indulgent romps. But

they powerfully illustrate Neiman's efforts to argue for his status as a unique and respectable artist.

* * *

Neiman also sought to justify his status in scholarly terms. In 1975, he asked the SUNY Binghamton art history professor Albert Boime to conduct a study that would explain his precarious place in the art world. Boime considered the offer, and even visited the Hotel des Artistes to meet with LeRoy, but ultimately he declined for lack of time.[8] Five years later, F. Lanier Graham's introduction to *The Prints of LeRoy Neiman* (1980) claimed it would be instructive to conduct a sociological survey of the artist's many collectors to determine what made LeRoy's art so popular.[9] Such academic consideration never materialized organically. As a result, Neiman and Knoedler launched an effort to support a study of the artist and his devoted audience for publication as the introduction to the second installment of *The Prints of LeRoy Neiman*, which collected the serigraphs produced between 1980 and 1990. The research would provide a way to battle against the critical dismissals that had intensified during the 1980s.

After some preliminary research, Knoedler and Neiman contacted the influential Columbia University sociologist Herbert J. Gans. Among his many works, Gans published *Popular Culture & High Culture* (1975), which championed cultural democracy and argued against the elitism that many Neiman critics so smugly exhibited. *Popular Culture & High Culture* countered the commonplace notion that popular culture harms high culture and argued that those who produce commercially successful work can and do make legitimate art.[10] Gans did not mention Neiman, but his book furnishes invaluable rhetorical ammunition that could be used against LeRoy's detractors. The sociologist would have been the perfect scholar to complete the sort of research Neiman and Knoedler envisioned. But like Albert Boime, Gans did not have the time to conduct the study. The professor was also likely wary of devoting himself to a research project underwritten by Neiman and his publisher—two entities with a material interest in promoting the artist's work and boosting his reputation. This

potential conflict of interest would have cost Gans some professional credibility.

So Gans did what many senior scholars do when offered a project they do not find appetizing: he passed the opportunity along to a younger mentee. David Halle was a rising star in cultural sociology who had earned his PhD at Columbia. He was an assistant professor at SUNY Stonybrook and an associate researcher at Columbia's Center for American Cultural Studies. Like Gans, Halle's research explored the intersections across social class and art culture. Halle had never heard of Neiman when he was approached about the project. But he became fascinated after doing some preliminary reading. Neiman "seemed to me to be an interesting case of the cultural elite being somewhat prejudiced to one who was popular," Halle recalled.[11] Halle admired Neiman's willingness to create figurative work even though it was less fashionable—and he was charmed by LeRoy's roguishness. He agreed to conduct the study in collaboration with his partner Louise Mirrer, who was then a faculty member in Fordham University's Spanish department.

The study was based on a fifty-two-question survey distributed to those who purchased Neiman serigraphs. Knoedler arranged to have the questionnaire, which Halle and Mirrer developed, distributed to Neiman buyers from galleries across the United States, mainly Hammer in New York, Hanson and Upstairs in Los Angeles, and Bowles in San Francisco. Participants received a signed Neiman poster as compensation for their efforts. The survey-driven project reflects the approach that the French sociologist Pierre Bourdieu took with *Distinction: A Social Critique of the Judgment of Taste* (1979), which Halle and Mirrer cite as a key influence on their study. The questionnaire tracked Neiman buyers' demographic information, including age, gender, education, profession, income, and marital status. It also asked respondents to list their favorite artists and writers and to note how often they visited museums and read books. Finally, it requested that participants explain precisely why they liked Neiman's art, how many of his prints they owned, and which of his works were their favorites.

Halle and Mirrer began analyzing the data after collecting one

thousand completed questionnaires. They titled the report "Prints of Power" and described it as a "study of the reasons for Neiman's popularity."[12] The scholars couched their report in academic terms by opening with an epigraph from cultural theorist Roland Barthes's essay "Erté, or À la lettre," a meditation on the popular illustrator Erté: "In order to be known, artists must suffer a minor mythological purgatory: we must be able to associate them quite mechanically with an object, a school, a fashion, a period of which we call them the precursors, the founders, the witnesses, or the symbols; in a word, we must be able to *classify* them easily, to subject them to a label, like a species to its genus."[13] The epigraph places Neiman into the register of serious academic discourse and previews the study's efforts to add nuance to Neiman's easy classification by critics who dismiss him out of hand. Demonstrating their intellectual debt to Gans, Halle and Mirrer contend that Neiman's popular artwork provides a more powerful "expression of social values and ideals" than many high cultural artifacts, which are often out of touch with and disconnected from everyday life. Neiman's popularity, they argue, derives from his art's tendency to "fortify such central values as competition, success and power" through his celebration of sport and leisure. They also cite his commitment to working out of a figurative and Impressionist tradition that resonates with the public. "Neiman understood that abstract art left a void amongst twentieth-century audiences insofar as it made no effort to reflect the leisure aspirations and activities of the well-to-do middle and upper middle classes after World War II." Survey respondents overwhelmingly listed impressionism as their favorite genre of painting. Neiman, as Halle and Mirrer observe, tapped into this popular interest in impressionism and updated it with scenes of contemporary leisure.[14]

The study's observations about the reasons for Neiman's popularity are generally unsurprising—his prints sell so well because they adopt a mainstream-friendly style, depict pleasurable subjects, and reflect common values. But the information Halle and Mirrer gathered on Neiman's admirers countered the stereotypes that those who enjoyed his work were uneducated, fast-food-eating TV junkies incapable of

appreciating any art that was not force-fed to them through mass cultural spigots. The questionnaire results indicated that Neiman buyers were members of the occupational elite: 80 percent had graduated from college, and 72 percent earned an annual household income over $80,000—a solidly upper-middle-class figure at the time. Moreover, 80 percent of those who purchased Neiman prints were men, which Halle and Mirrer acknowledge as "unusual in the art world, where pieces are typically bought by men and women together."[15]

As a courtesy and to fact-check, Halle and Mirrer sent Neiman a copy of their study before it went to print.[16] While Neiman made no editorial suggestions, Halle remembered a Knoedler official recommending some minor changes that would give the report a more celebratory tone by, for example, replacing a mention of LeRoy's "talent" with "brilliance!" "I didn't like to be pushed around so I said, 'definitely not,'" Halle remembered. "And then I said to LeRoy, 'Look, if someone didn't like the way you depicted them would you change it?' And he said, 'No, I wouldn't.' He liked people who were outspoken."[17] But Neiman had little to worry about since Halle and Mirrer's essay contained few criticisms of his art, and mostly defended him against his detractors. The study ingratiated Halle to Neiman, who later hired the scholar to pen introductions to the exhibition books *LeRoy Neiman: The Culinary Arts, Paintings, Drawings and Serigraphs* (1998) and *A View from the Table: Paintings and Works on Paper, 1955–2003* (2003).

"Prints of Power" was published only in *The Prints of LeRoy Neiman* and never appeared in the sort of scholarly venue in which Halle and Mirrer's academic work typically showed up. Consequently, the study was encountered mainly by those who already admired Neiman enough to purchase a large and expensive compendium of his works. The essay reassured Neiman disciples that their favorite artist was legitimate and that their investment in his serigraphs placed them into an exclusive, educated, and affluent community of connoisseurs.

Along those lines, "Prints of Power" mainly served as market research for Neiman and his publishers that masqueraded as scholarship. By asking respondents to list their favorite Neiman prints,

the survey offered guidance on what sorts of works Neiman would do well to continue producing or compiling. Those polled listed golf as their preferred leisure activity and many cited LeRoy's depictions of elephants and tigers as their favorite Neiman artworks. Neiman published the books *Big Time Golf* (1992) and *Neiman on Safari* (1997), which assemble his art on these topics, after gathering this information on his buyers' interests.

* * *

LeRoy's hometown seemed a welcome place to help the artist boost his image. St. Paul had repeatedly demonstrated its affection for Neiman by hosting his retrospective exhibition in 1975, commissioning him to illustrate its official Bicentennial poster, and naming him grand marshal of its Winter Carnival Parade in 1985, for which it hired him to paint the city's Ice Castle. Neiman gave himself a cameo in the piece to underscore his affectionate relationship to St. Paul. His black-haired visage stands in the center foreground outside of the Ice Castle bundled in a full-length fur coat and sketching the chilly festivities.

Father Terrence Murphy, a childhood friend of Neiman's who entered the priesthood and later became president of the University of St. Thomas, also approached LeRoy about helping the St. Paul school.[18] These plans took a firmer shape after Murphy officiated Lydia's funeral, which put him into frequent contact with LeRoy. Murphy began raising money to finance a Neiman mural that would be installed on the south wall of St. Thomas's Schoenecker Arena. Neiman quoted St. Thomas $100,000 for the mural, in addition to the usual cost for travel and lodging while the painting was being completed. He included in the estimate cost-saving measures like hiring St. Thomas students to be his assistants. "It can come to be," Neiman wrote Murphy of the pricey undertaking. "St. Paulites I've talked to are very receptive."[19] Murphy advised St. Thomas's vice president of external affairs Quent Hietpas that he ought to stress "the size of the wall and that this is to be a monumental work of Neiman's which could well be his legacy in St. Paul" when soliciting donations for the project. "We should emphasize that this is not just an ordinary work

of his, but a very special work and one that will be magnificent in size," Murphy continued. "It will be a genuine showpiece and attraction for people from all over."[20] The university, however, was unable to gather the necessary money, and the project petered out.

Murphy stayed in touch with LeRoy about a collaboration and launched a renewed effort in 1991—shortly after he stepped down as St. Thomas president. As Murphy reported to his successor Dennis J. Dease, Neiman "feels that he has never been fully recognized in St. Paul. Things that he has done for St. Paul haven't really caught on. He is in a reflective mood, thinking about his significance of life and his place in history." The priest concluded that the time was ripe to ask the wealthy artist for a donation. "I think LeRoy can be cultivated. He has a lot to learn about philanthropy," Murphy continued. "I urged him strongly to make the gift to St. Thomas and to do this in memory of his mother and in that way he would be doing something for the good of the church and for his community and it could be a kind of memorial that he would leave here."[21] Murphy knew that LeRoy's love for Lydia might have overpowered even the artist's substantial vanity. The crafty fundraiser tugged at both emotional levers to secure a gift for St. Thomas. Murphy and Dease began the flattery by offering LeRoy an honorary doctorate and inviting him to deliver the commencement address at its spring 1992 graduation ceremony. It would be the fifth honorary degree Neiman received after gathering decorations from the Art Institute of Boston (1975), Franklin Pierce (1976), St. John's (1980), and Iona (1985). As part of the event, St. Thomas planned to host an exhibition, which would include several pieces LeRoy gifted to the university. Neiman enthusiastically accepted the offer. "I consider it an honor for such a noble institution to bestow such a distinguished honor on a kid from Frogtown," he wrote to Dease.[22]

Shortly after the university announced Neiman's selection as commencement speaker, the graduating senior and student council vice president Mark Quayle condemned the decision in the school newspaper, *The Aquin*. He panned LeRoy as shallow, chauvinistic, and trashy—hardly the sort of person whom the student body should

admire. "His work," Quayle wrote, "is largely considered to be so lacking in content or ideas that he is constantly ridiculed by art critics."[23] Quayle considered Neiman antithetical to the values St. Thomas officially endorses. Neiman's invitation, as Quayle saw it, revealed the school's hypocritical prioritization of fundraising and publicity. The perceptive Quayle hit on the economic motives driving the invitation that Murphy and Dease articulated in their behind-the-scenes plotting to secure Neiman's donation.

Quayle's article prompted a lively debate around the small and tight-knit university. Several students launched a petition to disinvite Neiman. The graduating senior John T. Dosch wrote a letter to *The Aquin* disagreeing with Quayle and the protesters and contending that many were excited for Neiman to speak at commencement.[24] The discord reached such a pitch that Murphy felt moved to register his point of view in the student paper. He rebutted Quayle's claims and praised Neiman as one who "lives simply, and is a good Catholic and a man of the highest integrity." Murphy illustrated these points by recalling a wake for Sister Marie de Lourdes, who taught LeRoy in the sixth grade at St. Vincent's. While at the wake, Murphy learned of a letter Neiman had written Sister Marie after he made it big to thank her for the encouragement she offered when he was a child—a note the nun kept among her most cherished mementos. "That's the LeRoy Neiman who I know," Murphy wrote. "And that's the LeRoy Neiman who the University of St. Thomas should have welcomed on its campus, not shunned."[25] St. Thomas's administration also defended Neiman against the claims about his work's sexist degeneracy by falsely averring that the artist, despite his association with *Playboy*, did not produce nudes. LeRoy, of course, had created many nudes over the years—within and beyond *Playboy*. The Femlin was naked every month. It was deliciously ironic—and a testament to cultural shifts that had occurred over the course of LeRoy's long career—that a group consisting mainly of priests defended Neiman against a cluster of offended college students.

LeRoy, who was expecting a glorious homecoming, was surprised and humiliated by the dispute. In his memoir, he claims to have told St.

Thomas to "get lost" when the dust-up occurred. In reality, he politely bowed out on the grounds that he did not want to distract from the graduates' special day. Dease sent Neiman an apology to smooth things over: "I am truly sorry this happened. Please forgive us for the embarrassment I know this has caused you."[26] But Neiman's monument in St. Paul would not be at the University of St. Thomas—and the school would not receive the gifts Murphy and Dease envisioned.

Four years after the University of St. Thomas hubbub, a group of St. Paul civic leaders concocted an idea for a permanent LeRoy Neiman museum to complement the city's downtown revitalization efforts— the centerpiece of which was a bid to acquire a National Hockey League expansion franchise. Mayor Norm Coleman was elected in 1994 partly because of his promise to transform downtown St. Paul into a commercial and tourist center by capitalizing on the city's natural resources—such as the scenic Mississippi riverfront—to create a cultural district. Coleman viewed Neiman as a similarly untapped resource. Neiman, who had not been back to St. Paul since his mother died in 1985, liked the idea. He agreed to donate an estimated $4.5 million worth of his work to fill the proposed museum once Coleman and his task force secured a location for it.

Coleman's group was eyeing the Jemne Building, a large art-deco structure on the corner of St. Peter Street and Kellogg Boulevard with a turret that overlooks the Mississippi. The Jemne was built in 1931 to house the Women's City Club of St. Paul. The ornate building includes terrazzo and parquet floors, brass stair rails, bronze window fittings, a theater with gold-leafed walls, and a dining room that seats 150. Financial challenges forced the Women's City Club to sell the Jemne to the Minnesota Museum of Art in 1969, which occupied the building until 1992. The architectural landmark had lain dormant since then and was used primarily for storage when talk about the Neiman museum began. LeRoy was familiar with and fond of the Jemne, which hosted his 1975 retrospective. The vacant building made good sense as a location for the proposed museum and dovetailed with the philosophy undergirding Coleman's revitalization push: it was an underutilized local asset with great potential.

But other constituencies were also vying for the Jemne. In particular, a women's group wanted to return the building to its original purpose by housing an organization that would aid women-owned local businesses.[27] Those pushing for the Neiman museum made their case on mostly economic grounds. One proposal estimated that the museum would annually yield $1.2 million from gift shop sales and $1.1 million from admission fees. "I look at this as a worthy project for downtown St. Paul and believe good judgment will prevail," said Larry Buegler, director of St. Paul's Planning and Economic Development Department. "We probably don't need another club. The museum will strengthen the cultural corridor."[28]

St. Paul's Housing and Redevelopment Authority voted 6–1 in favor of purchasing the Jemne with the intention of selling it to the Neiman supporters once they raised the capital, which proved more challenging than the group anticipated. Reflecting the University of St. Thomas incident, critics were quick to condemn the city's decision. The group that lost out on the Jemne remarked on the irony of the storied building transforming from a sanctuary for the city's progressive women into a monument to an artist who became famous by working for *Playboy*. And the *Star Tribune* called the plan "the worst real-estate deal" of 1996 because of the Neiman group's bumbling inability to make good on its promise for payment. "Nothing wrong with the idea of honoring Neiman," the paper remarked. "But turning the Jemne—with its gold-leafed theater and black terrazzo floors—into a Neiman shrine would be like converting a cathedral into a casino."[29]

Neiman was not naive enough to expect that all of St. Paul would uncritically support the project. But he was especially vexed by *St. Paul Pioneer Press* columnist Katherine Lanpher's argument in June 1997 that the Neiman museum should not proceed because his art, as she bluntly put it, "stinks." Lanpher lambasted the project as a commercial ploy with little value for the so-called cultural district in which it would be located. The columnist maintained that the Neiman museum should not be sacked because of LeRoy's work for *Playboy*— a perspective that she believed "smacks of censorship and a restriction on freedom of expression." Instead, she simply thought Neiman pro-

duced bad art and that museums should devote themselves to higher-minded fare. Similar to Mark Quayle's article five years earlier, Lanpher chided St. Paul for presenting the museum project as anything other than a moneymaking scheme. "It makes you wistful for the days when Sinclair Lewis was around," she wrote. "Think of the fun he could have."[30]

The St. Thomas controversy did not spread beyond the small private school. But Lanpher's column made a citywide mockery of Neiman. "He felt like he was being rejected by his own town. That's what pissed him off," recalled the local art dealer Robert Varner, a member of the Neiman group. And LeRoy made it worse by publicly responding to the column—a surefire way to extend the article's life span. He called it a "cheap shot" and a "savage, insulting attack on my character and work" from a cruel journalist. "I feel like I was mugged on June 24 in my own hometown," he wrote in a fax sent to several news outlets. "If this is the sort of reception I can expect, there is no choice other than to withdraw." He continued venting in a separate conversation with the *Star Tribune*. "Everybody has got a right to their opinion, and I don't expect 100 percent of my audience to be in agreement," LeRoy blustered. "But I've never seen anyone say my life's work stinks. I think that's strong and I don't think I should stick my neck out to recruit more silliness."[31] Critics, of course, had said far worse. But the words carried a special sting coming from the hometown that he thought was eager to celebrate him.

"He seems awfully thin-skinned," Lanpher said in response to Neiman's rant and abrupt decision to withdraw from the museum project. "As someone who lives in Manhattan, he should know a mugging leaves a more severe bruising," she joked.[32] The story—with its juicy combination of art, commerce, local politics, and gender relations—snowballed amid the back-and-forth and remained in the local papers for nearly three weeks. *Pioneer Press*'s city reporter Ann Baker framed the controversy as a "battle of the sexes" and the newspaper held a poll for readers to weigh in on whether the Jemne should be given to the Neiman museum or the women's collective. The women won by a vote of 70–64.[33]

The dispute morphed into a referendum on Neiman's gender politics as well as the quality of his artwork. LeRoy insisted that he did not want the museum debate to become "a sociological problem" that pitted him against women. He eventually argued that the women's collective deserved the Jemne. "I'm not out to battle with the women's group," he told the *Star Tribune*. "I'm all for it. I think [the city] should give it to the ladies."[34] He punctuated this somewhat condescending remark by taking a poke at the group's exclusivity. He recalled trying to convince his mother to join the club after her husband passed away. "But she was shy," he said, explaining his mother's reluctance. "The club was ladies of means and education. I thought it would be good for her to broaden her life there. She didn't want to."[35] The group, he implied, was not particularly welcoming toward women from Frogtown. A separate *Pioneer Press* column by Joe Soucheray offered a populist retort to Lanpher by praising Neiman's ability to make art that nonspecialists could understand and appreciate. "We should get down on our knees and welcome LeRoy home," he wrote. Lanpher owned up to her cultural and aesthetic biases. But she surmised that her point of view pricked those like Soucheray because it undermined "a lot of Babbits who owned one piece of art, and it was a Neiman."[36] She made these Neiman lovers feel insecure about their taste.

Lanpher was the first female news columnist at the *Pioneer Press*. Hate mail and threats—much of which was tinted with sexist invective—were routine for her. But she never received a more impassioned response during her sixteen-year career at the paper than she did after declaring that Neiman's art stinks. Lanpher remembers upward of 150 voicemails responding to the column.[37] One reader called Lanpher a "feminist airhead" and Robert Varner discredited her column as a feminist rant—even though her assessment of Neiman was issued on squarely aesthetic and commercial grounds.[38] St. Paul City Council president David Thune discredited Lanpher as "not a particularly well-read or respected columnist" before blaming the *Pioneer Press* for depriving St. Paul of someone with Neiman's singular "stature and importance."[39]

The *Pioneer Press* defended Lanpher against the blowback. One

editorial chided Neiman's reaction as petulant. Another reminded its readers that columnists have a right to share their opinions, however contentious.[40] And Lanpher did not let up. She refused to apologize and claimed that LeRoy's childish response was an effort to court more attention. "I believe that Neiman's threatened pull-out is one great publicity sting," she wrote. "I may not appreciate his artwork, but I respect Neiman's flair for publicity. His thin-skinned posture guarantees that the quest for his museum will linger for at least a few more news cycles."[41] But Lanpher and the *Pioneer Press* seemed more invested than Neiman in stretching the story to borderline-exploitative lengths. Their continued commentary worked to wring out as much print-worthy discussion as possible. Neiman sold art; they sold papers.

Desperate to change Neiman's mind, a Minnesota delegation that included Governor Arne Carlson, Norm Coleman, and David Thune flew to New York for an emergency lunch meeting at the Café des Artistes. Coleman left the rescue mission optimistic that LeRoy might reconsider abandoning the project. "We all just needed our first face-to-face, look-in-the-eye meeting to get the commitment," the mayor remarked. "LeRoy has lived with the rich and famous, but his heart is still with the people and he's proud of his Frogtown roots.[42] The gambit worked, and Neiman changed his mind. "I was convinced by the sincerity and the enthusiasm of the people who came to visit and I will be proud to express myself by representing my life's efforts to the old neighborhood," LeRoy told the *Star Tribune* after the lunch.[43] While Neiman supported the idea for the museum and was committed to furnishing the art, he was unwilling to be involved in any ways that might further expose himself to criticism on the effort's behalf— especially after his feud with Lanpher and the *Pioneer Press*. But again, the fundraising efforts foundered and the effort to build a LeRoy Neiman museum was abandoned for good.

"I'm very apart from St. Paul," LeRoy admitted with some resignation during the museum controversy. Despite the sentimental value the city held, he never returned home. The closest Neiman came to reconnecting with St. Paul was when he painted a portrait of Min-

nesota governor Jesse Ventura in 1999. A populist politician, retired wrestler, and occasional actor, Ventura was a perfect subject for Neiman. LeRoy painted the plainspoken governor after attending a speech Ventura gave at the National Press Club in Washington, DC. Neiman was happy with the piece, which depicted the bald and thick-necked Ventura flashing peace signs with either hand. He eventually offered it to Ventura for use as his official governor's portrait, which would install it alongside the paintings Neiman admired as a child while loitering in the capitol. Ventura, however, chose to have his portrait done by Steve Cepello, another former wrestler who offered a rendition of the governor that was far kitschier than anything Neiman could have cooked up. The painting depicts Ventura on a bluff over-looking St. Paul and the Mississippi River. The navy veteran wears an American flag necktie and military lapel pins while heroically peering into the distance and resting his right hand on Auguste Rodin's *The Thinker*. Even Lanpher probably would have preferred Neiman's por-trait of Ventura to Cepello's heavy-handed and quasi-fascist artwork.

* * *

Respectable institutions outside of St. Paul were happy to aid Nei-man's legacy building, for the right price. In 1995, LeRoy gave Colum-bia University's School of the Arts $6 million to create the LeRoy Neiman Center for Print Studies. It was the largest gift the School of the Arts had ever received. Neiman was thrilled to offer the dona-tion, which garnered significant media attention. And he was relieved that the gift did not elicit a negative response. "During the height of the Renaissance, the Venetians felt money did not give power in and of itself. They felt the accumulation of money simply meant you could buy more pleasure," LeRoy told *Manhattan* magazine. "But the Columbia gift symbolizes the fact that I'm finding more uses for myself. And it symbolizes as well as the luck I've had, to earn the $6 million to donate."[44]

Neiman deliberately devoted the new center to print instead of painting or drawing. "I wouldn't have the money to contribute if it weren't for them," he explained. But the Neiman Center also aided

LeRoy's effort to legitimize the mass-produced medium. "Just because prints reach a wide and sometimes uninitiated public does not mean you can just knock them out," he told the *New York Times* after the gift was announced. "For example, to do silkscreens with 40 or 50 colors, that takes dedication." The Center for Print Studies would be in what Neiman described as a "state-of-the-art environment blessed by academia."[45] And not just any institution—but an Ivy League university in the heart of New York City. Just as important, it permanently installed Neiman in this rarefied setting. The thousands who daily walk down the cobblestone path in front of Columbia's Dodge Hall, a stone's throw from Broadway, see a painted sign that reads LeRoy Neiman Center for Print Studies.

As an added benefit of the donation, Robert Fitzpatrick—who publicly disparaged Neiman while overseeing the 1984 Olympic Arts Festival in Los Angeles—was named dean of Columbia's School of the Arts shortly before LeRoy gave the gift. Neiman's donation provided a transformational resource for Fitzpatrick as he was beginning the position. But it also put the dean under the wealthy artist's sizable philanthropic thumb. Suddenly, Fitzpatrick was working down the hall from a center named for an artist whose work he once called "second-rate schlock," and he was obligated to give speeches that praised Neiman. "In a period when the federal government, the state government, and the city government is cutting, here is an individual, an artist, who said 'I'd like to help,'" Fitzpatrick gushed of LeRoy after the donation.[46] Fitzpatrick, of course, was not the first administrator to let practical economic realities override cultural idealism. But Neiman surely relished Fitzpatrick's sudden conversion from denigrator to sycophant. The gift proved an effective but expensive way to turn the tables on a former critic.

Two years later, Neiman endowed the LeRoy Neiman Center for the Study of Society and Culture at UCLA. LeRoy wanted to build on the study he and Knoedler commissioned in the late 1980s by creating a permanent institute that attached him to scholarly inquiry. He had an academic ally in David Halle, whom LeRoy put on the board

of advisers for his Center for Print Studies at Columbia. Halle was still employed at SUNY Stonybrook, which runs the Pollock-Krasner House and Study Center and organizes diverse events related to the work and legacy of Jackson Pollock and Lee Krasner. Neiman envisioned something similar that would be centered on him. After Halle left Stonybrook for UCLA's sociology department, LeRoy gave him $1 million to establish and direct the Neiman Center in Los Angeles. Halle described Neiman as "an ideal link to our Sociology Department because he is a first-rate observer of American society who can help us see issues we need to explore." The Neiman Center would support interdisciplinary research initiatives on the arts and culture. As Neiman explained in a press release: "The educational world doesn't have the same concerns and fears that influence corporate America— faculty and students are looking for the truth, and they are welcome to new interpretations of facts and opinions. I find that very healthy."[47]

The UCLA Center hosted an annual conference, a speaker series, and an artist-in-residence program. Many of the events complemented Halle's research, such as the 1999 conference devoted to comparing New York and Los Angeles—a precursor to the sociologist's eventual book on the topic. The entrepreneurial Halle secured several grants to augment Neiman's seed money for the center and was frequently sought out to offer expert commentary on a range of popular culture topics. Such comments—including an endorsement for a new edition of Herbert J. Gans's *Popular Culture & High Culture* published in 1999—captioned Halle as director of UCLA's LeRoy Neiman Center and further emphasized the popular artist's position as namesake of an institution that confers cultural authority.

But UCLA suddenly closed the Neiman Center in 2003. "It was a political issue," remembered Halle, who was miffed by the decision. A new chairperson took over the sociology department who, according to Halle, "just didn't like the idea of a center being funded by an artist and having the artist's name." Neiman pulled his funding once the chair expressed reservations. "The chair had a very purist view," Halle said. "In New York no one would look twice at someone

funding a center that had their name on it." Neiman's friend Tommy Hawkins, a former professional basketball player who went on to work for the Los Angeles Dodgers, recalled that LeRoy was generally underwhelmed with the returns his investment in the UCLA center yielded and probably would have discontinued the funding anyhow. He claimed Neiman "never felt UCLA did anything for him."[48]

16

All Told

LeRoy continued to rise early and work seven days a week as the 1990s arrived and the artist entered his seventies. But he scaled back his hectic travel schedule. In 1988, he was forced to cancel an invited trip to Seoul, where he was again set to serve as the official Olympics artist, after fracturing his kneecap on a separate journey to Russia. As his traveling slowed, his artwork began to focus on the bygone era with which he was increasingly associated. He regularly did paintings commemorating athletes' retirements and inductions into halls of fame. The Boston Celtics, for example, hired Neiman to create of portrait of Larry Bird as part of the festivities surrounding the star ballplayer's retirement in 1992. LeRoy had painted Bird before, and the team photographer Steve Lipofsky provided him with sample photographs. But the artist insisted on flying to Boston to meet the basketball player and sketch courtside while Bird played during his final season. "For two games he sat there and just drew," recalled Celtics vice president of communications Tod Rosensweig, who organized the visit. The painting Neiman wound up creating—which was transformed into a serigraph and sold to fans the following year—reproduced a predictable image of Bird taking a jump shot. It was a pose nearly identical to one of the photos Lipofsky provided LeRoy. It occurred to Rosensweig that Neiman simply wanted the notice he would get from attending the games in person, where he would interact with fans, hobnob with athletes who dreamed of someday ending up in one of his artworks, and be introduced by the PA announcer at Boston Garden.[1] He missed and craved the limelight.

As he demonstrated in Boston, the aging Neiman still attended convenient or vital events. He did not miss, for instance, opportunities to sketch rising phenoms like Ken Griffey Jr., Tiger Woods, and Venus and Serena Williams. In March 1999, he participated in a contest organized around a heavyweight title fight at Madison Square Garden. The winner got to sit next to Neiman at ringside while he sketched.[2] But Neiman increasingly took jobs depicting historical subjects that he could complete from photos and without leaving the studio. In 1997 Wheaties hired him to paint five NFL legends for a collectible series of its cereal boxes that reimagined LeRoy's partnership with Burger King during the 1976 Summer Olympics. The same year, Chase Bank contracted LeRoy to paint a Jackie Robinson portrait to observe the fiftieth anniversary of Major League Baseball's racial integration. And LeRoy contributed several paintings to various projects devoted to celebrating Muhammad Ali—especially a cluster of initiatives that praised the boxer as the greatest athlete of the twentieth century. While many of these late-career projects seem like easy paychecks, Neiman maintained exacting technical standards. In 2003, he got into a spat with the German art-book publisher Benedikt Taschen about the quality of reproductions used in the ambitious *GOAT: A Tribute to Muhammad Ali*. Neiman threatened to remove his work if Taschen did not meet his expectations. Neiman may have also been annoyed that Taschen gave several other contributing artists—including Jeff Koons, whose work LeRoy thought was idiotic—more prominent placement in the book despite his personal friendship with Ali and involvement in the boxer's career.[3] Beyond personally disliking Koons's work, LeRoy likely resented how the so-called King of Kitsch managed to gain critical esteem despite making millions by producing intentionally tacky art.

While Neiman's output did not wane, prices for his work, especially the prints, started plummeting. The main reason for this decline was the sheer abundance of prints in circulation—including fakes. Christies stopped accepting Neiman prints for auction as early as 1989. In 1993, *Forbes* reported that Neiman's serigraphs were selling for five to twenty cents on the dollar of their original price.[4] But clients still

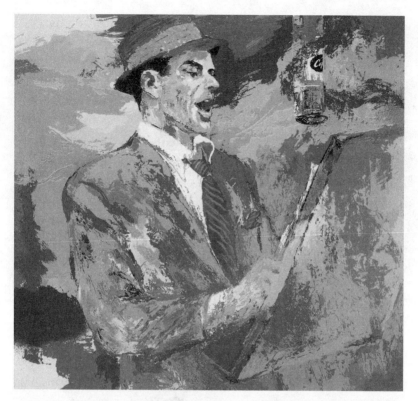

FIGURE 31. LeRoy Neiman, painting for the cover of Frank Sinatra's *Duets*, 1993. © 2023 LeRoy Neiman and Janet Byrne Neiman Foundation / Artists Rights Society (ARS), NY.

sought out and valued the Neiman treatment. LeRoy's old chum Frank Sinatra hired the artist to create the cover art for his last two studio albums, *Duets* (1993) and *Duets II* (1994). Other companies had Neiman endorse products related to the good life he celebrated. He created a label for Duval-LeRoy Champagne, appeared in advertisements for Universal Genève watches, and, in 1997, collaborated with Don Diego on a signature cigar. The cigars came in a box emblazoned with a Neiman painting titled *Wine, Women, and Cigars*, which depicted the artist dining alongside a woman while a waiter presents him a fine cigar. The Don Diegos were limited to five thousand boxes, which sold for $500 apiece. An ad featured a photograph of the Neimanified box and encouraged purchasers to "Hang This When You're Finished" with

the stogies. Aside from the custom box, the cigars had an image of LeRoy on the band. Reflecting Neiman's childhood tendency to show off his cigar bands when he managed to procure the spendy Dutch Masters, Don Diego made LeRoy's visage into a mark of prestige that its smokers could use to broadcast their own classiness.[5]

The Frank Sinatra album covers and Don Diego cigars seamlessly jibed with Neiman's persona. But the attention-hungry artist continued accepting nearly any convenient opportunity to get exposure. The US Olympic Committee moved on from Neiman in 1992, when it hired Hiro Yamagata to serve as the official artist for the Summer Games in Barcelona. It again tapped Yamagata, whose art is known for its electric colors and use of laser technology, for the 1996 Games in Atlanta. As Yamagata got to work in Atlanta, Neiman did a weeklong residency on the TV talk show *Live! with Regis and Kathie Lee*. Reprising his efforts in Munich and Montreal, Neiman sketched a goofy pasta-making competition called the Pastalympics. Never looking to pass up an opportunity to tweak LeRoy, *Sports Illustrated* published a satiric interview with Olympic Games founder Pierre de Coubertin before the 1996 Games commenced. "You know, it was my original intent to award prizes for the arts as well as for sport at the Olympics," the fictionalized Coubertin wearily said. "I hoped to inspire another Monet, a Cézanne, a Renoir! How could I know we'd get LeRoy Neiman instead?"[6]

As the Pastalympics indicate, Neiman was often happy to be ridiculous, mildly self-deprecating, and campy. But he still fumed at the negative press that came along with those behaviors. In 1995, LeRoy convinced *New York Times* reporter Robert Lipsyte to give him some exposure in the paper of record. Lipsyte, who wrote mostly about sports, was a friendly acquaintance whom Neiman had known since the early 1960s. The journalist agreed to write an article but refused to do a puff piece, which his editors would have rejected anyhow. "I wrote the piece," Lipsyte recalled. "But I didn't feel that I could really give him a blow job because that's not what I did. I felt that I had to put him in some sort of context." That context included mentioning Neiman's fake age, negative reputation among art critics, and

his hearing aid—a fact that was not public knowledge and embarrassed LeRoy. Beyond these contextual details, the article offered a generally positive depiction of Neiman as a popular artist who, as Lipsyte put it, "defies the critics and keeps on painting." But Neiman was incensed. "He never talked to me again," Lipsyte shrugged. Neiman even had the journalist removed from the guests lists of parties to which they were both invited. Lipsyte was astonished by LeRoy's pettiness. "I feel sorry for him that he was so insecure, a man of that accomplishment." Neiman's anger toward the journalist spilled over into his journals, in which he called Lipsyte's mention of the hearing aid a "blind side."[7]

The multilayered effort to protect his image exposed both Neiman's insecurity and generosity. In 2000, he used his nonprofit foundation to establish the LeRoy Neiman Art Center at the New Traditions School in San Francisco. It was the first of many Neiman Centers organized around an effort give underprivileged children a chance to practice and appreciate art. Neiman's niece Heather Long did not learn about the extent of his philanthropy, particularly the support he offered to young artists, until after her uncle passed away. "He was pretty self-involved, as a lot of geniuses are," she said. "But I had no idea he had been giving away millions of dollars." Neiman unsurprisingly made sure that his name was prominently attached to the many charitable initiatives.

* * *

Neiman's struggle to control his legacy extended to one of his final major paintings, *LeRoy Neiman's Big Band* (2005). The project began during the late 1990s, when Neiman started sketching Wynton Marsalis's orchestra at Lincoln Center, a short walk from the Hotel des Artistes. LeRoy initially planned to create a painting of Marsalis's band for display at Lincoln Center. But the lifetime jazz enthusiast changed course and decided to paint his own fantasy group that combined his favorite musicians from across eras. Resembling Neiman's *Olympic Ring*, the 9′ × 13′ painting offered a colorful montage of eighteen jazz legends, including Marsalis, Duke Ellington, Miles Davis, Ella Fitzger-

ald, Charles Mingus and, in the top left corner, Frank Sinatra. Neiman considered the painting among his finest works. But Ahmet Ertegun, the cofounder of Atlantic Records and a powerful patron of Lincoln Center, rejected the piece. Ertegun was puzzled by the inclusion of Sinatra, whom he did not consider a jazz musician. Unusually intimidated by the influential Ertegun, Neiman obediently painted over the crooner and replaced him with Billie Holiday. Despite the revision, Ertegun stood firm in his disapproval of the painting's suitability for Lincoln Center. As a result, the large artwork hung in LeRoy's studio for ten years until his foundation made a deal to place it at the Smithsonian in 2015 (plate 16).

Shortly after Ertegun's rebuff, Neiman funded a documentary that would offer his story of the homeless masterwork. He hired the filmmaker Eric Marciano to direct. The documentary, also titled *LeRoy Neiman's Big Band*, combines voice-over narration, interviews with LeRoy, and images of his featured painting and other jazz-themed works. It also animates some of the figures in *Big Band* to make it seem that they are playing along with the jazz standards that compose the film's soundtrack. The production recounts how Neiman conceived of the painting and discusses how jazz music informed his work. Neiman gave Marciano a mostly free hand in creating the film, but the artist did insist that he would be the featured attraction. "He didn't want anyone else to be interviewed," Marciano reflected. "His ego wouldn't allow him to give up the spotlight."[8] In the film, Neiman continually stresses his identification with the jazz musicians who inspired his work. "If you get somebody who's arrogant, confident, they're posing all the time. The vanity is incredible. I think I picked up a lot of it," Neiman says as the documentary displays a shot of him posing in front of *Big Band* to suggest he is cut from the same cloth as the famed musicians he included on the canvas. "I liked the way they lived; I liked their attitude," he continues. "They were always a little pissed. They were always happy and pissed at the same time."

The film gives special attention to Neiman's disagreement with Ertegun regarding Sinatra. LeRoy explains that he liked having Sinatra in the painting, and he maintains that Marsalis supported the orig-

inal version: "I put Frank in there and he worked very well in the corner." Neiman, with palpable disappointment, explains, "Frank was my friend," before recounting how he replaced the singer with Holiday. "But I do miss Frank in there," LeRoy regretfully comments as the documentary displays the final, revised version. "He felt slighted by Ahmet Ertegun," Marciano says.[9] The documentary offered a small way for Neiman to assert himself against the powerful tastemaker who forced him to compromise his artistic vision.

According to Marciano, Neiman was overjoyed with the documentary, which was completed in late 2007. They held a test screening at the Maysles Center in Harlem before the official premier at the Skirball Cultural Center in West Los Angeles on February 17, 2009. Tommy Hawkins emceed the premier, which attracted roughly three hundred guests. Energized by the positive response, Marciano was hopeful that the film would enjoy a broader release. But Neiman would not spring for the considerable licensing fees that the documentary's soundtrack required. The production amounted to another expensive vanity project that was ultimately seen by very few. The film's abandonment also likely had something to do with LeRoy's health, which began rapidly deteriorating around the time of the premier. Marciano noticed a significant decline in Neiman's vitality over the course of the film's production. LeRoy was hardly able to function at the premier. "I remember escorting him to the men's room and him saying how tired he was," Marciano said. "I could tell he was not going to be around much longer."[10]

* * *

Neiman's popularity waned along with his health. Noticing that its aging cash cow was slowing down, Knoedler Publishing started releasing larger editions of his serigraphs. The market became even more saturated. The artist's devotees already had full walls, and he was not attracting a new generation of buyers to replace them. Additionally, LeRoy's physical state prevented him from traveling to galleries for personal appearances promoting the release of new serigraphs. The Las Vegas–based wholesaler Gigi Olman claims that Neiman's inability

to attend these events alienated him from gallerists who counted on the sales spike they generated.[11]

These shifts prompted Knoedler to sever ties with LeRoy in 2009. He had become expendable—like a once-stellar pitcher who lost his fastball or a prizefighter who could no longer take a punch. It was a cold business decision after their thirty-five-year partnership, especially considering how Neiman's prints helped Knoedler to turn around its previously moribund economic fortunes. The separation agreement stipulated that Knoedler would keep half of its print inventory and give the remainder to the Neiman Foundation, which began to sell them online. LeRoy unsurprisingly took Knoedler's decision as a humiliating personal betrayal.

Without a publisher, Neiman set about to complete his long-percolating memoir. LeRoy wanted to have the last word on his legacy before passing away, a fate that seemed imminent after he suffered a heart attack that necessitated the installation of a pacemaker and stent. Neiman had been working haphazardly on the autobiography for years. But his efforts to that point resulted only in scattered notes, written whenever a reflective mood happened to strike. LeRoy preferred to record his memories in longhand, which he treated as a form of drawing by executing his prose in an elegantly swooping style. His writings were strewn in boxes and folders spread throughout his cluttered studio. Some were in carefully dated notebooks; others were on loose scraps of paper stowed alongside old cigar bands, business cards, and matchbooks. LeRoy's assistants periodically organized and typed out his notes on the studio's office computer, which Neiman never bothered learning to use and suspiciously called "that machine." For several years spanning the 1990s and early 2000s, Neiman employed the ghostwriter Patty Otis Abel to help with his memoir and other book projects, such as *LeRoy Neiman on Safari* (1997) and *Five Decades* (2003). But the autobiography was a relatively low priority that was usually superseded by more pressing tasks.

The memoir leaped to the top of Neiman's to-do list after Knoedler cut him loose. He hired the literary agent Steve Ross, who imme-

diately noticed that the project required considerable work. Ross brought in David Dalton, a founding editor of *Rolling Stone* who once worked for Andy Warhol and had assisted the musicians Paul Anka and Marianne Faithful with their autobiographies. Dalton helped Neiman and Abel to shape the narrative, punch up the prose, and ready a proposal that Ross could shop to publishers.[12] Abel then worked from Dalton's framework to complete the book, making sure that LeRoy's voice, which she had come to know well over the years, sounded consistent and authentic throughout the manuscript.[13]

Reflecting Neiman's general dip in notoriety during the twenty-first century, the memoir generated only modest interest among publishers. The best deal Ross could secure was a $25,000 advance from Lyons Press—a pittance compared to the staff costs LeRoy had invested in the project. But it was another expensive, legacy-building investment that the otherwise-stingy Neiman was willing to make. LeRoy and Abel originally titled the tome *Diary of a Passionate Observer*. Lyons, however, preferred *All Told*, which suggested the more revealing approach of "tell all" celebrity memoirs. The only ground rule Neiman gave Abel was that nothing in the book should embarrass or disrespect Janet—a condition that would also help him to look better.[14] The memoir had some candid moments of vulnerability when Neiman discussed his struggles with post-traumatic stress disorder after the war, the resentment he harbored toward his absent father, and his sometimes-shabby treatment of women. Otherwise, *All Told* was not particularly spicy. It was filled with exaggerated and self-congratulatory reminiscences and mainly recounted his unlikely rise from poverty to a rollicking life among the stars.

The autobiography also continued Neiman's obsession with his critical reputation and continually recited his populist insistence that he was unbothered by his status among art world gatekeepers. He ended the memoir on this point: "Critical appraisal, or should I say that lack of appraisal, has been a monkey on my back. But I wouldn't do battle. I didn't have the time. . . . While I wasn't accepted in some art circles, I was embraced by a public more loyal than anything I knew growing

up. And if I could choose to take anyone with me, I'd choose them hands down."[15] As usual, the extent to which he dwelled on this dismissal makes his indifferent posturing hard to believe.

* * *

LeRoy's health worsened as he and Abel were finishing the memoir. He was admitted to Cornell Presbyterian Hospital in December 2009 with acute pneumonia. He returned home with an infection in his right leg that did not heal with antibiotics. The leg became gangrenous, and he was sent back to the hospital on January 16, 2010. He suffered another heart attack three days later, which kept him at Cornell Presbyterian for ten more days of treatment and observation. LeRoy's ailing right leg deteriorated amid the heart troubles and his medical team opted to remove it just below the knee.

The heart condition and amputation sapped Neiman's physical and emotional energy. But he continued smoking cigars and did little to change his rich diet. LeRoy also kept painting and drawing daily, which he could not help but do after so many decades. He could no longer climb the ladders that his larger paintings required or work for more than a couple of hours without growing fatigued. The dealer Richard Perry worked around Neiman's disability by sending LeRoy small pieces of Masonite onto which the artist could paint from his wheelchair.[16] The opportunistic Perry seemed to be wringing some final paintings out of the debilitated artist, but Neiman appreciated the busywork. Because he was no longer accepting commissions, LeRoy depicted whatever subjects satisfied him, such as a nostalgic series of eleven charcoal drawings of mobsters that he admired as a kid.[17]

LeRoy also did his best to maintain his buccaneering persona whenever he had an audience. "He was always in character as if someone was about to come by and do a story on him," Neil Leifer remembered of the aging artist. On his ninetieth birthday, LeRoy continued his annual Hefnerian tradition of hosting an all-female soiree, which he attended in his wheelchair. The *New York Times* published a flattering story to commemorate Neiman's milestone—a piece that celebrated

him as "still bright, bold, and name-dropping at 90." Neiman ably fired up a cigar for the *Times* photographer. Although the article mainly recounts anecdotes about his heyday, Neiman acknowledged that he no longer went to many sporting events because he had "trouble walking." The vain artist either did not tell the journalist his leg had been removed (assuming the interview was done over the phone or while he was seated behind a desk) or asked the reporter to withhold this newsworthy but inessential item.[18]

But Neiman had become a veritable shut-in who rarely left the Hotel des Artistes apart from doctor's appointments. The artist famous for constantly moving had become tragically inert. He mostly used his wheelchair around the studio. He was fitted for a prosthetic leg, but he did not like the artificial appendage and never took the time to learn how to use it without significant strain that resulted in a graceless hobble. LeRoy outfitted the leg with a purple Muhammad Ali sneaker he designed for Adidas in 2007, which featured one of his paintings of the boxer. When he wore the fake leg, he did so with Neimanesque flair. And he sometimes did upper-body physical therapy exercises by throwing punches with a fourteen-ounce glove that Muhammad Ali gifted him. LeRoy might have been taking inspiration from his friend and favorite athlete, who was bravely dealing with his own physical deterioration at the time due to Parkinson's disease.

While Neiman could always be temperamental, Esther Penn noticed that her friend became noticeably "gloomier" toward the end of his life. The stationary artist felt helpless, as if he were watching parts of his identity melt away along with his leg. LeRoy used to eat nearly every meal out on the town, which allowed him to enjoy the inspiring atmospheres he visited, sketch whatever caught his gaze, and bask in the recognition he always attracted. The furthest he went those days was the Café des Artistes on the ground floor of his apartment building. And he used to attend big sporting events, which he could now only watch on television. "For a self-reliant codger like me who has never expected or asked for help, it's a daunting position to find myself in," he wrote in the memoir. "Where I was always ready to hop on a plane as a guest of whoever on whatever commission to

wherever, I'm now at anchor like a barnacle-encrusted old vessel."[19] Angelo Dundee and Neil Leifer would occasionally drop by, and he would chat on the telephone long-distance with buddies like Tommy Hawkins. But Hawkins recalls that LeRoy's hearing difficulties made it hard for him use the phone. Such logistical frustrations discouraged Neiman from taking the trouble to reach out. And he was too proud to muse about his ailments or ask for accommodations—at least when dealing with his male friends. "We weren't each other's psychiatrists," laughed Hawkins, who ascribed to the same manly and generational sensibility that guided Neiman's stoicism. "I wasn't aware he was seriously ill," said Leifer. "I never heard LeRoy complain."[20]

Because Neiman refused to gripe about his health, his staff—which included around-the-clock nurses—found other ways to monitor his well-being. LeRoy typically began his days in the studio by signing the serigraphs his foundation had sold and was about to ship out. He took pride in his signature, which was as outsized as the rest of his persona. His staff could tell how LeRoy was feeling on a given day by how cleanly he executed the autograph. They would then prepare for his needs accordingly. Most days, his signature was perfect and appeared the same has it did in the 1970s—the spindly L leading to the bubbling capital R in LeRoy, followed by the rounded and peaked N that began his last name. But it started to look untidy in the late winter of 2012. His previously lucid memory and sharp cognition began withering at this same time. His paintings appeared only moderately recognizable and often did not resemble the subject matter he claimed they were representing. Robert Grenon remembers seeing a monochromatic "red color field" consisting of vertical strokes and without any discernible subject. Another piece had Neiman's typically vibrant palette, but the generally punchy colors bled together in sludgy, runny blurs. The painting featured a white patch with red accents in its center that LeRoy said was a skiing scene. But it only vaguely resembled his style, which had never drifted that far beyond the figurative. "You couldn't tell what he was doing," mentioned Esther Penn of the last works. "And I'm sure he wasn't voluntarily going into abstract expres-

sionism."[21] But the paintings, despite how they turned out, gave LeRoy a needed creative outlet and sense of normalcy during the upheaval he was enduring. It was his own form of art therapy that provided a sense of achievement when he was no longer capable of accomplishing much.

All Told was finally released on June 8, 2012—LeRoy's ninety-first birthday. Steve Ross asked Lyons to rush the first copy directly to the Hotel des Artistes "in what felt increasingly like a race against time."[22] Neiman was elated to receive the book, which he viewed as a capstone to his career. A studio assistant took a picture of LeRoy beaming with pride while raising the volume above his head in triumph. While Neiman looked thrilled, it was clear that the artist had not been in public for some time: his thinning hair was left undyed, and his mustache was shorn at the corners of his mouth. His hands were knotty, and he seemed to be straining to keep the book aloft and steady long enough for the photo to be snapped. Neiman's staff and a few associates gathered shortly thereafter to celebrate the book's long anticipated release. At one point, LeRoy called everyone to attention to make some remarks. A long pause ensued while he struggled to gather his thoughts. He then slammed the heel of his hand down on a table, frustrated by his inability to conjure the proper words. "My fucking brain!" he huffed before abandoning the speech.[23]

Days later, LeRoy was back at Cornell Presbyterian with another case of pneumonia. It shortly became apparent that he would never return home. Neiman died at 8:20 p.m. on June 20, just before sunset and two days before his fifty-fifth wedding anniversary. His hospital room had a view of the East River, where Jet Skiers were zigzagging through the indigo water as the sun went down. It was the sort of colorful and energetic scene LeRoy would have loved to sketch.

Funeral and burial arrangements were decided upon long before LeRoy's death. The image-obsessed artist insisted as much. On June 24, a wake was held at the Frank E. Campbell Chapel, which handled memorials for celebrities like Jaqueline Kennedy Onassis, Greta Garbo, James Cagney, and John Lennon. A Catholic funeral service

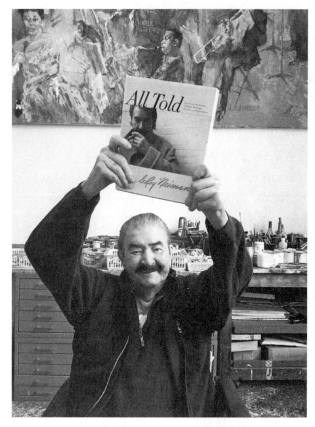

FIGURE 32. LeRoy Neiman with the first copy of *All Told*, June 8, 2012.
Courtesy of the LeRoy Neiman and Janet Byrne Neiman Foundation.

took place the next day at St. Ignatius Loyola on Park Avenue and
East Eighty-Fourth Street. LeRoy was then laid to rest at Woodlawn
Cemetery in the Bronx—in a plot he and Janet had purchased in 1993.
Reflecting Campbell Chapel, Woodlawn is known for its famous resi-
dents, which include Herman Melville and J. C. Leyendecker. The roll-
ing four-hundred-acre complex is, in a sense, the Hotel des Artistes of
New York cemeteries that provides LeRoy with an address in death
that is as flashy as the one he boasted for most of his life.

Neiman's headstone is a large, curved rectangular slab of red gran-
ite perched on a small berm. It faces west between two mature oak
trees at the intersection of several walking paths. Neiman's trade-

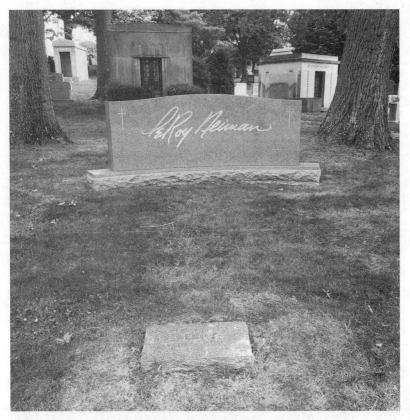

FIGURE 33. Neiman's grave at Woodlawn Cemetery, n.d.
Photo by Dennis C. Abrams. Wikimedia Commons.

mark signature is engraved on the headstone between two crosses
and under script that reads "Rest in Peace. Forever Remembered."
The bulky headstone is hard to avoid noticing by any who pass by. It
is a stone billboard advertising LeRoy's brand in a high-traffic part of
Woodlawn. Neiman's grave is near that of the sportswriter Grantland
Rice, who also made a career out of mythologizing athletes. It is also
just north of where jazz legends Duke Ellington, Miles Davis, and
Lionel Hampton are buried—all of whom appear in *LeRoy Neiman's
Big Band*. The grave site was yet another effort to insert Neiman into
the cultural milieu he spent his life documenting, celebrating, and
infiltrating.

CONCLUSION

Fame and Legacy

Most major news outlets ran predictably respectful obituaries for Neiman. They mentioned, but did not dwell upon, his critical reputation. Amid the polite memorials, the *New York Times* critic Ken Johnson published a brutal denunciation, which appeared on the first page of the newspaper's arts section one day before LeRoy's wake. The unsparing piece discouraged readers from granting Neiman the sort of generous, if only momentary, reconsideration that polarizing figures often receive immediately after death. Johnson called Neiman an "archetypal hack" and "a bad artist in every way." Neiman, according to Johnson, enjoyed tremendous "fame" without creating an aesthetic "legacy" of any importance. The critic recalls that when he was attending art school being likened to Neiman stood among the harshest appraisals imaginable. "To compare a student's work to Mr. Neiman's meant 'You are trying to distract the viewer from noticing your wooden draftsmanship and your ineptitude with matter of form and structure by larding your canvas with loud color and patchy accretions of paint' or 'what you are making is all frosting, no cake.'"[1] Neiman, Johnson suggests, is an irredeemably kitschy commercial artist. It is an unusually cruel article that contributes no insights that other critics had not issued many times before. But the piece demonstrates the extraordinary enmity Neiman attracted, even in death.

The respected but controversial artist Richard Prince—who had absorbed significant criticism throughout his career for rephotographing the works of others—posted a tribute to Neiman on his provoca-

tive and stream-of-consciousness blog. "LeRoy Neiman passed away yesterday," Prince wrote. "Neiman's work was never embraced by the art world or its critics. He didn't stand a chance. He was a stud muffin. A guy with a mustache that crossed his entire face. A bon-vivant. A rake. A man about town. He was right out of central casting." Prince posted an incensed follow-up three days later after reading Johnson's *New York Times* article. He called Johnson a "hack," a stuffy elitist who has "never been in a position to claim responsibility" for anything he created. Five months after that, Prince excitedly reported his plan to purchase a Neiman (he did not specify which piece). "I'm going to buy a LeRoy Neiman this coming weekend. There's an especially juicy one up for sale in Texas," he wrote. "I'm serious. I know what you're going to say . . . 'is he fucking kidding?' But I'm not . . . and . . . AND . . . I don't care. Jimmy Crack Corn. A rat's ass mother fucker."[2] The irreverent Prince clearly relishes the fact that he is not supposed to admire LeRoy's work. This heresy of taste, in fact, seems to make Neiman even more attractive to Prince. LeRoy would have appreciated the kind words from his internationally celebrated peer— but he also would have been pissed that Prince failed to capitalize the *R* in his first name.

* * *

The Neiman Foundation's efforts to assert LeRoy's legacy never slowed throughout his illness or after his death. In 2011 it collaborated with the School of the Art Institute of Chicago to build a LeRoy Neiman Student Center. The SAIC had been hounding Neiman for donations since the early 1980s.[3] It took nearly thirty years, but LeRoy and Janet finally gave $5 million to create the student center. The massive donation came with conditions. LeRoy stipulated that the SAIC had to find a place for *Summertime along the Indiana Dunes*—an 8′ × 56′ mural that the Mercantile Bank of Hammond, Indiana, had commissioned in 1965. *Summertime*, which had been in storage since the bank closed in 2003, is the only piece on which he shared authorship with Janet, who assisted LeRoy and signed it just below her husband. *Summertime*

is also Neiman's most classically impressionist work. People lounge under umbrellas on a bright sandy Lake Michigan shore as factories puff smoke in the distance. The mural's composition, subdued color palette, and themes reference Georges Seurat's *Bathers at Asnières* (1884) and *A Sunday on La Grande Jatte* (1884), which was one of the SAIC's main attractions and a work Neiman studied while attending the school.

Summertime was installed on the first floor of the LeRoy Neiman Student Center, which opened one month before Neiman's death. Neiman was too ill to attend the ceremony, but students honored their benefactor by posing with fake mustaches. The center is housed one block west of the SAIC's main campus in the old Carson Pirie Scott Building—the precise location where LeRoy and Janet met in 1952.[4]

The foundation used similarly philanthropic methods to find a home for *LeRoy Neiman's Big Band* in 2015. It gave the Smithsonian $2.5 million to support jazz-related programming and create a LeRoy Neiman Jazz Café on the condition that the museum display *Big Band*. The Jazz Café was opened in the lobby of the National Museum of American History. Neiman's mural overlooks the eatery. As with the SAIC center, the Smithsonian arrangement continues the foundation's efforts to keep LeRoy's work visible—even if it functions more like wallpaper than a featured artwork. It is appropriate that works like *Summertime* and *Big Band* hang in student lounges and cafés. They are sites of urban leisure akin to the locations that captivated Neiman throughout his career. But they also show the continued reluctance to let Neiman inside of the museum spaces where the most valuable and renowned artworks are housed.

LeRoy Neiman does have an important legacy. But it is not the sort that critics tend to value, or even the type that Neiman himself would have preferred. LeRoy's legacy mainly exists within the popular cultural contexts that made him famous. When Hugh Hefner died in 2017, his son Cooper took over as *Playboy's* chief creative officer. The younger Hefner faced the considerable challenge of helping the dated magazine stay afloat in a cultural, technological, and economic

environment vastly different from the one his father navigated when launching *Playboy* during the 1950s. His first move was to make the organization seem more inclusive and relevant by changing its slogan from "Entertainment for Men" to "Entertainment for All." The new motto debuted on the May–June 2018 issue, which featured Playmate of the Year Nina Daniele on its cover. Daniele is unmistakably dressed as the Femlin. She seductively reclines in a martini glass while wearing jet-black bangs, thigh-high stockings, elbow-length gloves, and stiletto heels. The motif suggests that while *Playboy* is changing, it is not abandoning all its traditions. It uses Neiman's creation to signify these stable roots.

In 2014, ESPN hired the artist Marcos Alexandre Jambeiro to paint a mural during its coverage of the World Cup soccer tournament in Brazil. Echoing Neiman's work at the 1976 Summer Olympics in Montreal, ESPN installed Jambeiro outside of its broadcast studios in Rio de Janeiro to paint his interpretations of the event on a wall around the corner from Fort Copacabana. Like Neiman in 1976, Jambeiro gave periodic updates on his mural's progress and explained his rationale for including certain teams and players. The effort plugged ESPN's World Cup coverage into the tradition of ABC's iconic Olympics broadcasts by referencing Neiman's on-air appearances nearly forty years earlier.

Neiman influenced a different thread in sports culture in November 2020, when the National Basketball Association's Cleveland Cavaliers hired the multidisciplinary artist Daniel Arsham to serve as the franchise's first creative director. Arsham's work frequently explores basketball, and his commercial partnerships with companies including Adidas and Dior have broadened his audience beyond the typical gallery artist. The Cavaliers hired Arsham to aid their branding efforts, which had dragged since the superstar LeBron James left the team in 2018 to join the Los Angeles Lakers. Arsham helped the team to rethink its look—from uniforms to on-court graphics—as well as its social media presence. He said his goal was "to make the Cavs brand as international as the [New York] Yankees." "The Cavs understand

that sports don't have to be confined to arenas and art doesn't have to just be in museums," Arsham remarked.[5] The partnership reimagined Neiman's work with the New York Jets in the late 1960s.

Neiman's art continues to circulate as well, but not as pervasively as it did during his life. The Neiman Foundation consistently collaborates with organizations that wish to stage exhibits, such as the US Olympic & Paralympic Museum in Colorado Springs, which devoted its first show to Neiman when it opened in 2021. It also licenses artwork for reproduction on clothing and for use in media. For instance, the 2022 HBO series *Winning Time*, which dramatizes the rise of the Los Angeles Lakers dynasty during the late 1970s and 1980s, incorporated Neimans as part of its retro set design. Specifically, Neimans decorate the office walls of Lakers owner Jerry Buss (played by John C. Reilly), a flamboyant businessman and devotee of the good life who hangs out at the Playboy Mansion. The Neimans authenticate *Winning Time*'s cultural and historical ambiance while characterizing Buss as a macho and forward-thinking executive who treats sports as entertainment. The gritty 2019 crime thriller *Uncut Gems* similarly uses Neimans to define its protagonist Howard Ratner (played by Adam Sandler), a jeweler and sports gambling addict. In his office, Ratner displays a serigraph of Joe Namath, whom the middle-aged New Yorker likely grew up idolizing. The print is the featured decoration in a room filled with sports memorabilia. Neiman's glamorous depictions of Namath presumably shaped Ratner's dual interest in fashion and sports.

More commonly than Neiman's specific art pieces, his style circulates indirectly as a generic aesthetic that mixes recognizable figurative subjects with abstract backgrounds. Corporate retailers and independent art-fair vendors alike sell work that borrows from LeRoy's colorful look. These artworks seldom reference Neiman, but they similarly cater to middlebrow consumers by depicting familiar subject matter through an identifiable fusion of impressionist and abstract expressionist conventions. Most frequently, Neiman's aesthetic is employed to signal fame and glamour, especially in the contexts of sports and entertainment. In 2022, the sports video game company 2K released editions of its annual PGA Tour and NBA titles that

respectively featured Tiger Woods and Michael Jordan on their covers. The illustrations evoke Neiman's style by depicting their famous subjects with effects that resemble brushstrokes and backgrounded by splashy and colorful painted mosaics. The covers use this recognizable look to underscore their subjects' status as sporting icons—the sorts of athletes who would receive the Neiman treatment. Donald Trump stretched this commonplace appropriation of Neiman's style to absurdly (but unsurprisingly) narcissistic lengths when he released a series of nonfungible token digital trading cards to kickstart the fundraising for his 2024 presidential campaign. The cards depict Trump in a combination of hypermasculine and heroic personas: an astronaut, a fighter pilot, a Western-style sheriff. One of the cards presents Trump as a golfer powerfully teeing off. This card includes textured effects to suggest a painting—the only card in the series to do so—and it features a background of sweeping multicolored brush strokes reminiscent of Neiman's work. It borrows LeRoy's style to depict Trump, a fan of Neiman's who commissioned the artist several times during the 1980s and 1990s, as a legendary sportsman.[6]

* * *

"I hope my paintings of the habits and manners of [the] life of my time will spare the social historians of the future unnecessary research," LeRoy wrote in an undated note that did not make it into *All Told*. Despite the remark's grandiosity, Neiman's work does have tremendous utility for those interested in the history of American popular culture. Neiman participated in a redefinition of popular and consumer culture that brought together leisure, fashion, sport, celebrity, and media in new ways that expanded each of these areas. Like his philanthropy, his contributions came with strings attached. Most obviously, Neiman reinforced regressive norms that were made a bit sturdier thanks to his art and persona. Among other things, his work follows *Playboy* by evincing a reverence for consumer capitalism that unapologetically caters to the heterosexual male gaze and tends to treat women as another commercial product packaged for men's edification. Needless to say, these gender and sexual politics have not aged

well. But LeRoy sometimes pushed against the entrenched social conventions he observed. He glorified Black athletes at a time when doing so came with political and economic risks, and despite the wishes of his gallery. Although LeRoy eventually reveled in the luxuries that the wealthy enjoy, he also critiqued the social inequities that undergirded their privilege. And despite his troubling gender and sexual politics, Neiman forged a variety of manliness that can comfortably accommodate fashion, art, and sport—even among epitomes of traditional masculinity like heavyweight champion prizefighters and Super Bowl–winning quarterbacks. LeRoy was never antiestablishment, and any critical edges his art possessed softened as he became a mainstream attraction with corporate ties, but a spirit of progressive populism simmered under the business-friendly surface of his work. Along those lines, and perhaps most importantly, Neiman democratized art by integrating it into places where it otherwise seldom showed up. His works helped to remake these areas—sports, TV, and so on—into sites of middlebrow cultural production that foster art without alienating popular audiences.

LeRoy Neiman was the ultimate insider in late twentieth-century American popular culture. He seemed to be everywhere and sketch everyone—from Wilt Chamberlain to the New York Dolls. He hung around with Hugh Hefner, Muhammad Ali, Frank Sinatra, and Joe Namath; ate at the finest restaurants; and lodged at the most exclusive hotels. He was a featured attraction at the Olympics and the Super Bowl, a guest on *Late Night with David Letterman*, and the subject of a *Saturday Night Live* parody. LeRoy's familiar face served as a sufficient press pass to enter the biggest events—occasions that his coveted presence made even more spectacular.

But the celebrity artist was also an outsider and interloper. He was never allowed into the so-called serious art world—one of the only arenas into which he unsuccessfully sought entry. Nevertheless, Neiman refused to identify as a commercial artist, and he bristled whenever anyone called him an illustrator. Although he used his talents to achieve tremendous fame and wealth, the new-money artist

never completely fit into the elite worlds he so often depicted. Neiman always felt like an underdog—a fatherless St. Paul ragamuffin and high school dropout. In this way, he is a descendant of Fitzgerald's quintessential American, Jay Gatsby, a nouveau-riche Midwesterner who infiltrated high society through fashioning a glossy persona but who remained apart from the world in which he masqueraded.

LeRoy's ostentatious affectations show the immense power of self-branding. They also make him difficult to take seriously. But Neiman was not a mere savant with a creative gift, promotional flair, and an uncanny knack for being in the right place at the right time. He took his work seriously and had a clear sense of the artistic and intellectual traditions on which he was building. Neiman was also religiously devoted to his craft, even if he sometimes compromised his creative druthers to serve wealthy clients who wanted a painting of their favorite hole at Pebble Beach. LeRoy knew what it was like to be poor, and he never forgot his mentor Clement Haupers's decree that artists need to be pragmatic—to enter the rat race—if they were going to turn their talents into a gainful career. And Neiman's career was nothing if not gainful.

Now that Neiman has been gone for a while, the animosity he once attracted has mellowed, and the jokes at his expense no longer have the same kick. Moreover, contemporary artists, critics, and other gatekeepers do not have the same hang-ups about commercialism and self-promotion that contributed to LeRoy's exile. Highly respected artists now self-brand in ways that would make Neiman look bashful. And MOMA now partners with the clothing company Uniqlo to sell shirts featuring the museum's artworks in an ostensible attempt to "make art accessible to all." The effort is not too different from the rayon dress shirts that once brandished Neiman's sports scenes. Despite these shifts, a radical reassessment of LeRoy's work that would suddenly propel him into the canon seems unlikely. Neiman's art has not been remembered as well or as fondly as the people, scenes, and events it helped to make memorable. His work remains secondary to those elements, and Neiman, like most chroniclers, remains an

adjunct (albeit an important and stylish one) to the subjects he show-cased. As for LeRoy, his most interesting and remarkable creation was his own unlikely, frustrated, and fast-paced life, which the penni-less street urchin turned prosperous cosmopolite seemed to savor like a hand-rolled Cuban cigar—with the band facing out for all to see.

Acknowledgments

Many generous and patient people helped to make this book happen. I know some of them very well. Others, I know only through brief email exchanges. But I appreciate their big and small contributions.

First, I want to acknowledge the LeRoy Neiman and Janet Byrne Neiman Foundation, especially Tara Zabor and Kate Knostman. Given Neiman's reputation and the ways that critics have treated him over the years, it would have been completely understandable for his foundation to look askance at this project. Instead, they welcomed it and encouraged me without attempting to influence the book in any way. They also allowed me to consult documents that are otherwise unavailable and to use images that otherwise would have cost a relative fortune to include. I am so grateful for their support, decency, and friendship.

Second, I benefited from the considerable labors of the Smithsonian Institution's Archives of American Art. Most of the research for this book was completed during the pandemic. Among the swirl of upheavals, I figured my project would have to be put on hold. But the saints at the Smithsonian developed a scanning service that allowed me to access materials after the staff returned to the building (but before the reading room reopened). This book would not exist, at least not in 2024, without their help.

Third, I want to thank Tim Mennel and the University of Chicago Press. I would be lying if I said that publishers were knocking down my door trying to get my LeRoy Neiman book under contract. But Chicago "got" the project and believed that I could pull it off.

That belief and encouragement—especially from a press as great as Chicago—helped to give me the motivation to complete this book. Tim guided the project through its development, review, and revision with clarity, reliability, and empathy. Aside from thanking Tim, I will also take this opportunity to apologize for all the solicitations he will eventually get from the friends and colleagues I send his way. Thanks as well to Susan Bielstein, James Toftness, Andrea Blatz, Tamara Ghattas, Katherine Faydash, and Nathan Petrie for their assistance. And I should thank the anonymous reviewers for putting me through the proverbial wringer but ultimately helping me to produce a better book.

Beyond the above-listed holy trinity, I benefited from research collections at many libraries and organizations. These include the Chicago Public Library, St. Paul Public Library, New York Public Library, Jimmy Carter Presidential Library, School of the Art Institute of Chicago, Minneapolis Institute of Art, Franklin Pierce University, University of St. Thomas, St. Francis College, SUNY Binghamton, Minnesota Historical Foundation, Kanabec County Historical Society, Muhammad Ali Center, Playboy Foundation, Woodlawn Cemetery, and the LeRoy Neiman Center for Print Studies at Columbia University.

I want to acknowledge the many people who took time to chat with me about LeRoy Neiman or otherwise help me to research his life, career, and world: Thomas Buechele, Marisa Bourgoin, Bill Byrne, Richard Byrne, Joan Byrne, Norm Coleman, Jeremy Dibbell, Al Eisele, Kathleen Elgougary, Joan Gage, Nick Gage, Bess Goldy, Joe Gonzalez, David Gould, Robert Grenon, David Halle, Michael Halsband, Christie Hartmann, Tommy Hawkins, Michele Horowitz, Liz Hunter, Pat Jordan, Tom Kapsalis, Liza Kirwin, Katherine Lanpher, Neil Leifer, Franz Lidz, Steve Lipofsky, Robert Lipsyte, Heather Long, Eric Marciano, Elizabeth Maruggi, Fiona Maynard, Mallory Miranda, Liz Neilson, Gigi Olman, Victoria Olsen, Patty Otis Abel, Esther Penn, Stan Penn, Elinor Penna, Richard Perry, Frank Ramos, Tod Rosensweig, Steve Ross, Debra Scholl, Dennis Scholl, Deborah Solomon, Eloisa Valenzuela-Mendoza, Robert Varner, and Tom Werblin.

I learned from audiences and copanelists over the years at conferences organized by the American Studies Association, Society for Cinema and Media Studies, and North American Society for Sport History. I also appreciated the opportunity to present bits and pieces of this project at the University of Wisconsin, University of Tulsa, University of Amsterdam, and University of California at Santa Barbara.

Research for this book was aided by an Arts & Humanities Initiative Award from the University of Iowa Office of the Vice President for Research and a book subvention from the College of Liberal Arts & Sciences. I also received ample support from the UI School of Journalism and Mass Communications and the Department of American Studies. Thanks to Tom Oates, Steve Warren, Laura Kastens, Lindsay Vella, Laura Kerr, David Ryfe, Melissa Tully, Liz Cecil, Jac Albrecht, Brittany Ogden, Michele Ketchum, Jenny Ritchie, and Mike Hendrickson for helping me to deal with the bureaucratic, budgetary, and technological dimensions of my scholarly career.

Most of the research for this project was conducted through the University of Iowa Library's many tools and services. Special thanks to Donald Baxter, Janalyn Moss, and Patricia Gimenez for helping me with some specific issues that came up along the way.

Love and respect to the following colleagues, friends, family, and heroes for their intentional and/or unintentional help: Aaron Baker, David Berman, Steve Bloom, Gabe Bodzin, Jaimie Branch, Sam Brotman, Emily Brown, Andrew Byers, Brandon Currie, Phil Deierling, Frank Durham, Gigi Durham, Bob Dylan, Brian Ekdale, Greg Ekdale, Seth Friedman, Jerry Garcia, Mike Gibisser, Mack Hagood, Eric Harvey, Rachael Horwitz, Vicky Johnson, Jennifer Jones, Will Kapp, Andrea Kelley, Joe Kendall, Mardell Kendall, Jake LaRiviere, Dylan McConnell, Don McLeese, Kembrew McLeod, Danny Nasset, the Owens family, Charlie Pierce, Jakey Pierce, Betsy Potter, Lauren Rabinovitz, Rebecca Raw, Justin Rawlins, Lou Reed, Rob Rouphail, Travis Gutiérrez Senger, Samantha Sheppard, Patti Smith, Markus Stauff, Melysa Vogan, Andrew Willhoit, Nick Yablon, and Rachel Young. Sorry if I forgot anyone. These sorts of paragraphs stress me out. Also,

my grandpa Doug died while I was writing this. I remember the very paragraph I was working on when I got the news that he passed away. We were tight and I miss him.

A humongous thanks to the staff at Kids' Depot in Iowa City for taking such great care of our children while we are at work.

Work for this project coincided with my entry into parenthood, which is far more interesting, challenging, and rewarding than writing books. Thanks to Caitlin, Ozzie, and Polly for being my family, which I think is probably the best thing someone can be for someone else. While I'm at it, I'll thank my own mom and dad for showing me what good and selfless parenting (and grandparenting) looks like.

Notes

INTRODUCTION

1 Jerry Kirschenbaum, "Scorecard," *Sports Illustrated*, December 14, 1981, 16.

2 *Astonishing X-Men*, Issue No. 2, Marvel Comics, 2004.

3 Robert Ward, "The Playboy of the Western Art World," *New Times*, February 6, 1978, 52–64, 55; Al Drooz, "An Artist Sees Games," *Cincinnati (OH) Enquirer*, July 23, 1976.

4 "Painter Neiman Loved, Hated for Same Reason," *Atlanta Constitution*, May 17, 1981, 5E1; Harper Hilliard, "Common People Flock to Painter of Uncommon Riches," *Los Angeles Times*, November 30, 1988, R1.

5 Clement Greenberg, "Avant Garde and Kitsch," *Partisan Review* 6, no. 5 (1939): 34–49, 46; Dwight Macdonald, "Masscult and Midcult II," *Partisan Review* 27, no. 4 (1960): 592.

6 Pierre Bourdieu, *The Field of Cultural Production: Essays on Art and Literature*, trans. Randal Johnson (New York: Columbia University Press, 1993), 254.

7 Robert Varner, interview with author, April 19, 2017.

8 See Pierre Bourdieu, *Distinction: A Social Critique of the Judgment of Taste*, trans. Richard Nice (Cambridge, MA: Harvard University Press, 1987), 7; Janice Radway, *A Feeling for Books: The Book-of-the-Month Club, Literary Taste, and Middle-Class Desire* (Chapel Hill: University of North Carolina Press, 1997), 9.

9 See Bourdieu, *Field of Cultural Production*, 40, 79.

10 Frank Ahrens, "The Master of Jock Schlock," *Washington Post*, May 22, 1997, C1.

11 Rogers Worthington, "With LeRoy Neiman, Not All the Color Is Splashed on the Artist's Canvas," *Chicago Tribune*, July 13, 1978, A1.

12 *Indianapolis News*, December 26, 1978.

13 "Olympic Artist LeRoy Neiman Would Move Games to Greece," *St. Louis Jewish Light*, February 27, 1980, 44.

14 Paul Valéry, *The Collected Works of Paul Valéry*, trans. Denise Folliot and Jackson Mathews (New York: Bollingen Foundation, 1962), 10:453; Bourdieu, *Distinction*, 7.

15 Ward, "Playboy of the Western Art World," 55.

16 Allen Guttmann, *Sports and American Art: From Benjamin West to Andy Warhol* (Amherst: University of Massachusetts Press, 2011), 222.

17 Dorothy Burkhart, "LeRoy Neiman Salves Criticism with Megabucks," *Indianapolis Star*, September 24, 1989, 15G.

CHAPTER ONE

1 Neiman Notes, document no. 1701, LeRoy Neiman Foundation (LNF), New York, NY, https://www.leroyneimanfoundation.org.

2 LeRoy Neiman, *The Arlene Herson Show* (television interview program), 1989.

3 Kathy Hogan Trocheck, "LeRoy Neiman: The Man behind the Mustache," *Atlanta Constitution*, June 3, 1989, B4; Neiman Notes, document no. 1662, LNF.

4 Correspondence, document no. 379, LNF.

5 LeRoy Neiman, *All Told: My Art and Life among Athletes, Playboys, Bunnies, and Provocateurs* (Guilford, CT: Lyons Press, 2012), 17. Beyond Neiman's memoir, I piece together the details of his family history and early life through a combination of birth records, marriage certificates, baptism records, immigration documents, local news coverage, and correspondence. I accessed most of these sources through the Minnesota Historical Society and the Kanabec County Historical Society.

6 Amy Troolin and Earl J. Foster, *Kanabec County* (Charleston, SC: Arcadia Publishing, 2012), 3.

7 *Braham Journal*, June 17, 1921, 1.

8 Neiman, *All Told*, 2

9 Neiman Notes, document no. 226, LNF.

10 Neiman Notes, document no. 1651, LNF.

11 Curt Brown, "After Striking It Rich, Artist Looks Back toward St. Paul," *Star Tribune*, July 11, 1997, 1A; Neiman, *All Told*, 3.

12 Neiman, *All Told*, 5.

13 Neiman Notes, document no. 1706, LNF.

14 Neiman Notes, document no. 227, LNF.

15 Neiman, *All Told*, 5; Neiman Notes, document no. 220, LNF.

16 Virginia Brainard Kunz, *St. Paul: The First 150 Years* (St. Paul, MN: St. Paul Foundation, 1991), 51; Alexius Hoffmann, *Frogtown* (St. Paul, 1925). Another origin story claims the neighborhood was originally called "fracht-town," or "freight town," because its mostly German residents worked for the railroad, and that name eventually morphed into "Frogtown."

17 See Steven T. Moga, *Urban Lowlands: A History of Neighborhoods, Poverty, and Planning* (Chicago: University of Chicago Press, 2020).

18 Judith A. Martin and David A. Lanegran, *Where We Live: The Residential Districts of Minneapolis and St. Paul* (Minneapolis: University of Minnesota Press, 1983), 28.

19 Neiman Notes, document no. 805, LNF.

20 Neiman Notes, document no. 1653, LNF.

21 Neiman Notes, document no. 805, LNF.

22 Neiman Notes, document no. 805, LNF; Neiman Notes, document no. 1700, LNF; Cobey Black, "Portrait of the Artist as a Swinger," *Honolulu (HI) Advertiser*, June 18, 1974, 9.

23 Neiman, *All Told*, 3; Neiman Notes, document no. 1700, LNF.

24 Neiman, *All Told*, 24.

25 Brown "After Striking It Rich," 1A.

26 F. Scott Fitzgerald, "Minnesota's Capital in the Role of Main Street," *Literary Digest International Book Review* 1 (March 1923), 35–36; F. Scott Fitzgerald, "The Popular Girl" in *The Popular Girl* (1920; London: Hesperus Press, 2005), 3–48, 16, 17.

27 F. Scott Fitzgerald to Anne Ober, March 4, 1938; F. Scott Fitzgerald to Alida Bigelow, September 23, 1919, in *F. Scott Fitzgerald: A Life in Letters*, ed. Matthew J. Bruccoli (New York: Scribner, 1995), 351–35, 33–34.

28 Neiman, *All Told*, 9.

29 Thorstein Veblen, *The Theory of the Leisure Class* (1899; Mineola, NY: Dover Thrift Editions, 1994), 43.

30 LeRoy Neiman, *Winners: My Thirty Years in Sports* (New York: Harry N. Abrams, 1983), 7.

31 Neiman Notes, document no. 1669, LNF.

32 Neiman, *All Told*, 6.

33 Neiman Notes, document no. 1709, LNF; Neiman, *All Told*, 1.

34 Neiman Notes, document no. 1710, LNF.

35 *Compendium of History and Biography of Northern Minnesota* (Chicago: George A. Ogle & Co., 1902), 347; Kanabec History Center, Mora, MN.

36 "Well Known Duluthians in Caricature," *Duluth (MN) Evening Herald*, June 9, 1909, 3; "Owns a Fine Ranch Place," *Two Harbors (MN) Iron News*, September 10, 1909, 1.

37 *Two Harbors (MN) Iron News*, May 23, 1902.

38 *Princeton (MN) Union*, April 6, 1911, 1.

39 Neiman, *All Told*, 15.

40 "Owns a Fine Ranch Place," 1.

41 Neiman, *All Told*, 6.

42 Neiman Notes, document no. 1708, LNF.

43 See John Toland, *The Dillinger Days* (New York: Random House, 1963), 42–43.

44 Paul Maccabee, *John Dillinger Slept Here: A Crooks' Tour of Crime and Corruption in St. Paul, 1920–1936.* (St. Paul, MN: Minnesota Historical Society Press, 1995), 42.

45 Alvin Karpis and Bill Trent, *The Alvin Karpis Story* (1971; New York: Ishi Press, 2011).

46 Kunz, *St. Paul*, 81.

47 Neiman Notes, document no. 2329, LNF.

48 Tony Weitzel, "Artist LeRoy Neiman," *Chicago Daily News*, January 14, 1965, 61; LNF, NN, 1660.

49 Kay Gilman, "Neiman Fits the Avant-Garde Artist Role," *Asbury Park (NJ) Sunday Press*, September 3, 1972, D3; Bob Sansevere, "LeRoy Neiman: Boxing Was My Big Thing," *St. Paul Pioneer Press*, June 14, 2007.

50 Jason Kelly, *Shelby's Folly: Jack Dempsey, Doc Kearns, and the Shakedown of a Montana Boomtown* (Lincoln: University of Nebraska Press, 2010).

51 Neiman Notes, document no. 1699, LNF.

52 Barney Nagler, "Jets Immortalized—In Vivid Colors," *The Morning Telegraph*, January 4, 1969, 3; "Painter Neiman Loved, Hated for Same Reason," *Atlanta Constitution*, May 17, 1981, 5EH; Sansevere, "Boxing Was My Big Thing."

53 Neiman Notes, document no. 1686, LNF.

54 Tony Weitzel, "Artist LeRoy Neiman," *Chicago Daily News*, January 14, 1965, 61; Neiman Notes, document no. 1686, LNF.

55 Neiman Notes, document no. 1699, LNF,; Gilman, "Neiman Fits the Avant-Garde," D3.

CHAPTER TWO

1 Neiman, *All Told: My Art and Life among Athletes, Playboys, Bunnies, and Provocateurs* (Guilford, CT: Lyons Press, 2012), 13.

2 Neiman Notes, document no. 1654, LNF; Neiman, *All Told*, 13; Mary Evertz, "LeRoy Neiman: High-Scoring Playmaker of the Art World," *Tampa Bay Times*, July 25, 1975, G1.

3 Paul-Hayden Parker, "Portrait of the Artist as a Bon Vivant," *Mainliner* 11, no. 4 (April 1973): 24–42, 24; Neil B. Thompson, *Minnesota's State Capital: The Art and Politics of the Public Building* (St. Paul: Minnesota Historical Society Press, 2005), 75–76.

4 Neiman Notes, document no. 1703, LNF.

5 Neiman Notes, document no. 1711, LNF.

6 Kay Gilman, "Neiman Fits the Avant-Garde Artist Role," *Asbury Park (NJ) Sunday Press*, September 3, 1972, D3; Al Bine, "Expressions of Our Time," *California Living*, June 24, 1973, 8–11; Gary Fallesen, *Democrat and Chronicle (Rochester, NY)*, October 9, 1992, 5; Bill Roberts, "Artist LeRoy Neiman: From Poverty to *Playboy*," *Indianapolis News*, November 23, 1972, 70; Dorothy Burkhart, "LeRoy Neiman Salves Criticism with Megabucks," *Indianapolis Star*, September 24, 1989; *Minneapolis Tribune*, November 8, 1978, 15G.

7 Neiman Notes, document no. 1657, LNF.

8 Neiman Notes, document no. 1673, LNF.

9 Jay Searcy "Neiman, Secure in His Place in the Art World," *St. Paul (MN) Pioneer Press*, March 14, 1999, 7B.

10 Neiman Notes, document no. 1699, LNF.

11 Neiman, *All Told*, 18–19; Neiman, *Art & Lifestyle* (New York: Felicie, 1974), 82; William Grimes, "Bold Life and Bright Canvases," *New York Times*, June 21, 2012, A1.

12 LeRoy Neiman, *Art & Lifestyle*, 82; Neiman Notes, document no. 1685, LNF; Neiman Notes, document no. 1680, LNF; Sansevere, "LeRoy Neiman: Boxing Was My Big Thing," *St. Paul (MN) Pioneer Press*, June 14, 2007.

13 Neiman Notes, document no. 1676, 1655, LNF.

14 Neiman, *Art & Lifestyle*, 83.

15 Barbara W. Sommer, *Hard Work and a Good Deal: The Civilian Conservation Corps in Minnesota* (St. Paul: Minnesota Historical Press, 2008); Perry H.

Merrill, *Roosevelt's Forest Army: A History of the Civilian Conservation Corps, 1933–1942* (Montpelier, VT: Perry H. Merrill, 1981); John A. Salmond, *The Civilian Conservation Corps, 1933–1942: A New Deal Case Study* (Durham, NC: Duke University Press, 1967).

16 LeRoy Neiman, Civilian Conservation Corps Record, National Personal Records Center, St. Louis, MO.

17 Civilian Conservation Corps, United States, Company 3703, Isabella, MN, 1939-03, *Baptism Blade*, March 1939, Minnesota Historical Society, https://reflections.mndigital.org/catalog/mhs:2063.

18 *Baptism Blade*, February 1939, 6, box 1, folder 26, LeRoy Neiman Papers (LNP), Smithsonian Archives of American Art, Washington, DC.

19 CCC Records; *Baptism Blade*, January 1939, 7, box 1, folder 26, LNP.

20 Neiman Notes, document no. 1716, LNF.

21 Neiman, *All Told*, 27.

22 Neiman Notes, document no. 1717, LNF.

23 Neiman, *All Told*, 80.

24 Douglass Howell, ed., *A History of the 461st Anti-Aircraft Artillery Automatic Weapons Battalion* (n.p., n.p., 1945).

25 "G.I. Picasso," *P.O.V.*, March 1998, 34.

26 *History of the 461st Anti-Aircraft Artillery Automatic Weapons Battalion.*

27 *History of the 461st*, D-16.

28 Neiman, *All Told*, 39; Mervin Block, "There's Nothing Still about Life This Artist Paints," *Chicago's American*, November 3, 1959, 1.

29 Gary Fallesen, *Democrat and Chronicle* (Rochester, NY), October 9, 1992, 5.

30 John English to LeRoy Neiman, March 31, 1982, box 1, folder 25, LNP.

31 Jim Murray, "To Win, Not Toulouse," *Los Angeles Times*, March 16, 1977, E1.

32 *Bicentennial Project of the Minnesota for the St. Paul Chamber of Commerce* (St. Paul, MN, 1976), 11.

33 "*Playboy* Gave Artist LeRoy Neiman His Start," *Berkshire Eagle*, September 16, 2007, E9.

34 Neiman, *All Told*, 28; Block, "There's Nothing Still," 1.

35 *Minneapolis Tribune*, November 8, 1978, 15G; "G.I. Picasso," *P.O.V.*, March 1998, 34. See also Mary Louise Roberts, *What Soldiers Do: Sex and the American GI in World War II France* (Chicago: University of Chicago Press, 2013), 166–67.

36 Neiman, *All Told*, 48; Neiman Notes, document no. 832, LNF.

37 Neiman, *Art & Lifestyle*, 11.

CHAPTER THREE

1 Ricardo J. Brown, *The Evening Crowd at Kirmser's: A Gay Life in the 1940s* (Minneapolis: University of Minnesota Press, 2003), 65.

2 Stewart Van Cleve, *Land of 10,000 Loves: A Queer History of Minnesota* (Minneapolis: University of Minnesota Press, 2012), 10.

3 Jane H. Hancock, *Clement Haupers: Six Decades of Art in* Minnesota (St. Paul: Minnesota Historical Society, 1979), 6.

4 Brian Szott and Ben Gessner, "Clement Haupers (1900–1982): Midwestern

Bohemian," in *Minnesota Modern: Four Artists of the Twentieth Century*, ed. Moira Harris, Brian Szott, and Ben Gessner (St. Paul: Minnesota Historical Society, 2015), 97–139, 107.

5 Szott and Gessner, 95; Brown, *Evening Crowd*, 66.

6 Jane H. Hancock, *Clement Haupers: Six Decades of Art in Minnesota* (St. Paul: Minnesota Historical Society, 1979), 11; Elisabeth Luther Cary, "Chosen by John Sloan," *New York Times*, March 2, 1930, 146; "Haupers Painting to Be Shown in Chicago," *Minneapolis Star*, November 21, 1931, 32.

7 Szott and Gessner, "Clement Haupers," 108.

8 See Victoria Grieve, *The Federal Art Project and the Making of Middlebrow Culture* (Urbana: University of Illinois Press, 2009); Thomas O'Sullivan, "A Job and a Movement: The WAP Federal Art Project in Minnesota," *Minnesota History* (Spring 1993), 184–195, 186; Kenneth E. Hendrickson Jr. "The WPA Federal Art Projects in Minnesota, 1935–1943," *Minnesota History* (Spring 1993): 170–183; Hancock, *Clement Haupers*, 19.

9 Martha Davidson, "Regional Review: Minneapolis–St. Paul 1943," *ARTnews* 41, no. 10 (January 1943) 15–31.

10 Nicholas Westbrook, "'Clement Haupers' Conversations on Six Decades of Painting in Minnesota," *Minnesota History* (Fall 1979): 296–99, 298; O'Sullivan, "A Job and a Movement," 191.

11 Szott and Gessner, "Clement Haupers," 135.

12 Interview with Clement Haupers, Minnesota Historical Society, June 27, 1977; Szott and Gessner, "Clement Haupers," 135; Westbrook, "'Clement Haupers': Conversations," 299.

13 Karin Winegar, "WPA Kept Both Arts and Artists Alive during Grim Days," *Minneapolis Tribune*, November 14, 1982, G9; Haupers interview, June 27, 1977.

14 Haupers interview, June 27, 1977.

15 Brown, *Evening Crowd at Kirmser's*, 66; Mary Abbe Martin, "Colorful Couple's Legacy," *Minneapolis Star Tribune*, October 13, 1988, E1.

16 Neiman Notes, document no. 2261, LNF.

17 LeRoy Neiman, *All Told: My Art and Life Among the Athletes, Playboys, Bunnies, and Provocateurs* (Guilford, CT: Lyons Press, 2012), 51.

18 Interview with Clement Haupers, George Reid, and Mary Harvey, Minnesota Historical Society, December 9, 1977; LeRoy Neiman, *The Prints of LeRoy Neiman: A Catalogue Raisonné* (New York: Knoedler Publishing, 1980), 23.

19 Neiman, *All Told*, 51, 56.

20 Haupers, Reid, and Harvey interview, December 9, 1977; Interview with Clement Haupers, Thomas O' Sullivan, and Elizabeth Knight, Minnesota Historical Society, April 3, 1981.

21 Carol Pinsky, "Peripatetic Portrait Painter," *Select Magazine*, March 1962, 29, 32–33.

22 Haupers, Reid, and Harvey interview, December 9, 1977.

23 LeRoy Neiman file, Special Collections, School of the Art Institute of Chicago. Neiman Notes, document no. 917, LNF.

CHAPTER FOUR

1 LeRoy Neiman to Lydia Hoelscher, August 9, 1947, LeRoy Neiman Foundation.

2 Neiman, *All Told: My Art and Life Among the Athletes, Playboys, Bunnies, and Provocateurs* (Guilford, CT: Lyons Press, 2012), 58.

3 Mervin Block, "There's Nothing Still about Life This Artist Paints," *Chicago's American*, November 3, 1959, 1; LeRoy Neiman file, Special Collections, School of the Art Institute of Chicago (SAIC).

4 Esther Penn, interview with author, February 10, 2020.

5 LeRoy Neiman File, Special Collections, SAIC; Neiman, *All Told*, 60.

6 Thomas C. Buechele and Nicholas C. Lowe, *The School of the Art Institute of Chicago* (Charleston, SC: Arcadia Publishing, 2017), 58; *Over a Century: A History of the School of the Art Institute of Chicago* (Chicago: School of the Art Institute of Chicago, 1982), 94; Franz Schulze, *Fantastic Images: Chicago Art since 1945* (Chicago: Follett, 1972), 6; Franz Schulze, "Art News from Chicago," *ARTnews*, February 1959, 49, 56.

7 Chuck Twardy, "Neiman Is a Superstar in the Arena of Sports Art," *Orlando (FL) Sentinel*, December 23, 1989, E1–E2; Simon Doonan, "Who's Our Grooviest Living Artist? It's Femlin's Papa, LeRoy Neiman," *Observer*, August 27, 2001.

8 Neiman, *All Told*, 67; Anthony DeBartolo, "Institute Throws Ball to Remember," *Chicago Tribune*, May 11, 1992, D16.

9 Neiman Notes, document no. 987, LNF.

10 Pitts Sanborn, "Art: The Metropolitan Concentrates on its Scenery," *Vogue*, November 15, 1918, 56.

11 Neiman, *All Told*, 62; Vladimir Markov, "Total Frankness in Art and Sport," *Olympic Review* (June 1989): 271–74, 272.

12 "Unforgettable Art Is Unforgivable: Boris Anisfeld and Divorced Truth," *San Francisco Examiner*, June 1, 1919, 22; Edith Weigle, "His Style Is His Own—Romantic, Realistic," *Chicago Tribune*, May 18, 1958, K7.

13 "Boris Anisfeld Invades the Realm of Fantasy," *Current Opinion*, December 1918, 390.

14 Mervin Block, "There's Nothing Still about Life this Artist Paints," *Chicago's American*, November 3, 1959, 1; Markov, 272.

15 LeRoy Neiman file, Special Collections, SAIC.

16 LeRoy Neiman file, Special Collections, SAIC.

17 LeRoy Neiman file, Special Collections, SAIC.

18 Neiman, *Prints of LeRoy Neiman*, 26; Neiman, *All Told*, 63.

19 Eleanor Jewett, "Michigan Plans Fall Exhibit of Juergens Art," *Chicago Tribune*, July 24, 1949, 7.

20 Neiman, *All Told*, 68–69; Block, "There's Nothing Still," 1.

21 Neiman Notes, document no. 225, LNF.

22 Neiman Notes, document no. 225, LNF; Neiman Notes, document no. 233, LNF.

23 Neiman, *All Told*, 79.

24 Frank Holland, "Anyone Can Paint, These Happy Amateurs Say," *Chicago Sun-Times*, November 23, 1952, 2:14.

25 Esther Penn, interview with author, February 3, 2020; Rita Marsh to LeRoy Neiman, February 25, 1965, box 3, folder 15, LNP; Kay O'Hara to LeRoy Neiman, January 1, 1993, box 16, folder 26, LNP.

26 LeRoy Neiman file, Special Collections, SAIC. Neiman did teach a figure drawing course for the SAIC's Saturday school during the 1954–1955 and 1955–1956 school years.

27 LeRoy Neiman file, Special Collections, SAIC.

28 Penn interview, February 3, 2020.

29 Polly Rayner, "Button-Down Art," *Morning Call*, August 31, 1986, E1.

30 Neiman Notes, document no. 1087, LNF.

31 Esther Penn, interview with author, February 10, 2020.

32 Neiman Notes, document no. 224, LNF.

33 Thomas Kapsalis, interview with author, October 18, 2020.

34 Bill Byrne, interview with author, August 9, 2019.

35 "Teachers Name Catholic High School Stars," *Chicago Daily Tribune*, May 17, 1942, SW1.

36 *Chicago Tribune*, September 18, 1945, 16; Bill Byrne, interview with author, August 9, 2019.

37 Byrne interview, August 9, 2019; Penn interview, February 3, 2020.

38 Block, "There's Nothing Still," 1.

39 Patricia Shelton, "LeRoy Neiman Prefers to Paint 'Real' People," *Chicago Daily News*, December 8, 1972, 25.

40 Neiman, *All Told*, 88, 78.

41 Paul-Hayden Parker, "Portrait of the Artist as a Bon Vivant," *Mainliner* 11, no. 4 (April 1973): 24–42.

42 Mark Kennedy, "American Original," *Associated Press*, September 13, 2007; William Caxton Jr., "LeRoy Neiman: An Exuberant Painter," *American Artist* (April 1961): 28–34, 76–78.

43 Rayner, "Button-Down Art," E1.

44 "Institute Buys 6 Works," *Minneapolis Star Tribune*, October 18, 1953, F15; *Minneapolis Star*, August 31, 1954, 14; *Prints of LeRoy Neiman*, 37. In 1959, Neiman painted *Idle Boats II*, which was similar to *Idle Boats* but updated it with the more electric colors that became his calling card in the late 1950s.

CHAPTER FIVE

1 Stan Isaacs, "Neiman Sketches the Sports on the Times," *Newsday*, March 27, 1968, 28A; Edith Weigle, "Carves His Niche in Bronze, Wood," *Chicago Daily Tribune*, January 12, 1958, F4; Marvin Block, "There's Nothing Still about Life This Artist Paints," *Chicago's American*, November 3, 1959, 1. See Charles Baudelaire, "The Painter of Modern Life" (1863), in *Baudelaire: Selected Writings on Art and Literature* (New York: Penguin, 1993), 390–436.

2 David Condon, "In the Wake of the News," *Chicago Tribune*, December 8, 1972, C3; Al Bine, "Expressions of Our Times," *California Living*, June 24, 1973, 8–11.

3 Alan Bostick, "LeRoy Neiman's Great Escapes," *The Tennessean*, May 5, 1993, D1; David Condon, "Neiman's Winners Lives Up to Its Title," *Chicago Tribune*, December 4, 1983, L5; Esther Penn, interview with author, February 3, 2020.

4 David Riesman, with Nathan Glazer and Reuel Denney, *The Lonely Crowd: A Study of the Changing American Character* (New Haven, CT: Yale University Press, 1950), 19, 22.

5 Frank Getlein, "Key Club, Casino and Race Track Are Painted by LeRoy Neiman," *Milwaukee Journal*, October 27, 1957, 5:5; Meyer Levin, "Chicago's Bar Baroque," *Chicago's American*, December 8, 1957, 39.

6 Neiman, *All Told: My Art and Life Among the Athletes, Playboys, Bunnies, and Provocateurs* (Guilford, CT: Lyons Press, 2012), 125.

7 Levin, "Chicago's Bar Baroque," 39; Barnard K. Leiter, "Show Young Artist's Bold Work, *Chicago Daily News*, October 12, 1959, 27.

8 LNF, NN, 2005; Simon Doonan, "Who's Our Grooviest Living Artist: It's Femlin's Paper, LeRoy Neiman," *New York Observer*, August 27, 2001, https://observer.com/2001/08/whos-our-grooviest-living-artistits-femlins-papa-leroy-neiman/.

9 Nelson Algren, *Chicago: City on the Make* (1951; Chicago: University of Chicago Press, 2011), 58, 23.

10 Algren, 18.

11 Nelson Algren, *Nonconformity* (New York: Seven Stories Press, 1996), 76. See also Colin Asher, *Never a Lovely So Real: The Life and Work of Nelson Algren* (New York: Norton, 2019), 212.

12 Barnard K. Leiter, "Show Young Artist's Bold Work," *Chicago Daily News*, October 12, 1959, 27; Harper Hilliard, "Common People Flock to Painter of Uncommon Riches," *Los Angeles Times*, November 30, 1988, R1.

13 Eleanor Jewett, "Deplores Art Show Influences," *Chicago Tribune*, March 18, 1956, 7:5; Edith Weigle, "Two Lively Art Shows Have Settings in the Loop," *Chicago Daily Tribune*, October 18, 1957, A3; Edith Weigle, "Carves His Niche in Bronze, Wood," *Chicago Daily Tribune*, January 12, 1958, F4; Ellen Borden Stevenson, "Does Modern Art Mean Anything?" *Chicago Daily Tribune*, August 19, 1956, F26; Mark Dery, *Born to Be Posthumous: The Eccentric Life and Mysterious Genius of Edward Gorey* (New York: Little, Brown & Co., 2018), 42. Jewett's antagonism toward the SAIC was long-standing. A SAIC-produced history of the school notes that a group of one hundred Art Institute students once marched down Michigan Avenue with an effigy of Jewett and signs condemning her views on art as outmoded. See *Over a Century: A History of the School of the Art Institute of Chicago* (Chicago: School of the Art Institute of Chicago, 1982), 93.

14 LNF, NN, 1011; "An Outstanding Show," *Arlington Heights (IL) Herald*, September 18, 1958, 67; *Chicago Tribune*, September 15, 1958, 44; Frank Getlein, "Down at Neiman's Bar and Grill," *New Republic*, November 11, 1957, 21.

CHAPTER SIX

1 Hefner file, document no. 1965, LNF.

2 Hefner file, document no. 1965, LNF.

3 "Marigold Gardens and the Strip Joints to Realms of the Rich," *Chicago Sun-Times*, December 3, 1972, 1, 14; Kay Gilman, "Neiman Fits the Avant-Garde Artist Role," *Asbury Park Sunday Press (NJ)*, September 3, 1972, D3.

4 *Playboy*, January 1994, 119, 267–68.

5 Frank Ahrens, "The Master of Jock Schlock," *Washington Post*, May 22, 1997, C1.

6 Hugh Merrill, *Esky: The Early Years at Esquire* (New Brunswick, NJ: Rutgers University Press, 1995), 131; Gay Talese, *Thy Neighbor's Wife* (New York: Ballantine, 1980), 31–32.

7 Russell Miller, *Bunny: The Real Story of "Playboy"* (London: Michael Joseph, 1984), 28.

8 Frank Brady, *Hefner* (New York: Macmillan Publishing, 1974), 43.

9 Hugh Hefner, *That Toddlin' Town: A Rowdy Burlesque of Chicago Manners and Morals* (Chicago: Chi Publishers, 1951).

10 Miller, *Bunny*, 31; Brady, *Hefner*, 45. William Leonard, "Tower Ticker," *Chicago Tribune*, April 4, 1951, A9. Hefner recycled much of the material from *That Toddlin' Town* to pad out early issues of *Playboy*. He used several of the cartoons, without their Chicago-specific elements, in an August 1954 featured titled "Street Scenes." Hugh Hefner, "Street Scenes," *Playboy*, August 1954, 20–21.

11 Miller, *Bunny*, 33; Carrie Pitzulo, *Bachelors and Bunnies: The Sexual Politics of "Playboy"* (Chicago: University of Chicago Press, 2011), 81; Thomas Weyr, *Reaching for Paradise: The Playboy Vision of America* (New York: Times Books, 1978), 4.

12 Joe Goldberg, *Big Bunny: The Inside Story of "Playboy"* (New York: Ballantine Books, 1967), 25.

13 Weyr, *Reaching for Paradise*, 19; Miller, *Bunny*, 33.

14 Miller, *Bunny*, 35; Brady, *Hefner*, 54.

15 Brady, *Hefner*, 56.

16 Brady, 56.

17 *Newsweek*, November 7, 1955; Brady, *Hefner*, 59; Weyr, *Reaching for Paradise*, 8; Bill Ogersby, *Playboys in Paradise: Masculinity, Youth and Leisurestyle in Modern America* (Oxford, UK: Berg, 2001), 126; David Abrahamson, *Magazine-Made America: The Cultural Transformation of the Postwar Periodical* (Cresskill, NJ: Hampton Press, 1996), 15–17.

18 Miller, *Bunny*, 39

19 Merrill, *Esky*, 139.

20 *Playboy*, December 1953, 3.

21 Brady, *Hefner*, 74.

22 *Playboy under the Covers*, 35.

23 See Michael MacCambridge, *The Franchise: A History of* Sports Illustrated *Magazine* (New York: Hyperion, 1998), 142–43.

24 "Playbill," *Playboy*, September 1954, 2.

25 Charles Beaumont, "Black Country," *Playboy*, September 1954, 6–8, 18–20, 32, 45–47.

26 Beaumont, 47.

27 "Letters to *Playboy*," November 1954, 3.

28 As part of the award, Neiman's "Black Country" illustrations were included in an exhibit curated by the Chicago Art Director's Club. "Playbill," *Playboy*, December 1954, 2; *The Best from "Playboy"* (New York: Waldorf Publishing, 1954), 67–83.

29 Charles Beaumont, "A Crooked Man," *Playboy*, August 1955, 8.

30 Kay O'Hara to LeRoy Neiman, January 1, 1993, box 16, folder 26, LNP.

31 Pitzulo, *Bachelors and Bunnies*, 80–81.

32 Elizabeth Fraterrigo, *"Playboy" and the Making of the Good Life in Modern America* (Oxford: Oxford University Press, 2009), 3–4; Weyr, *Reaching for Paradise*, 55.

33 Weyr, *Reaching for Paradise*, 57

34 Sinclair Lewis, *Babbitt* (1922; New York: Signet, 1980), 326; David Halberstam, *The Fifties* (New York: Ballantine Books, 1994), 576.

35 Ray Russell, *Writer's Digest*, April 1954, 9.

36 Pitzulo, *Bachelors and Bunnies*, 6; Joanne Hollows, "The Bachelor Dinner: Masculinity, Class, and Cooking in *Playboy*," *Continuum* 16, no. 2 (2002): 143–55; Barbara Ehrenreich, *The Hearts of Men: American Dreams and the Flight from Commitment* (New York: Anchor, 1983), 42, 51.

37 Neiman, *All Told: My Art and Life Among the Athletes, Playboys, Bunnies, and Provocateurs* (Guilford, CT: Lyons Press, 2012), 84.

38 Neiman Notes, document no. PB1, LNF.

39 Miller, *Bunny*, 64; Blake Rutherford, "The Marks of the Well-Dressed Man," *Playboy*, March 1957, 47, 69–70.

40 "The *Playboy* Reader," *Playboy*, September 1955, 36.

41 Becky Conekin, "Fashioning the Playboy: Messages of Style and Masculinity in the Pages of *Playboy* Magazine, 1953–1963," *Fashion Theory* 4, no. 4 (2000): 447–66, 449.

42 Weyr, *Reaching for Paradise*, 31; Miller, *Bunny*, 52; Brady, *Hefner*, 93; Pitzulo, *Bachelors and Bunnies*, 78; Ogersby, *Playboys in Paradise*, 129.

43 Blake Rutherford, "At Ease—Lounge Wear for the Man of Leisure," *Playboy*, February 1956, 58–59.

44 "Playbill," *Playboy*, June 1957, 2.

45 *Playboy's Penthouse* took inspiration from *Studs' Place* (1950–1951), a largely unscripted show starring Studs Terkel that was set in a Chicago diner.

46 Miller, *Bunny*, 75; Goldberg, *Big Bunny*, 43.

47 Ivan Gold, "A Change of Air," *Playboy*, February–March 1955, 6–8, 12, 16, 47–50; "Playbill," *Playboy*, June 1955, 2. Neiman's award-winning illustration was chosen to be exhibited as part of the Art Directors Club 34th Annual Exhibition, a government-sponsored show that toured Europe. See *Playboy*, September 1955, 4.

48 Ray Bradbury, "A Season of Calm Weather," *Playboy*, January 1957, 26–29, 71.

49 Richard Gehman and Robert George, "Bird," *Playboy*, January 1957, 37–38, 46, 52, 76.

50 *Playboy's Silverstein around the World* (New York: Fireside, 2007), 4. Kurtzman edited *Playboy*'s short-lived humor offshoot, *Trump*, which launched in 1957 and published only two issues.

51 Neiman, *All Told*, 82; *Playboy's Silverstein around the World*, 4.

52 *Playboy's Silverstein around the World*, 4.

53 Neiman Notes, document no. 1675, LNF; Neiman, *All Told*, 107–8; Lisa Rogak, *A Boy Named Shel* (New York: Thomas Dunne Books, 2007), 36.

54 Miller, *Bunny*, 159–60; Hugh Hefner to LeRoy Neiman, August 17, 1971, box 3, folder 19, LNP.

55 Al Bine, "Expressions of Our Times," *California Living*, June 24, 1973, 8–11; Kay Gilman, "Neiman Fits the Avant-Garde Artist Role," *Asbury Park Press*, September 3, 1972, D3.

56 "The Nudest Jayne Mansfield," *Playboy*, June 1963, 118–125. The nude pictorial was made to publicize Mansfield's film *Promises! Promises!* Noonan-Taylor Productions used *Playboy*'s feature and the controversy it sparked to market the otherwise poorly reviewed film.

CHAPTER SEVEN

1 Elisabeth Laurence, "LeRoy's Neiman's Drawings Are in Town," *San Francisco Examiner*, September 11, 2007, 23.

2 *Playboy*, December 2007, 24.

3 See *LeRoy Neiman's Femlin* (Milwaukie, OR: M Press, 2007).

4 *Playboy's Party Jokes* (New York: Pocket Books, 1963); *More Playboy's Party Jokes* (New York: Pocket Books, 1965); Patty Farmer and Will Friedwald, *Playboy Swings: How Hugh Hefner and "Playboy" Changed the Face of Music* (New York: Beaufort Books, 2015), 236.

5 *Playboy* attempted to hire Rockwell to place some work in the magazine in 1966. Rockwell, who was worried that this image was becoming stale, was apparently enticed by the idea. He developed cold feet, however, and backed out of the arrangement. Richard Christiansen, "*Playboy* at 25: A Bunny Empire Spawns the 'High Art of Low Art,'" *Chicago Tribune*, December 17, 1978, 136. See also Deborah Solomon, *American Mirror: The Life and Art of Norman Rockwell* (New York: Farrar, Straus & Giroux, 2013), 389–90.

6 Neiman, *All Told: My Art and Life Among the Athletes, Playboys, Bunnies, and Provocateurs* (Guilford, CT: Lyons Press, 2012), 123.

7 Elizabeth Fraterrigo, *"Playboy" and the Making of the Good Life in Modern America* (Oxford: Oxford University Press, 2009) 66–67.

8 Neiman, *All Told*, 125.

9 "Man at His Leisure," *Playboy*, December 1958, 60–61.

10 "Dear *Playboy*," *Playboy*, April 1959, 10; "Dear *Playboy*," *Playboy*, March 1960, 3.

11 "Man at His Leisure," *Playboy*, August 1964, 62; "Man at His Leisure," *Playboy*, January 1968, 57; "Man at His Leisure," *Playboy*, February 1960, 52–54. See Christopher Knight, "LeRoy Neiman Made Art Safe for *Playboy*-Reading Heterosexuals," *Los Angeles Times*, June 25, 2012, https://www.latimes.com/entertainment/arts/culture/la-et-leroy-neiman-notebook-20120625-story.html; Marvin Block, "There's Nothing Still about Life This Artist Paints," *Chicago's American*, November 3, 1959, 1.

12 Neiman, *All Told*, 121.

13 Neiman Notes, document no. 920, LNF.

14 Block, "There's Nothing Still," 1; *Chicago Daily Tribune*, December 21, 1959, B10.

15 Dorothy Walker, "Painting His Way into Nation's Restaurants," *San Francisco News*, July 26, 1958, 12T; "The Local Scene," *San Francisco Examiner*, August 3, 1958, 5–6.

16 Colin Asher, *Never a Lovely So Real: The Life and Work of Nelson Algren* (New York: Norton, 2019), 381; Nelson Algren, "Chicago IV," in *Algren at Sea: Travel Writings* (Chicago: Seven Stories Press, 2009), 229–66, 229–30; Brady, *Hefner*, 19.

17 "The Local Scene," *San Francisco Examiner*, August 3, 1958, 5–6; Block, "There's Nothing Still," 1.

18 Andrew McNally III to LeRoy Neiman, July 1, 1957, LeRoy Neiman file, Special Collections, SAIC.

19 Norman B. Boothby to LeRoy Neiman, December 21, 1959, LeRoy Neiman file, Special Collections, SAIC.

20 A. C. Spectorsky to LeRoy Neiman, February 4, 1960, LeRoy Neiman file, Special Collections, SAIC.

21 Neiman, *All Told*, 82, 121; Marian Christy, "LeRoy Neiman: An Artist Who Thrives on Breaking the Rules," *Boston Globe*, May 13, 1987, 39.

22 *Variety*, February 25, 1959, 2; Will Jones, "He'll Paint Bardot—Sans Towel," *Minneapolis Star Tribune*, April 16, 1961, 49.

23 Oehlschlaeger Gallery Exhibition Announcement, 1959, box 20, folder 9, LNP.

24 Edith Weigle, "Nonobjective Art on Wane: Gallery Owner" *Chicago Daily Tribune*, August 9, 1959, E2; Neiman Notes, document no. 1296, LNF; Neiman, *All Told*, 175.

25 Armand Hammer with Neil Lyndon, *Hammer* (New York: G. P. Putnam's Sons, 1987), 238–39.

26 *Playboy*, April 1967, 76.

27 Erika Doss, *Benton, Pollock, and the Politics of Modernism: From Regionalism to Abstract Expressionism* (Chicago: University of Chicago Press, 1995), 411–12.

28 "On the Scene," *Playboy*, March 1961, 61.

29 "Painting a Playmate," *Playboy*, September 1960, 67–73.

30 Sidney Tillum, "The Fine Art of Acquiring Fine Art," *Playboy*, January 1962, 60–63.

31 Hefner, *That Toddlin' Town*, n.p.; *Playboy*, December 1953, 62. See also Doss, *Benton, Pollock, and the Politics of Modernism*, 399.

32 Solomon, *American Mirror*, 360; Richard Halpern, *Norman Rockwell: The Underside of Innocence* (Chicago: University of Chicago Press, 2006), 150.

33 *Playboy* August 1955, 11; *Playboy*, November 1960, 117; *Playboy*, June 1962, 122; *Playboy*, April 1966, 178; *Playboy*, February 1967, 191.

34 *Playboy*, April 1965, 173; *Playboy*, November 1964, 169; *Playboy*, September 1966, 261.

35 *Playboy*, July 1956, 64; *Playboy*, July 1969, 178.

36 *Playboy*, March 1959, 35; *Playboy*, December 1962, 106; *Playboy*, December 1967, 303.

37 "Man at His Leisure," *Playboy*, January 1972, 171–73, 173.

38 Jones, "He'll Paint Bardot—Sans Towel."

39 "Man at His Leisure," *Playboy*, June 1961, 60–61; "Man at His Leisure," *Playboy*, July 1963, 102–3.

40 Neiman, *All Told*, 138–139.

41 "They Say," *Detroit Free Press*, March 10, 1962, 16; "LeRoy Neiman Starting One-Man Art Show," *Daily Chronicle*, March 5, 1962; "Expressionism on the American Scene," *Topic Magazine*, March 17, 1962, 36; O'Hana Gallery, LeRoy Neiman Exhibit, 1962, box 20, folder 12, LNP; Michael Shepherd, "LeRoy Neiman," *Arts Review*, March 10–24, 1962, 8; Paul Tanfield, "High Life," *Daily Mail* (London), January 1, 1962, 4.

42 "LeRoy Neiman's New Galleries," *New York Herald Tribune* (Paris), December 1, 1962, 3.

43 W. F. Fox, "A Matter of Course," *Indianapolis News*, May 28, 1962, 29.

44 Hal Bock, "The Art of Sport," *Winona* (*MN*) *Daily News*, February 13, 2000, 2B; Neiman Notes, document no. 1298, LNF.

45 "Cornerstone Rite Slated at NYU's Catholic Center," *Kingston* (*NY*) *Daily Freeman*, March 26, 1964, 38.

46 Robert Hudovernik explains that some of the figurative sculptures on the facade of the Hotel des Artistes were influenced by the architect Cass Gilbert, who designed the Minnesota State Capitol, which inspired LeRoy as a kid. He also speculates that several bust sculptures that adorn the building's facade might have been made by Daniel Chester French, a colleague of Gilbert's who designed the *Progress of State* quadriga that adorns the Minnesota State Capitol and also influenced Neiman as a youngster. See Robert Hudovernik, *Manhattan's Hotel des Artistes: America's Paris on West 67th Street* (Atglen, PA: Schiffer Press, 2020), 29–30.

47 Hammer Galleries, press release, October 1, 1963, microfilm, Clement Haupers and Clara Gardner Mairs Papers, Smithsonian Archives of American Art, Washington, DC.

48 Frank Getlein, "Printmaker and Painter," *New Republic*, November 30, 1963, 30–31; Leonard Lyons, "The Lyons Den," *New York Post*, November 1, 1963, 49; "Recent Gallery Exhibitions Summarized," *New York Times*, October 12, 1963, 29; "Gallery Guide," *New York Journal American*, October 12, 1963, 7.

49 LeRoy Neiman, "Letter to Clement Haupers," October 2, 1963, Clement Haupers and Clara Gardner Mairs Papers, Smithsonian Archives of American Art, Washington DC.

CHAPTER EIGHT

1 William R. Conklin, "Clay Forecasts 5-Round Victory," *New York Times*, May 17, 1962, 48.

2 Thomas Hauser, *Muhammad Ali: His Life and Times* (New York: Touchstone, 1991), 183–284.

3 Thomas Hauser, *Thomas Hauser on Sports: Remembering the Journey* (Fayetteville: University of Arkansas Press, 2013), 160.

4 "He's the Smartest and Fastest Man that There Is/With Brushstroke or Foot-

work Muhammad Ali's a Whiz," *Esquire*, September 1, 1967, 136–37; José Torres, *Sting Like a Bee: The Muhammad Ali Story* (New York: Abelard-Schuman, 1971), 176.

5 Tom Wolfe, "The Marvelous Mouth," *Esquire*, October 1, 1963, 146.

6 "I'm Just as Pretty as a Girl' Enthuses Unruffled Cassius," *Atlanta Constitution*, March 14, 1963, 36; "Boxers End Drills: Garden a Sellout," *New York Times*, March 12, 1963, 8; Larry Boeck, "Invitation to Murder: Clay May Get a Crack at Liston this Summer," *Louisville Courier-Journal*, March 14, 1963, 2:7.

7 "Man at His Leisure," *Playboy*, December 1963, 169–71.

8 Bob Mee, *Ali and Liston: The Boy Who Would Be King and the Ugly Bear* (New York: Skyhorse Publishing, 2011), 170–72.

9 Budd Schulberg, "Background and Battleground," *Playboy*, January 1963, 115–16, 136–44, 144.

10 "On the Scene," *Playboy*, July 1963, 110.

11 LeRoy Neiman, *All Told: My Art and Life among Athletes, Playboys, Bunnies, and Provocateurs* (Guilford, CT: Lyons Press, 2012), 203.

12 George Plimpton, "Miami Notebook," *Harper's*, June 1964, 54–61, 55.

13 "LeRoy," *Playboy*, January–February, 2012, 81–82, 82; Neiman, *All Told*, 206.

14 Alex Haley, "Interview with Cassius Clay," *Playboy*, October 1964, 67–82, 190–92, 82.

15 "Golden Boy a Champ with Sammy in the Ring," *Billboard*, August 15, 1964, 10.

16 After Malcolm X's 1965 assassination, productions of *Golden Boy* excised the lyrical references to the fallen Muslim leader. They replaced the lyrics with a reference to Cassius Clay, which served the same purpose of characterizing the setting. Dave Potter, "Meet Hillard Elkins, The Golden Boy of Sammy's 'Golden Boy,'" *Chicago Daily Defender*, March 2, 1968, 12. See also Wil Haygood, *In Black and White: The Life of Sammy Davis Jr.* (New York: Knopf, 2003), 351.

17 Neiman, *All Told*; Robert Ward, "The Playboy of the Western Art World." *New Times*, February 6, 1978, 52–64, 59.

18 Neiman, *All Told*, 204.

19 In his datebook, Neiman notes that Cleveland Williams also provided him with predictive sketches to counter Ali's visual taunts. Datebook, November 15, 1966, LeRoy Neiman Foundation.

20 Dave Brady, "Neiman Sees Prosperity in Title Bout," *Washington Post*, June 22, 1969, C4; "He's the Smartest and Fasted Man," 136–37.

21 Rogers Worthington, "With LeRoy Neiman, Not All the Color Is Splashed on the Artist's Canvas," *Chicago Tribune*, July 13, 1978, A1.

22 Nick Seitz, "Neiman—Sports Artist-in-Residence," *Christian Science Monitor*," May 2, 1972, B2; Robert Ward, "Playboy of the Western Art World," 59.

23 Gerald J. Bayles, "Artist Unveils Himself at Bank," *Hammond (IN) Times*, February 18, 1966, 1.

24 Roone Arledge *Roone: A Memoir* (New York: Harper Perennial, 2004), 26; Travis Vogan, *ABC Sports: The Rise and Fall of Network Sports Television* (Oakland: University of California Press), 28. Arledge had his name appended to the closing credits of all ABC Sports productions. Like a signature on a

painting, this uncommon sports television practice positioned ABC Sports' programming as artworks and cast Arledge as an auteur rather than a technician.

25 Vogan, *ABC Sports*, 24–25.

26 Bob Oates, "Commercial Sports Art," *Los Angeles Times*, May 28, 1976, E1.

27 See *Sports Illustrated*, July 26, 1962.

28 *ABC Wide World of Sports 1964* (New York: American Broadcasting Co., 1965), 136.

29 LeRoy Neiman, *Winners: My Thirty Years in Sports* (New York: Harry N. Abrams, 1983), 8.

30 "Giving the World the Brush," *New York Sunday News*, April 21, 1968.

31 LeRoy Neiman to Susan E. Meyer, February 24, 1977, box 4, folder 9, LNP. Neiman created a key for Madison Square Garden that lists the many people included in the painting.

32 Neiman Notes, document no. 443, LNF.

33 Stan Isaacs, "Neiman Sketches the Sports of the Times," *Newsday*, March 27, 1968, 28A.

34 David Condon, "In the Wake of the News," *Chicago Tribune*, April 8, 1968, 65.

35 Nick Gage, interview with author, January 23, 2020.

36 Larry Merchant, "Oh, How LeRoy Suffers for his Art," *Jock*, February 1970, 24–33; Mary Evertz, "LeRoy Neiman: High-Scoring Playmaker of the Art World," *St. Petersburg (FL) Times*, July 25, 1975, G1.

37 Stan Isaacs, "Neiman Sketches the Sports on the Times," *Newsday*, March 27, 1968, 28A.

38 Gage interview, January 23, 2020.

39 Nick Gage, "Sinatra's Pals," *Wall Street Journal*, August 19, 1968, 1.

40 Kaplan, *Sinatra: The Chairman* (New York: Doubleday, 2015), 765–67; Kitty Kelley, *His Way: The Unauthorized Biography of Frank Sinatra* (1986; New York: Bantam Books, 2015), 423–24; Nick Gage, interview with author, June 9, 2021.

41 *BoxOffice*, June 19, 1967, E5; Neiman, *All Told*, 103.

42 Box 3, folder 15, LNP.

CHAPTER NINE

1 Tom McEwan, "As the World Turns Artist Paints Sports," *Tampa (FL) Tribune*, July 23, 1975, 14.

2 Heather Long, interview with author, October 14, 2019.

3 Gage interview, January 23, 2020.

4 Neiman, *All Told: My Art and Life among Athletes, Playboys, Bunnies, and Provocateurs* (Guilford, CT: Lyons Press, 2012), 325.

5 Esther Penn, Interview with author, February 10, 2020.

6 Gage interview, January 23, 2020.

7 Joan Gage, interview with author, January 23, 2020.

8 Robert Daley, "Before and after Vatican II," *ARTnews*, September 1975, 94–96.

9 Gregory Baum, "Earl Neiman: A Great Artist," *Catholic World*, May 1971, 69–74.

10 Daley, "Before and after Vatican II," 96.

11 Penn interview, February 10, 2020; Gage interview, January 23, 2020.

12 Penn interview, February 10, 2020.

13 Neiman Notes, Corr 477, LNF.

14 Gage interview, January 23, 2020.

15 Penn interview, February 10, 2020.

16 Kay Loring, "Front Views & Profiles," *Chicago Tribune*, February 9, 1965, A2.

17 Sally Falk, "Sports Artist Neiman Leads," *Indianapolis Star*, January 22, 1967, 22.

18 Neiman Notes, document no. 213, LNF; LeRoy Neiman datebook, November 21, 1971, Neiman Foundation.

19 Cobey Black, "Portrait of the Artist as a Swinger," *Honolulu (HI) Advertiser*, June 18, 1974, 9; Mary Evertz, "LeRoy Neiman: High-Scoring Playmaker of the Art World," *Tampa Bay (FL) Times*, July 25, 1975, G1.

20 "Cherokee Charlie Says," *Chicago Defender*, December 8, 1969, 13.

21 Black, "Portrait of the Artist as a Swinger," 9; Evertz, "High-Scoring Playmaker," G1.

22 Robert Ward, "The Playboy of the Western Art World," *New Times*, February 6, 1978, 52–64, 59.

23 Linda Moreno to LeRoy Neiman, 1974, box 15, folder 3, LNP; Penn interview, February 10, 2020.

24 LeRoy Neiman datebooks, January 8, 1966; June 2, 1972; March 13, 1973; January 5, 1977, LeRoy Neiman Foundation; Neiman, *All Told*, 326.

25 Penn interview, February 10, 2020.

CHAPTER TEN

1 Tom Werblin, interview with author, June 9, 2021.

2 Larry Merchant, "Oh, How LeRoy Suffers for his Art," *Jock*, February 1970, 24–33; Mickey Herskowitz, "Different Strokes," *Pro!* 6, no. 7, 1975, 5A; Frank Ramos, interview with author, July 6, 2021.

3 Rogers Worthington, "With LeRoy Neiman, Not All the Color is Splashed on the Artist's Canvas," *Chicago Tribune*, July 13, 1978, A1.

4 Larry Merchant, "An Original," *New York Post*, December 5, 1967, 106; Neiman, *All Told*, 199.

5 Mark Kriegel, *Namath: A Biography* (New York: Penguin, 2004), 247.

6 *Atlanta Constitution*, December 28, 1973, 2C; Merchant, "An Original," 106.

7 "Neiman on Namath: A Portfolio by LeRoy Neiman," *Pro! The Official Publication of the National Football League*, November 1, 1970, n.p.; Sidney Fields, "Portrait in Jet," *Daily News (NY)*, December 26, 1968, 62.

8 Mickey Herskowitz, "An Artist's Impressions of the Game," *Houston Post*, November 11, 1968, 5:1, 5:5.

9 Dan Jenkins, "The Sweet Life of Swinging Joe," *Sports Illustrated*, October 17, 1966, 42–55, 44.

10 In the book, Namath credited Ali with showing him how to handle the

sportswriters that constantly swarmed around prodding for a juicy quote. See Joe Namath and Dick Schaap, *I Can't Wait until Tomorrow . . . 'cause I Get Better-Looking Every Day* (New York: Random House, 1969), 234.

11 Dave Anderson, "Hong Kong Flu Latest Bug in Jets' Game Plan," *New York Times*, December 5, 1968, 65; Dave Anderson, "The Old Ties Won't Bind Today," *New York Times*, January 12, 1969, S1; James Roach to LeRoy Neiman, January 17, 1969, box 3, folder 15, LNP.

12 Dave Anderson, *Countdown to the Super Bowl* (New York: Signet, 1969), 121, 178.

13 Joseph Durso, "Namath Is Hero of the Hour," *New York Times*, January 23, 1969, 58. See Marian Christy, "Joe Namath: Business, Booze and Broads," *Boston Globe*, November 9, 1969, A6; "Coslet Can't Coach Jets Old Sketches," *New York Times*, February 7, 1990, B9; Kriegel, *Namath*, 272.

14 "Athlete as Peacock," *Time*, January 4, 1971.

15 Donald M. Schwartz, "The Changing Lifestyle of LeRoy Neiman," *Arizona Daily Star*, December 5, 1976, D7.

16 Maury Allen, "Pigskin Picasso," *New York Post*, November 5, 1968.

17 Larry Merchant, "An Original," *New York Post*, December 5, 1967, 106. See also John D. Bloom, "Joe Namath and Super Bowl III: An Interpretation of Style," *Journal of Sport History* 15, no. 1 (Spring 1988): 64–74.

18 Ward, "Playboy of the Western Art World," 59; Larry Merchant, "Championship Canvas," *New York Post*, December 27, 1968, 16.

19 Nick Seltz, "Neiman—Sports Artist-in-Residence," *Christian Science Monitor*, May 2, 1972, B2; Diana Stepp, "Artist Who Likes Action People Tries Atlanta for Glamor," *Atlanta Journal Constitution*, May 23, 1968, 11.

20 Thomas Weyr, *Reaching for Paradise: The Playboy Vision of America* (New York: Times Books, 1978), 161.

21 Studs Terkel, "Jowl to Jowl," in *Law & Disorder: The Chicago Convention and Its Aftermath* (Chicago: Donald Myrus and Burton Joseph, 1968), 10–12.

22 "Painter: Art Aids Ghettoes," *Fort Lauderdale News*, March 5, 1969; Ann Carter, "Artist Poses Famous People," *Atlanta Journal*, September 6, 1968, A24; "Painter Neiman to Lecture," *Atlanta Constitution*, May 4, 1968, 10; *Philadelphia Daily News*, January 21, 1969.

23 Dean Eagle, "Ali Sees Future in Painting," *Louisville Courier Journal*, December 8, 1970, B5.

24 Bud Collins, "Ali Turns to Art, Puts Bonavena on Canvas without Landing a Punch," *Boston Globe*, December 7, 1970, 25.

25 Randy Roberts and Johnny Smith, *Blood Brothers: The Fatal Friendship between Muhammad Ali and Malcolm X* (New York: Basic Books, 2016), xxi.

26 Neiman, *All Told: My Art and Life among Athletes, Playboys, Bunnies, and Provocateurs* (Guilford, CT: Lyons Press, 2012), 215.

27 Dean Eagle, "Clay Paints Away at His Camp Despite the Turmoil in Atlanta," *Louisville Courier Journal*, October 25, 1970, 42.

28 Michael Arkush, *The Fight of the Century: Ali v. Frazier, March 8, 1971* (Hoboken, NJ: Wiley, 2008), 50.

29 Thomas A. Johnson, "Foreman Hits 220, Ali 216½ at Weigh-In," *New York Times*, October 17, 1974, 5:1.

30 "Clay, Quarry Stage Bout," *Chicago Daily Defender*, September 1, 1970, 30; "Clay-Quarry Bout Sealed for October 26," *Washington Post*, September 11, 1970, D5.

31 Jerry Kirschenbaum, "Sport's $5 Million Payday," *Sports Illustrated*, January 4, 1971, 20–23, 20; Jonathan Eig, *Ali: A Life* (Boston: Houghton Mifflin Harcourt, 2017), 308.

32 John Crittenden, "Muhammad: The Babble Goes on Endlessly," *Boston Globe*, February 28, 1971, 85. In his datebook, Neiman described the Ali-Frazier match as "the biggest nite in fight history." LeRoy Neiman, datebook, March 8, 1971, LeRoy Neiman Foundation.

33 Arkush, *Fight of the Century*, 158

34 "Ali-Frazier—World Watches, Bare Fisted," *Boston Globe*, March 5, 1971, 25.

35 "Carl Eller Heads Fight's Fashions," *Los Angeles Sentinel*, March 11, 1971, B1; Howard Cosell, "Ali Returns to the Ring, Gets Frazier, *The Argus* (Fremont, CA), January 25, 1974, 15; Judy Klemesrud, "Outside the Ring, Another Dazzling Spectacle," *New York Times*, March 9, 1971, 42.

36 "Carl Eller Heads Fight's Fashions," B1.

37 LeRoy Neiman, *Winners: My Thirty Years in Sports* (New York: Harry N. Abrams, 1983), 184.

CHAPTER ELEVEN

1 John V. Hurst, "On the Air," *Sacramento (CA) Bee*, March 13, 1971, 20.

2 Gerald Eskenazi, "Frazier, Ill at Ease, Shuns TV Review," *New York Times*, March 14, 1971, S2.

3 Neiman appeared on camera during the taping to explain his drawings, but his segment was cut before *Wide World* went to air. LeRoy Neiman, datebook, March 13, 1971, LeRoy Neiman Foundation.

4 "Chess Match in Danger: Fischer Hints He Will Quit Over TV," *Chicago Tribune*, July 29, 1972, P; "FDR-Eleanor Story among ABC Specials," *Los Angeles Times*, June 29, 1972, A8.

5 *Fischer-Spassky: The New York Times Report on the Match of the Century* (New York: New York Times Co., 1972), 96–97.

6 "Fischer's Appeal of Chess Forfeit Rejected," *Chicago Tribune*, July 15, 1972, A22; Frank Brady, *Profile of a Prodigy: The Life and Games of Bobby Fischer* (New York: David McKay Co., 1973), 243–44; Jim Ward, "Grandmasters Say Fischer Now Had Advantage," *The Times* (Shreveport, LA), July 25, 1972, 5.

7 "Home from Reykjavik," *Broadcasting*, August 7, 1972, 25.

8 LeRoy Neiman, *All Told: My Art and Life among the Athletes, Playboys, Bunnies, and Provocateurs* (Guilford, CT: Lyons Press, 2012), 235; Leonard Lyons, "The Lyons Den," *Kenosha (WI) News*, August 3, 1972, 24.

9 Neiman, *All Told*, 235; LeRoy Neiman, *Art & Lifestyle* (New York: Felicie, 1973), 242–47.

10 Lynn Spigel, *TV by Design: Modern Art and the Rise of Network Television* (Chicago: University of Chicago Press, 2008), 3, 55–56; Lynn Spigel, "Back to the Drawing Board: Graphic Design and the Visual Environment of Television at Midcentury," *Cinema Journal* 55, no. 4 (2016): 28–54, 28.

11 Horace Newcomb, *TV: The Most Popular Art* (New York: Anchor Press, 1974).

12 ABC did not cover the 1980 Summer Games in Moscow, which the United States boycotted, or the 1972 Winter Games from Sapporo, Japan, which were broadcast on NBC.

13 *New York Times*, August 27, 1972, S5.

14 Roone Arledge, *Roone: A Memoir* (New York: HarperCollins, 2003), 30–33.

15 LeRoy Neiman, *Winners: My Thirty Years in Sports* (New York: Abrams, 1983). 314.

16 Bill Roberts, "Artist LeRoy Neiman: From Poverty to *Playboy*," *Indianapolis News*, November 23, 1972, 70.

17 Neiman, *Winners*, 10, italics added; Neiman, *All Told*, 238.

18 Roberts, "Artist LeRoy Neiman," 70.

19 *LeRoy Neiman: XXth Olympiad, München 1972* (Indianapolis: Indianapolis Museum of Art, 1972), n.p.

20 Roberts, "Artist LeRoy Neiman," 70.

21 Travis Vogan, *ABC Sports: The Rise and Fall of Network Sports Television* (Oakland: University of California Press), 28.

22 John J. O'Connor, "Olympic Games Make a Spectacular Show—Coverage of Events Is Technically Flawless," *New York Times*, August 30, 1972, 75; Les Brown, "Olympics Boost Web's Stature," *Variety*, September 6, 1972, 31.

23 Frank Shorter to LeRoy Neiman, January 10, 1973, box 4, folder 1, LNP; LeRoy Neiman to Frank Shorter, January 27, 1973, box 4, folder 1, LNP.

24 Sally Welty to Roone Arledge, September 14, 1972, box 3, folder 20, LNP.

25 ABC Sports Holiday Cards, box 15, folder 6, LNP.

26 Mary Daniels, "LeRoy Neiman: Artistic Ambassador for the World at Play," *Chicago Tribune*, November 5, 1974, A14.

27 "ITN Global Horserace on 114 U.S. Stations," *Variety*, November 8, 1972, 34; *All Told*, 237.

28 Barry Tarshis, "A Lot Preceded the Ms.-Match," *New York Times*, September 23, 1973, 3; "The Ultimate Hustle," *Atlanta Constitution*, September 16, 1973, 20D. See also Susan Ware, *Game, Set, Match: Billie Jean King and the Revolution in Women's Sports* (Chapel Hill: University of North Carolina, 2011); Selena Roberts, *A Necessary Spectacle: Billie Jean King, Bobby Riggs, and the Tennis Match That Leveled the Game* (New York: Crown, 2005).

29 Melvin Durslag, "Libber, Lobber, and Clobber," *Sporting News*, October 6, 1973, 44.

30 F. Lanier Graham, "The Neiman Phenomenon," in *LeRoy Neiman, Andy Warhol: An Exhibition of Sports Paintings* (Los Angeles: Los Angeles Institute of Contemporary Art, 1981), 42.

31 See Marshall McLuhan, *Understanding Media: The Extensions of Man* (New York: McGraw-Hill, 1964).

32 Susan Murray, *Bright Signals: A History of Color Television* (Durham, NC: Duke University Press, 2018), 136.

33 Cobey Black, "Portrait of the Artist as a Swinger," *Honolulu (HI) Advertiser*, June 18, 1974, 9.

34 Bob Oates, "Brushing Up on the Games," *Los Angeles Times*, May 26, 1976, F1.

35 Steve Weinberg, *Armand Hammer: The Untold Story* (Boston: Little, Brown and Co., 1989), 376.

36 Grace Glueck, "Knoedler's Bought by Hammer Group," *New York Times*, December 9, 1971, 62.

37 LeRoy Neiman, *The Prints of LeRoy Neiman: A Catalogue Raisonné of Serigraphs, Lithographs, and Etchings* (New York: Knoedler, 1980), 355.

38 Neiman, *All Told*, 246.

39 Felicie Schumsky to LeRoy Neiman, January 25, 1971, box 2, folder 10, LNP.

40 Felicie Schumsky to LeRoy Neiman, January 7, 1971, box 2, folder 10, LNP; Neiman Super Stars, n.d., box 2, folder 10B, LNP.

41 Robert Ward, "The Playboy of the Western Art World," *New Times*, February 6, 1978, 52–64, 64.

42 See Wendy A. Woloson, *Crap: A History of Cheap Stuff in America* (Chicago: University of Chicago Press, 2020).

43 LeRoy Neiman, Deposition to Supreme Court of New York State, June 8, 1978, box 2, folder 13, LNP; Shirley Percival Jr. to Felicie Schumsky, September 5, 1972, box 3, folder 20, LNP.

44 Publishing Contract, February 14, 1973, box 2, folder 12, LNP; Larry Swindell, "What's Felicie? It's a Who & a Her," *Philadelphia Inquirer*, November 17, 1974, 10H.

45 Tom C. Brown, newsletter, October 1974, box 4, folder 2, LNP.

46 Neiman, *Art & Lifestyle*, 9.

47 Neiman, 13, 16.

48 Mike Meyers, "Mass Marketing Boosts St. Paul Native's Career," *Star Tribune*, August 21, 1989, 1D.

49 LeRoy Neiman, *Five Decades* (New York: Harry N. Abrams, 2003), 148; Janet Muchovej, "What It's Like Being Married to Howard Cosell: A Candid Talk with Emmy Cosell," *Bangor (ME) Daily News*, March 15, 1975, 8.

50 Neil Leifer, interview with author, February 11, 2020.

51 Paul-Hayden Parker, "Portrait of the Artist as Bon Vivant," *Mainliner* 11, no. 4 (April 1973): 24–42, 24.

52 Circle Gallery LTD to LeRoy Neiman, February 21, 1973, box 2, folder 10, LNP; *Spokesman Review*, December 21, 1975, A9.

53 LeRoy Neiman, Deposition to Supreme Court of New York State, December 20, 1976, box 2, folder 12, LNP; LeRoy Neiman, Deposition to Supreme Court of New York State, May 24, 1977, box 2, folder 13, LNP.

54 Neiman, *All Told*, 247; LeRoy Neiman, Deposition to New York Superior Court, February 2, 1978, box 2, folder 13, LNP. Circle Gallery also sued Neiman because he refused to sign several serigraphs produced under Felicie Inc.'s direction. See Jack Solomon Jr. to Richard M. Michaelson, November 14, 1975, box 2, folder 10, LNP.

55 LeRoy Neiman, Deposition to New York Supreme Court, February 2, 1978, box 2, folder 13, LNP.

56 LeRoy Neiman, Deposition to New York Supreme Court, February 2, 1978, box 2, folder 13, LNP.

57 Neiman, *All Told*, 247.

58 Sandra Salmans, "The Selling of LeRoy Neiman," *New York Times*, Novem-

ber 8, 1980, 29; Tom Dunkel, "A Brush with Success," *Northwest Orient,* August 1985, 46–49, 49.

59 Oates, "Brushing Up on the Games," F1.

CHAPTER TWELVE

1 Malcolm Lein, "Prologue," *LeRoy Neiman: Retrospective Exhibition* (St. Paul: Minnesota Museum of Art, 1975), 8.

2 Mike Steele, "LeRoy Neiman," *Minneapolis Tribune,* December 18, 1975, 13B.

3 Ray Johnson, "Injustice to an Artist," *Minneapolis Tribune,* January 1, 1976, 4A.

4 Pat Jordan, interview with author, September 29, 2021.

5 Pat Jordan, "LeRoy Neiman's Work Reveals Himself, in Some Ways, as a Carbon-Copy Dalí," *Sports Illustrated,* January 13, 1975, 8.

6 Oates, "Brushing Up on the Games," F1.

7 Rogers Worthington, "With LeRoy Neiman, Not All the Color Is Splashed on the Artist's Canvas," *Chicago Tribune,* July 13, 1978, A1; Ward, "Playboy of the Western Art World," 55.

8 Robert Lipsyte, "Neiman Defies the Critics and Keeps on Painting," *New York Times,* November 19, 1995, S11.

9 ABC Sports, press release, 1976, box 22, folder 6, LNP; Travis Vogan, *ABC Sports: The Rise and Fall of Network Sports Television* (Oakland: University of California Press, 2018), 144–45.

10 "St. Paul's LeRoy Neiman Will Create Painting on TV," *St. Paul (MN) Pioneer Press,* July 11, 1976, 18.

11 Peter Plagens and Walter Gabrielson, "LeRoy Neiman Calls Himself the Modern Michelangelo," *New West,* August 30, 1976, 50–51.

12 Plagens and Gabrielson.

13 Diane Lanken, "Viewers Got Unique Games Picture," *The Gazette* (Montreal), August 4, 1976, 38; Plagens and Gabrielson, "LeRoy Neiman Calls Himself," 50–51.

14 Bettelou Peterson, "Olympic Seen the French Way," *Detroit Free Press,* July 27, 1976, 5B.

15 Therese Schwartz, "Art and/or the Spectator Sport," *Arts Magazine,* 53, no. 4 (1978): 122.

16 Charles A. Smiley to Maury Leibovitz, November 1, 1976, box 15, folder 6, LNP; Plagens and Gabrielson, "LeRoy Neiman Calls Himself," 51; *New York Times,* December 26, 1976, X28.

17 Burger King advertisement, 1976, box 22, folder 3, LNP. A Bakersfield, California, framing shop called Ted Brown's sought to capitalize on the Neiman posters by offering a sale centered specifically on those prints. "Attention! Burger King Munchers and Olympic Artist LeRoy Neiman Fans! We will drymount and frame your Burger King LeRoy Neiman prints with choice of frame color for only $6.98." *Bakersfield Californian,* August 1, 1976, 14.

18 Jose Alberni to LeRoy Neiman, July 13, 1976, box 22, folder 3, LNP.

19 Ward, "Playboy of the Western Art World," 60; LeRoy Neiman, *All Told: My*

Art and Life among the Athletes, Playboys, Bunnies, and Provocateurs (Guilford, CT: Lyons Press, 2012), 240.

20 ABC Sports, LeRoy Neiman contract, March 29, 1977, box 15, folder 2, LNP.

21 Chuck Weiss to Adrian M. Butash, November 7, 1978, box 4, folder 14.5, LNP.

22 Agreement between LeRoy Neiman and Laureate II Productions, May 10, 1976, box 4, folder 7, LNP; "Neiman's New York" (Proposal), n.d., box 4, folder 9, LNP.

23 Plagens and Gabrielson, "LeRoy Neiman Calls Himself," 50–51; Worthington, "With LeRoy Neiman," A1.

24 "Worldwide Recognition in His Own Lifetime," *New Yorker*, February 5, 1979, 28–29.

25 Harper Hilliard, "'Common People' Flock to Painter of Uncommon Riches," *Los Angeles Times*, November 30, 1988, R1; Ward, "Playboy of the Western Art World," 54.

26 Susan C. Larsen, "Sports Illustrati," *Art News*, March 1982, 133–34; Franz Lidz, "LeRoy, You're a Real Piece of Work," *Sports Illustrated*, October 21, 1985, 60–70, 60.

27 Sally Russell to LeRoy Neiman, September 9, 1976, box 4, folder 14, LNP; Nancy Muzzy to LeRoy Neiman, November 2, 1976, box 4, folder 8, LNP. For more information on the Picture Lady initiative, see Helen J. Anderson, "Picture Lady Program: Seven Years Old and Still Going Strong," *School Arts* 69, no. 1 (September 1969): 36–37; Micki Van Deventer, "Picture Ladies," *School Arts* 75, no. 1 (September 1975): 58–59.

28 LeRoy Neiman to Nancy Muzzy, November 15, 1976, box 4, folder 8, LNP.

29 Tina Lee to LeRoy Neiman, November 1, 1978, box 4, folder 16, LNP; Don Terry to LeRoy Neiman, April 4, 1977, box 4, folder 15, LNP.

30 Jeff Korbman to LeRoy Neiman, March 31, 1975, box 4, folder 5, LNP; Lee Maddox to LeRoy Neiman, July 22, 1976, box 4, folder 14, LNP; Greg Small to LeRoy Neiman, n.d., box 4, folder 14, LNP.

31 Clement Greenberg, "Avant Garde and Kitsch," *Partisan Review* 6, no. 5 (1939): 34–49, 46.

32 Nick Baldwin, "Neiman at Work," *Des Moines (IA) Register*, April 29, 1979, 8C; Ward Bushee, "Neiman Exhibit Is Right Up This Bowling Alley," *Salinas Californian*, February 24, 1979, 34; Robert McDonald, "At the Galleries," *Los Angeles Times*, August 1, 1986, J13.

33 Chip Bodanski to LeRoy Neiman, September 19, 1977, box 4, folder 15, LNP; Stan Bell to LeRoy Neiman, January 18, 1977, box 4, folder 15, LNP.

34 Robert Grenon, interview with author, January 13, 2020; Joe Gonzalez, interview with author, October 14, 2022.

35 Neiman Notes, document no. 819, LNF; Worthington, "With LeRoy Neiman," A1.

36 Esther Penn, interview with author, February 10, 2020.

37 McDonald, "At the Galleries," J13; Gene Kilroy to LeRoy Neiman, October 2, 1977, box 4, folder 12, LNP.

38 Ward, "Playboy of the Western World," 56.

39 Neiman Notes, document no. 1906, LNF.

40 The network guaranteed Neiman $5,000 for each subsequent appearance he made over the course of their yearlong agreement.

41 "AVC: Ampex, CBS Turn Video into Art," *Broadcasting*, October 13, 1980, 64; "CBS-TV to Treat Super Bowl Fans to Latest Wizardry," *Wall Street Journal*, January 12, 1978, 18; "Two New Devices Debut in CBS's Coverage of the Super Bowl," *Broadcasting*, January 16, 1978, 60; "CBS/Ampex 'Electronic Palette' Scores at Super Bowl XII," *Back Stage*, January 27, 1978, 16.

42 "CBS/Ampex 'Electronic Palette' Scores," 16.

43 Two New Devices Debut in CBS's Coverage," 60; Gerald Eskenazi, "The City That Flipped Its Lid," *Atlanta Constitution*, January 16, 1978, 5C.

44 Alan Goldstein, "Another Day," *Baltimore Sun*, January 17, 1978, C7; Jack Craig, "CBS Coverage Comes Up with High Marks for Low-Key Delivery," *Boston Globe*, January 16, 1978, 30; Stan Hochman, "Super Bowl: Only in America Can this Happen," *Philadelphia Daily News*, January 16, 1978, 58.

45 Gene Duffey, "Super Bowl May Determine Top Network for Year," *Gannet News Service*, January 18, 1980.

46 Craig K. Tanner to LeRoy Neiman," February 27, 1978, box 25, folder 2b, LNP; Het Vennenbos, "Graphic Designers Not Happy with Their Electronic Tools," *Broadcasting*, March 2, 1981, 18–19. In 1974, Neiman was involved in a venture organized by James Talcott Inc. that aimed to humanize increasingly technologized office spaces by leasing computers that had been decorated with reproductions of familiar artworks. A Neiman tennis scene composed one option. Others included a Frederic Remington western and a landscape by Maude Gatewood. See Rita Reif, "Art on Computers Aims to Cut 'Antiseptic' Look," *New York Times*, November 11, 1974, 47.

47 CBS Sports contract, June 20, 1979, box 15, folder 2, LNP.

48 While his work for CBS Sports concluded, the network commissioned Neiman to create artwork for the 1983 made-for-TV movie *Quarterback Princess*, which stars Helen Hunt as a girl who battles against sexism to join her high school football team. Gary Goodman to LeRoy Neiman, October 17, 1983, box 6, folder 2, LNP.

49 Neiman appeared as himself and sketched on camera only in *Rocky II*. He played a ring announcer in *Rocky III* (1982), *Rocky IV* (1985), *Rocky V* (1990), and *Rocky Balboa* (2006).

50 *Sporting News*, November 29, 1982, 27.

51 In 1986, Ted Turner's Turner Broadcasting Company hired Neiman to serve as the official artist for the inaugural Goodwill Games it staged in Moscow in 1986.

52 Neiman Notes, document no. 1906, LNF.

53 Maury P. Leibovitz to Roone Arledge, November 17, 1983, box 15, folder 6, LNP; Maury P. Leibovitz to James E. Duffy, November 17, 1983, box 15, folder 6, LNP.

54 Eamonn Fingelton, "Portrait of the Artist as a Money Man," *Forbes*, February 1, 1982, 58; Robert Hughes, "The Rise of Andy Warhol," *New York Review of Books*, February 18, 1982, 6–10, 6.

CHAPTER THIRTEEN

1 Darius Azari, Christopher Goode, Eric Goode, Shawn Hausman, Joe Dolce, and Maureen Gallace to LeRoy Neiman, n.d., box 6, folder 11, LNP; Eric Goode and Jennifer Goode, *Area, 1983–1987* (New York: Abrams, 2013), 206–21.

2 LeRoy Neiman, *All Told: My Art and Life Among the Athletes, Playboys, Bunnies, and Provocateurs* (Guilford, CT: Lyons Press, 2012), 316.

3 Michael Halsband, interview with the author, March 7, 2022.

4 Bud Schmeling, "LeRoy Neiman: Through Line," *Victory* 8 (Winter 2014), 42.

5 Richard Harden to LeRoy Neiman, November 21, 1978, box 4, folder 14.5, LNP; Susan Clough to LeRoy Neiman, December 5, 1978, box 4, folder 14.5, LNP.

6 Blake Gopnik, *Warhol* (New York: Ecco, 2020), 807; Marjorie Hunter, "Carter Meets American Artists Who Portrayed His Inauguration," *New York Times*, June 15, 1977, 30; Jo Ann Lewis, "Limited Edition Prints," *Washington Post*, June 11, 1977, B8.

7 Richard Harden to LeRoy Neiman, December 20, 1978, box 4, folder 14.5, LNP.

8 Jonathan Alter, *His Very Best: Jimmy Carter, A Life* (New York: Simon & Schuster, 2020), 338.

9 "Olympic Artist LeRoy Neiman Would Move Games to Greece," *St. Louis (MO) Jewish Light*, February 27, 1980, 44.

10 LeRoy Neiman, *All Told*, 267.

11 Richard Harden to Jimmy Carter, memo, January 19, 1980, Jimmy Carter Presidential Library.

12 Jimmy Carter schedule, January 30, 1980, Jimmy Carter Presidential Library, Office of Staff Secretary, Presidential Files, Folder: 1/30/1980, container 149.

13 "Lillian Carter Presents Sadat with Painting," *New York Times*, April 25, 1980, A3.

14 LeRoy Neiman, "Review of Famous for 15 Minutes," *Cover* (January 1988), p. 32; Neiman, *All Told*, 267; Pat Hackett, ed., *The Andy Warhol Diaries* (New York: Twelve, 1989), 314.

15 Hackett, *Andy Warhol Diaries*, 314; Maxine Cheshire, "What Erased Miss Lillian's Tapes?" *Los Angeles Times*, August 29, 1980, I20.

16 *LAICA Journal*, 1, no. 1 (1974), 1; Robert Smith, *LeRoy Neiman–Andy Warhol: An Exhibition of Sports Paintings* (Los Angeles: Los Angeles Institute of Contemporary Art, 1981), 11.

17 Smith, *LeRoy Neiman–Andy Warhol*, 11–12.

18 Robert A. Smith to LeRoy Neiman and Maury Leibovitz, October 9, 1980, box 24, folder 3, LNP.

19 Smith, *LeRoy Neiman–Andy Warhol*, 10; Barbara Isenberg, "An Artist Who Wants More Respect," *Los Angeles Times*, September 25, 1981, H1.

20 See Isenberg, "Artist Who Wants More Respect," H1.

21 Anthony Haden-Guest, "Sphinx and Superstar: What It Was Like to Know the Real Andy Warhol," *Daily Beast*, November 14, 2018, https://www.thedailybeast.com/sphinx-and-superstar-what-it-was-like-to-know-the-real-andy-warhol.

22 Andy Warhol, *The Philosophy of Andy Warhol: From A to B and Back Again* (New York: Harcourt Brace Jovanovich, 1975), 6; Benjamin Secher, "Andy Warhol TV: Maddening but Intoxicating," *Telegraph*, September 30, 2008, https://www.telegraph.co.uk/culture/film/3561451/Andy-Warhol-TV -maddening-but-intoxicating.html.

23 Lynn Spigel, *TV by Design: Modern Art and the Rise of Network Television* (Chicago: University of Chicago Press, 2009), 264.

24 Richard Weisman, *Picasso to Pop: The Richard Weisman Collection* (New York: Atelier Press, 2002), 24; Brandy McDonnell, "Oklahoma City Museum of Art to Show Andy Warhol's 'The Athletes' Series," *The Oklahoman*, April 12, 2015, https://www.oklahoman.com/story/entertainment/columns /brandy-mcdonnell/2015/04/12/oklahoma-city-museum-of-art-to-show-andy -warhols-the-athletes-series/60754007007/, qtd. in LeRoy Neiman, *The Prints of LeRoy Neiman* (New York: Knoedler, 1980), 38.

25 Weisman, *Picasso to Pop*, 24.

26 Steve Wilstein, "Andy Warhol Paints Top Ten World Athletes," *Lebanon (PA) Daily News*, December 5, 1977, 25; Tony Kornheiser, "Pictures at an Exhibit," *New York Times*, December 11, 1977, S5.

27 Victor Bockris, *Muhammad Ali: In Fighter's Heaven* (London, Hutchinson, 1998), 127; Franz Lidz, "LeRoy, You're a Real Piece of Work," *Sports Illustrated*, October 21, 1985, 60–70, 68.

28 Andy Warhol, *Andy Warhol's Exposures* (New York: Andy Warhol Books, 1979), 211.

29 Warhol, 212–13; Victor Bockris, *Warhol: The Biography* (Boston, Da Capo, 1989), 412.

30 Bockris, *Muhammad Ali: In Fighter's Heaven*, 125–26; Warhol, *Andy Warhol's Exposures*, 213.

31 Bockris, *Muhammad Ali*, 127.

32 Spigel, *TV by Design*, 253; David James, "The Unsecret Life: An Advertisement," *October* 56 (Spring 1991): 21–42; Thomas Crow, "Saturday Disasters: Trace and Reference in Early Warhol," in *Modern Art in the Common Culture* (New Haven, CT: Yale University Press, 1986), 49–65.

33 Bob Colacello, *Holy Terror: Andy Warhol Close Up* (New York: Vintage, 1990), 340; *Andy Warhol Diaries*, 386.

34 *Playboy* Press Release, November 11, 1981, box 6, folder 83, LNP; *Neiman-Warhol Report*, October 14, 1981, LAICA Papers, box 24, folder 4, Smithsonian Archives of American Art, Washington, DC.

35 Press Release, November 12, 1981, LAICA Papers, box 6, folder 82, Smithsonian Archives of American Art, Washington, DC.

36 LeRoy Neiman, "Review of Famous for 15 Minutes," *Cover*, January 1988, 32.

37 Gopnik, *Warhol*, 746–47.

38 Suzanne Muchnic, "Neiman-Warhol Exhibition is Causing a Flap," *St. Paul (MN) Pioneer Press*, November 22, 1981, 4; William Wilson, "The Artistic Promise of 1981," *Los Angeles Times*, December 27, 1981, J84; Robert Smith, "Letter to the Editor," *Los Angeles Times*, January 10, 1982, L87; Emily Hicks, "Kitsch's Revenge," *LA Weekly*, November 20–26, 1981, 27.

39 Suzanne Muchnic, "The Highs and Lows of Neiman-Warhol Show Art," *Los*

Angeles Times, November 16, 1981, G1; Tricia Crane, "Andy Warhol: Walking the Fine Art Line," *New York Daily News*, November 20, 1981, 25.

40 Peter Schjeldahl, "L.A. Demystified! Art and Life in the Eternal Present," *Village Voice*, June 3–9, 1981, 1, 32–37.

41 LAICA Newsletter, November 1981, box 24, folder 3, LNP.

42 Peter Plagens, "Mixed Double," *Art in America* (March 1982), 9–15.

43 Bockris, *Warhol*, 452; Robert Hughes, "The Rise of Andy Warhol," *New York Review of Books*, February 18, 1982, 6–10, 6.

44 Christopher Knight, "Big Name Art Show a Fiasco," *Los Angeles Herald Examiner*, November 19, 1981, B6; Neal Menzies, "Warhol and Neiman: A Losing Proposition," *ArtWeek*, December 12, 1981, 1. See also Christian Viveros-Faune, "And the Brand Plays On," *Village Voice*, September 1, 2010, 33; Colacello, *Holy Terror*, 453.

CHAPTER FOURTEEN

1 Debbie Sorrentino, "Neiman's Strokes Set for Games," *St. Paul (MN) Pioneer Press*, June 24, 1984, 3D; US Olympic Committee, press release, September 30, 1983, box 26, folder 15, LNP; LeRoy Neiman, Contract with US Olympic Committee, March 19, 1984, box 25, folder 16, LNP.

2 Bob Seizer, "SportsCast," *Hollywood Reporter*, July 19, 1984, 8.

3 Debbie Sorrentino, "Artist LeRoy Neiman Captures Thrill of Victory," *Los Angeles Times*, 1984.

4 Don Shirley, "Spectacle before the Sport," *Washington Post*, February 5, 1984, H1.

5 Shirley.

6 Barbara Isenberg, "Olympic Arts: Games, Culture as Teammates," *Los Angeles Times*, July 18, 1982, 6–7; Sylvie Drake, "Olympic Arts and Theaters: No Meet," *Los Angeles Times*, June 30, 1983, 2; Don Shirley, "Spectacle before the Sport," *Washington Post*, February 5, 1984, H1.

7 Robert J. Fitzpatrick, *Olympics Arts Festival* (Los Angeles: Los Angeles Times Syndicate, 1984), 14; Josh R. Lieser "Los Angeles and the 1984 Olympic Games: Cultural Commodification, Corporate, Sponsorship and the Cold War," PhD diss., University of California, Riverside, 2014, 198.

8 M. L. Sterin, "16 Top Artists Create Olympic Posters," *Boston Globe*, January 12, 1983, 36; Olympic Posters: A Celebration of Creativity," *Los Angeles Times*, July 24, 1984, U64; Barbara Isenberg, "Olympics Posters on View," *Los Angeles Times*, January 12, 1983, G1.

9 Elizabeth Venant, "Czar of the Arts," *Los Angeles Times*, January 15, 1984, K1; Don Shirley, "Spectacle Before the Sport," H1; Mark Donnelly, "Letter to the Editor," *Los Angeles Times*, January 29, 1984, M95.

10 Hammer Galleries Press Release, August 13, 1984, box 26, folder 15, LNP.

11 Robert Lipsyte, "Neiman Defies the Critics and Keep on Painting," *New York Times*, November 19, 1995, S11.

12 Invitation to the White House, 1981, box 5, folder 6, LNP.

13 Tom Dunkel, "A Brush with Success," *Northwest Orient* (August 1985), 46–49, 49.

14 LeRoy Neiman, "The Open Heart," 1982, box 24, folder 23, LNP; Dewey D. Schade to LeRoy Neiman, January 18, 1982, box 24, folder 23, LNP.

15 Richard H. Guthrie to LeRoy Neiman, July 30, 1982, box 5, folder 8, LNP; Mark Simon to LeRoy Neiman, June 23, 1989, box 23, folder 25, LNP.

16 Peter J. Venison to LeRoy Neiman, May 18, 1984, box 6, folder 4, LNP; Peter J. Venison to LeRoy Neiman, January 10, 1985, box 6, folder 11, LNP.

17 Philip H. Dougherty, "Arrow Man is Painted by Neiman," *New York Times*, January 6, 1986, D10; Lisbeth Levine, "Shirt Maker Points Elegant 'Arrow Man toward the Fast Track," *Palm Beach (FL) Post*, November 22, 1986; Polly Rayner, "Button-Down Art," *Morning Call*, August 31, 1986, E1; *Arrow Shirt Advertisement*, 1986, box 27, folder 10, LNP; John Wilson, "Outtakes the Sequel: Phoning Home," *Los Angeles Times*, May 24, 1987, K24; *Back Stage*, May 22, 1987, 65; "Michael/Daniel Shoots Sharply with Todd Allan," *Back Stage*, June 5, 1987, 27. The GE ad was intended to run as a national spot, but it never made it to air.

18 "Silvercup Studio for Neiman," *Back Stage*, July 27, 1984, 3; "Ciani/Musica Answers G.E.'s Mobile Phone," *Back Stage*, December 7, 1984, 86; Outline for GE Neiman Commercial, May 7, 1984, box 26, folder 19, LNP; GE, contract with LeRoy Neiman, June 26, 1984, box 26, folder 19, LNP; Sheila Fox to LeRoy Neiman, February 20, 1985, box 26, folder 19, LNP.

19 James C. Somers, "LeRoy Neiman: Art, Corvettes, and 'Monkeyshines,'" *Corvette News* (Summer 1985), 12–19.

20 Curtis W. Casewit, *Making a Living in the Fine Arts* (New York: Macmillan, 1981), 144; Richard Perry, interview with author, June 6, 2017.

21 Paul Farhi, "Bordello Solicits Investors," *Washington Post*, September 23, 1988, F1; Katherine Bishops, "For Sale: Nevada Ranch w/105 Rms," *New York Times*, March 23, 1989, A16.

22 Robert Varner, interview with author, April 19, 2017; Richard Perry, interview with author, June 6, 2017.

23 Varner interview, April 19, 2017; Knoedler Publishing to Lynn Quayle, August 1, 1983, box 5, folder 12, LNP; Lynn Quayle to Don Mackey, December 27, 1989, box 17, folder 9, LNP.

24 M. S. Wyeth Jr. to LeRoy Neiman, November 18, 1977, box 17, folder 9, LNP.

25 Robert Bennett Neiman promotional material, n.d. box 17, folder 8, LNP.

26 See Charles Leerhsen, Nikki Finke Greenberg, Maggie Malone, and Renee Michael, "The Party's Over," *Newsweek*, August 4, 1986, 50–56; Steven Watts, *Mr. Playboy: Hugh Hefner and the American Dream* (Hoboken, NJ: Wiley, 2008), 346–47.

27 Richard S. Rosenzweig to LeRoy Neiman, May 2, 1988, box 16, folder 10, LNP; Alexandra Peers, "Playboy Enterprises Discovers Art Is Enriching as It Turns to Its Collection to Boost Results," *Wall Street Journal*, January 27, 1989, C2; Kevin Allman, "Bat Art Marks 50 Years of Caped Crusading," *Los Angeles Times*, July 2, 1989, 460.

28 LeRoy Neiman to Hugh Hefner, November 14, 1989, box 16, folder 10, LNP; Hugh Hefner to LeRoy Neiman, November 21, 1989, box 16, folder 10, LNP.

29 Kathy Hogan Trocheck, "LeRoy Neiman: The Man Behind the Mustache," *Atlanta Constitution*, June 3, 1989, B4; Knoedler Publishing, press release,

"Artist LeRoy Neiman Introduces New Techniques," March 18, 1989, box 3, folder 12, LNP.

30 *Doonesbury*, February 5, 1981.

31 Terry Clifford, "The Remade Classic: Pond Scum on the Waters of Time," *Chicago Tribune*, October 24, 1988, C5.

32 Jane Stern and Michael Stern, *The Encyclopedia of Bad Taste* (New York: HarperCollins, 1990), 229.

33 "Can'tcha Take a Joke?" *Chicago Tribune*, November 24, 1983, D28.

34 Pete Dexter, "Dying for Art's Sake," *Esquire*, July 1984, 167.

35 LeRoy Neiman to Russell Sebring, July 2, 1986, box 6, folder 17, LNP.

36 Edward Lewine, "LeRoy Neiman Looks in the Mirror," *New York Times*, September 22, 1996, CY4.

37 Louis Nizer to *Saturday Review* magazine, June 6, 1980, box 5, folder 4, LNP.

38 Franz Lidz, "LeRoy, You're a Real Piece of Work," *Sports Illustrated*, October 21, 1985, 60–70, 66, 70.

39 Franz Lidz to *Sports Illustrated*, n.d., box 6, folder 11, LNP; Franz Lidz to LeRoy Neiman, n.d., box 6, folder 11, LNP. *Sports Illustrated* published two letters to the editor in its November 4, 1985, issue from Neiman fans who took issue with Lidz's article.

40 Franz Lidz, interview with author, December 5, 2022.

41 LeRoy Neiman to David L. Gould, January 4, 1984, box 16, folder 24, LNP; David L. Gould, interview with author, May 4, 2022.

42 Debbie Sorrentino, "Neiman's Strokes Set for Games," *St. Paul (MN) Pioneer Press*, June 24, 1984, 3D.

CHAPTER FIFTEEN

1 Dorothy Burkhart, "LeRoy Neiman Gets No Credit, But His Art Piles Up the Cash," *Philadelphia Inquirer*, September 24, 1989, 12H.

2 LeRoy Neiman, *Monte Carlo Chase* (New York: Alfred Van Der Marck Editions, 1988), 17, 13.

3 Neiman, 28, 29.

4 Alan Citron and Louis Sahagun, "Art Boom: A Market for Fraud," *Los Angeles Times* (Valley Edition), October 30, 1989, A1.

5 Neiman, *Monte Carlo Chase*, 25.

6 Neiman, 41, 42, 43.

7 Ralph Novak, "Picks & Pans," *People*, September 19, 1988, 11–12.

8 Albert Boime to LeRoy Neiman, October 27, 1975, box 4, folder 4, LNP.

9 F. Lanier Graham, "The Neiman Phenomenon," in *The Prints of LeRoy Neiman* (New York, Knoedler, 1980).

10 Herbert J. Gans, *Popular Culture & High Culture: An Analysis and Evaluation of Taste*, 2nd ed. (New York: Basic Books, 1999), xi, xiv.

11 David Halle, interview with author, May 4, 2017.

12 David Halle and Louise Mirrer, "Prints of Power: A Sociological Study of the Artist, LeRoy Neiman, and 1,000 Neiman Collectors," in *The Prints of LeRoy Neiman, 1980–1990*, by LeRoy Neiman (New York: Knoedler, 1991), 13–22, 13.

13 Roland Barthes, "Erté, or À la lettre," in *The Responsibility of Forms: Critical*

Essays on Music, Art, and Representation, trans. Richard Howard (New York: Hill and Wang, 1985), 103–28, 103.

14 Halle and Mirrer, "Prints of Power," 13, 15.

15 Halle and Mirrer, 18.

16 LeRoy Neiman to David Halle, November 1, 1990, box 3, folder 17, LNP.

17 Halle interview, May 4, 2017.

18 Terrence Murphy to LeRoy Neiman, February 1, 1979, University of St. Thomas Special Collections.

19 LeRoy Neiman to Terrence Murphy, November 3, 1985, University St. Thomas Special Collections.

20 Terrence Murphy to Quent Hietpas, November 2, 1985, University of St. Thomas Special Collections.

21 Terrence Murphy to Dennis J. Dease, November 26, 1991, University of St. Thomas Special Collections.

22 LeRoy Neiman to Dennis J. Dease, February 3, 1992, University of St. Thomas Special Collections.

23 Mark Quayle, "Sports Artist to Deliver Whopper of a Commencement Speech," *The Aquin*, February 21, 1992, 5, University of St. Thomas Special Collections.

24 John T. Dosch to the Editor, *The Aquin*, March 6, 1992, 5, University of St. Thomas Special Collections.

25 Terrence J. Murphy, "Neiman Unfairly Shunned," *The Aquin*, May 8, 1992, 4, University of St. Thomas Special Collections.

26 LeRoy Neiman, *All Told: My Art and Life among Athletes, Playboys, Bunnies, and Provocateurs* (Guilford, CT: Lyons Press, 2012), 304; Dennis J. Dease to LeRoy Neiman, March 6, 1992, University of St. Thomas Special Collections.

27 Mary Lynn Smith, "Women's Group, Art Museum Vie for Jemne Building," *Star Tribune*, June 4, 1997, 2B.

28 Mary Abee and Joe Kimball, "Museum Would Honor St. Paul Artist Neiman," *Star Tribune*, June 26, 1996, 1A; Ann Baker, "Knutson or Neiman?" *St. Paul (MN) Pioneer Press*, June 4, 1997, 1A.

29 Katherine Lanpher, interview with author, June 21, 2022; "1996: The Year in Review," *Star Tribune*, December 29, 1996, 8F.

30 Katherine Lanpher, "Neiman Is Popular, but His Art Stinks," *St. Paul Pioneer Press*, June 24, 1997, 1B.

31 Curt Brown and Mary Lynn Smith, "Artist Neiman Angrily Quits St. Paul Museum Project," *Star Tribune*, July 3, 1997, 1B; Ann Baker, "Neiman Pulls Out of St. Paul Museum Plans," *St. Paul (MN) Pioneer Press*, July 3, 1997, 1B.

32 Ann Baker, "Neiman Pulls Out of St. Paul Museum Plans," *St. Paul (MN) Pioneer Press*, July 3, 1997, 1B; Curt Brown and Mary Lynn Smith, "Artist Neiman Angrily Quits St. Paul Museum Project," *Star Tribune*, July 3, 1997, 1B.

33 Ann Baker, "Knutson or Neiman?" *St. Paul (MN) Pioneer Press*, June 4, 1997, 1A; Ann Baker, "Neiman Remains Out of the Jemne Museum Plan," *St. Paul (MN) Pioneer Press*, July 9, 1997, 1B.

34 Ann Baker, "Neiman Remains Out of Jemne Museum Plan," *St. Paul (MN) Pioneer Press*, July 9, 1997, 1B.

35 Baker.

36 Joe Soucheray, "Neiman Makes Art I Can Understand," *St. Paul Pioneer Press*, July 13, 1997, 1B; Katherine Lanpher, interview with author, June 21, 2022.

37 Lanpher interview, June 21, 2022.

38 Walker Lundy, "Does This Paper Tolerate Opinionated Provocations on Its Pages?" *St. Paul (MN) Pioneer Press*, July 13, 1997, 15A; Robert Varner, interview with author, April 19, 2017.

39 Ann Baker, "Neiman Pulls Out of St. Paul Museum Plans," *St. Paul Pioneer Press*, July 3, 1997, 1B; Mary Lynn Smith, "Museum's Fate May Hinge on Power Lunch with State Delegation," *Star Tribune*, July 11, 1997, 21A.

40 "Proposed Neiman Museum: Artist Should Reconsider His Act of Petulance," *St. Paul (MN) Pioneer Press*, July 6, 1997, 18A; Walker Lundy, "Why Does This Paper Tolerate Opinionated Provocations on Its Pages?" *St. Paul (MN) Pioneer Press*, July 13, 1997, 15A.

41 Katherine Lanpher, "Neiman Flap Proves Money Drives Plan," *St. Paul (MN) Pioneer Press*, July 6, 1997, 1B.

42 "Neiman Market," *Star Tribune*, December 29, 1996, F8; Curt Brown, "The Art of the Re-Deal: Neiman Commits to St. Paul Museum," *Star Tribune*, July 15, 1997, 1A.

43 Curt Brown, "The Art of the Re-Deal: Neiman Commits to St. Paul Museum," *Star Tribune*, July 15, 1997, 1A.

44 "Patron of the Arts," *Manhattan* (Winter 1996), 10–13.

45 "LeRoy Neiman Donates $6M to Columbia for an Art Center," *New York Times*, September 30, 1005, 20; Neiman, *All Told*, 262.

46 "Neiman Gift Celebrated at Miller Theatre Opening," *Columbia Magazine* (Columbia University), Winter 1996, 16.

47 UCLA, press release, October 9, 1998, box 32, folder 11, LNP.

48 Halle interview, May 4, 2017; Tommy Hawkins, interview with author, July 19, 2017.

CHAPTER SIXTEEN

1 Tod Rosensweig, interview with author, June 12, 2019; Steve Lipofsky, interview with author, June 6, 2019.

2 Timothy W. Smith, "No Ducking: Holyfield Says He'll KO Lewis," *New York Times*, March 10, 1999, D5.

3 LeRoy Neiman to Benedikt Taschen, September 30, 2002, box 34, folder 3, LNP.

4 Mike Meyers, "Collecting Art for Investment's Sake," *Star Tribune*, October 1, 1989; "Resort Art," *Forbes*, January 18, 1993, 100.

5 Nadine Brozan, "Chronicle," *New York Times*, April 8, 1997, B22.

6 Steve Rushin, "Little Daddy," *Sports Illustrated*, July 22, 1996, 250.

7 Robert Lipsyte, interview with author, May 10, 2017; Robert Lipsyte, "Neiman Defies the Critics and Keeps on Painting," *New York Times*, November 19, 1996, S11; LeRoy Neiman Notes, LeRoy Neiman Foundation, 1661.

8 Eric Marciano, interview with author, May 27, 2022.

9 Eric Marciano, interview with author, May 1, 2017.

10 Marciano interview, May 27, 2022.

11 Gigi Olman, interview with author, April 18, 2017.

12 Steve Ross, interview with author, November 5, 2019.

13 Patty Otis Abel, interview with author, December 9, 2022.

14 Abel interview, December 9, 2022.

15 LeRoy Neiman, *All Told: My Art and Life among Athletes, Playboys, Bunnies, and Provocateurs* (Guilford, CT: Lyons Press, 2012), 331.

16 Richard Perry, interview with author, June 6, 2017.

17 LeRoy Neiman, Author Interview, *Curled Up with a Good Book*, n.d., https://www.curledup.com/int_leroy_neiman.htm.

18 Corey Kilgannon, "From Neiman at 90, Canvases as Bold as Ever," *New York Times*, July 9, 2011, A16.

19 Esther Penn, interview with author, December 8, 2022; Neiman, *All Told*, 290.

20 Tommy Hawkins, interview with author, May 3, 2017; Neil Leifer, interview with author, November 28, 2022.

21 Robert Grenon, interview with author, November 29, 2022; Esther Penn, interview, December 8, 2022.

22 Ross interview, November 5, 2019.

23 Grenon interview, November 29, 2022.

CONCLUSION

1 Ken Johnson, "Fame without a Legacy," *New York Times*, June 23, 2012, C1.

2 Richard Prince, Bird Talk, June 20, June 23, and October 6, 2012, http://www.richardprince.com/contact/.

3 Roger Gilmore to LeRoy Neiman, November 9, 1981, School of the Art Institute of Chicago Special Collections.

4 The SAIC awarded Janet Neiman an honorary doctorate in 2015 to acknowledge the support she and LeRoy provided the school. Janet shared the stage with the producer and musician Kanye West, a Chicago native who was also being awarded an honorary degree.

5 Tim Schneider, "The Cleveland Cavaliers Have Hired Artist Daniel Arsham," Artnet.com, November 17, 2020, https://news.artnet.com/art-world/daniel-arsham-cleveland-cavaliers-nba-1924041; Taylor Stoddard, "The Cleveland Cavaliers Tap Artist Daniel Arsham as Creative Director," Forbes.com, November 19, 2020, https://www.forbes.com/sites/taylorboozan/2020/11/19/the-cleveland-cavaliers-tap-artist-daniel-arsham-as-creative-director/?sh=cec9066caaa8.

6 Donald Trump hired Neiman on several occasions to create artwork for his casinos, which often hosted boxing matches. Trump also commissioned portraits of his father (1987), his first wife, Ivana (1988), and his second wife, Marla (1992). Neiman gifted Trump a portrait for his birthday in 1986. See Donald Trump to LeRoy Neiman, November 17, 1987, box 16, folder 20, LNP; Donald Trump to LeRoy Neiman, August 18, 1992, box 16, folder 20, LNP; Hammer Galleries inventory description, May 30, 1996, box 16, folder 20, LNP.

Index

Page numbers in italics refer to illustrations.